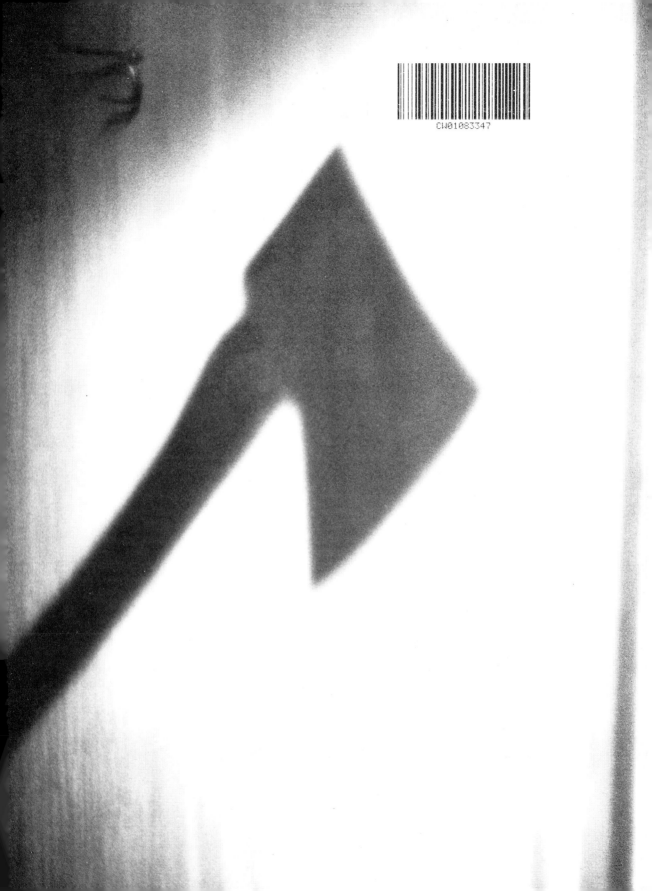

MAKING FRIDAY THE 13TH
THE LEGEND OF CAMP BLOOD

First edition published by FAB Press, February 2005

FAB Press
7 Farleigh
Ramsden Road
Godalming
Surrey
GU7 1QE
England, U.K.

www.fabpress.com

Front cover illustration
Adapted from poster artwork used for original theatrical release of **Friday the 13th Part Two**.

Back cover illustration
Promotional artwork for the fourth film in the series, **Friday the 13th: The Final Chapter**.

Frontispiece illustration
The killer's weapon casts an ominous shadow during the first night of terror at Camp Crystal Lake, in the original **Friday the 13th**.

Acknowledgements page illustration
Jason Voorhees weilding a machete, his fearsome weapon of choice, in **Friday the 13th Part VII: The New Blood**.

A CIP catalogue record for this book is available from the British Library

ISBN 1903254310

MAKING FRIDAY THE 13TH

THE LEGEND OF CAMP BLOOD

DAVID GROVE

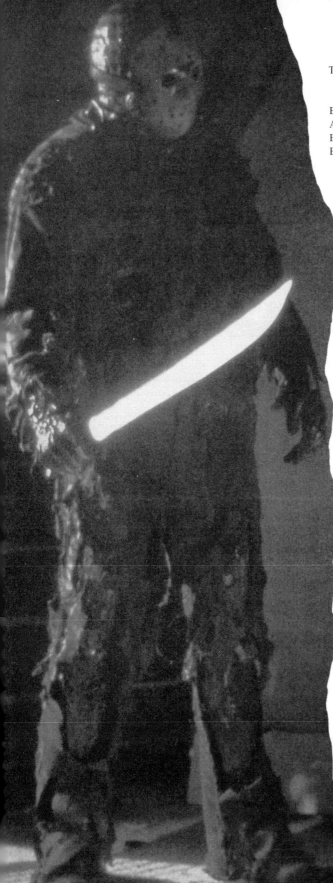

Acknowledgements

The author would like to thank the following people for their contributions to the creation of this book:

Barry Abrams, Melyssa Ade, Waleed B. Ali, Glenn Allen, Allan A. Apone, David Avallone, Kevin Bacon, Kirsten Baker, Chas. Balun, Gabe Bartalos, Peter Barton, Laurie Bartram, Pamela Basker, Kimberly Beck, Martin Becker, Don Behrns, Martin Blythe at Paramount Home Entertainment, Mitchell Bogdanowicz, Marty Bowen, Peter M. Bracke, Jimmy Bradley, Dominick Brascia, Francis Brewster, Joe Bob Briggs, Richard Brooker, Lammert Brouwer, Peter Brouwer, Paul Brown, John Carl Buechler, Ronn Carroll, Stokely Chaffin, Fern Champion, Chris Charlston, Stu Charno, Randolph Cheveldave, Wanda Clark, Barney Cohen, Jennifer Cooke, Wes Craven, Harry Crosby, Cliff Cudney, Juliette Cummins, Noel Cunningham, Sean S. Cunningham, Jensen Daggett, Steve Dash, Jeffrey S. Delman, Michael De Luca, Jack Dirr, Lexa Doig, John Dondertman, Roger Ebert, Robert Englund, Tibor Farkas, Todd Farmer, Gerald Feil, Corey Feldman, Richard Feury, Virginia Field, John Foster, Paul Freedman at Cards Inc., Bill Freda, William Fruet, Carl Fullerton, John Furey, Richard Gant, Warrington Gillette, Crispin Glover, Joel Goodman, C.J. Graham, Tim Greaves, Bruce Green, Tom Gruenberg, Simon Hawke, Debra S. Hayes, Rob Hedden, Tiffany Helm, George Hively, Kane Hodder, Barbara Howard, James Isaac, Katharine Isabelle, Greg Johnson, Diane Kamahele at Sideshow Collectibles, David Katims, Sean Kearnes, Kari Keegan, Joan Kessler, Dana Kimmell, Adrienne King, Melanie Kinnaman, Steven Kirshoff, Ken Kirzinger, Martin Kitrosser, Marta Kober, Heidi Kozak, Paul Kratka, Ron Kurz, Kyle Labine, Louis Lazzara, Erik Lee, Ari Lehman, John D. LeMay, Lar Park Lincoln, Dean Lorey, Frank Mancuso, Jr., Harry Manfredini, Adam Marcus, Jack Marks, Thom Mathews, Tom McLoughlin, Peter Mensah, David Miller at David Miller Creations, Victor Miller, Ron Millkie, Armen Minasian, Steve Miner, Steven Monarque, Laurel Moore, Tom Morga, Robbi Morgan, Barry Moss, Lee Anne Muldoon, Dennis Murphy, Kenny Myers, Mark Nelson, Dean A. Orewiler at Orewiler Photography, Betsy Palmer, Francisco X. Perez, Petru Popescu, Marilyn Poucher, Bill Randolph, Scott Reeves, Jason Ritter, Louise Robey, Shavar Ross, Kelly Rowland, Lisa Ryder, Martin Jay Sadoff, Bruce Hidemi Sakow, Nick Savage, Tracie Savage, Tom Savini, Ariel Shaw, John Shepherd, Kevin Spirtas, Taso N. Stavrakis, Amy Steel, Peter Stein, Danny Steinmann, Steve Susskind, Jeannine Taylor, Lauren-Marie Taylor, William Terezakis at WCT Productions, Russell Todd, Christine Torres, Cindy Veazey, Deborah Voorhees, Douglas J. White, Ted White, Brooke Wheeler, Chris Wiggins, Ronny Yu, Michael Zager, Larry Zerner, Joseph Zito...
and
My Mother.

Author's note: All quotes in this book are taken from interviews conducted by the author.

Contents

Ghosts of Camp Blood

It must have been 1982 or 1983 and I was about ten years old, still young enough to hide under the covers at night - frightened of what might be lurking in my closet or hiding under the bed. I had just been terrified by a film I'd seen whilst curled up in front of the television set; it was a film like no other I'd ever seen before. The name of the film was *Friday the 13th*.

Friday the 13th wasn't the first film that had a big effect on me: my earliest film memories were of seeing *Star Wars* and *Superman*. However, *Friday the 13th* was the first film that scared the hell out of me and the memory of that wonderful feeling has stayed with me to this day. What was it that scared me so much? I was scared by the sight of the camp counselors being slaughtered one by one in the kind of inventive ways I'd never seen before (the sight of Harry Crosby pinned to the door with arrows is a vision I still can't shake). I hadn't seen *Halloween* yet, or the films of Argento and Bava. *Friday the 13th* was it. Still is.

What really scared me the most though was the appearance of Mrs. Pamela Voorhees, *Friday the 13th*'s cackling and totally demented killer, with those black eyes and that deranged smile that suggested such dark madness. I now have to remind myself that the hockey mask hadn't yet become a part of Americana when *Friday the 13th* made its debut in 1980. Jason was just a drowned dead twinkle in his psychotic mother's eyes. He *was* dead... wasn't he? This was 1980. Things sure changed after that.

It's almost hard to believe, given what was to follow in the next twenty-plus years, that the *Friday the 13th* series began with real suspense and genuine tension, two qualities that were crudely abandoned in the course of nine increasingly dishevelled sequels. I remember. Camp Crystal Lake was a very scary place once, full of ghosts. If only the Christy family - the camp's doomed benefactors and founders - had known of the horror that was to follow, they might well have blown the area to bits. How could they have known though? And how could horror fans have known what was to to be spawned by the original *Friday the 13th*?

Between 1980 and 1984, the *Friday the 13th* films changed not only the horror landscape, but also the way that Hollywood conducted business.

This was a period when these films reigned at the box office, a definable era that would see the spawning of an entire sub-genre of *Friday the 13th* clones, many of which struggled at the box office. *Friday the 13th* however lived on.

Of course, the endless *Friday the 13th* copycats (*The Burning, Final Exam, Graduation Day, Happy Birthday to Me*, etc.) that began to appear at the beginning of 1981 are legion, all trying to repeat the commercial success of their role model, and all failing. It's notable that, in 1981, every studio in Hollywood bankrolled its own slasher movie, its own *Friday the 13th* if you will. The boom period for this type of genre film was short-lived, but the *Friday the 13th* series had a life of its own and, indeed, it went on to experience even more

opposite:
Pamela Voorhees (Betsy Palmer) roams in the woods after dark, murderous vengeance on her mind, in a publicity still from *Friday the 13th.*

below:
William Terezakis's hockey mask design for Jason Voorhees (Ken Kirzinger) in *Freddy Vs. Jason* featured removable eyes. (Illustration courtesy of William Terezakis.)

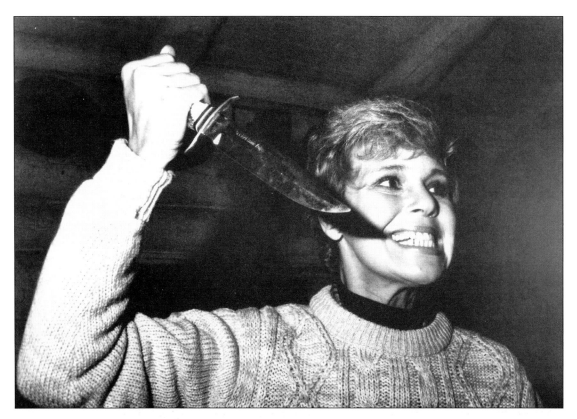

above:
Betsy Palmer assumes a murderous pose. Palmer was hired only after Estelle Parsons turned down the part, but it is now impossible to imagine anyone else taking the role.

popularity between 1982 and 1984. The cycle seemed like it was never going to end, like a magical summer vacation before a dreaded school semester.

This book documents the making of not only *Friday the 13th* and its popular sequels, but the making of a horror phenomenon - one that appeared to have died towards the end of 1984 with the release of *Friday the 13th: The Final Chapter*, for many years the last commercially successful *Friday the 13th* film. Prior to the release of the phenomenally popular *Freddy Vs. Jason* in 2003 the entire *Friday the 13th* franchise had been caught in a downward spiral ushered in by the appearance, in 1985, of *Friday the 13th Part V: A New Beginning*. If only *The Final Chapter* had lived up to its titular promise, perhaps it would've been a fitting end to a specific and unique era in film history. However, after *A New Beginning*, fans lost interest, weary of tired plots and watered-down shocks. A monster by the name of Freddy Krueger might have had something to do with it as well. Times had changed. By the mid-1980s, *Friday the 13th* was no longer the only horror game in town. Elm Street was the place to be.

This book might well have been called *1980-1984: Birth of a Slasher Nation*, a reference to a specific place and time in the movie business when everyone and their sister were making horror films,

slasher films, all trying to copy the *Friday the 13th* formula (the artistic brilliance of John Carpenter's *Halloween* was most likely regarded as an unattainable goal for these filmmakers). I started writing this book whilst visiting the set of *Freddy Vs. Jason*, an attempt to resurrect not just the *Friday the 13th* series but the *Nightmare on Elm Street* franchise as well, which after dethroning the *Friday the 13th* series at the top of the horror landscape had also found itself in steep decline by the end of the decade. But resurrection is sweet and paybacks are hell, especially when they happen on a Friday the thirteenth.

I'm standing on the edge of Camp Crystal Lake, even though this place is really located near the small town of Ioco, British Columbia, up near an isolated patch of forest known as Buntzen Lake. It's about fifteen minutes away from my house. I used to go to camp around here, at Camp Howdy. Safety. You can hear traffic through the trees, but the place is still haunted. This is Camp Crystal Lake, but to millions of *Friday the 13th* fans around the world, this place will forever be known as Camp Blood - the fictional nickname given to the lakeside setting in the original *Friday the 13th* film. This is where it all began. Camp Blood. As I listen closely, I can almost make out the screams of a child. The ghosts are everywhere.

Humble Beginnings

The roots of *Friday the 13th*, indeed of the modern horror genre itself, can be traced back to the dawn of the 1970s and a group of obscure Boston-based businessmen whose names will probably be unfamiliar to most *Friday the 13th* fans. Stephen Minasian and Philip Scuderi are, unbeknownst to legions of horror fans around the world, two of the most important figures in the history of horror films. If it weren't for them, the work of Mario Bava might never have been discovered by American audiences and genre filmmakers such as Wes Craven, Sean S. Cunningham and Steve Miner might never have burst onto the scene.

Minasian and Scuderi were partners with Robert Barsamian (whose own daughter, Lisa Barsamian, would later produce several *Friday the 13th* sequels) in a New England-based theatre chain called Esquire Theatres of America. *Friday the 13th* would, ultimately, become the defining achievement of their careers, but that was still a decade away. It was 1970 and Minasian and Scuderi were on the verge of rewriting horror history with the help of some talented filmmakers, the most important of whom would be, in terms of the ultimate birth of the *Friday the 13th* franchise, Sean S. Cunningham.

Cunningham, born in New York on December 31, 1941, had graduated from Stanford University with a Masters Degree in Drama and Film only after giving serious consideration to attending medical school with the intention of becoming a Doctor. However, he soon decided that he loved film and the theatre more than medicine. "I knew that I didn't want to practice medicine," says Cunningham. "Theatre, and later Film, seemed like a great way to make a living; a job you could have fun with and be creative in."

Cunningham spent the early part of his professional career as a stage manager on theatrical productions. Anxious to make his mark in the world of filmmaking, he moved into a West 45th Street Building in New York to set up a fledgling production company. Cunningham started out by producing commercials, industrial films, anything to keep himself alive, then in early 1970, he made his feature filmmaking debut by directing and producing – without giving himself any sort of screen credit - a sex-education film entitled *The Art of Marriage*. Later that same year, Cunningham got together with then-production partner Roger Murphy to make another pseudo-documentary sex film, this time entitled *Together*, and featuring an early starring role by none other than Marilyn Chambers, who was destined to become one of the first major American porn superstars.

Cunningham shot *Together* in and around his home town of Westport, Connecticut, and financed the production by selling shares in the film. By all accounts the editing process was nightmarishly difficult, but by the end of 1970 he had assembled a finished cut of the film and immediately set about looking for a distributor. Cunningham travelled to Boston to meet with Minasian and his associates who, by this time, had decided to expand the Esquire theatres empire to include film distribution

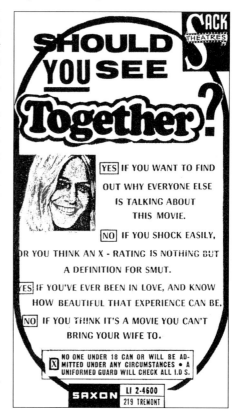

left:
The X-rated hit *Together* marked the beginning of Sean S. Cunningham's working relationship with Stephen Minasian and Philip Scuderi.

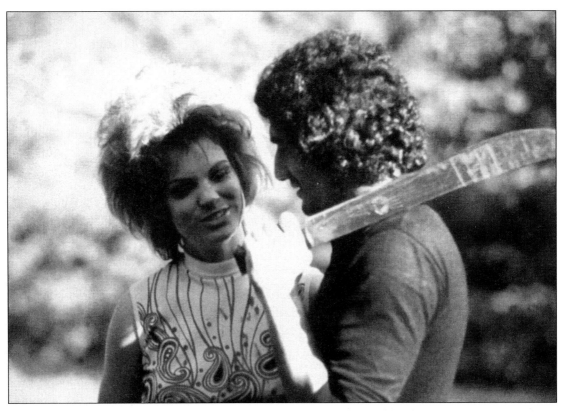

above:
David Hess weilds a machete in a scene from *Last House on the Left*, which marked Sean S. Cunningham's first teaming with Steve Miner. The two men later joined forces again to make *Friday the 13th*.

under the Hallmark Releasing Corporation banner. *Together* became the first film that Hallmark would handle in this capacity, after Cunningham was paid $10,000 for the rights. A key component in the birth of the *Friday the 13th* film series had been established.

Cunningham was impressed by the work that Hallmark was doing, and had a lot of faith in Minasian and Scuderi. "Phil and Steve were both marketing geniuses – everyone at Hallmark was," recalls Cunningham. "They had a keen sense in terms of what audiences would pay to see."

Despite its soft-core sex content, *Together* was a significant film for horror fans all over the world – especially fans of the *Friday the 13th* and *Nightmare on Elm Street* franchises – because it marked Cunningham's first collaboration with Wes Craven, a former college professor and budding filmmaker who had been contracted by Cunningham to help in the completion of *Together*.

When *Together* was officially released in August of 1971, the film was greeted with generally favourable critical reactions - surprisingly so considering its subject matter - and performed well at the box office. Encouraged by this success, Hallmark expressed their interest in financing a film to be developed by Craven and Cunningham, who

had developed an instant working chemistry on *Together* and were anxious to collaborate on another film. $50,000 was allocated for the project, and Cunningham duly embraced the idea, but this time he wanted to create a film that was truly significant while at the same time being irresistibly commercial. It was a state of mind that Cunningham would grow accustomed to over the course of his long filmmaking career.

By September of 1971, Craven and Cunningham had mapped out the idea for their next project, which at the time they referred to as *Sex Crime of the Century*. By the time of the film's release, its title had been changed to *Last House on the Left*, and it is of course now regarded as a seminal horror classic. Craven's completed script for *Last House on the Left* was read by Minasian and Scuderi with stunned enthusiasm, and a much-increased budget. "Phil and Steve were very passionate about film and horror films in particular," recalls Craven (who incidentally met Peter Locke, producer of his 1977 film *The Hills Have Eyes*, at the very same office where he'd been working for Cunningham).

Last House on the Left marked the beginning of another important relationship for Cunningham. Steve Miner was, at the time, a young film devotee

who dreamed of a career in filmmaking. Miner was an art school graduate who had just returned to Westport, Connecticut after some time spent drifting. He was at a crossroads in his life. "After I finished college, I wasn't sure what I wanted to do for a career so I went out to Los Angeles with some friends who were in a rock band," recalls Miner. "We lived in an apartment right next door to Stan Winston who was, at the time, a struggling stand-up comedian. Stan told me about his aspirations of becoming a great makeup artist in the movies. I was just about to go to Colorado to become a ski bum. Next I heard from Stan, he was a rising young star in the makeup field, which was a great inspiration for me. I made up my mind that I was going to pursue a career in film, but I didn't know how I was going to get my start."

Miner was only twenty years old when he made Cunningham's acquaintance. "He was full of energy and enthusiasm and I could see he had a lot of talent," recalls Cunningham. Miner's mother was a film librarian, who worked close to the family's home in Westport, which was just a stone's throw away from Cunningham's base of operations. "My mother would always bring home movies for us to watch," recalls Miner. "I'd see a lot of 16mm films and that's when I really started to fall in love with cinema and when I started to think about it in terms of a career. Living in Connecticut, it seemed really far away at the time. I was desperate to work on a film, any film. When I heard that Sean and Wes were doing *Last House* in Connecticut, near my home, I begged them for a job. I spent a lot of time making coffee for the actors and the crew but I learned so much about filmmaking."

When *Last House on the Left* was released in 1972, the film garnered much attention, its profile greatly aided by the controversy that dogged it wherever it played. It went on to do sizable business in the drive-in and urban neighbourhood movie house circuits. *Last House on the Left* made millions for its financiers and gave the careers of both Craven and Cunningham a mighty boost. "You know, I just started to make movies because it was a job," says Cunningham. "I was in college and I loved cinema, and I just thought that if I could ever make a living making films that it would be better than any other job I could get. I wasn't cut out for a typical nine-to-five job. I've always approached film on a very basic and simple level. It's not brain surgery."

1972 was a great year for the fledgling Hallmark Releasing Corporation, who also released such films as *Tombs of the Blind Dead*, *Deep End* and the notorious *Mark of the Devil*. Hallmark showed their deep understanding of the exploitation film market when they promoted *Mark of the Devil*

Produced by Sean S. Cunningham
Written and Directed by Wes Craven
Original Score by David A. Hess
Distributed by Hallmark Releasing Corp.
Starring David Hess, Jeramie Rain, Fred Lincoln,
Marc Sheffler, Sandra Cassell, Lucy Grantham

THEATRE

above:
Very early admat for *Last House on the Left* under one of its test-marketing titles.

by providing theatres with specially-branded vomit bags to excite the imagination of audiences. Another inspired Hallmark pickup that year was Mario Bava's *Twitch of the Death Nerve* a.k.a. *A Bay of Blood*, which the company initially renamed *Carnage* for its first release in the spring of 1972. Minasian was enamoured with the film and with Bava's work in general, and by the end of the year, they had changed the name of the film to *Twitch of the Death Nerve*, an inspired moniker which has stuck until the present day. The film is notable for its gory and inventive death scenes, and Hallmark exploited this fact, marketing the film heavily on the strength of its violence. No one at that time, certainly not Cunningham, knew that *Twitch of the Death Nerve* was destined to become an acknowledged classic, or that the film was destined to be identified as a major influence upon *Friday the 13th*.

"People always ask me what the actual inspiration was for *Friday the 13th* and, you know, it was a bunch of things," says Cunningham. "Obviously, from a financial standpoint, which was the most important factor at the time of making *Friday*, the success of *Halloween* was the main inspiration. I think Bava certainly inspired me. His films were shocking and really visually-stunning and they made you jump out of your seat, which

below:
Last House on the Left owed a large part of its success to its innovative marketing campaign, which utilised a wide variety of ominous slogans to draw in the crowds.

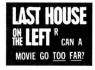

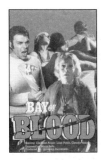

above:
A rare video cover for *Twitch of the Death Nerve* under one of its numerous alternative titles. Bava's film was a huge hit for Hallmark distribution.

below:
Reggie Nalder's star turn in the notorious *Mark of the Devil*, another successful Hallmark acquisition.

was what I wanted *Friday* to be all about. I knew *Friday the 13th* had to be totally different from *Last House on the Left*, which was a very raw, painful, cynically-edged film. I wanted to make a roller-coaster ride; a trip to Magic Mountain in a movie theatre."

The similarities between *Friday the 13th* and *Twitch of the Death Nerve* are obvious, although Bava's film could be described as a black comedy-horror film with its phantasmagoric story of greedy couples meeting their grisly ends while trying to steal a piece of lakefront property. The death scenes in both films rely on throat-cuttings, stabbings, and sundry other 'in your face' type shocks for their visceral impact. *Twitch of the Death Nerve* was not just a prototype slasher film: it used its kills to punctuate the flow of the story at carefully-timed intervals, amazing the audience with a flurry of shocking images, much as *Friday the 13th* would do a decade later. Is the violence contained in *Friday the 13th* and *Twitch of the Death Nerve* logical or grounded in reality? No. The violence in these films is the stuff of pure fantasy. But does it really matter as long as the audience screams?

The filmmaking adventure that was *Friday the 13th* was Cunningham and Miner's destiny, but in

the immediate aftermath of *Last House on the Left*'s release that was all a long way off in the future; first there was more pragmatic work to be done. The early 1970s saw the pair teaming up again to work on a series of industrial films. Miner worked as a production assistant on these projects (the first of which was about the thrilling subject of brake lining) as both men kept throwing around ideas for the next feature film they would, hopefully, make together. "Steve really went about learning the whole technical process of filmmaking. I'm very proud of him. We worked very well together," says Cunningham. "Working on the industrial films really gave me a grasp of editing, the whole cutting process," says Miner. "I feel like editing was a great foundation for my directing aspirations."

By the end of 1973 both men were anxious to make another film, even more so since Craven had decided to try his luck in Hollywood and appeared to be making some headway there. "I had my editing business in New York, but I was dying to do features," recalls Miner. "Wes was a great example because he'd taken the initiative and gone to Hollywood and gotten an agent and done it. I wanted to follow Wes's example because I could tell that he was headed for bigger and better things."

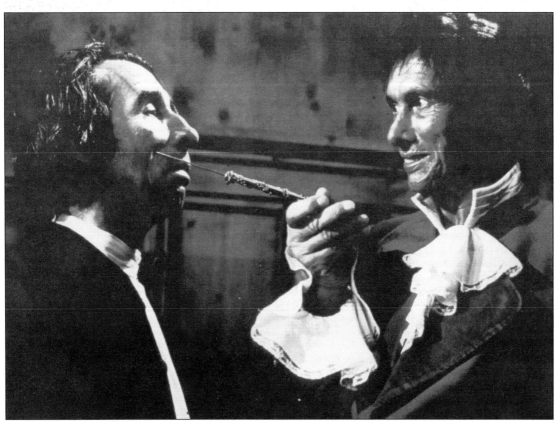

Cunningham and Miner made their next feature film in 1974, when they teamed up to shoot the X-rated comedy smut caper *Case of the Full Moon Murders* (a.k.a. *Case of the Smiling Stiffs, Sex on the Groove Tube*). Cunningham co-directed (with Brad 'Brud' Talbot) and produced the frankly ludicrous film, which featured notorious porn star Harry Reems. Miner worked on it as an editor. "It's the kind of film I'd never made before, not even with *Together*, and which I'll never make again," says Cunningham with a laugh.

The association with Talbot is important because it was he who introduced Cunningham to Victor Miller, the man who would script Cunningham's next two directorial efforts, *Here Come the Tigers* and *Manny's Orphans*, and who would then go on to become *Friday the 13th*'s writer (of record). "It was around the mid-1970s when a lovely woman named Karen Hitzig introduced me to a man named Brud Talbot," recalls Miller. "Brud introduced me to Sean Cunningham and then to Saul Swimmer. I wrote a screenplay for Brud and Saul called *The Black Pearl*, which got made. I never saw the film, but I heard it was a disaster. Brud died very young and he just couldn't buy a hit film. It was sad. Soon,

Sean and I began to really hit it off. We just started hanging out and talking about films that we'd like to make together."

Born in New Orleans in 1940, Miller would go on to graduate from both Yale College (in 1962) and Tulane University, where he obtained a degree in Theatre and Speech. The sixties and seventies would see him live through a whirlwind of occupations, all somehow leading him back to his true vocation: writing. Miller represents yet another Connecticut connection in the world of *Friday the 13th*: he spent a decade writing plays for theatres all over the East Coast. In the early 1970s, a turning point in Miller's life occurred when Pocket Books asked him to novelize a series of *Kojak* episodes. "That's when I knew I was a real writer; when somebody paid me three grand to write something," Miller recalls. "I quit the theatre immediately and started looking ahead although, as it turns out, I ended up having to get a day job because writing the novels didn't end up paying enough to live on. But I was hooked."

Cunningham's next two feature films were both released in 1978, and the first of them, *Here Come the Tigers,* was written by Miller under the pseudonym Arch McCoy. In common with Cunningham's next effort, *Manny's Orphans*, the

above:
Two lovers are about to be impaled whilst having sex in *Twitch of the Death Nerve*. Although *Friday the 13th* and *Twitch of the Death Nerve* contain many similarities, Sean S. Cunningham and Tom Savini deny any direct influence upon individual scenes in the later film.

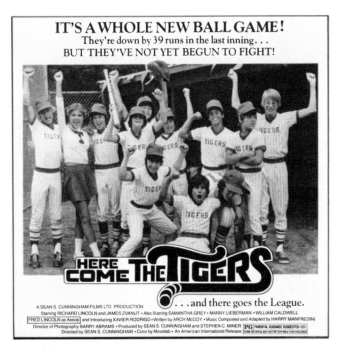

IT'S A WHOLE NEW BALL GAME!
They're down by 39 runs in the last inning. . .
BUT THEY'VE NOT YET BEGUN TO FIGHT!

HERE COME THE TIGERS
. . .and there goes the League.

A SEAN S. CUNNINGHAM FILMS LTD. PRODUCTION
Starring RICHARD LINCOLN and JAMES ZVANUT • Also Starring SAMANTHA GREY • MANNY LIEBERMAN • WILLIAM CALDWELL
FRED LINCOLN as Aesop and Introducing XAVIER RODRIGO • Written by ARCH McCOY • Music Composed and Adapted by HARRY MANFREDINI
Director of Photography BARRY ABRAMS • Produced by SEAN S. CUNNINGHAM and STEPHEN C. MINER | PG PARENTAL GUIDANCE SUGGESTED
Directed by SEAN S. CUNNINGHAM • Color by Movielab • An American International Release

above and below:
Advertisements for *Here Come the Tigers*. The financial failure of this *Bad News Bears* rip-off, written by Victor Miller under the pseudonym Arch McCoy, and featuring a cameo by Philip Scuderi, prompted Sean S. Cunningham to make *Friday the 13th*.

film was a blatant rip-off of *The Bad News Bears*, one of the big hits of 1976. The films also tried to copy the safe Disney-style commercial formula; the same formula that Steven Spielberg once remarked "produced films that all made $16 Million at the box office." Judging from financial records, it appears that neither film may have even made sixteen cents. Regardless, Cunningham enjoyed the leisurely tone of these light-hearted films, his first feature film efforts in three years. The films also reflected Miner's growing status within Cunningham's organisation: he co-produced and edited *Here Come the Tigers*, and co-produced and came up with the story for *Manny's Orphans*. Miner considers his co-production credits to be little more than deceptively impressive-sounding job titles. "We were basically just a couple of losers making films out of a garage in Connecticut," recalls Miner with a laugh. Not for long.

Cunningham is indifferent about these films, writing them off as learning experiences. "They were formula pictures and I had fun doing them," he says. "I knew they weren't going to be master-pieces. We had a theory at the time and the theory was that America was looking for some good old-fashioned family fare. That's where we made the mistake. The fact that they didn't make money put some pressure on me because, once again, I was desperate for a hit."

The films also cemented a few more profes-sional relationships of direct relevance to the

Friday the 13th story. For example the film's production designer Virginia Field also served as Art Director on *Manny's Orphans*, and *Friday the 13th*'s director of photography, Barry Abrams, performed the same duties on both *Here Come the Tigers* and *Manny's Orphans*. The films also marked Cunningham's first meeting with composer Harry Manfredini, the man who was destined to score *Friday the 13th* and so many sequels afterwards. Manfredini composed the music for both *Here Come the Tigers* and *Manny's Orphans* (interestingly enough, his first movie credit was the 1976 surrealist horror-porn film *Through the Looking Glass*) and - long before Manfredini's ki-ki-ki-ma-ma-ma riff became the definitive theme of the 1980s slasher generation - Cunningham and Manfredini became quick friends. "I'd kill for Sean Cunningham," says the composer. "I met Sean through a friend who was making his own kid's film at the same time that Sean was making his films. One thing led to another and soon I had the job scoring *Here Come the Tigers* and then the soccer movie which, I believe, was originally called *Kick* or something like that."

Manfredini studied music at Columbia University, where he earned two degrees in music. He spent many years as a saxophonist in his home town of Chicago before moving to New York, where he made some key contacts that led him, quite by accident, into the film business. "Those early movies, like many of the *Friday* films, were very simple and so, as a composer, I take the approach of simplicity," says Manfredini. "I liked horror movies because, oftentimes, they had great music. I adored Bernard Herrmann's *Psycho* score and I always stayed up late to watch those movies, mostly for the music. When it came to working with Sean, like I said, I'd do anything for Sean because he's been so good to me over the years. I'd work for Sean for free."

Barry Abrams, Virginia Field, Harry Manfredini, Victor Miller, Steve Miner. Cunningham had most of the people he needed to make not just horror film history, but cinematic history as well, even though he didn't know it yet. After the disappointing releases of *Here Come the Tigers* and *Manny's Orphans* in 1978, Cunningham spent some time carefully consid-ering his career options. Then, in the last months of the year, a film called *Halloween*, made for a cost of about $300,000 (next to nothing in the film business), shocked critics and moviegoers across America. The film went on to become, at the time, the most successful independent production in motion picture history, grossing more than $40 Million in the U.S. alone. Cunningham knew what he had to do.

Slash for Cash

*H*alloween seemed like a godsend for Sean Cunningham, who finally had what he thought was the perfect model for success. It was late 1978 and it wasn't as if any of the major Hollywood studios were rushing in to produce *Halloween* clones, but Cunningham was immediately plotting how to capitalise on John Carpenter's masterpiece.

"You don't think I could've gotten a horror film financed in the seven years prior to *Friday*?" Cunningham asks. "I'd spent the past five years trying not to be trapped within the horror genre, trying to do other things. The success of *Last House on the Left* was a bit of a curse in that I thought it would lead to more serious feature work, but it just had the effect of typecasting me. Hollywood always does that to you - especially back in the 1970s. I think *Halloween* showed that you could make a popular genre film and not be pigeonholed to the extent that *Last House* had pigeonholed me."

The commercial success of *Halloween* had taken everyone by surprise. Even more surprising was the fact that the film was a shocking critical success. Its writer-director John Carpenter had been considered a hot young director in Europe, where his cult classic *Assault on Precinct 13* had been extremely well received following its release in 1976. Famed American film critic Roger Ebert also acknowledges the film's importance, saying, "I've often compared *Halloween* to *Psycho*. I think it's a fair comparison because, with *Halloween*, it's such a terrifying experience to watch that film and you also feel a real joy with the director in the way that he's toying with the audience."

If Cunningham was going to make his own 'scary movie,' he knew he'd have to be really smart. He was unlikely to mirror Carpenter's masterful use of suspense and tension, not to mention the amazing camera-work and innovative lighting strategies that made even *Halloween*'s daylight scenes creepy. Cunningham started to deconstruct the film in terms of its plot structure and technique, trying to unlock the key to its success to aid him in the development of his own film.

According to Cunningham, the origins of *Friday the 13th* - in relation to *Halloween*'s success - stemmed from the fact that he had studied Carpenter's film, but not too closely. Also, while he saw *Halloween* as a clear inspiration in terms of its ability to excite and shock audiences, he was not interested in making another film like *Last House on the Left*. "I wanted to make a real scary movie, the kind of thing where people would have fun, where they would scream and then laugh because they were having so much fun," he says. "While *Last House* had a very disquieting effect on the audience, and was hard to enjoy, I knew that *Friday the 13th* had to be fun at least in terms of creating jolts in the audience, like *Halloween* had. Since I wasn't John Carpenter, I knew I'd have to find a unique approach to try and get to that same place."

If there was one idea that Cunningham was bringing to *Friday the 13th* from the experience of making *Last House on the Left*, it was a particular

below:
Michael Myers from the
Halloween film series.

above:
Halloween poster. Sean
S. Cunningham was
inspired by the success
of John Carpenter's
masterpiece during the
early development of
Friday the 13th.

stylistic approach to filmmaking. "I knew, before we made *Friday*, that the film would certainly have a very primitive look and feel, like *Last House*," he recalls. "As was the case with *Last House*, I knew I would have to take this approach because I'd have very little money with which to make it."

Cunningham wanted *Friday the 13th* to terrify audiences just like *Last House on the Left* did, but his new film had to be constructed so as to appeal to a mass audience. "I've always felt that a big part of the attraction of these films is that the people watching them probably think they could direct them themselves," he explains. "They're so raw in some ways that they almost seem like documentaries. My challenge was to try and turn *Friday the 13th* into a very real viewing experience, but a film that would also be a lot of fun to watch, unlike *Last House. Last House* was very painful, maybe too much for a lot of people."

The film's basic outline came together very quickly - Cunningham wanted his film to be full of young characters, ideally teenagers, who had to be in an isolated setting that was fresh and not hackneyed. The primary purpose of the film was to shock the audience, inducing the same reaction that Bava's *Twitch of the Death Nerve* had delivered with its groundbreaking and outrageous death scenes. "*Halloween* was a real artistic piece of work, but I knew that *Friday* was going to be very gory and very much like a Bava film," explains the director. "I think that the main inspiration I got from *Halloween*, aside from its success, was just the title. It was such a great title that, I think, even if they'd made a bad film, it would've done very well. I mean, some people said that *Halloween* copied *Black Christmas,* which came out years earlier. With *Friday the 13th*, I knew that the project was going to be nothing like *Halloween*, except that I wanted that same kind of impact; the jolts, the roller-coaster ride."

Fundamentally, *Friday the 13th* began with its title and no more. (Another moniker that had been floated around during the writing and pre-production process was *Long Night at Camp Blood*, but it did not last long.) Cunningham was absolutely convinced that he was onto something, so he took out an ad in the Hollywood trade magazine *Variety* that contained a now famous pronouncement: "From the producer of *Last House on the Left* comes the most terrifying film ever made." One problem: there was no workable script and without a script, Stephen Minasian and Phil Scuderi, then working under a production banner that would come to be called Georgetown Productions, weren't going to put up the cash. "The ad got a lot of attention, but I knew that I still had to come up with a great script to attract the money," recalls Cunningham. "I loved the title and I think everyone did at that point,

especially Phil and Steve, but I needed a story. The title itself, *Friday the 13th*, was really scary."

In truth, the ad in *Variety* was necessitated by the fact that Cunningham was terrified that someone else would take the name *Friday the 13th*, or indeed might have taken it already. A New York advertising agency was commissioned to develop the trademark broken glass insignia that would become *Friday the 13th*'s imprimatur in the franchise's early years. The agency then commissioned a young photographer named Richard Illy who, working with blocks and various camera lenses on the floor of his house, designed the first *Friday the 13th* logo. "I wanted to stake a claim to the title, get it out there. It was such a great title that I couldn't believe that *somebody* didn't own it. The big block letters and broken glass was my idea but the guys at the ad agency did a great job with the concept."

There was still the matter of financing, which was contingent upon the development of an excellent script. Cunningham turned to his old friend, Victor Miller, for help. "Sean told me, straight-out, that he wanted to do something that was an emotional roller-coaster ride," recalls the writer. "Sean called me up and told me about the great business that this film *Halloween* was doing. He asked me if I thought we could create the same kind of machine. Immediately, I went to see *Halloween*, several times, and I carefully studied the genre and the technique they used in that film."

This research led Cunningham and Miller to make a few important early decisions. "We made up some rules," says Cunningham. "I couldn't think of a location where the teenagers would be totally isolated, but that was the key. The summer camp idea just floated out and everything just spun off from there and I'd have to give Victor credit for that." Miller developed the concept quickly: "I came up with the summer camp idea and it seemed perfect except for the fact that there were lots of kids at summer camp," he explains. "Where's the terror in that? That's when I thought that it was a summer camp that was just about to open. I also knew that we had to begin with some kind of curse on the camp, some kind of ancient evil that haunted the place. Something from the past that haunts the present which is, obviously, the drowning of Jason. Secondly, we had to have these kids who are totally on their own with no one to help them. Total isolation. Third, if there was anyone who was having sex, they had to die. Sex equals death."

Miller completed a first draft script of *Friday the 13th* in just a couple of weeks. "I thought Victor did a good job on the script," says Cunningham. "He got the nuts and bolts, the basic formula of what I was looking for. The script worked. Structure was Victor's big strength as a writer and the script had a

good pace to it. I knew that me and Steve and some of the others would be able to tweak the dialogue a little bit and make it even stronger." As it turns out, the script for *Friday the 13th* was about to go through more twists and turns than anyone thought possible.

Once Cunningham had Miller's script in-hand, he went about approaching Minasian and Scuderi for financing. Scuderi was the first to hear Cunningham's pitch and read Miller's script, and to put it bluntly, he hated it. Scuderi loved the title, but thought Miller's script was silly and tepid. Still, he saw enough promise in the concept and had enough faith in Cunningham, given their past association, to want to salvage this project, so Scuderi decided to approach another writer to see if he could make the *Friday the 13th* script everything he knew it could be. This man was Ron Kurz, a sometime novelist and screenwriter from New England. If Kurz's name sounds familiar to longtime *Friday the 13th* fans, it's because he was destined to write the script for *Friday the 13th Part 2*, a distinction that would earn him, like Miller and many other writers associated with the *Friday the 13th* films, a lucrative creator credit on several of the later films in the series. What is not known by many fans, is just how much responsibility Kurz had in the development of the original *Friday the 13th*.

It was early 1979 and Kurz was living in New Hampshire with his then-wife and small child. Unable to concentrate on his writing with a baby in the house, he took the drastic step of renting an apartment in Boston to escape to for four or five days every week so he could write. "That's where I hooked up with Phil," recalls Kurz. "I knew that Phil and his partners ran a chain of movie theatres because I'd known him since my days as a theatre manager in Baltimore in the early '70s."

Scuderi told Kurz about Georgetown Productions and then offered him a job writing a non-union *Animal House* rip-off (1979's *King Frat*, written under the pseudonym Mark Jackson). "He needed a writer because he'd just fired one who wasn't working out," recalls Kurz. "I was a member of the Writers Guild at the time because I'd done work on a script for producer Bud Yorkin called *Lethal Gas*, which was based on a novel I'd written. That project languished for seven years. I started working for Phil under the table, using a nom de schlock. Phil was a very dynamic figure. Just picture a cross between Roger Corman and Michael Corleone and you'll have Phil. You'll never see his name on anything, but Phil was hands-on involved with scores of films. He gave Wes Craven, Sean Cunningham and Steve Miner

above:
left to right: Steve Miner, Ari Lehman and Sean S. Cunningham on the Blairstown, New Jersey set of *Friday the 13th* during the filming of the climactic lake scene.

above:
Friday the 13th composer Harry Manfredini, who began his longtime association with Sean S. Cunningham on the 1978 children's film *Here Come the Tigers.*

Cunningham - who would act as *Friday the 13th*'s director and producer - a little over $500,000 to make the film. However, that did not mean that Cunningham was going to be given free reign, as by this time Scuderi was beginning to take a passionate interest in this little film called *Friday the 13th*, convinced that it could not only be the most successful film he had ever been associated with, but also a piece of celluloid history. Scuderi – in close partnership with Minasian - would be watching Cunningham like a hawk. It's not that he didn't trust Cunningham – in fact he had a generally favourable opinion of him as a director - but he wanted to make sure that *Friday the 13th* was done just right. This wasn't going to be just another cheapjack exploitation film destined for the redneck drive-in circuit. There was a chance that *Friday the 13th* could be something special.

Cunningham was relieved to get the green-light for *Friday*, but not terribly nervous. "I never thought about whether or not *Friday the 13th* would be my last chance as a director," he says. "I've always approached film from the business side, not the artistic side. After the two kiddie movies, I said, 'Okay, what kind of a film can I get the money to make?' and the answer was, obviously, a horror film called *Friday the 13th*. If *Friday* had been another box office failure, I suspect that I still would've been able to finance another horror film because of the success of *Last House*. It's all about getting the money to make them."

With financing in place, Cunningham started to assemble his team. He appointed Bill Freda as editor, a gruelling job considering the type of shoot that was about to follow. His wife, Susan Cunningham, would serve as associate editor while Abrams, Field and Manfredini would assume their roles as director of photography, production designer and musical composer, respectively. Steve Miner, who was now Cunningham's most trusted associate, would serve as unit production manager and associate producer. "We were excited in the weeks leading up to filming," recalls Miner. "There was a lot to do. We had to find a suitable location for the camp, and we knew that a lot of the summer camps were going to freak out when they found out we were making a slasher film, which they did. Then we had to find good actors for little money and get a good makeup crew to work on the film because the effects were, in a large part, going to make or break the film."

One of the key people hired by Cunningham and his team was, of course, the man who would be most responsible for *Friday the 13th*'s shocking images: its special makeup effects expert, Tom Savini. It was Savini, along with his assistant and long-time friend, Taso Stavrakis, who would,

their starts in the film business. Phil was also a real creative force; he wasn't just a money man. He would come up with some of the wildest scenes you could imagine, right off the top of his head, usually acting them out in restaurants, that I merely had to write down the next day."

Scuderi soon explained his *Friday the 13th* dilemma to Kurz: "Phil told me that he was approached by a man named Sean Cunningham and that he was a down-and-out producer," he recalls. "I knew they had done *Last House on the Left* together. Basically, all Sean had to offer Phil was a great-sounding title and a really tepid script by Victor Miller who, I was told, was a soap opera writer and guild member working under the umbrella of Sean's production company. Phil brought me in to totally revise the script. He wanted me to add humour, my forté, and give it something. Phil didn't know what, but he knew that it needed something." Just what that something was would turn out to change horror movie history.

With Kurz's scripting chores completed, Scuderi was happy and it was handshakes all around. Georgetown would agree to give

ultimately, be singled out as being the main factor in the success of *Friday the 13th*. "Tom was a genius," recalls Cunningham, who allocated a makeup effects budget of "just under $20,000" to create horror movie history. "Tom did things that we didn't think were humanly possible in the film. He was a magician. Without Tom, we would've had to cut a lot of things and you wouldn't have seen the spectacular effects that everyone still talks about."

In mid-1979, Savini drove up to Connecticut to talk with Cunningham and Miner about the *Friday the 13th* job, flush with the acclaim and success he was enjoying for his recent work in *Dawn of the Dead* and *Martin*, both directed by his long-time friend George A. Romero. "I went up to see Sean and Steve and they were really excited to meet me because of *Dawn of the Dead*," Savini recalls. During their discussions, Cunningham and Savini both agreed that the script didn't really have a proper ending, or at least an ending that was going to make moviegoers jump out of their seats. "We talked a lot about what I could do with the story. There really wasn't an ending. That's when I came up with the idea of having Jason jump out of the lake at the end. I thought it would be really spectacular. That was my idea, it really was," claims Savini. Just who did come up with *Friday the 13th*'s climactic scene is

the stuff of great conjecture and debate. The truth would eventually surface, but not before Jason's slimy face jumped out of Crystal Lake and he dragged a stunned Alice (Adrienne King) below the deceptively calm surface of the lake.

During his meeting with Cunningham, Savini had also wholeheartedly endorsed Stavrakis (who had worked as Savini's assistant on *Dawn of the Dead*), a multi-talented individual who offered the additional benefit of being a superb stuntman.

above:
Tom Savini and Ari Lehman fool around.

below:
Savini prepares Lehman to take his place in film history as the first manifestation of the Jason Voorhees character.

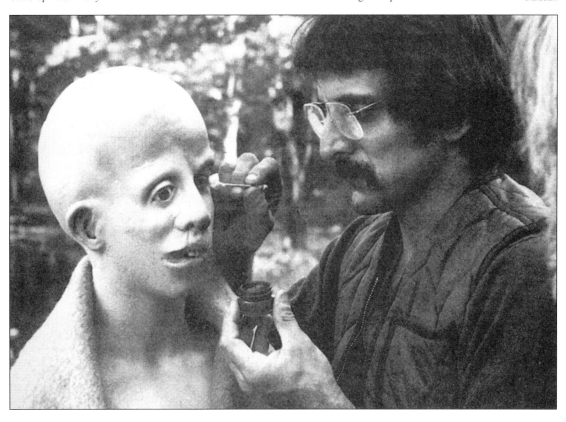

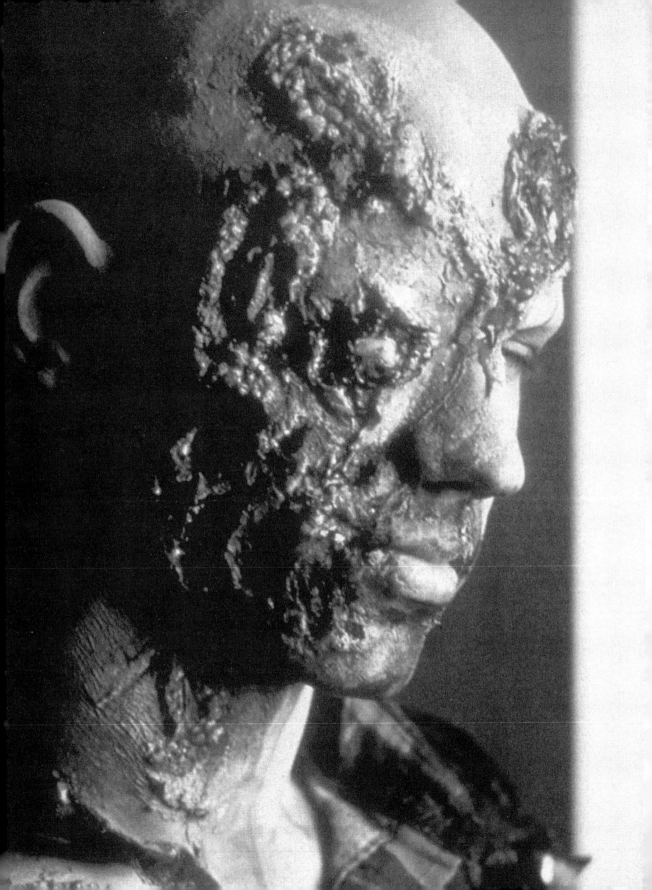

Savini and Stavrakis first met at Pittsburgh's Carnegie-Mellon University in the early 1970s. "Tom and I became best friends at college and, oftentimes, we'd take these swords and capes into the park near the college and play after school," Stavrakis recalls with a laugh. "Before *Friday the 13th* began shooting, Tom and I worked in a makeshift shop behind Steve's house in Connecticut where we built most of the props for the film."

Of course, not in his wildest dreams could Stavrakis have imagined that his duties on *Friday the 13th* would include playing the film's demented killer for the majority of the film, stalking and killing most of the members of the *Friday the 13th* cast. The over-the-top violence was nothing however for Savini, since he was a Vietnam Veteran, having served as a combat photographer. Savini had actually enlisted in the army in a program called Hold, which he thought would keep him out of the draft. He attended photography school at Fort Monmouth, and by the time he had finished his course it was the late 1960s and George Romero was about to shoot a little film called *Night of the Living Dead*. He wanted Savini to do the effects but fate interceded and Savini was sent straight to Vietnam, an experience that not only changed his life, but his work. "Yeah, that's how I missed out on

Night of the Living Dead," recalls Savini. "I think George and I made up for it over the years, don't you think? Vietnam fucked with me, like everyone else who was there, but it helped my work. When I did *Dawn*, my head was full of images of what I'd seen in Vietnam and it was much of the same with *Friday*. I have these books on war-wounds and these are the kinds of wounds that you don't see in horror films. That's why audiences were so shocked by what they saw in *Friday the 13th*."

Cunningham and Miner now had the key pieces in place to make *Friday the 13th*; everything except cheap and highly disposable actors. The film basically required eight young adult actors to assume the roles of Camp Crystal Lake's would-be staff. Cunningham hired the New York-based casting firm headed by Julie Hughes and Barry Moss (unbeknownst to them at the time, this was the beginning of a long working relationship with the producer) to find some exciting and fresh faces on a tight budget. "We weren't looking for the greatest actors in the world," says Cunningham. "I wanted kids who were somewhat likable; responsible camp counselors, not your typical horror movie geeks. Basically, they had to be reasonably good-looking and they had to be able to read dialogue fairly well, and they had to work cheap."

above:
Betsy Palmer poses for a publicity still that was later published in *Time* magazine. This picture was taken in the Camp No-Be-Bo-Sco cafeteria.

opposite:
A sublime example of Tom Savini's mastery of special make-up effects, as seen in 1978's *Dawn of the Dead.*

There was also the tough chore of finding an actress who could convincingly portray Mrs. Pamela Voorhees, *Friday the 13th*'s killer, whose stunning appearance was meant to totally throw audiences for a loop. Actress Estelle Parsons, who'd won a Best Supporting Actress Academy Award (her greatest notoriety ultimately proved to be her role as Roseanne Barr's mother on the hit television comedy series *Roseanne*) more than a decade earlier for her work in *Bonnie and Clyde*, had already turned down the role after initially warming to the idea. "Too violent," her agent eventually responded. What kind of actress could play Jason's mother?

While the search was on for actors, Cunningham and Miner went about locating their fictional Camp Crystal Lake. "We were lucky, being on the East Coast, because there's so many wonderful areas," says Cunningham. Miller had very similar ideas when working on the first draft script: "I imagined the camp being in someplace like New Hampshire or Vermont - one of the places where I went to summer camp as a kid," he recalls. Camp Crystal Lake was eventually found in a little piece of the world known as Camp No-Be-Bo-Sco, located in the tiny municipality of Blairstown, New Jersey, one of twenty-three such areas in the surrounding Warren County. The production team

was able to bamboozle the proprietors into letting them use the surroundings for the duration of the shoot, which was scheduled to begin in mid-September and last for approximately thirty days. The timing was ideal, since the real life camp operates from June to August every year. The *Friday the 13th* production team would have their run of the place.

Blairstown is Warren's largest township, occupying about thirty-one square miles, easily accessible from either New Jersey or New York (or Pennsylvania from the opposite direction), via Route 80. The camp has been around for three quarters of a century. "It's a very beautiful community, small town America," says Jack Dirr, Camp No-Be-Bo-Sco's assistant camp director. "We do get the occasional visitor looking to see some of the old sites from *Friday the 13th* and we're not shy about turning them away. We don't want strangers around here." Miner recalls that the site was almost ready-made for the film: "We didn't need a lot of things from the campsite, but our needs were very specific. The area was really beautiful and we all loved being there. You know, we needed an archery range, some cabins, a certain feeling of isolation and, of course, a lake for young Jason to jump out of."

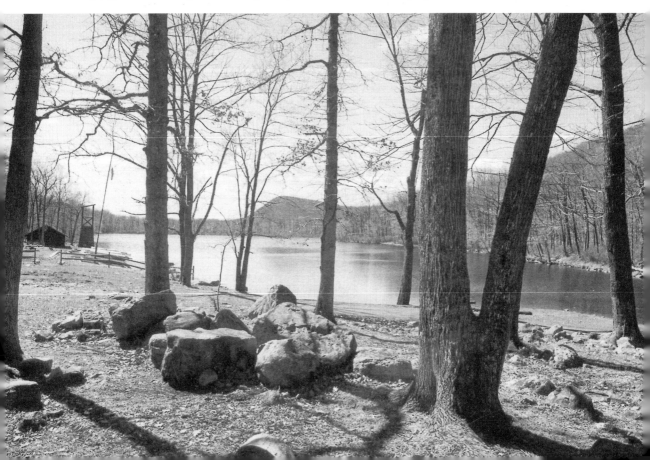

A Long Day and Night at Camp Crystal Lake

By mid-1979, Julie Hughes and Barry Moss were intensely focused on finding a cast that Cunningham and Miner would find acceptable. "We saw a lot of nice kids and I didn't think we'd have a problem finding suitable actors," recalls Hughes. "We were lucky because New York is always full of good young actors who are excited about appearing in movies, even if they are low-budget, independent films." Of the eight principal actors who would comprise the would-be camp counselors in *Friday the 13th*, actors Kevin Bacon, Laurie Bartram, Peter Brouwer and Adrienne King all had done substantial time on the soap opera scene prior to appearing in *Friday the 13th*. "Soap opera actors were a good choice because you know they can handle dialogue and they know where the camera is at all times," says Moss. "We found some good actors from the soaps."

Adrienne King, who would become *Friday the 13th*'s heroine and lone survivor, at least until the prologue of *Friday the 13th Part 2*, was one of those finds. King, a former child actor, had extensive theatre experience and had also appeared on the soaps *All My Children*, *Another World* and *The Edge of Night*. King didn't know what to make of *Friday the 13th* when it was first offered to her. "It was kind of strange at first because I'd gotten word that Sean and the producers were trying to find a big star to be in the film," recalls King, a native of Oyster Bay, Long Island. "I think they were seriously trying to get a big-name actress like a Meryl Streep or a Sally Field, which surprised me because I wondered how they would've been able to pay someone like that, even if they'd gotten them to agree to be in the film." Eventually, all parties involved settled on King - the new blood so to speak - and she set forth on an odyssey that would see her become, arguably, one of the most beloved and recognised scream queen heroines in horror film history. "I remember being in the casting office and seeing hundreds of other girls," says King. "I think I had a look that was different and fresh. I wasn't just a pretty blonde or anything like that. I looked like I could handle myself. When I read the script, I was excited that I

was going to end up being the only survivor in the entire film. I also liked that Alice was a brave and strong woman, not your typical horror film bimbo. I knew *Friday the 13th* wasn't going to be a work of art, but I was the star."

For Kevin Bacon, who played Jack (later identified as Jack Kendall in Simon Hawke's 1987 novelization), the road to a long and illustrious career (via horror FX immortality) was paved with more than a few hardships. In 1978, Bacon was given a major role in the John Belushi comedy blockbuster *Animal House*. "I'd done *Animal House* and I kind of thought I was a big star then. I thought I'd made it. Six months later, I was waiting tables back in New York, taking any roles I could get." After doing a bit part in the 1979 Burt Reynolds comedy *Starting Over*, Bacon went in to audition for *Friday the 13th*. "I'd known Mark Nelson because we'd sort of moved in some of the same acting circles and I'd known Jeannine Taylor a bit as well. I think they just looked at the three of us, figured we'd work well as a threesome and decided to cast us as the three friends driving to the camp in a truck."

below:
Alice (Adrienne King) searches for other survivors at Camp Crystal Lake.

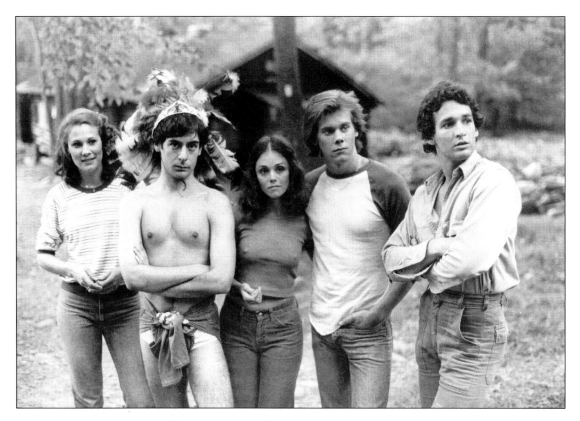

above:
Brenda (Laurie Bartram), Ned (Mark Nelson), Marcie (Jeannine Taylor), Jack (Kevin Bacon), and Bill (Harry Crosby) enjoy their last day on earth.

Mark Nelson was cast in the role of Ned, a character that made the practical joker horror victim a staple of the genre. To his mind, being in *Friday the 13th* was just a gruesome job, especially since he had recently graduated from Princeton. "I was in the casting office and I think Julie just looked at me and said, 'You're Ned, you look like a practical joker,' something like that," recalls Nelson. "Jeannine had auditioned for the film as well and I knew Jeannine because we'd both done some plays for director Gene Saks. We knew Kevin too so we all had a great chemistry together."

With three of the main young roles cast, all the producers needed for the film was a best friend type, a good-hearted hitchhiker in the wrong place at the wrong time, and a stubborn, slightly middle-aged campsite owner who'd rather die than admit that opening a summer camp around Crystal Lake was probably a really bad idea. Throw in a kind-hearted beauty who could play a mean game of Strip Monopoly for good measure, and of course, there was also still the matter of finding someone to play the film's killer, Pamela Voorhees. Hughes and Moss had sent a copy of the script to the agent of Betsy Palmer, a light comedy actress and television personality from yesteryear. They hoped she would say yes.

When Betsy Palmer received a call from her agent to discuss an offer for work on a low budget horror film called *Friday the 13th*, she was more confused than anything else. "I said, 'A horror film? What do they want me for?'" recalls Palmer. The East Chicago, Indiana native had been out of the public spotlight for a few years. She started her show-business career as a television showgirl of sorts, a model. It wasn't until her starring performance in the classic 1955 comedy *Mister Roberts*, with Henry Fonda and Jack Lemmon, that Palmer's career started to take off. Roles in *The Last Angry Man* and *The Tin Star* followed but, by the dawn of the 1960s, she was relegated to the status of guest television personality on such programs as the first incarnation of *Wheel of Fortune* and *The Garry Moore Show*.

Palmer, a sweet old lady whose slight figure belies the frightening reputation that her role in *Friday the 13th* gave her, has an amazing sense of humour and isn't shy about telling stories. Take the numerous appearances she made on such 1950s television playhouse series as *Studio One*, and *United States Steel Hour* alongside pop culture icon James Dean, of whom she casually mentions, "James Dean and I had an eight month fling." Palmer approached the *Friday the 13th* offer with a

sense of incredulity. "I'd just come back home to Connecticut from doing a play and my Mercedes had broken down," she recalls. "I needed to buy a car and so I was kind of desperate for any kind of work, but a horror film? It was totally ridiculous because everyone knows I'm a light actress. Anyway, my agent sent the script over to me and I read it and I just thought it was a total piece of shit, but I did the film anyway because I needed to buy a new car."

The feisty actress drove a battered old jalopy to the New Jersey set to take up her role, for which she was contracted for ten days of work in return for a fee of approximately $10,000, although this figure would be upped somewhat when, towards the end of principal photography, Cunningham needed to film some additional closeups back near Westport, Connecticut. "I don't know what they would've done if I wouldn't have had my own transportation to the set," says Palmer. "I guess they would've had to go find someone else. Never in my wildest dreams did I think this would be the role that people would forever remember me for. It's been an amazing ride. I still don't know how I feel about it. Right before I had to drive up to the set, I tried to make some notes about my character, as I've been taught. Then, when I drove up to the set and saw the 'Welcome to Camp Crystal Lake' sign my spirits started to brighten."

The role of Bill, the shy best friend type who for a while looked set to join King as a *Friday the 13th* survivor before meeting a spectacularly gruesome fate about ten minutes before the end credits, was

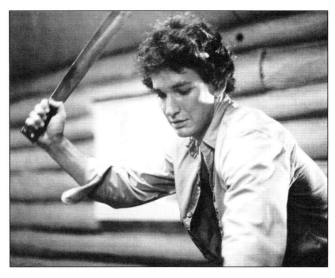

above:
Bill (Harry Crosby) attempts to kill a snake. The snake scene was created by Tom Savini who found a snake in one of the cabins during filming.

given to Harry Crosby, son of the legendary Bing Crosby. (Incidentally Bing Crosby had a horror link himself since his production company, Bing Crosby Productions, produced the hit 1971 rat epic *Willard*.) Harry Crosby had a strong background in the arts, having studied at the prestigious London Academy of Music and Dramatic Art in England before moving back to America. "I was in New York, doing plays and pilots and, actually, Kevin Bacon and I were staying in this little flop apartment and sleeping on a mattress," recalls Crosby. "I just went in and auditioned for Sean and we really hit off and I really came to respect Sean as a director. Sean told

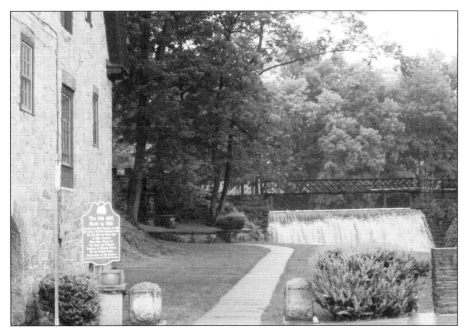

left:
Downtown Blairstown, New Jersey as it appears today, near the old Mill which hitchhiker Annie (Robbi Morgan) passes on her way to Camp Crystal Lake in *Friday the 13th*. (Photo courtesy of Glenn Allen.)

me about all of the ups and downs he'd been through and he just seemed like a really good director to me. I also liked the fact that I was going to be in the film a long time and that I was going to be able to play the guitar."

Laurie Bartram has an interesting place in the *Friday the 13th* universe as, it seems, fans of the series have warmly embraced her over the years, more so than most of the lead heroines. Bartram's old fashioned beauty, reminiscent of the natural looks of the depression era film stars, reinforces the impression that her character, Brenda, is a really sweet girl; a genuinely concerned young woman who's determined to make Camp Crystal Lake a happy and safe place for everyone. Prior to being cast in *Friday the 13th*, Bartram was already a well-established veteran of the Los Angeles and New York acting scenes: she'd appeared on such '70s TV staples as *Emergency* and, shortly prior to her appearance in *Friday the 13th*, had a recurring role on *Another World* (at the same time that King was a day-player on the show). "I liked Brenda and I think they chose me for that role because I was a little older than the other actors," says Bartram. "At some point, I thought they were going to give me a different part, maybe the lead heroine role, but I was really happy to be doing a film and I felt like Brenda was a very compassionate character."

Robbi Morgan played Annie, a sweet-looking girl who arrives in the small town of Crystal Lake, just hoping for a summer of fun as one of Camp Crystal Lake's counselors. Ironically, Annie was hired to be a cook, the same job previously held by Pamela Voorhees. Morgan's appearance as *Friday the 13th*'s first main victim (following two killings in the film's pre-credit sequence) was a case of happy misdirection. "Prior to doing *Friday*, my brother had appeared on stage with Betsy Palmer in *Peter Pan*," recalls the actress. "It was funny because Betsy played Peter and Sandy Duncan was Wendy. I'd done a horror film before *Friday* called *What's the Matter with Helen?* which was one of the last films that Debbie Reynolds made before she had her personal problems. I was in Julie's office for something else altogether and Julie just pointed at me and said, 'You're a camp counselor.' Living on the East Coast, I drove out to the set the next day."

One of the most important, yet understated, characters in *Friday the 13th* is that of Steve Christy, Camp Crystal Lake's doomed benefactor. If Christy hadn't made the fateful decision to reopen the cursed camp, scores of characters might still be alive. No sequels, no *Freddy Vs. Jason*, none of that stuff. Of course, if Steve Christy's parents had been more responsible in choosing employees for their camp in the first place, then a great human tragedy

below:
Alice and Bill enjoy a
moment in the sun.

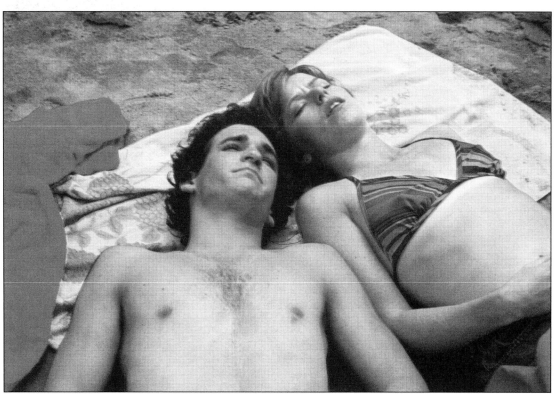

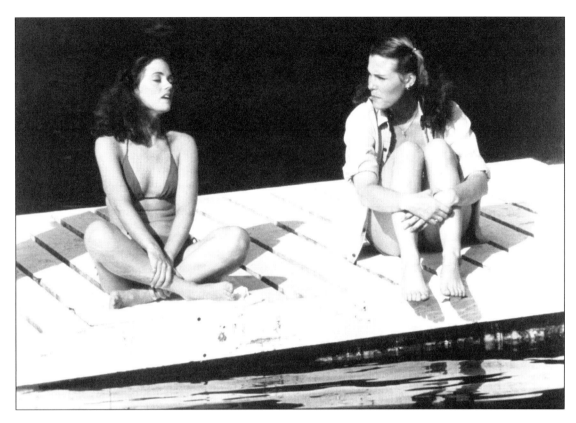

above:
Marcie and Brenda
discuss life while Marcie
has a premonition of
death.

might've been cosmically prevented. The Christy role went to Peter Brouwer: "I was doing a soap called *Love of Life*," recalls the actor of the show that also featured the late *Superman* star Christopher Reeve. "I was written out and, needing work, I went back to Connecticut to spend time with my girlfriend, Cindy, and look for a job until I could get back to New York for auditions. My girlfriend (Cindy Veazey) had gotten a job as an AD (assistant director) on *Friday* and I asked her if there was anything for me. They told me that they were looking for big stars, especially for my role, so I thought I was out of luck." Brouwer had taken a job on a landscape crew for the summer when he had a fateful meeting with Cunningham. "I was working on a garden near Sean's home and Sean came by one day to give Cindy a message," he recalls. "He saw me and, a few weeks later, I got the call asking me if I wanted to play the part of Steve Christy."

Another important member of the *Friday the 13th* cast - Ari Lehman, who played Jason Voorhees in the film - was already known to Cunningham and other members of the production team. "I actually knew Sean and the guys from *Manny's Orphans* where I'd failed to land a big part in the film," recalls Lehman, who was barely fourteen when he did his four days of work on *Friday the 13th*. "I was

determined to get the part in *Friday the 13th* and I went in and was very intense when Sean just smiled and told me I was perfect for the part."

Rex Everhart played Enos, the pessimistic truck driver who gives would-be camp counselor Annie a ride and ends up depositing her halfway to hell. Everhart, who died in 2000 of lung cancer (some records indicate that he died on March 13 of 2000, a date that does not, however, fall on a Friday...) went on to have a substantial stage and television career, later receiving a Tony nomination for a play called *Working*. He was a native of Branford, Connecticut where he'd made Cunningham's acquaintance. "Rex was a great actor," recalls the director. "That truck scene with him and Annie was very tricky to do, in more ways than one, and he was a total pro. I think Rex was like sixty years old when we did *Friday* and it was amazing how much energy he had."

Another friend of Cunningham's to act in *Friday the 13th* was Ronn Carroll who appeared in the brief but historically significant role of Sgt. Tierney, the decent cop who, near the end of *Friday the 13th*, looks like he might become Steve Christy's - and Alice and Bill's - saviour until a rather poorly timed (to say the least) 911 emergency fire call transforms him into something

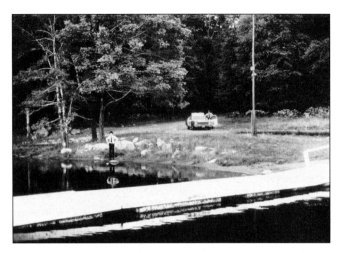

above:
Dorf (Ron Millkie) and Sgt. Tierney (Ronn Carroll) arriving at Crystal Lake to rescue Alice. Adrienne King was not present when Carroll and Millkie filmed this scene.

of a cursed figure. "I'd been acting professionally for about twenty years before I'd met Sean and appeared in some of Sean's commercials and technical films," says Carroll. "I've appeared in almost all of Sean's films and I love working with him. With *Friday the 13th*, I think I was one of the first people he thought of in that I've played a lot of cops. That's really all I knew about the role - I didn't know the rest of the story or Tierney's eventual significance in the film - because I was just focused on the couple of scenes I had in the film. The scenes didn't link with the rest of the film so I didn't really find out the rest of the story until later." Like Everhart, Carroll would go on to

transcend his moment of *Friday the 13th* notoriety and become an award-winning Broadway stage actor. He would later re-team with Cunningham in films like *Spring Break* and the 1986 comedy-horror-thriller *House*, a film that would re-team Carroll and Cunningham with Miner, and a film in which the actor played, once again, a cop.

Sgt. Tierney's deputy, of sorts, in *Friday the 13th* is the dementedly serious motorcycle cop Dorf, who rides up to Camp Crystal Lake on his Harley Davidson looking for an old man named Crazy Ralph, and wanting to give the young camp counselors a stern warning. Dorf was played by Ron Millkie, another Cunningham alumnus from New York. "I'd worked for Sean on one of his industrial films," says Millkie. "One day, I saw the *Friday the 13th* ad in one of the trades and I immediately called up Sean and asked him to give me a part in the film. I got Dorf, who I never dreamed would become as famous as he has over the years, especially amongst the fans. I went up to the camp on a bus and I was only there for a couple of days."

Crazy Ralph was played by Walt (Walter) Gorney. In the film the demented old curmudgeon - as insane as he appears and sounds - turns out to be totally correct. Gorney (who died in March of 2004) made a lasting impression with *Friday the 13th* fans and the filmmakers themselves. "Walt was actually a very well trained actor, a New York actor, very serious," recalls Miner, who later had Gorney reprise his role in 1981's *Friday the 13th*

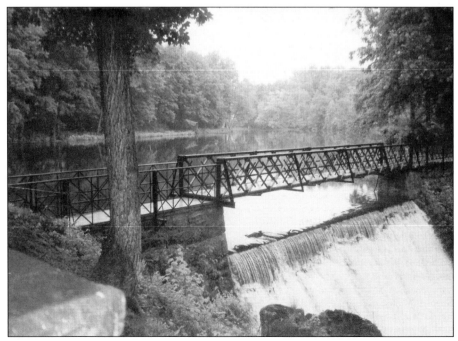

right:
Beside the old mill in Blairstown, New Jersey today.
(Photo courtesy of Glenn Allen.)

Part 2. "I remember sometimes, in between scenes, you'd see him off in the corner talking to himself, but when it came time to shoot a scene, he was money in the bank."

It appears that no-one on the *Friday the 13th* set was flown into town, with most of the people involved with the production providing their own transportation or riding on chartered buses that had been requisitioned by the production office for the film. "I rode up on a bus that the film company sent us up on, with Harry Crosby and Jeannine Taylor," recalls Mark Nelson. "It was a lot of fun getting to know each other and getting a chance to enjoy all of the scenery." Jeannine Taylor concurs, "The company made it real easy for us to get back and forth from the location back to New York." Ronn Carroll commuted to the set: "I was doing a play at the same time I was doing the film," he recalls. "That's another reason why I was just focusing on my scenes and not the overall story. I'd only get parts of the script that I would use to prepare for my scenes. I was doing a play in New York and Sean actually drove me up to the set along with Kevin Bacon."

Once the cast and crew arrived at the Camp No-Be-Bo-Sco set, they settled in for what was expected to be a routine month-long shoot. It would turn into much more. The personnel were put up in local motels, although some of the crew (including Savini and Stavrakis) elected to stay on the campgrounds as there were plentiful cabins on both sides of the lake. There are actually three motels within eight miles of Blairstown - Blue Mountain Inn, Days Inn and Hunters Lodge - and every lodge in town was filled up during principal photography. Before the *Friday the 13th* crew arrived Blairstown was just a sleepy little slice of small-town Americana. "It was a very beautiful area, very scenic," recalls Crosby. "Lots of times we'd finish work and then go out to a local restaurant for dinner and then we'd just walk around."

The summer camp location offered more than just archery and toasted marsh-mellows. "What I remember most about the New Jersey location is the beautiful terrain," recalls Brouwer. "My girlfriend and I would always go hiking along the Appalachian Trail and we loved going into the woods. It wasn't scary at all." Camp life was a little more intense for Savini and his crew when, one day, they made a shocking discovery. "We basically had the run of the cabins to ourselves, which was fun, but one day, in one of the cabins, I found a big

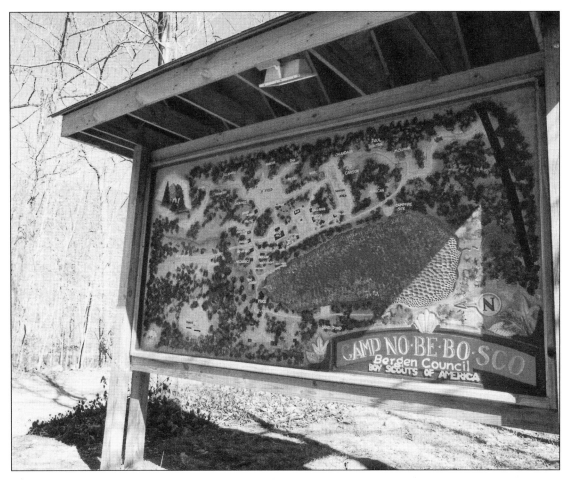

snake," Savini recalls. "That's where we got the idea for the scene where Adrienne runs in and finds the snake. That wasn't in the script."

Camp No-Be-Bo-Sco is still fully-functioning; in fact it has moved on with the times since becoming immortalised as the fictional Camp Crystal Lake. "The camp's changed a lot over the years so that most fans of the film wouldn't even recognise it," says Dirr. "There's things at the campsite like chapels, numerous lodges for different activities - fields, health rooms, a big parking lot, everything. The place is very modernized."

It's interesting to note that today's Camp No-Be-Bo-Sco has some strict rules; for example campers may not bring sharp objects (knives, machetes) onto the campgrounds. The camp provides emergency services, such as transporting any wounded campers to the nearest hospital, and everyone who attends No-Be-Bo-Sco is taught emergency procedures. Ironically enough, the camp's manifesto mentions a provision for 'lost bathers' or any campers who happen to 'disappear'

into the lake. If someone is unfortunate enough to become a 'lost bather,' campers are instructed to report the incident to the camp office where a long and steady siren is then sounded. It's unclear whether this rule was influenced by the drowning of an eleven year old camper named Jason Voorhees back in 1957. Isn't Jason the ultimate 'lost bather?' One wonders what the camp's policy would be towards those camp counselors who knowingly, or through their ignorance or carelessness, let campers like Jason drown.

The cast and crew of *Friday the 13th* may have felt comfortable at the Blairstown location but, as they say, the mood was about to change, and some rather horrific business was about to kick in. It was Friday the thirteenth at Camp Crystal Lake, in the year 1980, and over the course of twenty-four hours, a lot of people were going to die horribly in a variety of gruesome and imaginative ways. The cast and crew of *Friday the 13th* were about to find out that Camp Crystal Lake can be a pretty scary place when night falls.

Summer Camp Bloodbath

Camp Crystal Lake in the Summer of 1958. These were simpler times. Buddy Holly was on top of the charts, computers and drugs weren't a part of a kid's everyday life. The old timers would say that things were much better back in those days and maybe they were right. Camp Crystal Lake seemed like an idyllic part of this idealised world. The camp was a nice, quaint piece of wilderness with a good reputation, on the surface at least, except for the mysterious drowning of a young camper the summer before. But that was an accident... wasn't it?

This was the setting for the pre-credit sequence in *Friday the 13th*. We open with the still shot of a full moon and then a campfire appears surrounded by young camp counselors. The camera stalks around the scene and, for the first time, we hear the ki-ki-ki-ma-ma-ma riff that will become the soundtrack of our terror youth. Still, all seems well. Two campers in particular - Barry and Claudette - are drawn to each other. They're anxious, like most adventurous teenagers, to mutually explore their bodies in the dark.

The campfire song they're singing is *Tom Dooley*, which is more than a little ironic since the song is about a man's impending doom. "Hang down your head, Tom Dooley," the camp counselors scream out, "poor boy, you're bound to die." Barry and Claudette lock gazes and the lust in their eyes is naked and unmistakable, certainly to the unseen stalker observing them. The watcher, as we know now, is Pamela Voorhees, Camp Crystal Lake's grieving cook. In Simon Hawke's novelization, he explains that Pamela begged the Christy family to take her back after the tragic loss of her son, Jason. They agreed. But we don't know any of that right now.

Friday the 13th's opening scene represents the 'inciting incident' in the film's script. It was the middle of September on the Blairstown location and Cunningham had *Friday the 13th*'s final shooting script in his hands, thanks to some last-minute work by himself and Miller, but mostly Ron Kurz. "Sean and Victor had been feverishly working on the script down in Connecticut, but most of the new scenes and revisions were mine," recalls Kurz who, unlike Miller, actually spent some time at the New Jersey

location. "As I was writing new scenes or totally revising old ones, Sean and Victor were taking them and putting them in their own draft, under Victor's name. I'm not mad and I don't blame them because Victor was a legitimate member of the Writers Guild and I'd been breaking every Guild rule in the book. Ultimately, of the final ninety-seven page second draft of Victor Miller's script, forty-five of the ninety-seven pages are either brand new scenes that I wrote or revised earlier scenes. That's the movie business." (By the time filming began, the *Friday the 13th* team also included script supervisor Martin Kitrosser, a veteran of the adult film industry who was destined to go on to script *Friday the 13th Part 3: 3-D* (with his wife and sometime writing partner, Carol Watson) as well as contributing to the script for *Friday the 13th Part V: A New Beginning*. Today, a writer-director in his own right, Kitrosser is most recognised for being Quentin Tarantino's script supervisor of choice on such films as *Reservoir Dogs*, *Pulp Fiction*, *Jackie Brown* and the *Kill Bill* films.)

Films are rarely shot in sequence, from first page to last, and *Friday the 13th* was no different as Cunningham chose to begin with the day scenes

below:
Barry (Willie Adams) suffers a slow death. Adams's character was the first screen victim in the history of the *Friday the 13th* film series.

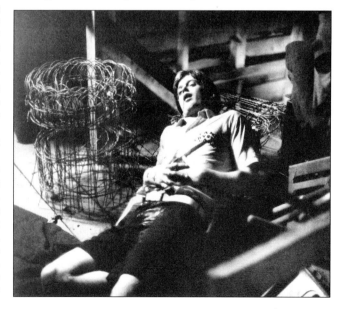

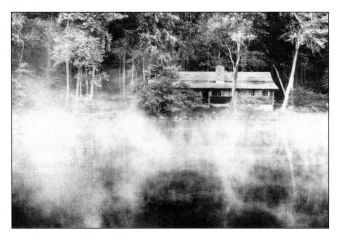

above:
This *Friday the 13th* promotional still reveals a creepy view of Camp Crystal Lake's main cabin hidden in the mist.

opposite:
Crazy Ralph (Walt Gorney) attempts to warn Annie about Camp Crystal Lake while Enos (Rex Everhart) tries to get rid of him.

the time). Just as they're about to get down and dirty, Claudette notices a figure in the shadows that turns out to be Camp Crystal Lake's killer, who interrupts the proceedings by brutally murdering the two young lovebirds.

Not only was this not the way Barry and Claudette planned for things to turn out, it also was not what Cunningham had envisioned. "The opening scene was originally supposed to take place with Barry and Claudette walking around the lake where they get stalked by the killer. Then there was going to be a big chase around the boathouse and around the water, other places too," recalls Cunningham. Brutal weather changed the director's plans. "We were going to shoot the opening scene on the first night, but it snowed," recalls Miner. "When we did it the second time, the generator died. We were forced to choose the barn out of necessity because that was the one location we could think of that had its own power source. We really didn't have a choice because of the limited budget we had. It would've been a great scene. I liked the scene we did, but the original sequence would've been very exciting."

At least the abandonment of Cunningham's intended prologue meant that the start of *Friday the 13th* would not end up being mercilessly compared to the opening scene in Carpenter's classic, which is ironic in as much as the first shots of Bob Clark's 1974 film *Black Christmas* are cited as a direct

and push the night scenes to the end of the schedule. Filming the opening scene turned out to be quite a challenge for the *Friday the 13th* crew as by the time they got round to shooting it, the cold weather forced them to make radical changes. The film continues with Barry and Claudette kissing and then entering a secret barn compartment so they can have sex (Willie Adams and Debra S. Hayes, who played Barry and Claudette, were two young actors from the East Coast acting scene, hired shortly before the start of production with Adams doing double duty as one of Cunningham's production assistants. Adams and Hayes were actually dating at

right:
A shot of downtown Blairstown, New Jersey as it appears today. Hitchhiker Annie (Robbi Morgan) is seen here at the beginning of the film. (Photo courtesy of Glenn Allen.)

influence on *Halloween*'s opening Panaglide scene. Still, it is interesting to wonder how Cunningham's original vision for the prologue would have turned out. According to an early draft of the *Friday the 13th* script, the opening sequence was set to begin near a baseball diamond located on the grounds of Camp Crystal Lake. Barry and Claudette, visibly attracted to each other, argue about Barry's supposed involvement with another camp counselor who can be seen in the background. The young lovers then clinch and move into the forest to make out - near the lake - when they're confronted by the unseen killer, named The Prowler in the original script.

The way in which Barry and Claudette were due to be killed differs greatly from what was filmed as well. "I remember that Willie and I walked through the scene and it was freezing," recalls Debra S. Hayes. "We were out near the forest - going through the paces with some of the guys from the crew - and then we were told that it was all going to be changed." Originally, Claudette was supposed to have been killed by The Prowler first, wielding a machete, while a stunned Barry watched in horror. Then, and most interestingly, Barry and the unseen Prowler were to struggle for the knife and - during the heat of the struggle - The Prowler's baby finger was to get chopped off.

The fact that it has been established that the weather was bitterly cold during the filming of the prologue sequence raises the question of whether the scene might have been filmed sometime later during the production. This doesn't seem to have been the case for a number of reasons though. First of all, Cunningham and the rest of the crew remember shooting this scene at the beginning even though, as previously mentioned, the need to re-shoot key scenes pushed the filming schedule into November. Secondly, it's not unusual on the East Coast for it to be cold enough for snow to fall as early as the middle of September. There's another piece of evidence that tells us that the opening sequence was, in fact, filmed right at the beginning and that's Tom Savini, who along with his assistant, Stavrakis, had only just arrived on the set.

"We really didn't work on the opening scene," recalls Savini. "What happened was that we came up to the set and got there when they were doing the opening scene and we applied a machete to the girl's neck, but we didn't build anything for that scene." While, in the film, Barry gets stabbed and dies off-camera with blood gurgling out of his gut, Claudette is framed against the white shriek of the *Friday the 13th* logo that then blows through her face, prompting the film's opening credits. Originally, we were supposed to see Claudette get whacked with the machete, pinned to the floor with a wide-eyed scream plastered across her face, her camp uniform stained with blood. "I don't think I ever saw that scene," says Savini. "People always ask me if there's anything we did that didn't make it into the film and I guess that's it but otherwise I'd say no. There really are no missing effects or any stuff of mine that was cut in a big way. Now, I've heard of versions that show kill

FRIDAY THE 13TH
(1980)

Production Company:
Georgetown Productions Incorporated
Executive Producer:
Alvin Geiler
Producer:
Sean S. Cunningham
Associate Producer:
Stephen Miner
Unit Production Manager:
Stephen Miner
Written by:
Victor Miller,
Ron Kurz [uncredited]
Director:
Sean S. Cunningham
Assistant Director:
Cindy Veazey
2nd Assistant Director:
Stephen Ross
Director of Photography:
Barry Abrams
Camera Operator:
Braden Lutz
2nd Unit Camera:
Peter Stein
1st Assistant Cameraman:
John Verardi
2nd Assistant Cameramen:
Richard Berger,
Robert Brady
2nd Unit Assistant Cameraman:
Mike Hirsch
2nd Electric:
Philip Beard
2nd Unit Electric:
William Klayer
Gaffer:
Tad Page
2nd Unit Gaffer:
Larry Reibman
Best Boy:
Jim Bekaris
Key Grip:
Bob Shulman
Grip:
Carl Peterson
Still Photography:
Richard Feury
Editor:
Bill Freda
Associate Editor:
Susan E. Cunningham
Assistant Editor:
Jay Keuper
Music:
Harry Manfredini

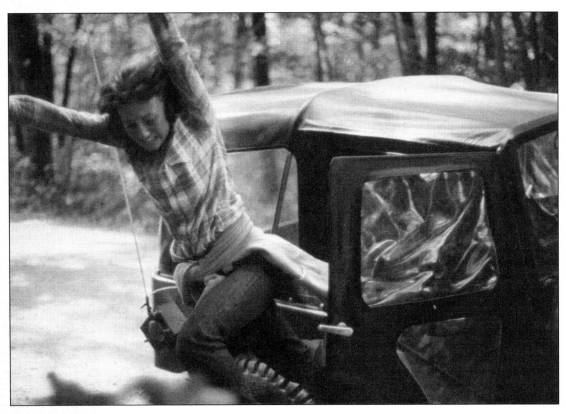

scenes that go on much longer, but there's nothing that's actually missing in the film."

Once the credits have finished rolling, we are introduced to the character of Annie, would-be summer camp counselor turned murdered hitchhiker, as played by Robbi Morgan. When Morgan finally arrived in Blairstown, she never dreamed that her brief role as Annie would earn her a place in the pop culture universe. Annie's screaming face has been replayed thousands of times over the years by *Friday the 13th* fans, who treat characters like hers as cinematic deities. "I only remember being there the one day, but oh, what memories. I remember doing the scene in the truck and then running through the bushes and then going to the camp to do the night scene. What I remember the most about doing *Friday the 13th* was meeting Taso and Tom. We became really good friends in a short amount of time," recalls Morgan who, in addition to being a young actress, was a trained acrobat and dancer. She is now married to Mark Walberg, host of the American reality television show *Temptation Island*. After *Friday the 13th*, Morgan went on to appear in the Broadway production of *Barnum*. She continues to occasionally perform in dance revues, but spends most of her time these days as a stay-at-home mom in California.

Annie arrives in the middle of town, early in the morning, looking for a ride up to Camp Crystal Lake. She enters a diner run by Trudy (played by Dorothy Kobs) who encourages a gruff truck driver, Enos (Rex Everhart), to give Annie a ride, albeit only halfway. Prior to this - outside the diner - Annie has a rather funny meeting with a dog whose sexual orientation she innocently mistakes. "The scene with the dog was entirely scripted," recalls Morgan. As her character rode in Enos's truck, she found herself in the odd position of acting without her on-screen co-star Everhart. "It's funny because I never really met that guy who played the truck driver except for when we walk out of the diner and meet that Crazy Ralph guy. What happened was that I did the scenes in the truck all by myself, or they had Taso in the truck with me. I was never with the guy who played the truck driver so I just had to imagine that there was someone there."

She gets dropped off about halfway to Camp Crystal Lake and continues walking, but it is not long before an old jeep appears and pulls up beside her. The jeep's driver is, of course, Pamela Voorhees. However, at the time of filming, Betsy Palmer had only just arrived on the Blairstown set and, in her fifties, was in no shape to be doing any heavy stunt-work anyway, especially given the fact

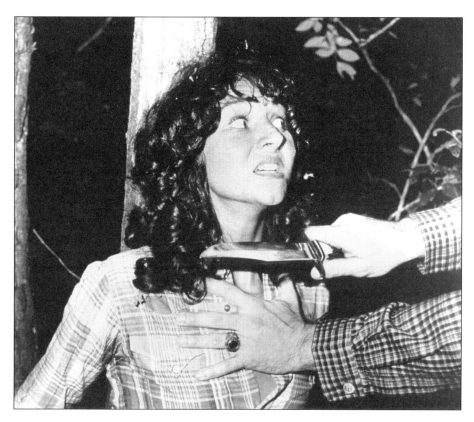

that she barely weighed a hundred pounds at the time, soaking wet. "You know, it's funny because I really don't remember meeting Betsy on the film," says Morgan. "Betsy and I have actually bumped into each other over the years when we've both been doing theatre and she's the nicest lady in the world. Hard to believe that she could ever kill me."

For the chase-and-kill scene, the part of Pamela Voorhees was played by Stavrakis, and with a background that includes training in the likes of archery, guns and knife throwing, he was perfect for the job. "Yes, that was Taso in the truck and we got along very well," recalls Morgan. "I remember when we did the scene where I had to jump out of the jeep and run into the woods. They were worried that I might get hurt, but with my training I was able to do the stunt no problem. "The crew were all there in the forest, giving me directions, telling me where to run. The scene ended with me moving against the tree," Morgan recalls, adding, "Taso really brought that knife near my throat and he scared me. We all laughed about it afterwards."

Stavrakis enjoyed working with Morgan. "I thought I did a great job of playing the killer," he says. "Me, Robbi and Tom hung out a lot. In fact, while we were on location, we had shirts made up for each of us. I think Robbi's shirt read *Mini Maniac*

and Tom's shirt read *Major Maniac* and my shirt said *Minor Maniac*. We were three maniacs and we had a great time working together. I've actually seen Robbi's brother a few times over the years."

Annie's death scene in the woods raises the logical question of why the killer, Mrs. Voorhees, would feel the need to haul Annie's body into her jeep to be paraded near the end of the film? Regardless of the motivation, Annie's lovely face was to make one last gruesome appearance - Colombian necktie and all - before *Friday the 13th* would be all said and done. Meanwhile, back at Camp Crystal Lake, the other seven would-be camp counselors are blissfully unaware that their prospective cook had been so crudely dispatched.

Sound Mixer:
Richard Murphy
Boom:
David Platt
Sound Re-Recordist:
Lee Dichter
Sound Effects:
Ross-Gaffney, Inc.
Atmospheric Effects:
Steven Kirshoff
Make-up:
Katherine Vickers
Hair Styles by:
Six Feet Under,
Westport, Connecticut
Miss Palmer's Hairstyle:
Katherine Vickers
Wardrobe Designer:
Caron Coplan
Wardrobe Mistress:
Jan Shoebridge
Wardrobe Assistant:
Anne King
Special Make-Up Effects
and Stunts:
Tom Savini
Assisted by:
Taso Stavrakis
Script Supervisor:
Martin Kitrosser
Art Director:
Virginia Field
Property Mistress:
Alice Maguire
Assistant Properties:
Chris Gardyasz
Location Auditor:
Michael Calvello
Production Office
Coordinator:
Denise Pinckley
Production Assistants:
Willie Adams, Michael
Barry, Michael Hall,
Cindie M. Verardi
Assistant to Art Director:
Danny Mahon
Titles by:
Ted Lowry
Casting:
TNI Casting, Julie
Hughes, Barry Moss

CAST

Betsy Palmer
(Mrs. Voorhees)
Adrienne King
(Alice)
Jeannine Taylor
(Marcie)

opposite top:
This promotional still shows the reverse angle of Ned's (Mark Nelson) view of the archery range with Brenda (Laurie Bartram) watching.

opposite bottom:
Brenda watches in disbelief as an arrow whizzes by her. The arrow was shot by Tom Savini. Actress Laurie Bartram was also an accomplished dancer, performing widely prior to her appearance in *Friday the 13th*.

One of the few emotional conflicts in *Friday the 13th* is the relationship between Steve Christy and Alice. Christy seems like the ultimate tragic figure - a man who would devote all of his energy and financial resources to restore the legacy of his destroyed parents. For what? "I think Steve Christy was a very driven man, a very stubborn man who was determined to make this place that he grew up in a good place," says Brouwer. "I saw Steve Christy as being a very brave and gallant man, someone who was determined not to believe in curses. In the end, he gets killed for his beliefs."

The relationship between Alice and Steve is also worth considering because, in the first draft of the *Friday the 13th* script, Alice was a somewhat less sympathetic character, although still very much the heroine. Originally, Alice was supposed to been involved in an affair with a married man on the West Coast, the real motivation for her desire to leave the camp, and a contributing factor to the deterioration of her relationship with Christy. "I had most of my scenes with Adrienne and we got along very well," recalls Brouwer. "I think the relationship between Alice and Steve was coming to an end and that may have added to the stress that Steve felt. He didn't know what to do to keep her."

For her part, King recalls playing Alice as a straightforward horror movie character. "I think that Alice is a great scream queen heroine. You got the feeling that Alice could handle anything which, in a way, she could. As for her and Steve, it's kind of tragic that we never found out what happened with them and I also think it would've been interesting to see if anything would've happened between Alice and Bill (Harry Crosby), but it was a horror film," says King, who recalls that the entire cast and crew "approached all of their jobs very professionally."

We learn at the end of *Friday the 13th* that Christy and the other counselors had been working at the camp for weeks, possibly months, trying to get it ready for the summer. One can speculate about whether Pamela Voorhees had spoken to Steve before he reopened the camp; had she warned him not to do so? (It is notable that, near the end of *Friday the 13th* she remarks to Alice that "Steve never should've opened this place again.") Did Pamela's friendship leave her somewhat torn when it came to the prospect of murdering Steve towards the end of the film? We'll never know. To such questions and others, director-producer Cunningham merely laughs and shrugs his shoulders: "We were just concentrating on trying to make an exciting movie, nothing more. We didn't ask any questions like that nor did they ever come up."

However, what we do know from the *Friday the 13th* legend (first told to us by truck driver Enos when he was trying to persuade Annie to forget about going to the camp), is that Christy and his family had tried to reopen Camp Crystal Lake many times prior to the events of *Friday the 13th*. Between 1959 and 1961, attempts to reopen the camp were thwarted by suspicious fires and in 1962, the camp's water supply was discovered to have been poisoned. The place seemed to have been cursed right from the start. "That's what Steve Christy's all about, I think," says Brouwer. "Everyone keeps telling him that his parents were crazy, and that he's crazy for opening this camp, and the more they tell him this, the more Steve feels like he has to prove them wrong. He's doing it for his parents as much as anything." Whatever his motivations were, Steve Christy was set to lose his investment (it was stated in the film, again by Enos, that Christy had spent $25,000 refurbishing the camp), his girlfriend Alice, and his life. But all this was yet to come... As the camp counselors adjust to their surroundings, Steve Christy soon leaves to go into town, where he'll remain until later in the film, when he makes his fateful and tragic return.

Yes, *Friday the 13th* is about a group of camp counselors who are stalked, one by one, and brutally slashed by a psychotic killer, but they are also human beings, even if they are in the lithe bodies of a bunch of camp counselors. "I thought Ned was someone who used humour to hide a lot of his insecurities," says Nelson. "I think he does a lot of that especially when he's around Brenda, who he's very attracted to. He doesn't know how to talk to her and he's also jealous because Jeannine and Kevin are very much in love." Ned's warped sense of humour comes out most vividly in the scene where Brenda (Laurie Bartram) is trying to set up a target at the archery range. Suddenly an arrow narrowly misses her. Shocked, she turns around and

below:
Steve Christy (Peter Brouwer) prepares to leave Camp Crystal Lake to drive into town.

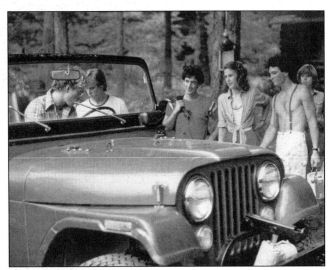

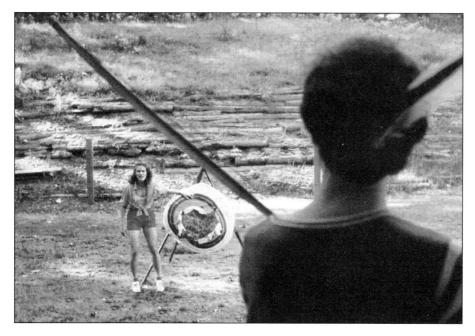

sees Ned laughing at her. "That arrow went right by me," recalls Bartram. "I believe it was Tom Savini who shot that arrow," says Nelson. "I also remember reading in one of the early versions of the script that Ned had polio or something and that his legs were deformed and his upper body was actually quite muscular."

Later on Ned and the other counselors receive a visit from Dorf (Ron Millkie), the slightly-demented patrolman hot on the trail of Crazy Ralph. "That was a funny scene to do, my only scene," recalls Millkie. "I remember the first time we did the scene, I really tried to make it over the top, make Dorf so serious that he's totally hilarious. Anyway, the first time we did the scene, Harry Crosby, who's a true gentleman, came over to me and told me that he was 'duly impressed' with my performance. They really made me feel welcome." After some heated words are exchanged, Dorf heads off, never imagining that he would be the last person to see this group of counselors intact and alive.

Millkie's most vivid memory from his brief role in *Friday the 13th* was his first meeting with an unknown actor named Kevin Bacon. "You know, people wouldn't believe me, but I noticed Kevin Bacon right from the beginning," says Millkie who, today, is a successful New York based acting teacher, having guided the careers of such young actors as Lacey Chabert and Kerr Smith. "It was the scene where I yell at them to keep their hands off my bike. I was acting really intense, trying to be intense. So, before we do the scene, Kevin walks up and touches the bike and I yell to him, 'Get your

damn hands off of my bike' and Kevin didn't even flinch. He was totally intense. I could see that he was a very intense and serious young actor. Kevin's a great guy and we've kept in touch over the years."

Millkie is shocked that, in retrospect, his seemingly minor role in the *Friday the 13th* universe has become the stuff of legend. "I can't believe how many fans are out there," he exclaims. "I get letters all the time. Recently, I got a letter from this kid who told me how he and his mother

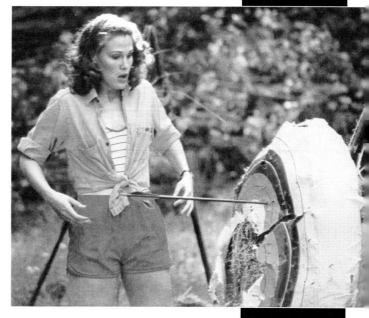

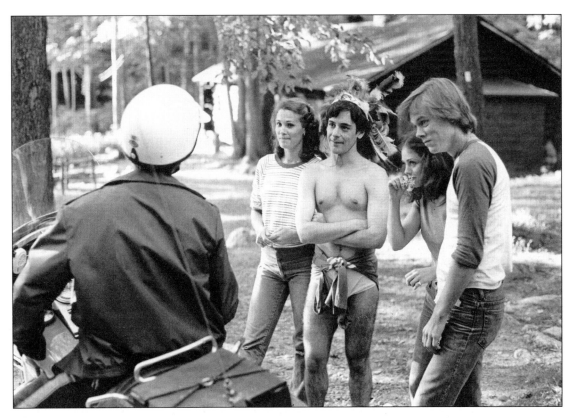

above:
Officer Dorf (Ron Millkie) issues a stern warning to Camp Crystal Lake's doomed staff. During filming, most of *Friday the 13th*'s cast and crew stayed at a local one-floor motel truck-stop in Blairstown. Some however elected to stay on the grounds of Camp No-Be-Bo-Sco.

loved watching movies when he was a kid and that *Friday the 13th* was his favourite film and I was one of his favourite actors. He wanted an autograph and he even enclosed a pen with the letter. Another guy's an independent writer-director named Tony Urban and he just told me how much he loved the film and my character and I found out that he has a production company that he called Crazy Ralph Productions."

Though only on set for a "couple of days," Millkie could sense a tremendous comradery amongst the cast and crew. "Well, Harry was a really class act, really nice, everybody was nice," he recalls. "I actually shared a motel room with Harry, just so I could change while I was there. Then, one night, I went with Harry and Kevin and the girls and we had dinner at this quiet little roadside diner. Actually, I've seen Harry Crosby over the years. We both used to live at the Manhattan Plaza and we used to belong to the same health club. He told me that he'd been involved with advertising and a bit of real estate and that he'd kind of given up acting. He was so nice, but I got the impression that acting wasn't really his true passion; that it was something he felt kind of obligated to do because of his famous last name. It's funny because, a few years ago, I was going to star in a stage version of Bernard Slade's

Romantic Comedy with Harry's mother, Kathryn, but it never came to pass."

Shortly after Dorf's departure the counselors have their first, and last, meeting with Crazy Ralph, who tries to warn them of the camp's death curse and convince them to leave the place immediately. "He was a really funny guy," recalls Jeannine Taylor. "I kind of shrieked when he just jumped out of the door like that, but we always rehearsed all of the scenes so there weren't that many surprises." Says Cunningham of Ralph, "He's your typical soothsayer, one of those real crazies who you think is totally insane, but who, in some ways, is more sane and more correct than those who are considered sane. That's all Ralph was: a bit of creepy humour and irony. We never intended for Ralph to have known about Mrs. Voorhees or anything that was really going on. He was just the kind of crazy character that lives in every small town."

Before meeting Dorf the counselors had spent some time by the lake, just having a little fun in the sun, completely unaware of their fate; only a few hours later, the sky would turn black with pouring rain, an ominous sign of the terror and carnage to come. *Friday the 13th* was about to make history, in more ways than one.

Cabin of Blood

The last happy moments the remaining counselors would enjoy, before being crudely stalked and slaughtered, were the precious few hours they spent at the lake. However, even in the midst of their joy, there was some tension. *Friday the 13th*, by its nature, bears a certain amount of pressure to produce a scare for the audience every few minutes. This is probably why Cunningham and his production team decided to give the otherwise happy-go-lucky lake scene a bit of a jolt as we apparently see the character Ned drowning. The other counselors, led by Brenda, jump into the water to rescue Ned, only to discover that he's joking around. "That was a tough scene to do. The water was freezing and we had to pull Mark out of there," recalls Bartram, who was given the rather thankless task of administering CPR to Ned. Ever the practical joker, his eyes flash open and he tries to swallow Brenda's face.

The scene forced Nelson to hold his breath. "That was the worst thing to do," he recalls. "Basically, I was forced to stay under the water until Sean would yell for me to come back out. The whole thing made me sick. While I was under the water, I was forced to continually doggy-paddle until Sean finally yelled that he had the shot. Once I came out of the water, I was dizzy and sick as a dog. It was probably the worst thing I ever did as an actor. The only good part was being able to kiss Laurie Bartram when she tries to give me mouth-to-mouth."

It's at this point that Manfredini's chilling musical score begins to take effect as we witness the killer's point-of-view from behind a patch of trees. The ki-ki-ki-ma-ma-ma riff echoes in the background. "That might've been my hand pulling the tree open and looking down at the counselors," recalls Miner. "We used lots of different people for feet and hands. Anyone who had smooth hands was used because it wouldn't make sense to see a hairy hand contrasted with a smooth hand, especially since the killer's a woman."

During this scene, Manfredini's score invites us inside the twisted and grief-stricken mind of Pamela Voorhees, who no doubt has been further enraged by Ned's silly prank which - ironically and certainly unbeknownst to Ned and the other counselors - is a cruel re-enactment of Jason's drowning more than

twenty years earlier. "The first film was definitely the toughest to do," recalls Manfredini. "I had no money and here I was scrounging around in front of a microphone trying to mouth the ki-ki-ki-ma-ma-ma thing while, at the same time, playing a whistle and experimenting with cymbals and orchestration."

According to Manfredini, the ki-ki-ki-ma-ma-ma riff represents more than just a peek into the mind of a madwoman. "It surprises a lot of people when I tell them that there's only maybe three chords in my entire score for *Friday the 13th*," says the composer. "Regarding the killer's voice; I looked at Mrs. Voorhees as someone who heard voices that made her kill. At the end of the film you see Betsy Palmer mouthing the words, 'Kill her, mommy' which kind of reveals everything, and she's using a child's voice too. Really, ki-ki-ki-ma-ma-ma represents her saying 'kill, mommy' and I created the sound by talking into a microphone."

Eventually, the counselors branch off into different parts of the camp. Alice, Bill and Brenda hover around the main cabin while Jack and Marcie go back to their cabin, intending to have sex. Unbeknownst to them however, a sulking Ned has also gone to the cabin, just minutes earlier. By the time these scenes were being filmed, the Blairstown location had been hit by torrential rain that,

below:
Practical joker Ned (Mark Nelson) fakes his own drowning.

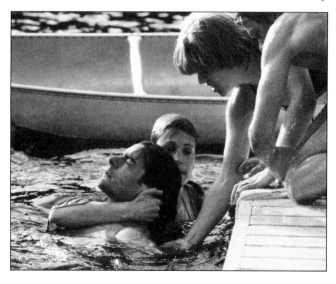

combined with clever lighting set-ups, ended up making *Friday the 13th* look atmospherically creepy and grainy. "We didn't have any cranes or fancy lighting to work with so we went for a very stark look, almost as if we were making a documentary," says Barry Abrams, *Friday the 13th*'s ace cinematographer. "It felt very real and the isolated locale added a lot to the film. One of my strategies was to frame the characters' faces, see the whites of their eyes. We used very practical lighting in the film - from any source that we could find - and we flashed the negative to highlight the shadows and the atmosphere in the scenes."

As Ned approaches the cabin, he notices a hulking shadow near the doorway that quickly vanishes as he approaches. Who was that? According to Nelson, it was Jason himself - young Ari Lehman. "Yeah, I recall that Ari was standing in front of the cabin," he claims. "Ari was a great kid and we all had a lot of fun with him because he had to dress up in all of that makeup. I also ended up meeting Betsy Palmer once. One day, I stumbled into the makeup cabin so Tom could work on my throat and I saw Betsy Palmer standing there. Tom introduced Betsy to me and told me, 'Mark, this is Betsy, your killer.' Betsy had her back turned to me because her hands were flat on the table. When she turned around, a third hand appeared. I jumped back and we all laughed. It was one of Tom's effects."

Before lovebirds Jack and Marcie enter the cabin, they pause to talk about Ned, and Marcie confides to Jack about a horrible nightmare she's had recently: a dream about a hard rain that slowly turned to drops of blood. Was this a psychic vision? "That scene took a long time to film because we did it in one take and I had a lot to say," recalls Taylor. "I had a lot of fun working with Kevin and Mark."

Upon entering the darkened cabin, Jack and Marcie immediately fall on a bunk and start having sex, oblivious to the fact that Ned is laying on the top bunk, throat slashed from ear-to-ear, the white lightning crudely illuminating his shocked visage. "I had to hold my breath for a long time in that scene," recalls Nelson. "Dying's not easy. You know, *Friday the 13th* isn't really something that's stayed with me in a lot of ways. I've done so much good work on Broadway and on television and that's what people know me by now. Films like *Friday the 13th* are very primitive and nobody in the industry takes them very seriously."

above:
Ned meets his doom alone on his bunk.

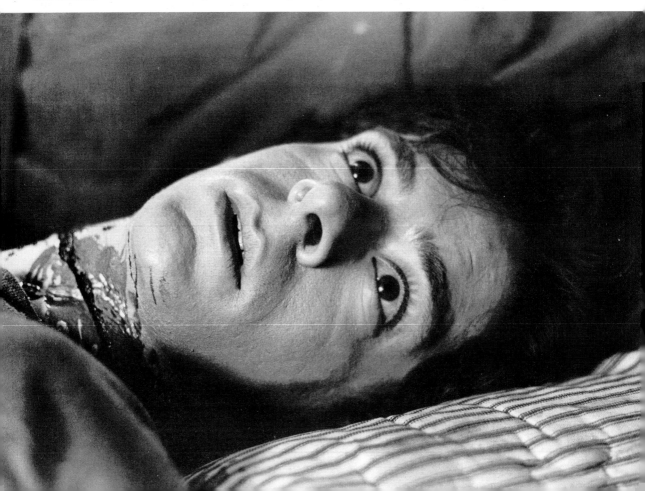

Most people outside out of the prestigious New York acting circles probably aren't aware of just what a celebrated actor the highly-trained Nelson is. He won an Obie award for his acclaimed portrayal of Albert Einstein in Steve Martin's comedic play *Picasso at the Lapin Agile*. A student of famed acting teacher Uta Hagen, he appeared on Broadway, to rave reviews, in Tom Stoppard's *The Invention of Love*. He has also made multiple TV appearances on shows such as *Law & Order* and *Spin City*. It is telling that, according to Nelson's bio, his supporting turn in the 1996 Goldie Hawn comedy *The First Wives Club* is his big-screen debut, thus forgetting - or maybe deliberately omitting - his memorable turn in *Friday the 13th*.

Actually, Nelson's character Ned is much more significant than merely being the one who bled on Kevin Bacon. Ned - it could be argued - gave birth to the 'practical joker victim' character that would become a staple of horror films, for almost every horror film after *Friday the 13th* featured a 'Ned clone,' whose lousy sense of humour signalled his impending horrible death. There was no equivalent character in *Halloween* or, before that, *Black Christmas*. No doubt about it, the character of Ned would serve as a character model for virtually all of the slasher film clones that were to follow *Friday the 13th*, as his type can be seen in everything from *The Burning* and *Happy Birthday to Me* to *Sleepaway Camp*. Such thoughts, no doubt, were not on the minds of Jack and Marcie as they finished having sex, as signalled by Marcie's orgasmic cry. She then tells Jack that she has to go to the latrine to "take a pee," but amazingly, when she gets up off the bunk, she doesn't see Ned's body at all. In reality, Nelson was already gone from the location, but still, how dark could that cabin have possibly been? Regardless, with Marcie gone, Jack is left to rest on the bunk alone, basking in the warm afterglow of summer camp sex. In a way, Jack and Marcie were lucky as most of the characters that have sex in the *Friday the 13th* films don't get to finish the sexual act to full completion. But that would be small comfort to Jack, because what would happen next wasn't just the killing off of a horror movie character, or indeed the killing of a character played by a then unknown actor who's now very famous.

Miller's script made no specific mention of exactly how Bacon's character Jack was killed, although it does mention that later on in the film Jack's body can be seen hanging from a tree, whereas the film itself completely ignores the issue of what happened to the bodies of Jack, Ned and Marcie. Despite such vagaries, the moment itself that Jack dies - a scene that would go on to forever be known as the 'arrow-through-the-neck' scene - is now an acknowledged piece of horror movie history.

above:
Kevin Bacon and Jeannine Taylor relax during the filming of their sex scene. This scene was filmed with a skeleton crew to make sure the actors did not feel uncomfortable.

This was the moment when Savini, Stavrakis and a few other unexpected contributors earned their money and made their reputations. Nevertheless, Steve Miner had carefully planned the whole thing, in full detail, with no one knowing whether or not the scene could even be filmed. "Man, I story-boarded that thing from top to bottom," recalls Miner. "It really was magic. To do a scene like that, it just didn't seem possible, but, somehow, we pulled it off, mainly thanks to Tom and the crew. It was amazing to stand there and watch it happen."

Savini needed to achieve the illusion of a blood-soaked arrow emerging from Bacon's neck. To do this he had to construct a full upper-body cast for the actor to wear, but the neck area, which was where the arrow would explode through the flesh, was the key to the success of the whole set-up. Savini did not have time to build the neck-cast on the set, so he arrived on the set with one in hand. "If you recall, there was a scene from *Martin* that was somewhat similar to the Kevin Bacon scene," says Savini. "I'd worked with a man named John Maldonado on *Martin* and that's whose neck we used for the scene. We brought it up to the shoot with us."

Just before the infamous arrow-through-the-neck moment occurs, the killer's hand falls over Jack's face, holding his head tight while the fatal wound is inflicted. Whose hand was that over Kevin Bacon's face? It certainly did not belong to Stavrakis, whose hairy hands – as is evident upon close inspection of Morgan's death scene - would spoil the idea that the killer was a woman. In fact, the hand that shot out from under the bed belonged to a man named Richard Feury, who was crammed under there along with Kevin Bacon and the effects team. "There were four of us under the bed at any given time," recalls Stavrakis. "Tom and I were under the bed and so was Kevin and the still photographer. We

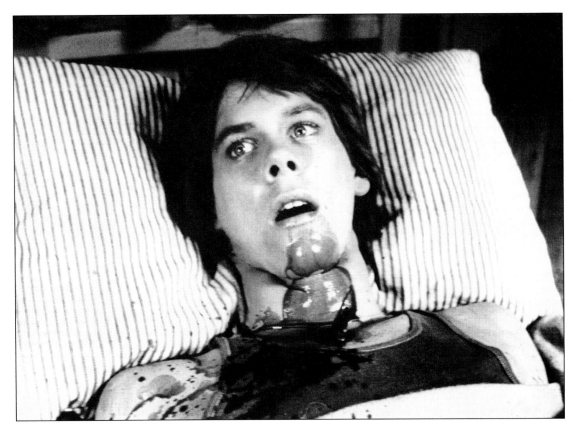

all had to work in unison to make things move right. Tom and I had to control the blood and the tubes."

This literally hands-on approach came as something of a shock for Feury, a recent film school graduate at the time. "This was my first film job and my job was to basically take publicity stills that would be used to promote the film," he recalls. "What would happen to me is that I would stand outside and wait for the actors to rehearse their scene and then I'd come in and get some pictures. I had to be careful not to get too close to the camera angle in case my taking of pictures would affect the lighting or the setup of the camera. Anyway, we were all standing in front of Kevin for the throat scene and Sean and Steve realised that they needed a hand to play the scene and it had to be a smooth-looking hand. Steve just turned and looked at me and said, 'You've got nice looking hands. You go under the bed.' That was it." Savini was also suitably impressed with Feury's 'delicate hands,' and so his – albeit unrecognisable - part in horror film history was sealed. (Despite his strange introduction to the world of filmmaking, Feury gained further work on the *Friday the 13th* films, as a year later he would serve as an assistant director on *Friday the 13th Part 2*, the start of a long and successful career as an AD.)

Another member of the crew who was having fun with this scene was the victim himself, Bacon, even though his neck did get a little sore from craning his head through the opening in the appliance. "That was an amazing scene to be part of," recalls the actor. "I remember having to be very still and then, right when the arrow appears, I had to start gargling like crazy. Eventually, I was able to stand up and look down on the whole thing and it was cool." The scene remains Savini's greatest trick. "This was the first film where I was using Dick Smith's Blood Formula," recalls Savini of his lifelong idol. "That's what we used for the blood in the bag. We filled the cold bag with blood and then pushed the arrow through and that's when you see the blood spray out of Kevin's throat."

If only all effects were that simple, and that effective. But the stunt did not go ahead entirely without a hitch, as at a key moment the tube that was supposed to supply the blood-flow came loose. Enter Stavrakis to save the day. "Tom worked the arrow and I pumped the blood," recalls Savini's assistant. "This was, basically, a one-shot deal, and what happened was that the hose on the blood pump became disconnected. The whole thing was almost blown for good. I had to think quick so I just grabbed

the hose and blew like crazy which, thankfully, caused a serendipitous arterial spray spurt. The blood didn't taste that bad either."

Once the scene was completed, the cast and crew sensed that they'd been witness to something special. "I've always said that Tom was, in many ways, the real star of the film," says Cunningham. "That scene just illustrated Tom's genius; doing something that all of us thought was logically impossible. Tom was the magician and we've lost that with films today. *Friday the 13th* was one of the last films where you could really see the magic being done by hand whereas you see films today that are all driven by CGI." Savini is fully aware of that moment's importance: "That scene in particular really made me a star. It was a scene that was done on-screen with virtually no cutaways. We didn't cheat at all." It was in large part due to this scene that Savini was hired for his next film - the 1981 *Friday the 13th* rip-off *The Burning*, which was produced by none other than Miramax co-founder Harvey Weinstein. *The Burning* was one of Miramax's first efforts. "Oh yeah, Harvey told me he wanted the same stuff for his film as we'd done for *Friday*. Then, after we'd finished *The Burning*, they flew me around to do all kinds of press as if I was the star of the film or something. *Friday the 13th* made me famous."

While Bacon was receiving his involuntary tracheotomy, Jeannine Taylor's character, Marcie, was busy in the latrine, blissfully unaware of her lover's fate, and just as unaware that his killer is listening to her as she does a bad Katharine Hepburn impression. "I improvised most of that scene," recalls Taylor. "Everyone laughed as we were doing it. I remember we rehearsed where I'd be walking with the killer stalking me and everything, and then it was decided that I should talk in Katharine Hepburn's voice. I just did it."

Marcie moves in the darkness, entering another room, when suddenly the shadow of an axe is cast over the back of her head. She turns and screams just as the axe is embedded into her pliant skull. This was one of the few effects in the film that didn't quite make it onto the screen, perfectly intact. "Tom did a full mould of my face for that scene," recalls Taylor who spent hours in Savini's makeup cabin in preparation for the shot. Marcie's death scene was planned as a frontal insert shot that was supposed to show the axe grinding right down the side of her face, in shockingly gruesome and visceral detail. Unfortunately, Marcie's mould didn't quite hold for the shot. "That's one scene that didn't work as well as I'd hoped," recalls Savini. "Every time we tried to do it with the mould, the axe would slide off. It just didn't work so we just had to apply the axe to Jeannine's face and do the cutaway shot. It was still effective, but the effect itself was somewhat disappointing."

above:
Effects design sketch for Kevin Bacon's death scene. This scene was storyboarded by Tom Savini and Steve Miner. (Illustration courtesy of Lammert Brouwer.)

Taylor's acting career, post-*Friday the 13th* – in common with that of many similar actors - is unremarkable. She had a few roles in the years immediately after *Friday the 13th*, but has no film or television credits to her name during the past twenty years. She resides in New York, and a few years ago she was active in various stage productions, including a touring production of *Oklahoma*.

As for Bacon, in all honestly it would be hard for anyone to argue that *Friday the 13th* did anything for his career - good, bad or indifferent. Bacon was a stage actor, first and foremost, having first made a name for himself in the Broadway play *Forty Deuce*, and it would be grossly inaccurate, and unfair, to trace the Kevin Bacon of today back to *Friday the 13th*. It was his supporting turn in Barry Levinson's acclaimed 1982 comedy *Diner* that set the actor on the path to his breakthrough role in the 1984 summertime smash *Footloose*, a role that subsequently led him to a twenty-year tenure as an above-the-line star in Hollywood. There have certainly been ups-and-downs in Bacon's career (his post-*Footloose* era work includes such bombs as *Quicksilver*, *She's Having a Baby* and *White Water*

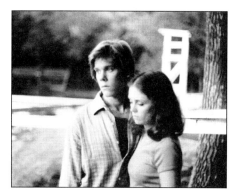

left:
Jack (Kevin Bacon) and Marcie (Jeannine Taylor) plan for a future they will never get to see.

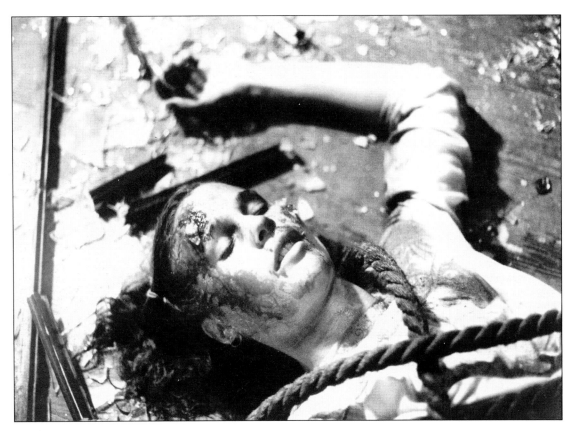

above:
Brenda's (Laurie
Bartram) corpse.
While living in New York
at around the time of
Friday the 13th's filming,
Bartram's cat was
accidentally killed by
cockroach poison while
being looked after by a
Friday the 13th crew
member.

Summer), but he has evolved into one of film's more interesting actors, a status emboldened by his strong work in such films as *Flatliners*, *JFK* and *Telling Lies in America*. Feury, Bacon's on and off-screen assailant recalls, "Kevin's the nicest guy in the world. A few years later, I worked with him on a film called *Enormous Changes at the Last Minute*. I told him to be nice to me because I still had pictures of me killing him."

With three of the cast dispatched in rapid succession, we move back to the main cabin, where Alice, Bill and Brenda are completely unaware of the carnage in their midst. To lighten the mood, the 'threesome' decide to smoke pot, drink booze and play a game of strip monopoly. Long considered to be the silliest diversion in the film, it transpires that Miller based the idea for the scene on a story he had heard about a certain big-name Hollywood actress/activist who had actually made a habit of playing strip monopoly with some other big name stars up in the Hollywood hills. Faced with this charge, Miller pleads no contest, but it was the three actors involved (Bartram, Crosby, King) who had to actually perform the scene, much to their amusement. "We just had fun with that scene," recalls King. "We always rehearsed scenes and I think, with that scene,

that there was a lot of room for improvisation. Some of the dialogue in that scene was pretty corny, but we laughed about it." Crosby concurs, "The strip monopoly scene was totally improvised and we all laughed about it because it was so silly."

The strip monopoly game is not played out to completion however, as in the midst of a powerful storm, Brenda has the sudden urge to go back to her cabin for sleep. It's at this point that *Friday the 13th* claims its next victim when, while comfortably in bed, Brenda hears a child's cries in the night. Concerned, she runs out of her cabin to investigate as the cries get louder and louder. Is this the voice of Jason? Not exactly. As we learn by the end of the film, Pamela Voorhees has become very adept at imitating her beloved son. Betsy Palmer portrayed the voice in the night. "Yes, I did the voice and, actually, I think I'd just met Laurie before that," she recalls. "I think I'd just come off doing *Peter Pan* and I'm very good, with my stage training, at doing voices, and particularly good at doing a child's voice. That Laurie was a very pretty girl. It's too bad she had to be killed off."

Brenda heads in the direction of the archery range, a grim reminder of Ned's fate and his unrequited affections for her. It's here that the killer

- or, to be more exact, the camera - strikes. As for us not seeing Laurie get killed the director recalls, "I was just following the script. Some of the scenes happened off-screen and some of them were very graphic. I just filmed what was scripted."

For her part, Bartram's job was to move around in the drenching rain and imagine what it's like to be stabbed to death with a broken arrow, all with the help of about twenty crew members. "When I was running through the rain, the crew was right with me, telling me where to run and where to look," recalls the actress. "Then, when I stopped and looked ahead, I think Sean and Steve and Tom were there in front of me. I pretended like I was looking at Betsy, something evil."

Bartram's career took a most unexpected turn, as she abandoned Hollywood following the release of *Friday the 13th* in 1980, having become a devout born-again-Christian. She went back to school - at a bible college in Virginia no less - and today can be found working as a financial advisor in Lynchburg, Virginia where she's married with children. After finishing her work on *Friday the 13th*, Bartram headed back to New York and briefly kept in contact with some of her fellow cast members. "Laurie had become very interested in religion even prior to *Friday the 13th*," recalls Crosby. "I remember that we hung out in New York after the film and Laurie dragged me down to this Church on 230th street, which was a very interesting experience."

With Brenda's fate sealed, panic has started to set in at the main cabin after Alice has heard what she thought were Brenda's screams coming from the archery range. They try to laugh it off, but - whilst searching the camp grounds - they soon come to the eerie realisation that everyone has seemingly vanished. Where are the bodies of Jack, Marcie and Ned though? Wouldn't the blood in their cabin still be visible when Alice and Bill look inside? "We never paid much attention to stuff like that, missing bodies," says Cunningham. "We thought that when the sun came up the next morning, all would be revealed."

Meanwhile, Steve Christy is having a cup of coffee at a diner in the middle of town run by the kind-hearted Sandy (Sally Anne Golden, who passed away in 1982, with *Friday the 13th* being her last film role), one of the few people in town who doesn't think Christy is totally insane. It's raining outside – the effect created artificially in this instance by Cunningham's crew - and inside, Christy has no idea of the bad luck that's about to befall him. "I thought that scene really humanized Steve, told you what he was all about," says Brouwer. "Then you have the woman in the diner who's one of the last people who'll ever see him

above:
The inside of the Blairstown Diner today. This is where Steve Christy (Peter Brouwer) enjoys his last meal. Cinematographer Barry Abrams applied green gel to the windows to give the scene more atmosphere. (Photo courtesy of Sean Kearnes.)

alive. What's she going to be thinking about the next morning?"

Fake rain was created for the diner scene along with other sequences in the film despite the fact that it occasionally rained during the shoot. Creating the downpours was the job of atmospheric effects expert Steven Kirshoff who, today, is a highly-regarded Hollywood professional with credits including *The Bone Collector* and *Independence Day*. "My favourite technique for creating rain in the film, I recall, was to just blow open a fire hose. It worked really well and the rain sort of became a character in the film." A year later, Kirshoff handled special effects chores on *Friday the 13th Part 2*.

Christy gets in his jeep and drives through the rain back towards Camp Crystal Lake but before he can get there he skids off the road and into a ditch. He looks stranded until Ronn Carroll's well-meaning Sgt. Tierney shows up to save the day and, inadvertently, lead Christy to his doom. If it weren't for Tierney showing up, the whole order of things might have changed. For one thing, Christy might have been stranded until morning, thus saving his life. Or if he had been picked up by a random motorist, perhaps the ensuing chain of events might have been altered in some way, but as it transpired, it was Tierney's subsequent fateful decision to drop Steve off at the edge of the camp entrance that resulted in the campsite owner's murder. Thus it was, that a simple emergency fire call may have altered everyone's lives forever, none more so than the lives of *Friday the 13th* fans all over the world...

above:
Exterior shot of the Blairstown Diner as it appears today. Fake rain was created for the scene, and at various other times during filming, by using fire hoses.
(Photo courtesy of Dean A. Orewiler/Orewiler Photography.)

"I think that scene is kind of the unlucky part of *Friday the 13th*," says Carroll. "At the same time, I think that had to happen to move the plot along. They had to isolate that character to kill him off. Sean had a hard time trying to figure out what to do because if I show up, the whole thing might've been blown out of the water. It destroys the mystery and tension of the film to have too many other characters. I think it's pretty creepy that Tierney's the last one to see Steve Christy alive." Carroll recalls that the car-scene between him and Brouwer was very straight-forward, saying: "I was driving the car and there was a camera mounted to the front like you'd do if you were shooting a commercial. Again, I was just learning my scene and I didn't really know what was going on with the whole story."

Christy starts walking the rest of the way towards the main part of the camp when he is suddenly dazzled by the glare of bright headlights. After a moment, Steve smiles in recognition. He walks towards the camera with a big grin on his face and then flinches backward as a knife plunges into his gut. "It's funny, but that's the one scene I don't remember very well," says Brouwer. "I remember hanging upside down in the gazebo when Adrienne finds my body, but I don't remember getting stabbed." The people that Brouwer was walking towards were Cunningham, Miner and camera operator Braden Lutz. The skills of Savini and Stavrakis were not required for this scene, which was filmed exactly in accordance with the description in the final shooting script. Of all the victims in *Friday the 13th*, Steve Christy is the least butchered of them all, and maybe that is because it reflects the notion that Pamela Voorhees had feelings towards the man and, in particular, his parents. Maybe, at this point, Pamela Voorhees wanted the nightmare to be over with too.

Life is much simpler these days for the man who played the part of Steve Christy, and it doesn't involve summer camps. Today, Peter Brouwer makes the occasional appearance on television (most of his recent credits have been on soap operas) but he is more likely to be seen working with the acclaimed Abingdon Theatre Company in New York City (of which he is a charter member), starring in many of the company's plays. Brouwer also grows orchids as well as working as an auctioneer. "If you want to sell something, I can make you money," jokes Brouwer. "It's funny because Steve Christy appeared in Part Four (in flashbacks during the opening sequence of *Friday the 13th: The Final Chapter*) so maybe he could come back from the dead and appear in another *Friday* film. Does that sound crazy?"

We mourn Steve Christy, a determined and passionate man who inadvertently brought mayhem and terror upon the world. May he rest in peace, along with all of the others who died before and after him. Sadly, violent death would be Steve Christy's true legacy, not the peaceful-looking lakefront area known as Camp Crystal Lake. Unbelievably, the worst was yet to come.

A Boy in the Lake

Friday the 13th is arguably at its scariest during the scene in which Bill walks down to the generator cabin, followed the whole way by the camera, which acts like an omniscient stalker. Even Bill - cool, calm Bill - seems nervous as he checks out the machinery. The scene is even more terrifying for what is to come, as Alice eventually goes down to the generator cabin to check on Bill, and makes a shattering discovery.

This standout scene starts back at the main cabin, where Alice and Bill are blissfully unaware that they are the last two survivors in the camp. They are nevertheless very nervous, as they have recently undertaken a search of the camp and uncovered a bloody axe, but no fellow campers. The phones are dead (the lines have been severed by a machete). Jack's truck won't start (the distributor cap is in pieces). Then, all of a sudden, the lights go out. So Bill puts on his slicker and walks down the muddy trail to check the generator again. Alice wants to come too, but Bill insists that she stay and get some much needed rest. Earlier in the film, it had been made apparent that a budding romance was developing between Alice and Bill, highlighted by a scene during which Bill played his guitar. "Sean let me play my own song in the film," says Crosby. "I can't remember the name of it, but it was a Norwegian song I'd picked up earlier. As for me and Adrienne, I'd met Adrienne back in New York, before we started filming, and she really impressed me as a serious actress. We had good chemistry together."

The various elements of this scene were filmed during the last few days on set (disounting the period needed for re-shoots). "It was very cold on the set by the end," recalls Crosby who had to act out the last walk poor Bill would ever take. "Sean and the others were all moving right beside me as I was walking down to the cabin. There was a real pleasant attitude on the set, but it was pitch-black out there at night. The scene, earlier in the film, when Adrienne finds the snake in the cabin was fun because I got to chop up a rubber snake with a machete. It took a long time to set that scene up. The night-time scenes, with me and Adrienne, were filmed in about a week."

When Alice's curiosity finally gets the better of her, she heads down to generator cabin, looking for Bill. Noticing that the hut's door feels strangely heavy, she turns to check it out and is shocked to find him nailed to the back of the door. This was one of the few scenes in the final draft shooting script that went into minute detail about a killing, a direction that Savini had fun following. "The script said that Harry was wounded in style of the martyrdom of St. Sebastian, and Sebastian was full of arrows," recalls Savini. "That's what we did to Harry although, actually, the scene kind of became a spoof of Steve Martin's arrow-through-the-head routine from *Saturday Night Live*. We wanted to make it shocking."

Making this scene shocking meant showing a lot of blood, and it also meant a lot of pain for Crosby whose eyes started to twitch in reaction to all the makeup. "That stuff killed my eyes, it was just horrible," recalls the actor, whose twitching actually made it seem like his character was going through some sick kind of death spasm. "Me and Tom and Taso really got along well during the shoot. We used to drive around in this old car of Tom's and, most of the time, I'd just hang out in the makeup cabin with Tom and play my guitar."

In creating the effect for the door scene, Savini and Stavrakis designed a special ledge, attached to the door, to support Crosby. Savini then applied the

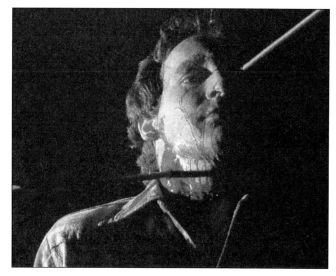

below:
Bill's (Harry Crosby) gruesome fate.

above:
Effects diagram for Harry Crosby's death scene. (Illustration courtesy of Lammert Brouwer.)

make-up and arrows. "It was pretty straightforward except for the fact that Harry's eyes were sore," says Savini. The scene had a big impact on King too as her character, Alice, is forced to confront an image of unimaginable horror. "I just screamed," she recalls. "I just felt like Alice would almost not even believe what she was seeing, that she'd almost be numb."

The problem with Crosby's sore eyes stemmed from the fact that the effect was achieved using Photoflo, a finishing agent designed for the processing of photos, that also happens to be a good substance with which to saturate and thin stage-blood. "They put it over my eyes, along with tubes that were put up my arm, and it kind of formed a mask over my face," reveals Crosby. "When the *Mission Impossible*-like mask was taken off, the oxygen hit my eyes and that caused the burning sensation." It was an innocent mistake of Savini's although, for the most part, he wasn't even there. "I wasn't on location when that effect happened, although I did mix the formula," he recalls. "Like I said, it was the first time that I'd been using Dick Smith's Blood Formula and I was just learning about what were the safest blood formulas to use in the eyes and the mouth. Photoflo's not one of the ingredients used in safe blood, which I soon discovered with this effect. It's a wetting agent used in the developing of film negatives and it helps the blood saturate garments instead of just beading. Basically, our unsafe blood had an opportunity to fill up Harry's eye, under the appliance used to keep the arrow looking like it was in his eye, and it surface-burned Harry. Not a proud moment. I wasn't actually there because I had to deal with some woman problems back home."

The generator cabin scene was a particular test of Cunningham's filmmaking skills. "If you want to talk about any technique in the film then I guess that would be it," asserts the director. "When he walks down to the generator cabin, the audience knows he's going to get killed, but when and how is the big question. We tried to exploit that in *Friday the 13th*. We tried to draw out the kill scenes and make the audience very nervous. Even worse, the character doesn't know that he's going to be killed. It worked very well."

The death of Crosby's character Bill also more or less signalled the end of his acting career. 1980 was quite a year for the actor and his family as *Friday the 13th* made its major debut in June, but it was far from the only news of 1980 for the Crosby clan as, in November of that same year, Harry's sister, actress Mary Crosby, made headlines when it was revealed that the character she played on the CBS night-time soap *Dallas*, Kristin Shepard, was indeed the person who shot JR in the record-breaking episode of the same name. Combine that with the endless barrage of tabloid publicity that the Crosby family had been receiving in the still fresh wake of his famous father's passing and it's easy to see why Harry Crosby would decide to opt out of acting. "Acting was a lot of fun, but it wasn't something that I was entirely committed to," he says. Like the other *Friday the 13th* cast members, he was only a kid when he made the film (Crosby was twenty-one; Brouwer was the oldest member of the main cast at thirty-four). Following the release of *Friday the 13th*, Crosby made a pilot for CBS, entitled *Riding for the Pony Express*, in September of 1980, but that died a horrible ratings death after just one episode despite kind reviews for Crosby's acting. He then enrolled at Fordham University where he went on to earn a business degree. By the end of the 1980s, Crosby was working at Credit Suisse First Boston in New York where he eventually rose to the position of Managing Director. In 1999, Crosby transferred to Merrill Lynch in New York where he holds the same position.

Just like his father, Harry Crosby is an avid golfer and serves on the board of directors of the AT&T Pebble Beach Pro-Am Tournament (formerly known as The Crosby) alongside fellow board member Clint Eastwood. Crosby lives in New York and is married to a scientist. In 2004, the couple had their first child. Crosby - like his character Bill – also plays guitar in his spare time. He used to play at clubs in New York with long-time family friend Rosemary Clooney until the singing legend passed away in 2002. Crosby was most recently in the news when he made an appearance on *The Today Show* to talk about the 9/11 terrorist attacks. His office was close to ground zero. Unlike Bill, he survived.

"I think acting taught me how to identify problems and how to come up with creative solutions, although I'm not sure I'd recommend someone wanting to enter the business world to spend four years studying acting," says Crosby who's not ashamed of his role in *Friday the 13th*. "No, it was a lot of fun and I'm very proud to have been a part of something that was so popular

although I've never seen any of the sequels and I wasn't even aware that they'd made sequels. We used to mention my role in *Friday the 13th* as part of our recruiting packages. I'm always amazed, to this day, that people still recognise me from the film."

The character of Bill represents the 'secondary protagonist' device that has gone on to be used in virtually every *Friday the 13th* sequel. Put simply, the secondary protagonist is a character that almost survives to the end of the film, almost becomes the hero of the piece, only to end up being killed off. What's the purpose of this device? Surprise. We all know that the hero or heroine (it's usually a heroine) in a horror film is going to survive to the end of the film, so by creating a secondary protagonist the filmmaker can provide a final devastating shock for the audience before the climactic showdown.

After discovering Bill's mutilated corpse, Alice runs back to the main cabin and tries to barricade herself inside, but the killer tosses Brenda's bloody corpse through the front window, limp arms trussed together with rope. Needless to say, it was not Bartram acting in this scene, but rather Savini who donned a half-convincing wig before performing the stunt himself. "Yeah, I put on the wig and the dress and just crashed through the window," recalls Savini. "I wasn't thrilled about it, but it had to be done. I think that might've been the last night of filming because we were really under the gun to do it. There

was no time. I remember when Laurie came in to lay on the floor as the corpse that she backed up against the wall and did a really funny pose of a dead horror movie victim. We all laughed."

As Alice tries to cope with this latest shock, help appears to arrive in the form of headlights that illuminate the inside of the cabin. Thinking that this is Steve - back from town at last - Alice runs out the door and towards the vehicle. Needless to say, it's not Steve, but a kindly-looking old woman named Pamela Voorhees with a crazed smile plastered across her face. "I think the first scene is when Adrienne runs out of the cabin and I remember noticing something strange," recalls Palmer. "Well, she's supposed to be barricaded inside the cabin, but when I arrive she just opens the door and runs out. I asked Sean about it and he said that no one would notice. I guess they didn't."

Although Palmer had not played the part of the killer in any of the previous scenes (this work was carried out by Feury, Savini and Stavrakis), the actress was determined to make Pamela Voorhees a real character. To accomplish this, she sketched a detailed profile of the woman. "Being an actress who uses the Stanislavsky method, I always try to find details about my character," says Palmer. "With Pamela, oddly enough, I began with a class ring that I remember reading in the script that she'd worn. Starting with that, I traced Pamela back to my own

below:
Alternate shot of Bill's corpse. When Harry Crosby damaged his eye during the filming of this scene, the producers of *Friday the 13th* were initially worried that he might sue the production, but Crosby handled the episode without complaint.

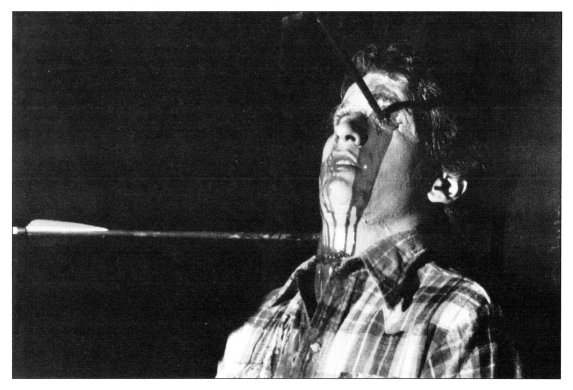

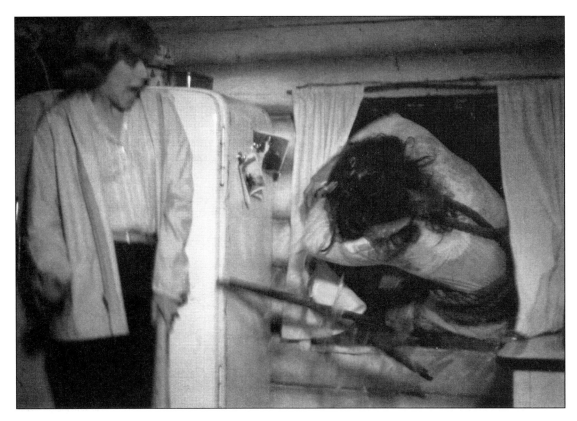

high school days in the early 1940s. So it's 1944, a very conservative time, and Pamela has a steady boyfriend. They have sex - which is very bad of course - and Pamela soon gets pregnant with Jason. The father takes off and when Pamela tells her parents, they disown her because having pre-marital sex and having babies out of wedlock isn't something that good girls do."

Palmer then completed her vision of Pamela Voorhees as the single mother from hell. "I think that she took Jason and raised him the best she could, but he turned out to be a very strange boy," she says. "Anyway, I imagined her taking lots of odd jobs and one of those jobs was as a cook at a summer camp. Then Jason drowns and her whole world collapses. What were the counselors doing instead of watching Jason? They were having sex, which is the way that she got into trouble. From that point on, Pamela became very psychotic and puritanical in her attitudes as she was determined to kill all of the immoral camp counselors. The two camp counselors who get killed at the start of *Friday the 13th* were having sex."

Writer Simon Hawke was commissioned to produce a novelization of *Friday the 13th* that was published by NAL (New American Library) and Signet in 1987. Hawke, a prolific fiction writer who

was formerly published under the pseudonym Nicholas Yermakov, allowed himself to go inside the heads of the *Friday the 13th* characters, particularly that of Pamela Voorhees. "Yeah, I was a fan of the *Friday* films and I had fun writing the books," says Hawke, whose last *Friday the 13th* novelization was his adaptation of *Friday the 13th Part 3*, published in May of 1988. "I imagined that Pamela had tried to get on with her life after Jason drowned - with the help of the Christy family - but that the seeds of her madness were just overwhelming. Steve Christy was re-opening the camp and she saw the whole thing happening again. She couldn't let Camp Crystal Lake open again and so she had to kill all of the camp counselors because, to her, they were all responsible for Jason's death." (Incidentally, the Voorhees name itself was conjured up by Victor Miller. "I went to high school with a girl named Van Voorhees," he explains. "I was always struck by the sound of the name because it was just a creepy-sounding name, a bit threatening." Getting the name Jason was even more simple for Miller. "My son, Ian, was born in 1968 and my son, Josh, was born in 1972," he explains. "I mixed the names together and came up with Jason Voorhees. It's funny when people blame me for creating Jason and they call me the 'father of Jason' because - like I've said before -

I intended this story to be about Jason's mother and her evil. Sean and the producers had a different vision of the story and that's when Jason took on a life of his own.")

Whatever was really going on inside the crazed mind of Pamela Voorhees, poor Alice is soon going to find out that she would never be able to reason with this woman, even if she had a Master's degree in psychology. Pamela Voorhees is determined to kill Alice, but her intentions do not become clear until after she has walked into the main cabin. She recoils in horror at the sight of Brenda's corpse, her face even revealing the slightest hint of disgust. Then, as Alice pleads for them to leave the place, Pamela spills the beans about Jason: about his drowning death, and the filthy and immoral camp counselors that, she believes, let him die.

Alice is able to avoid Pamela's ensuing knife attack and escape the cabin by hitting her attacker with a baseball bat. At this point, it is easy to wonder why Alice doesn't finish Pamela off, as she is briefly at her mercy. Why doesn't she just take Pamela's hunting knife and slash her throat? The answer is of course that Alice has not yet been pushed far enough to have it in her to perform such a horrific act. Alice will need to be put through much more before she is able to reach down far enough into the dark depths

of her soul to do something so irreversibly profound. She takes one of those fateful steps almost immediately; her terror is further compounded when she runs out of the cabin and towards Pamela's jeep where she makes the gruesome discovery of Annie's throat-slashed corpse (was Pamela planning on collecting all of the victims, as was to happen in several subsequent slasher movies including *Happy Birthday to Me* and *Stagefright*?). Starting the jeep in order to drive off proves to be more than Alice is capable of in her current state of mind.

The terrified girl's fear is compounded when she turns to look for an escape route, only to spot Steve's corpse hanging from a tree. "I actually was hung from a bar in a gazebo. I let go of a handhold camera and just swung right into the frame," recalls Brouwer. For Alice, the sight of Steve's body (in the first draft of Miller's script, Jack's corpse was also visible in the same frame) is almost too much for her to cope with as not only are her friends all dead, but Pamela - who knows the area like the back of her hand - is obsessed with killing her too. "The fight scenes between me and Betsy were really bruising and tough," recalls King. Once again, it fell upon Savini to quickly choreograph King and Palmer's fighting movements, and things didn't always go that smoothly. "I think it was the scene where

Adrienne runs into one of the offices and I find her and start slapping her around," recalls Palmer. "I'm trained, from the stage, to pull the punches, to really make contact but in a way that doesn't hurt. It's just supposed to make it believable. Well, when I was smacking Adrienne around, I got a little carried away and I really whacked her good."

This scene took place in Steve Christy's office. By now Pamela, unbelievably, has seemingly re-started the generator, and Alice has found an empty rifle, which she points at her attacker to little avail, allowing Pamela the opportunity to grab Alice and start slapping her around. When Palmer knocked King to the ground, King promptly called out for Cunningham who ran in to check on his leading lady. "Betsy hadn't done a film in a few years, so I was worried that she might be a little rusty," recalls the director. "She did a great job, but you're not supposed to hit the other actors."

Palmer credits Cunningham for not allowing the Pamela Voorhees character to degenerate into a ridiculous parody. "Sean had very good instincts, and one of his big things was for me not to overact in any way, which I think was a very good idea," she recalls. "You know, I think Jack Nicholson's performance in *The Shining* became a big influence around that time and Sean didn't want any of that."

Cunningham concurs, "I don't like actors to go over-the-top. It's very risky for unknown actors to do that. Jack Nicholson was born over-the-top, but when we were making *Friday*, I still wasn't sure if people were going to accept Betsy as a scary villain. It could've been unintentionally funny, but she made the character terrifying."

The action continues with Alice running into a storage area adjacent to the main cabin, the girl possibly figuring that Pamela would never suspect that her quarry would retrace her steps. Any notions Alice might have had of hiding out until the crack of dawn are soon shattered when Pamela starts chopping through the door, pausing only to poke her smiling face through a crack that has opened up. The two women have another close-quarters confrontation and, this time, Alice whacks Pamela across the back of the head with a skillet, drawing blood. It looks like Pamela is incapacitated, but again Alice can't bring herself to pick up Pamela's blade and finish her off. Dazed from the phantas-magoric stream of images that have assaulted her senses over such a short period of time, Alice stumbles out of the cabin and heads for the lake, scene of her final confrontation with her would-be murderer. Pamela Voorhees - seemingly so ruthless and superhumanly strong - was about to lose her

below:
Alice tries to defend herself with Steve Christy's empty rifle.

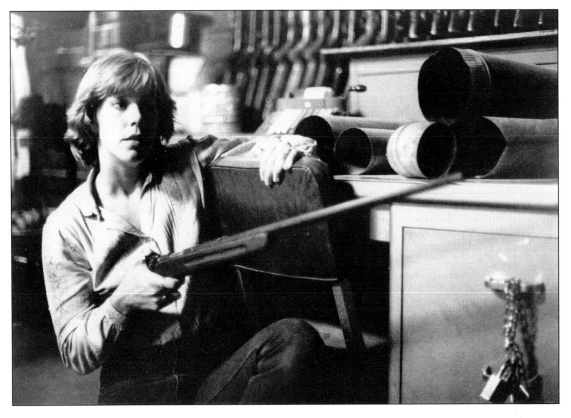

head at the hands of skinny little Alice, but this wasn't going to be a head problem that any psychiatrist could fix. Alice was about to decapitate Pamela - with a hunting knife no less - right in the face of the MPAA.

As Alice arrives at the edge of the lake, she glimpses Pamela heading straight for her, and the two women engage in a desperate physical battle. "Betsy was so strong," recalls King. "The sand felt like hard rock. Every time you hit the floor, it was like falling on pavement." According to Palmer, if the fight scenes were difficult, it wasn't because of her physique. "I'm about five-foot-seven and I weigh a little over a hundred pounds," she says with a laugh. "Who the hell am I going to beat-up or scare? They didn't give me any wardrobe or nothing. All they gave me was the knife and the sweater. If it wasn't for the long underwear I had on, I probably would've died of pneumonia. The heavy sweater made me look tough."

The battle continues until Pamela rises up - knife in hand - and tries to plunge the blade down into Alice's virginal heart. Thankfully she misses though, and is thrown off balance, giving Alice the chance to scramble to her feet and grab the dislodged knife. There's no hesitation in Alice's eyes now. She is overcome with animalistic fury. With a crazed look on her face, the now armed Alice races towards a stunned and terrified Pamela Voorhees and - in one swift stroke - separates the murderer's head from her body. "I was shocked that Sean was able to get away with that decapitation scene," recalls King. "It was really shocking when people saw it for the first time." King wasn't nearly as shocked as the victim herself, Palmer, who's a little miffed that - after a career spanning more than fifty years in show business - her enduring legacy is that of a severed head. "We were standing on the beach and Tom and the guys came over and said to me, 'Hey, Betsy, do you want to see your head get cut off?' I was shocked."

In doing the scene, Savini and Stavrakis were faced with a similar challenge to that encountered with the Kevin Bacon throat scene - the need for another one-take effort. In reality, King and Palmer were nowhere to be seen during the actual decapitation, which was yet another Savini 'magic trick' that required a tremendous amount of skill and precision, and a degree of good luck. "I'm very grateful to have had a director like Sean who would let us do effects like this," says Savini. "Sean reminded me a lot of George Romero in that way. Sean always knew what he wanted to do and how to set scenes up. With the decapitation, it was me who swung the knife across the neck. That's how we started. Taso stood in for Betsy."

The years that followed the release of *Friday the 13th* saw the careers of Savini and Stavrakis

above:
Adrienne King pulls a nasty surprise out of Tom Savini's effects oven on the set of *Friday the 13th*. (Photo courtesy of Lammert Brouwer.)

move in radically different directions. Savini, of course, went on to become the greatest make-up expert of his generation, a title that he earned for his groundbreaking work on such films as *Creepshow*, *Day of the Dead* and, ironically, enough, *Friday the 13th: The Final Chapter*, the film that Savini thought would give him the opportunity to kill off the legend of Jason, and the *Friday the 13th* series itself, for good. That wasn't the case, but in the past twenty years, Savini has been transformed from mere make-up effects artist to the status of pop culture icon. Savini does not work on mainstream Hollywood films, preferring to stick to the 'real effects' that can only be created and shown in independent horror films. His cult status was emboldened when, in 1995, Robert Rodriguez and *Pulp Fiction* mastermind Quentin Tarantino cast him in the comically horrific role of Sex Machine in their vampire opus *From Dusk Till Dawn*. Savini has done all of this, and much more, yet he still lives in Pittsburgh where, in his spare time, he lends valuable advice to students attending his self-titled make-up school. Lamentably, Savini also directed the ill-fated 1990 *Night of the Living Dead* remake, but no-one's perfect.

Stavrakis's career post-*Friday the 13th* has been more low-key than Savini's. He has been given a fair amount of acting and stunt-work, having earned credits on such films as *Day of the Dead*, *Creepshow 2* and *The Mask of Zorro*. More recently, he has been working with The Hanlon-Lees Action Theatre, a travelling medieval entertainment troupe that's similar in conception to the subject of the 1981 George Romero film *Knightriders*, in which he appeared alongside Savini. "Part of my problem has been that people haven't known if I'm an actor, a stuntman or an effects guy," he says. "I've been my own worst enemy because I've spoiled lots of good

above:
Betsy Palmer and Adrienne King attempt to coordinate their moves for a fight scene.

opportunities. Recently, some friends of mine landed me a job on a Johnny Depp movie, *Pirates of the Caribbean*. It was going to be a cushy gig: eighteen weeks of work, no problems. I screwed things up and I only ended up getting one day out of it. I've given up Hollywood and I've moved back to Florida to spend time with Gus, my son."

It's more than a little ironic that Taso Stavrakis played Pamela Voorhees both as a killer and, eventually, a decapitation victim. "You can see the hairy hands if you look really close," he says with a laugh. Savini explains, "After she gets decapitated, she raises her hands in the air, in a death reflex, and you can see the hairy knuckles. That's because Taso was wearing a head and shoulder piece of Betsy Palmer which was placed on his back. The head was already severed and it was held in place by toothpicks. All that was left was for me to swing the machete hard enough that it separated the head from its position. We had to over-crank the camera so the whole thing would play in slow-motion. We were lucky that the head ended up spinning in the air like it did."

Betsy Palmer has high praise for the makeup master's work. "People say I was the star of *Friday the 13th*, but I always say that the real star of the film was Tom Savini," she asserts. "Tom was so funny and sweet and very talented. He kept talking about how Dick Smith was his favourite makeup artist and

how much he wanted to be like him. One time, Tom had to leave the set to go have a meeting with Dick Smith. When he came back, he was so happy because Dick Smith had liked his work. Tom was so happy."

The only people happier than Savini were Cunningham and Miner. "The scene was in the script, but, again, Tom just amazed us with his imagination. The decapitation appeared on-screen in the most powerful and visceral way possible," recalls Miner. Cunningham was worried the scene might've worked too well. "Tom's such a genius that my temptation was to go over-the-top with the gore effects," he recalls. "We could've easily had lots more effects in the film, but I think that would've been overkill because once you've shocked the audience, they can get numb. I was able to balance this during the editing process when I could be more objective. I also knew that the film couldn't end with the decapitation. It had to have the big shock, the jump-out-of-your seat shock, like magic mountain."

The lake is the setting for *Friday the 13th*'s climactic scene, carefully designed by Cunningham and his team specifically to end on a heart-stopping moment that audiences would never forget. The horrific violence that preceded this moment constituted the body blows, but this was intended to be the knockout. Whilst very exciting in its own right, it's the construction and conceptualization of the scene that's even more interesting.

The mysterious team of Minasian and Scuderi re-enter our story at this point, as they considered the filming of the climactic scene in the lake to be so crucial to the success of the film that they travelled to the New Jersey location to personally supervise Cunningham's work. "They were like the men in black," recalls Palmer. "You'd see these strange men lurking around on the set and all they told us was that these were the money-men from Boston." Aside from Minasian and Scuderi, other visitors to the set at various times included business associate Alvin Geiler, who received an executive producer credit on *Friday the 13th*, Cunningham's son, Noel, who ran errands for his father on the set, and his friend Adam Marcus, who would eventually grow up to direct 1993's *Jason Goes to Hell: The Final Friday*. Wes Craven also showed up.

The film's climax also marks the re-introduction of writer Ron Kurz whom Scuderi entrusted to bring Jason out of the lake, literally. "The scene with Jason jumping out of the lake became Phil's obsession," recalls Kurz. "I wasn't there when they filmed the scene, but I know that Phil was all over Sean to do it exactly right. Basically, I came up with the idea of Jason the monster. In Victor Miller's script, Jason was merely a normal kid who had drowned the year before, nothing more. As I was rewriting, I came up with the idea of making Jason 'different.' I made him into a mongoloid creature and I came up with the idea of having Jason jump out of the lake at the end of the film."

Kurz claims that his pitch had suitably impressed Scuderi during a dinner meeting in Boston, when the two men discussed their ideas for *Friday the 13th*. "I knew that once the audience was lulled into thinking that the closing credits were about to roll, that it was the perfect time for Jason to jump out of the water," recalls the writer. "Well, when I told that to Phil, during our dinner, Phil listened intensely and then he got up, without a word, and walked out into the lobby. Phil's secretary and I could see him - just pacing around - and she turned to me and said, 'Wow, you really got him good with that one.' I knew it was a great idea."

Where does that leave Savini, who also claims to have been responsible for the final scene? "Like I said, when I drove up to meet Sean and Steve at the house in Connecticut, there was no ending," asserts Savini. "My true inspiration was the idea that the audience wouldn't know what was real or not, and that's why I think the scene worked so well. Doing the makeup itself was very problematic as Jason only became a mongoloid after the original look didn't work very well. In our original design, Jason had lots of hair and then we changed the look to make him have a weird-shaped head and chin. It was my idea. There was no script that had that kind

of description, and how could there have been with the tight schedule we were on?"

So how does one untangle these claims and counter-claims? It appears - given all of the evidence, which includes numerous script drafts and vast reams of production notes - that the monster that would become famous the world over was truly a team effort. Firstly, Miller deserves credit - and the undying gratitude of horror fans around the world - for creating Jason Voorhees, the victim, the catalyst for the two-plus decades of terror that was to follow. Kurz then developed this thread, but he visualized Jason as a monster. And finally it was Savini who actually brought Jason to life as a horrifying creature that jumped out of a lake and shocked the world so, in practical terms, Savini is perfectly entitled to claim that he created Jason. But Jason was the result of a creative collaboration, no doubt about it, and surely none of the people involved at the time could have imagined that their creation was set to become a legend.

The lake scene was very different in Miller's original script. Alice – exactly as she does in the finished film - stumbles into a canoe after fighting Mrs. Voorhees. But at this point the film goes in a markedly different direction. In Miller's script, Alice drifted in the canoe for hours before a blood-soaked Pamela attacked her in her canoe, appearing from a bough overhanging the shallow water in the dark. The two women struggle in the water, and eventually Alice defeats Pamela when she gets hold of her assailant's blade and decapitates her with it. Alice then stumbles onto the road where a couple of unsuspecting troopers stumble upon her. Miller's version then ends with a shot of the lake, dark and serene. Fade out.

below:
Alice guards herself against the rampaging killer.

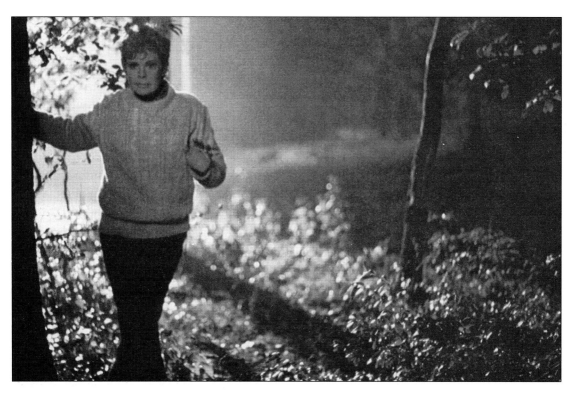

above:
Pamela Voorhees hunts
for Alice.

If it weren't for Kurz and Savini, maybe there would never have been any *Friday the 13th* sequels as we know them today, namely with the masked Jason as the killer. Indeed, maybe *Friday the 13th* would never have become the hit it was without the shocking sight of young Jason appearing from beneath the surface of the lake. "That was the scene that excited people and really made the film," recalls King. "Just watching it in a theatre, you could see people relaxing, thinking it was all over, and then the monster appears." Peter Brouwer agrees: "When I saw Jason jump out of the lake, I knew *Friday the 13th* was going to be a big hit. All of the girls in the movie theatres would grab their boyfriends for dear life. When you get that kind of reaction, you've tapped a nerve."

Given the scene's importance, it's probably not much of a surprise to learn that it took three months to get the necessary footage in the can. Whilst the bulk of the scene was filmed at the Blairstown location, Cunningham would later return - along with a skeleton crew - to a location near his home in Connecticut in order to film additional close-up and exterior shots that would ultimately be spliced together to create horror film history. For everyone on the film crew, raising Jason from the bowels of Crystal Lake was pure hell. "We filmed it for the first time in September, during the main shoot, and then we filmed it sometime in October and, finally, we

shot it in November," recalls King. "Something always seemed to go wrong." Her abiding memory however is that of being dragged into the freezing water over and over again: "It was miserable. Sean was really nice and, finally, after a take, he told me that the next take was going to be the last."

King and Palmer were both immortalised eternally as sworn enemies in *Friday the 13th*, but their subsequent careers headed off in wildly different directions. After the release of the film King went to England to study theatre until, around June of 1980, she returned to prepare for her pre-credit appearance in *Friday the 13th Part 2*. "It's great that people love the movie and love my performance," says the actress, adding wistfully, "but the only effect the film had on my career was that it forever typecast me as a horror movie heroine and it's something that just won't die."

In the early '90s, King would occasionally make appearances at horror conventions, such as the *Weekend of Horrors* event which is run by the American horror film magazine *Fangoria*. By this time, the actress had turned her attention to voice-over work, providing background voices for such films as *What's Eating Gilbert Grape?* and *While You Were Sleeping*. Finding work in this field was no accident for King who, by this time, was married to Richard Hassanein, a post-production executive with Deluxe Laboratories in California. King and her

husband live in Azusa, California where she enjoys a quiet life, devoting much of her spare time to charitable activities, including work with The Variety Club. King might well find the quiet life very welcome as, years ago, she found herself the victim of a crazed stalker, a sick fan, who actually broke into her home and threatened her life. "She's doing great," says Cunningham who has kept in touch with King over the years. "She's very happy and she really enjoys what she's doing now."

Whilst King was trying to escape the influence of *Friday the 13th*, Palmer made a second career out of it. No other actor has benefited more from their appearance in *Friday the 13th* than her (if you accept the argument that Kevin Bacon's work on the film played no part in his future success). In the past twenty-plus years, the actress has made numerous television guest appearances on such shows as *FreakyLinks*, *Knots Landing* and *Murder, She Wrote*, notwithstanding her numerous appearances at autograph shows and conventions. "Being in *Friday* has allowed me to work again, but, sadly, it didn't lead to more great film roles like that of Mrs. Voorhees. That's why I mostly do theatre, because that's real acting to me. I've never liked film because film is such a slow process," she reveals.

If King had a difficult time in the freezing waters of Camp Crystal Lake, one can only imagine what it was like for Jason himself, fourteen year old

Ari Lehman. It's not surprising that *Friday the 13th* was Lehman's first and last screen appearance. Today, he enjoys an acclaimed musical career under the professional name Ari Ben Moses, mixing Middle-Eastern and Reggae sounds. "I was naked out there in the water except for a jock I had on," recalls Lehman. "Talk about humiliating, and I didn't know what kind of monster I was supposed to be playing. I was only there for about four days, but it felt like a month. With the scene in the lake, we'd rehearse it over and over and, every time we'd shoot it, I'd reach down into the dirt and rub mud over my body to make myself look really slimy."

Although many on the *Friday the 13th* set recall Lehman basically having plaster poured over his head in preparation for his scene, according to Savini the actual creation of Jason was a bit more subtle. "It was a complex process to try and turn Ari into a mongoloid creature," recalls the make-up maestro. After the head prosthetic was prepared his work was not complete however, as he needed to be at the location during shooting to continually touch-up Ari's make-up between takes. Savini is suitably proud of his work: "Ari really looked disgusting," he says with a smile.

A piece of celluloid history had been conjured, but could anyone involved have predicted that Jason would grow to be anything more than Alice's bad dream? "We never intended there to be a

above:
Jason Voorhees (Ari Lehman) rises from the bowels of Crystal Lake to attack a stunned Alice while Tom Savini monitors the filming of the scene. The first take of the scene worked almost perfectly but was spoiled when a shocked Adrienne King screamed out of place when Lehman jumped out of the water. Sean S. Cunningham hadn't warned King when Lehman was going to attack because he wanted her to be genuinely surprised.

sequel," asserts Cunningham. "Maybe - given the success of the film - the idea that Jason might've been still out there forced the issue. If Pamela's dead, who's left to continue the killing? There's just Jason. Maybe it was inevitable."

It's quite possible that the *Friday the 13th* legend might have ended here; fading away to the soft chords of Harry Manfredini's closing score, but Cunningham and crew had added one last scene during the final script rewrite. After the camera has completed its last lingering scan of the lake, a drowsy Alice is shown in a hospital room, asking the cop, Sgt. Tierney, about her dead friends and about the boy in the lake who tried to kill her. "We weren't sure how to end the film. The scene at the lake seemed perfect, ending the film on a jolt, but I felt like the film needed some closure," recalls Cunningham. "We wrote that little scene with Adrienne and Ronn and it really set up the idea of a sequel which, again, we weren't even thinking of." The biggest surprise regarding this scene might be the fact that Cunningham wasn't even there and nor was Abrams, his cinematographer; it was actually

directed by Steve Miner and shot by Peter Stein, who had previously done some pickup shots for Cunningham on *Here Come the Tigers* and who would, just a year later, serve as Miner's director of photography on *Friday the 13th Part 2*. "I was assigned to do some additional photography," recalls Stein. "I only worked on that one scene because Barry wasn't able to shoot it and Sean was too busy with other chores on the film to direct it. I don't think I even met any of the other actors because I was never on the camp set. However, a few years earlier, Betsy Palmer had done a commercial with me back in New Jersey and I remember her being a very nice lady."

When Alice looks up at Tierney and asks about the boy in the lake, Jason, Tierney shakes his head and just looks at her like she's crazy and grief-stricken. The nightmare is over for Alice, they all think, until Peter Stein's camera closes in on Adrienne King's cherub face as she mutters the infamous words, "But... then he's still out there."

Ultimately, *Friday the 13th* would leave behind only one survivor: Jason.

below:
Alice thinks she's safe floating on the still waters of Crystal Lake.

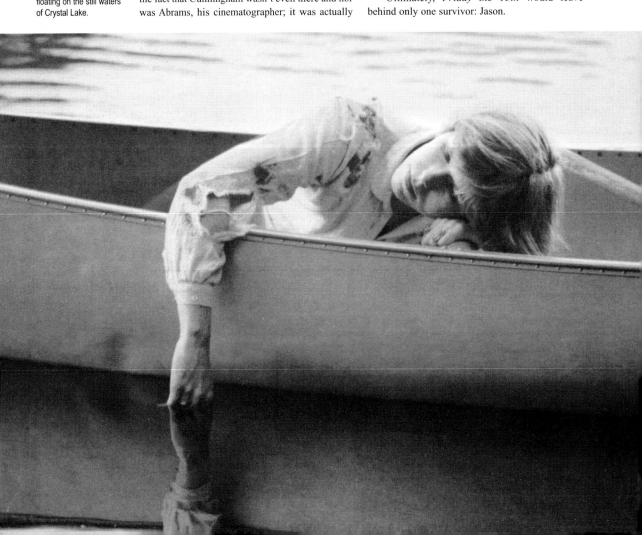

The Aftermath of Friday the 13th:
A Commercial and Cultural Perspective

Friday the 13th was finally screened for Paramount executives in early 1980. Betsy Palmer joined her fellow cast members - most of whom her character had killed - for one of those early screenings. "I wasn't expecting this film to do anything, but we were at the Paramount office and I remember thinking, 'Paramount actually bought the movie?',", recalls Palmer. "The other members of the cast who were there barely spoke to me; nobody even introduced me to anyone. I thought the movie was horrible, but then again, I don't like film in general."

For his part, Cunningham was supremely confident - once the film had been cut to Minasian and Scuderi's specifications - that there was an audience for *Friday the 13th* somewhere. "I knew when I saw the film that it worked exactly the way we'd hoped," recalls the director. "The violence hadn't totally enveloped everything, even though it was a very gory film. It had those jolts. It was the magic mountain ride that I'd wanted to make. A year later, when I had to re-cut the film for the television debut, I only had to cut about twenty seconds because the gory scenes were all really concentrated in specific parts of the film." Paramount shared Cunningham's excitement and bought *Friday the 13th* for distribution at a price of $1.5 million. Still, very few of the film's participants thought they'd ever hear of *Friday the 13th* again.

"I went back to New York and I wasn't expecting the film to be released," recalls Mark Nelson. "Then, one day, I was in my apartment and I saw the commercial where it showed the thirteen different scary parts and I just flipped out. Then, a couple of months later, I see that the film's playing at Loews Astor Plaza on 44th street. I had a big party at my apartment, celebrating my first big movie role."

Robbi Morgan recalls taking a call from her brother telling her that there were crowds at the local movie house: "I was only on the set for a day and here was this movie playing in all of these theatres. I sort of had the Janet Leigh *Psycho* role in *Friday the 13th* in some sense. It's so weird to go from total obscurity to seeing yourself on the big-screen."

Paramount initially spent approximately $500,000 on advertising and print publicity for *Friday the 13th*, eventually adding another $1 million to the marketing of the film once it began doing strong business towards the end of June. Kevin Bacon remembers that time well: "I was back in New York, working on some theatre stuff, and then *Friday the 13th* made a splash. It was a great conversation piece. I'd say it probably gave me some confidence, which I needed after my slow period after *Animal House*. It was fun."

below:
Friday the 13th was front cover news immediately in the world of horror fan publications, as shown by this May 1980 issue of *Famous Monsters*.

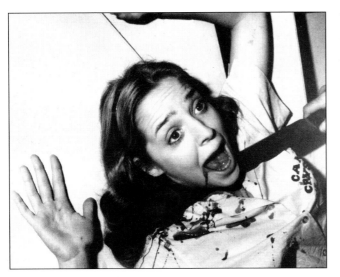

above:
Claudette (Debra S. Hayes) shrieks as she is attacked with a machete. The scene was not included in the finished version of the film. Effects expert Tom Savini hadn't arrived on the set soon enough to design any props for the effect, so the machete was simply placed over Hayes's throat. Inclement weather forced the makers of *Friday the 13th* to alter their planned shot-list, and this was the first main dramatic scene filmed. The very first shots in the can for *Friday the 13th* were miscellaneous driving scenes.

The ads for *Friday the 13th* spewed lines like, 'You'll wish it were only a nightmare' and 'They were warned... They are doomed... And on *Friday the 13th*, nothing will save them,' but the tag that read 'Fridays will never be the same again' was probably most prophetic. Not only would Fridays never be the same again, but neither would the box office. *Friday the 13th* would change the marketplace forever.

Friday the 13th had a handful of low-key pre-release public screenings in a few small cities on May 9, 1980 in order to gauge the level of interest in the marketplace. The same strategy would be used for the release of the sex-comedy blockbuster *Porky's* two years later, and that film went on to gross more than $100 million. *Friday the 13th* didn't make nearly as much money as that, but the shock it gave the movie business was perhaps even more profound. *Friday the 13th* officially debuted on June 13, 1980 in approximately 1,100 theatres. On that opening weekend, the film grossed a staggering $5.8 million, which may not seem like a lot of money now, but when analysed in context it really is impressive. The number of theatres in which *Friday the 13th* premiered was small compared to roll-outs today, with films commonly enjoying debuts in anything from 2,500 to 3,000 theatres, many of which also have the benefit of multiple screens. Factor this in - along with inflation adjustments - and the $5.8 million figure is more comparable to something like a $30 million opening weekend in today's figures. They were queueing up to see *Friday the 13th*.

Unlike the films that followed it - sequels that would come and go in the space of ten days or so - *Friday the 13th* continued to do strong business right through the summer of 1980, long after Paramount

had stopped spending money on advertising. Eventually, the film would generate $39.7 million of box office business, almost identical to the take of *Halloween* two years earlier. Indeed, this total is even more impressive when you consider that the figure would today, when adjusted for inflation, be equivalent to nearly $90 million, a total that would rival the success of any of the *Scream* films.

Friday the 13th returned $17 million in rentals to a giddy Paramount, who were not expecting the film to have huge appeal beyond the drive-in circuit. Rentals figures represent the amount of money that the studio collects after the theatres have taken their share of the boxoffice receipts. This figure usually represents a fifty-fifty split of the total gross although, occasionally, studios have been known to demand, and receive, upwards of eighty percent of a film's opening weekend take if it's a hot film. In the case of *Friday the 13th*, Paramount ended up receiving slightly less than fifty-fifty due to the difficulties the studio had in booking the controversial film in some of the national theatre chains.

Due to its success, *Friday the 13th* received more media attention than anyone had expected which, for all parties involved - particularly Paramount Pictures executives - was good and bad. Film critics across America began to carefully scrutinize *Friday the 13th*, analysing it in terms of its perceived acceptance of violence against women.

The critics who lambasted *Friday the 13th* are, for the most part, the same people who praised John Carpenter's *Halloween* - after much nudging from influential critics like Roger Ebert and Pauline Kael - as a work of art. But they hated *Friday the 13th*. What was it about *Friday the 13th* that got people so angry? Why did anyone care? And what about the simple question of whether or not it's a good film? Perhaps the strangest reaction was that of the late-and-great film critic Gene Siskel who, for a time after the release of *Friday the 13th*, waged a tongue-in-cheek personal campaign against the film. In his print review of *Friday the 13th*, Siskel even gave away the film's ending in an effort to deter people from seeing the film. The campaign continued when Siskel appeared with his long-time review partner, Pulitzer Prize winning film critic Roger Ebert, on their show *Sneak Previews* and advocated against people going to see the film. Even more drastically, Siskel urged unhappy viewers to write to then-Paramount head Charles Bludhorn, and star Betsy Palmer, to voice their displeasure. If such a letter-writing campaign took flight, it did not have much of an impact. "I heard there were some letters sent to Connecticut," recalls Palmer. "I never saw any of it because Mr. Siskel had said my hometown was Connecticut when I'm really from East Chicago, Indiana. The whole thing was silly."

In the interest of fairness, it must be pointed out that, during this period, both Siskel and Ebert did support many other horror films including *Halloween*, *The Howling*, *The Funhouse*, *Scanners* and *Dawn of the Dead*, so one cannot accuse the critics of having a bias against horror films. This is especially true since Siskel, in particular, was long an outspoken advocate against film censorship, even going so far as to defend 1980's *Caligula*, another *cause célèbre* of the censorship lobby. But the fact remains that Siskel and Ebert – in common with many other film critics from the same era - felt that *Friday the 13th* and other films from that specific genre represented the worst kind of exploitation in film: nothing but slashing and stalking and mindless killing inspired by casual sex and geek-like behaviour.

Arguably, the debate over *Friday the 13th* should be centred on the one simple question: is it a good film? Yes, I think it is a good film, I really do, but maybe the term 'good' misses the point somewhat too; maybe the only real test that should be applied to *Friday the 13th* is whether or not the film is scary. Yes. Unlike its sequels, *Friday the 13th* truly is a scary movie - and this is all that really matters in the final analysis - it is a mercilessly effective horror film. It works on its intended level, and no critic can take that stark legacy away.

"I once interviewed Sean S. Cunningham and thought he was a very nice and intelligent man," says Roger Ebert. "This was fifteen years ago and it was interesting because he told me how trapped he felt within the horror genre. It was almost as if he was a victim in one of the *Friday the 13th* films in the way that he told me that he couldn't escape the genre."

It is true that Cunningham was unable to escape the reach of *Friday the 13th*. When his next film, an adaptation of novelist Mary Higgins Clark's *A Stranger is Watching*, was released in 1982, it was met with commercial indifference. "I thought *Friday* would let me become a mainstream director, but it made me a prisoner," says Cunningham. "I felt like it was my sample reel to show the studios - to show them what I could do with no money and no-name actors - but I was just like the new girl in the whorehouse and everyone wanted to screw me. They just wanted more of the same. Part of the problem was that I didn't have a clear idea of the films I wanted to make. After *Friday the 13th*, they just wanted me to repeat that film over and over again."

"If you look at a series like *Friday the 13th*, or even the *Porky's* films, they just get worse and worse," says Ebert, adding, "I recall - a short time after *Friday the 13th* came out - that everyone was making slasher films, but after a while they stopped making money and they stopped. That's very cynical filmmaking. It shows that there was no artistry in the genre to begin with."

Indeed, it is now common knowledge that the first couple of years of the 1980s saw everyone and their mother trying to capitalise on the moneymaking phenomenon, trying to produce their

above:
Pamela Voorhees (Betsy Palmer) stalking the woods of Camp Crystal Lake.

below:
Brenda (Laurie Bartram) attempts to rescue Ned (Mark Nelson) from his own faked drowning.

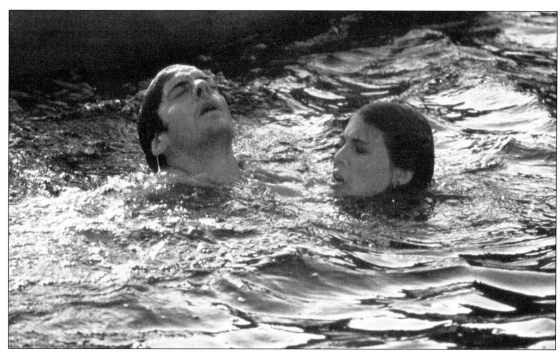

above:
Alice (Adrienne King) makes a gruesome discovery inside Pamela Voorhees's jeep. Cinematographer Barry Abrams's lighting concept for *Friday the 13th* consisted primarily of little Mole-Richardson lights and lots of grainy atmosphere.

own *Friday the 13th* – which, let us not forget, was itself motivated by the success of *Halloween*. These days it's hard to believe that there was a time when the prospect of seeing teenagers getting slaughtered like a bunch of stuck pigs was really fresh and exciting. These 'good old days' did not last for long; indeed by the end of 1981, *Friday the 13th* was the only game in town, especially given the long hiatus between *Halloween* and its first sequel (*Halloween II* was released three years after the original stalk-and-slash classic). The *Hell Nights* and *My Bloody Valentines* - pretenders to the horror throne - had sunk like rocks in the box office waters (*Prom Night* would turn out to be the most profitable of the *Friday the 13th* clones), but it is worth considering this era in a little more detail to truly understand the film's impact on genre cinema.

It has already been established that the typical *Friday the 13th* cinema crowd was predominantly populated by teenagers, and indeed teen films in general were big business at the time. Comedy hits like *Porky's*, *Private Lessons* and *Spring Break* (directed by Cunningham) may not have featured teens getting stabbed in the gut, but their teenage characters were cut from the same socio-economic cloth. The '*Friday the 13th* teenage character' can be described as dumb, one-dimensional and completely lacking in ambition, unless getting laid is an ambition. Interesting then that *The Burning* and *Sleepaway Camp*, the two most direct *Friday the 13th* copycats - released in 1981 and 1983 respectively - were, from a sheer entertainment standpoint,

far more exciting than the other slasher films that were released during the early 1980s. While films like *Graduation Day* and *Happy Birthday to Me* tried to hide their gory intentions under the guise of 'psychological drama' and decent technical credits, here were two films that wore their slasher film badges like cinematic get-out-of-jail-free cards.

Maybe *Sleepaway Camp* missed the curve a bit; the slasher craze, save for the *Friday the 13th* juggernaut, was long dead by 1983, but *The Burning* is arguably the single most significant post-*Friday the 13th* slasher movie. Certainly more impressive than any of the *Friday the 13th* sequels, *The Burning* followed the *Friday the 13th* formula to a tee and actually improved on it in many ways. We had the isolated campsite (much more expansive and full of adventurous opportunity than the grounds of Camp Crystal Lake), and a gruesome legend in the form of a disfigured stalker who, after failed attempts at reconstructive surgery, is determined to make the new breed of campers pay with their lives.

The Burning features tremendous set-pieces; the scene where a group of campers, riding in a canoe, are suddenly attacked by the monster, Cropsy, who chops off their digits in ruthless fashion, is an outstanding horror moment masterminded by Tom Savini, clearly working under few constraints. It's a lot of fun, and seen today is more than a little nostalgic, as the film introduced two future superstars in Jason Alexander and Holly Hunter (whereas *Friday the 13th* only produced one in Kevin Bacon).

However, *The Burning* directly copied the *Friday the 13th* movies - a campfire scene in the film is identical to one in *Friday the 13th Part 2* - and *Friday the 13th* had taken its inspiration from the formula for *Halloween*, which itself was a direct descendent of Bob Clark's *Black Christmas*. The fact that the stories in these films repeated themselves over and over again would be enough to kill any genre. In which case, the 'summer camp slasher film' genre has a legacy similar to that of disco: fondly remembered, warmly nostalgic but deservedly left in the past. It's too late to go back now, and Hollywood would never allow it to happen, anyway.

Maybe the biggest legacy that *Friday the 13th* left for horror fans though, was a sense of purity. It is a pure horror film, certainly in comparison to the watered down efforts that were to follow. "It's a very sentimental film for a lot of horror fans," asserts noted author and genre journalist Chas. Balun. "*Friday the 13th* brings back lots of memories for lots of people and it's still one of the most effective teen slasher films ever made. It's still a very effective and powerful film." Author and outspoken television personality Joe Bob Briggs has made a mini cottage industry out of dissecting the *Friday the 13th* films over the years. The former host of the now defunct programmes *Joe Bob's Drive-In Theater* and *MonsterVision* once hosted the *Joe Bob Briggs Dusk-To-Dawn Friday the 13th Marathon*. He agrees that *Friday the 13th* set a standard for horror that has never quite been matched since, certainly not by any of the direct *Friday the 13th* sequels. "It was very exciting at the time," says Briggs. "I remember when *Friday the 13th* was out that *The Shining* was out at the same time and I think *Friday the 13th* had a much greater impact. It was just a basic, pure formula that every kid could relate to: teens having sex and getting killed because of it. The other *Friday the 13th* films kind of forgot what made *Friday the 13th* so special."

It can be argued that along the way, horror fans have lost a great opportunity, as the twenty-plus years since the end of the slasher boom has seen the genre become increasingly fractured. To an extent filmmakers have even lost sight of what a horror film is. The *Friday the 13th* model has been cleaned up for our politically correct times, with goofy in-jokes, cartoon cinematography and Technicolor CGI blood that fails to convince. We wonder why Tom Savini doesn't work on mainstream studio horror films today, but who's going to let him? They call them 'psychological thrillers' these days, and it's lame catchphrases like this that should make every self-respecting horror fan want to, metaphorically, thrust an arrow into the throats of Hollywood studio executives and the bureaucratic dolts at the MPAA, if for no other reason than to have a visceral reminder of the slasher movie's all too brief glory days.

below:
Pamela Voorhees poised
to kill her final victim.

There were many, many more misses than hits at this time, and that fact undoubtedly contributed to the form's swift decline. Such revolutions, however, need someone to bankroll them, and all that the filmmakers during the immediate post-*Friday the 13th* era cared about was the bottom line: low budgets, commercial elements, violent quotas, risible horror. Look at Stephen Minasian, *Friday the 13th*'s mysterious benefactor, who spent the better part of the 1980s trying to copy his own *Friday the 13th* formula with misfires like *Don't Open Till Christmas*, *Pieces* and *Slaughter High*; inept, misogynist horror films made on the cheap. Aside from the lure of money, did anyone really want to make these films? Did anyone actually have a passion for them?

The isolated protests that followed the release of *Friday the 13th* prompted many to wonder whether or not Paramount Pictures was ashamed of the film itself. This question would be repeated throughout the 1980s, a decade that saw Paramount release sequel after sequel with little or no advanced publicity. "No, they weren't ashamed of *Friday the 13th*," says Cunningham. In fact, *Friday the 13th* was a wonderful surprise for the company since 1980 ultimately proved to be a year of box office disappointments for Paramount, making the success of *Friday the 13th* all the more welcome.

Friday the 13th would become the eighteenth highest grossing film of 1980, nestled in between *Caddyshack* ($39.8 million) and the Robert Redford prison drama *Brubaker* ($37.1 million). 1980 was a year in which (aside from the year's box office king - *The Empire Strikes Back*) big stars appeared in would-be blockbusters that somehow failed to generate sensational buzz or electrifying grosses. The list of minor disappointments included *Flash Gordon*, *Popeye* and *Urban Cowboy*. In fact, the success of the *Friday the 13th* films in general - up

It seems that *Friday the 13th* made money for all parties involved. "Oh yeah, everyone with their name on the picture did well," says Cunningham. "I finally felt like I didn't have to struggle anymore. I never envisioned that it would be so big." Writer Miller was also well-rewarded for his efforts: "It made Sean and I real hot in Hollywood for a short time, which was a very interesting and unusual experience. I had a meeting with Frank Price, the head of Columbia Pictures, and he was just gushing at the sight of me. I think he might've bought anything that I'd pitched him. I made a deal for a script called *Asylum* which never got made, but for which I was paid well."

The friendship between Cunningham and Miller eventually dissolved. "Sean and I had a big falling-out on *Spring Break* and we haven't really spoken since," says Miller who's spent the past twenty years of his career as an Emmy Award-winning soap opera writer on such daytime favourites as *All My Children* and *The Guiding Light*. "With *Spring Break*, Sean had moved from wanting to emulate *Halloween* to wanting to emulate *Porky's*, which was a massive hit in 1982, much bigger than *Friday the 13th*. I wrote some drafts of the script, but then Sean decided he wanted to use another writer and, for the past twenty years, we've gone our separate ways."

Of Miller's regrets, Cunningham says only, "Victor's a very good writer and I have only fond memories of the times we worked together." Indeed, the only relationships that seemed to have survived the making of *Friday the 13th* - aside from the hold that Minasian and Scuderi would assume over the franchise - are those between Cunningham and his tight-knit team of future collaborators, including Carroll, Miner, and Field, not to mention, of course, Cunningham's wife (and an editor on several more of his films), Susan. "Sean helped to give me a career," says Miner, who has moved on to establish himself as a successful film and television director on such projects as *Dawson's Creek*, *The Wonder Years*, *Forever Young*, and *Halloween: H20*, a film that, ironically, became the highest-grossing entry in the long-running history of the *Halloween* film series. "I was able to use *Friday the 13th* as a vehicle, a training ground for the career I have today. What more could I ask for?"

Maybe the greatest legacy of the original *Friday the 13th* film are the fond memories that remain in the hearts and minds of fans all around the world. It was the film every kid had to see. However people feel about *Friday the 13th*, no one can deny that the film is an integral part of pop culture and of the horror landscape that exists today. Sadly, what happened in the years that were to follow would cause such fond memories to become diminished. The 1980s had officially arrived and the times were changing - in more ways than one.

until the mid-1980s - helped to offset some poor box office performances by many of the studio's bigger-budgeted, more prestigious films. The *Friday the 13th* films didn't have big budgets, and they certainly weren't prestigious, but they were at least profitable.

It did not take long for *Friday the 13th* to spread across the world, in fact it was awarded its uncut theatrical 'X' certificate in Great Britain as early as May 8th, 1980. The film was even re-released overseas in 1986 in the midst of the overwhelming popularity of the ongoing series. Although the actual figures are hard to verify, it's estimated that *Friday the 13th* grossed $90 million in worldwide box office business during its theatrical life. Of course, in the twenty-plus years since its release, the film has generated tens of millions of dollars more in video sales and revenues from cable TV screenings.

The Boy... Jason

During the making of *Friday the 13th*, no one involved with the film had the slightest idea that there might be a possibility of making a sequel, but as the money started rolling in, things moved fast. Within just a few months of the release of *Friday the 13th*, a sequel was in the planning stages, to be directed by none other than Steve Miner. Miner had paid his dues for the better part of a decade, and now this was his big opportunity to direct. "It was a natural transition for me," says Miner. "I felt - working with Sean and Wes - that I'd learned the nuts and bolts of filmmaking on a grassroots level. I'd done every job on a film that you could imagine and I felt like I was ready to direct. It wasn't that big of a transition, given the duties I'd performed on *Friday the 13th*, but it's always exciting to be in the director's chair for the first time."

Hiring Miner to direct *Friday the 13th Part 2* was a logical choice for Minasian, Scuderi and the people at Georgetown Productions. In some ways it was a process of elimination, with Cunningham busy developing several other projects at the time. "I didn't interfere with Steve's work on the film at all," says Cunningham, who had given thought to directing a 3-D sequel to *Friday the 13th* before opting to direct the film *A Stranger is Watching*, which was released in 1982. "I basically just acted as a mentor, giving advice if Steve needed it, but I was sure that he'd do a great job." Ultimately, Miner was someone that all parties - particularly Minasian and Scuderi - had great confidence in. He was, after all, a part of the close-knit *Friday the 13th* family; he'd done a great job on *Friday the 13th* and *Last House on the Left* and he'd more than proven himself. "Georgetown wanted to start a sequel very quickly and, originally, I thought that I would just produce the film," recalls Miner. "When Sean was unavailable, it just became clear that I was probably the best person to do the job. Keep in mind that I'd directed a lot of industrial films and I'd done lots of second unit stuff. I wasn't scared."

Actually, when *Friday the 13th* was released in June of 1980, Miner had been preparing to shoot a film called *Marimba* in Rome in collaboration with Wes Craven. The film never got made as Georgetown became adamant about starting

production on *Friday the 13th Part 2*. Production on the sequel started in September of 1980, and the abandoned *Marimba* script was eventually picked up and adapted to become the Ruggero Deodato jungle adventure *Cut and Run* (1985). The fact that *Friday the 13th Part 2* would ultimately be released on May 1, 1981 makes it one of the quickest arriving sequels in film history. In terms of his first feature directing assignment, Miner's mind was eased by the fact that he'd be surrounded by familiar faces: Peter Stein, who had filled in for Barry Abrams to photograph the hospital scene in *Friday*

below:
American theatrical poster art.

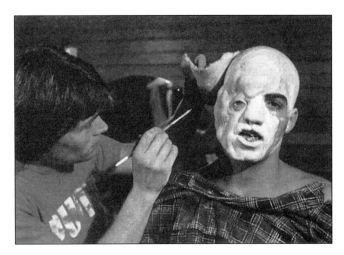

above:
Effects expert Carl Fullerton prepares actor Warrington Gillette for his appearance as Jason Voorhees. Although Gillette received the only screen credit as Jason Voorhees in *Friday the 13th Part 2*, actor Steve Dash played the character in most of the film's scenes.

the 13th, was promoted up to the cinematographer's chair; Cunningham's wife, Susan, would edit the film; Virginia Field would return to work as the production designer, a mere differentiation without a difference from her art director title on *Friday the 13th*. As previously mentioned, *Friday the 13th*'s still photographer - and Kevin Bacon's mysterious assailant - Richard Feury would serve as an assistant director on *Friday the 13th Part 2*. At this point, finding someone to play Jason Voorhees was the least of anyone's worries: Miner needed a script.

The man drafted in to tell the tale of Jason's first 'live' appearance – the most ground-breaking

aspect of *Friday the 13th Part 2* - was Ron Kurz. The decision to hire Kurz was made by Phil Scuderi. "By this time, Phil had some really good connections with Frank Mancuso, Sr. at Paramount," recalls Kurz. "Phil had a deal to make *Part 2* which Georgetown would make and Paramount would distribute. I would write the movie. When I heard Paramount was involved, I said 'Screw this, I'm going legit.' I squared things with the Writers Guild about my errant ways, which was a smart move since I still get quarterly residual payments from *Part 2*. I only had a few weeks to come up with a script."

The tight deadlines were being monitored and managed by the film's producers whose members now included two new faces: Executive Producer Lisa Barsamian, an employee of Georgetown Productions who was sent by Minasian and Scuderi to safeguard their interests (she would repeat her duties on *Friday the 13th Part 3: 3-D* and *Friday the 13th: The Final Chapter*), and Frank Mancuso, Jr., whose position as a co-producer on *Friday the 13th Part 2* would be just the beginning of a decade-long involvement with the *Friday the 13th* series. Mancuso, son of former Paramount Pictures president Frank Mancuso, Sr. - whose own rise to power would correlate to that of the *Friday the 13th* franchise in the early 1980s - began his film career as a booker, handling short films for Paramount Pictures in Canada. "*Friday the 13th* was a great way for me to get started in features," says

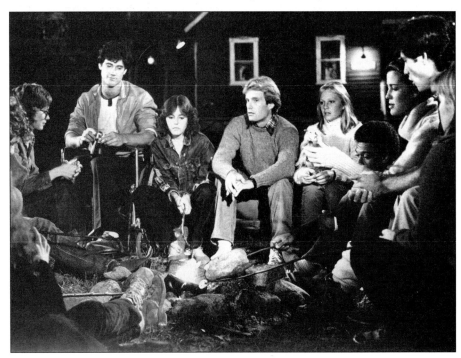

right:
Paul Holt (John Furey) tells his camp counselors a ghost story.

Mancuso, Jr. "It gave me a chance to learn the movie business from the ground floor. Because I had connections, I could've gotten nicer opportunities, but I wanted to earn my own way and get my hands dirty and working on *Friday the 13th Part 2* gave me the chance to do that."

With the production team keeping a close eye on the whole operation, Miner was doing his best to bring back Tom Savini so he could recreate the groundbreaking effects from *Friday the 13th* for the follow-up. "I would've loved to have gotten Tom back for the sequel," says Miner. "Not only did I think he was brilliant, but we'd become very good friends. Sadly, Tom was too busy in Buffalo, working on *The Burning*. His schedule just kept getting pushed back and he just wasn't going to be able to do it."

Miner then called a young and relatively unknown effects expert named Stan Winston who was, at the time, best known for his work on the Dan O'Bannon-scripted film *Dead and Buried*. "I loved Stan's work and I called him and asked him if he'd like to do the film," recalls Miner. "Stan told me that, yes, he'd like to do the film, but, much like Tom, he had some other work that was really eating into his schedule. The main problem was that we were going to shoot in Connecticut, for mainly financial and logistical reasons, and Stan, of course, is based out of California." However, Winston did eventually help Miner greatly by casting Betsy Palmer's face for a now infamous severed head sequence that would be used several times throughout the film.

Next, Miner contacted makeup legend Dick Smith who recommended that he should hook up with a young and talented makeup artist named Carl Fullerton. At the time, Fullerton - who would go on to receive two academy award nominations during the course of his illustrious career - was best known for his work on *Saturday Night Live* along with such films as *The Wiz* and *Wolfen*. "I'd heard how great the effects were on *Wolfen* and so I had Carl bring in something to show me," recalls Miner. "He brought in one of the heads from the film and it was a real great piece of work. I knew that some of the fans would be disappointed because Tom was kind of a draw at that point, but I was also sure that Carl would do a great job." Fullerton was officially hired in August, just a couple of weeks before another member of the makeup team, legendary effects expert John Caglione, Jr., also joined the team. A decade later, Caglione, Jr. would go on to win an Academy Award for his acclaimed work on the 1990 Warren Beatty blockbuster *Dick Tracy*.

It's ironic that, in retrospect, it can be seen that *Friday the 13th Part 2* was blessed with one of the most brilliant effects crews - particularly Caglione

above:
Terry (Kirsten Baker) and Vickie (Lauren-Marie Taylor) enjoy their first day of summer camp.

and Fullerton - of any of the *Friday the 13th* films, or indeed any other horror film of that period; ironic because many fans would ultimately condemn *Friday the 13th Part 2* for not delivering on a gory or visceral level. The blame for that does not lie with the makers of the film though, but was rather due to the demands of the MPAA, who ordered the producers to cut back on the gory thrills if the film were to be granted its essential R-rating. Before Miner and his production team could think about effects and the MPAA however, there was the small matter of deciding just what kind of *Friday the 13th* film this would be. Would Pamela Voorhees return from the dead to haunt Camp Crystal Lake again? Would Adrienne King return as the heroine? Was this going to be Jason's story? In a strange way, *Friday the 13th Part 2* would try to combine all three of those concepts.

As Kurz was working on early drafts of the script, Minasian and Scuderi were in negotiations with Adrienne King's agent. However, it proved impossible to reach a financial agreement for her to take a major role. "Phil felt that Adrienne's agent was demanding too much money and so that's when the decision was made to only write her into the beginning of the film. Basically, she had to be killed off early. That's why she was killed off. If Phil had been able to sign Adrienne, I assume that Alice would've been the heroine again, but I never wrote that script so who knows," recalls Kurz.

For his part, Miner feels that the script, at that time titled *Jason*, suited the purpose for making a respectable *Friday the 13th* sequel. "I approached directing the sequel with the idea that the first film worked really great, but that there were some things that could be improved on and even strengthened," says Miner. "For one thing, I knew we weren't going to have any strip monopoly, that's for sure. Things like that. As far as having Alice being the

below:
Jeff (Bill Randolph) and Sandra (Marta Kober) during the build-up to their ultimate fate of after-sex impaling.

right:
Australian daybill for
Friday the 13th Part 2.

below:
Mark (Tom McBride) and
Jeff arm-wrestle to the
dismay of Sandra who is
only interested in getting
Jeff to join her upstairs
for sex.

main character goes, I thought it made sense that this film would be about Jason since the mother was dead. From there, we knew that *Part 2* was going to, more or less, follow the story of part one: a bunch of teens in a camp situation who are being killed off one by one. Did it work as well as the original? Well, I think some of the cuts we ended up making robbed the film of its impact, but I feel it worked really well."

Casting for the film was handled by the New York based firm Simon & Kumin, led by Meg Simon and Fran Kumin, who scoured the East Coast acting scene to find fresh new faces to play the new victims. "We had the whole office working on casting the film," recalls Kumin. "We saw lots of good-looking and talented actors. We were looking for actors who were attractive, but not stereotypes. I was happy with the actors we got." Unlike *Friday the 13th*, *Friday the 13th Part 2* would feature two leads instead of one in the form of actors Amy Steel and John Furey, who were hired to play Ginny Field (an in-joke tribute to Virginia Field) and Paul Holt respectively. "I enjoyed the first film when I saw it; I found it kind of funny," recalls Steel. "I had fun with it. I knew it was a sequel to a slasher film, but it was a starring role in a feature film, that I knew was going to be seen, and I felt like it would really open some doors for me in the business, which it did." Prior to pursuing acting, the lovely Steel had hailed from West Chester, Pennsylvania where she attended the Westtown School of Dramatic Arts. She attended college in Florida where her striking beauty was noticed by the prestigious Elite Model Agency. In 1979, Steel travelled to New York to pursue film, modelling opportunities and television work (including parts on such soaps as *All My Children* and *The Guiding Light*), completely unaware of the fateful destiny ahead of her, one that would change her life forever.

1980 was a year of back-to-back horror roles for Furey. "I did this really bad killer crab movie called *Island Claws* in Florida right after I made *Friday*," he recalls (the film - released before *Part 2* - is also known under the title *Night of the Claw*). In *Part 2*, Furey played Paul Holt, a man who decides to open a camp counselor training centre... in the Camp Crystal Lake area! "I was excited when I saw that Paul Holt was the lead and that he was a really smart and strong man," says Furey adding, "I was also really comfortable the first time I met Steve Miner. I knew I was in good hands with Steve as director." Prior to appearing in *Friday the 13th Part 2* and *Island Claws*, Furey - like many other actors in the *Friday the 13th* universe - had enjoyed a career that appeared to be heading in a completely different direction. In fact, he had already been a working actor for five years, appearing on such

television series as *The Blue Knight*, *CHiPs*, *Eight is Enough* and *Emergency*. In 1980, Furey even did a guest-shot on *The Waltons*. Of course, Furey could not have imagined the mystery that would surround his character's eventual fate in *Part 2*, and the rampant conjecture and false rumours that would erupt in the years to follow.

Russell Todd, who played Scott, had appeared in a bit role in the 1980 slasher film *He Knows You're Alone*, a film whose cinematographer Gerald Feil would incidentally perform the same duties on *Friday the 13th Part 3: 3-D*. "I answered an ad that was in a publication called *Backstage*," recalls Todd. "I went into the audition, without an agent, and was lucky enough to get the call to play Scott. It was very simple and, unlike most films, there weren't many call-backs. I was really excited, except for the fact that Scott dies early in the film."

The rest of the cast, namely the parts of the would-be camp counselors, was filled with relative unknowns. They were mostly green to film acting although Bill Randolph, who played the role of Jeff, had previously done a memorable turn as a sly cab driver who runs interference for a terrified Nancy Allen in Brian De Palma's classic 1980 thriller *Dressed to Kill*, Kirsten Baker, who played Terry -

perhaps the most beautiful camp counselor in the entire *Friday the 13th* series - had appeared in such trash classics as 1979's *Gas Pump Girls* and 1980's *Midnight Madness*, and co-producer Dennis Murphy had also worked on such films as *Cherry Hill High* (1977) and the immortal *Cheerleaders' Beach Party* (1978).

The most interesting decision that needed to be made during *Friday the 13th Part 2*'s pre-production was the casting of an actor to play Jason Voorhees, Crystal Lake's drowned mama's boy run horribly amok. Just who would ultimately play Jason Voorhees would become the stuff of horror film legend and one of the more fascinating stories in the history of the series, but in the early stages, a young actor named Warrington Gillette was the first choice to play the killer. "My real name's Francis Warrington Gillette III and I was studying business when I got the part of Jason in the film," he recalls. "When I was in the casting office, I was in there to get one of the speaking parts, like one of the camp counselors – possibly John Furey's role - but they gave me Jason instead. I wasn't sure, at the time, if I should be happy or sad. It was a weird feeling. Eventually, I really got into the idea of playing this masked killer and starring in my first

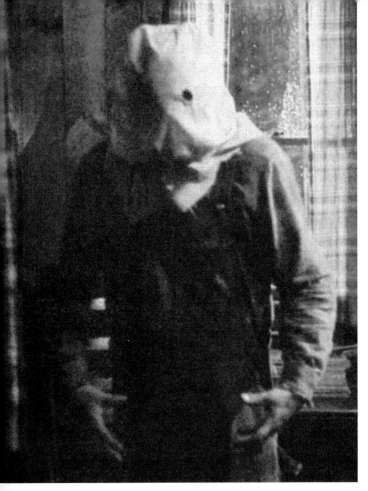

above:
Steve Dash poses for the camera on the set of *Friday the 13th Part 2*.

to play Jason, long before Gillette came on the scene: Taso Stavrakis. Recalls Stavrakis, "It's one of those big career mistakes I've talked about that I've made. I was standing in Tom Savini's kitchen when the phone rang. It was Steve and he was calling because he wanted me to play Jason in the sequel. For whatever reason, I just said no."

Enter Steve Daskawisz - today known as Steve Dash (he changed to his current professional name several years ago because he felt Daskawisz 'sounded too ethnic' in terms of getting work in the film industry) - a former cop and aspiring actor-stuntman who never dreamed that he'd end up playing a character like Jason Voorhees. "Cliff Cudney and I became friends when he was working on a Sylvester Stallone film called *Nighthawks*," recalls Dash. "This was the film where Stallone fired the director, Bruce Malmuth, who ended up working as an extra, like me, even though he got credit for directing the film. This was before the SAG strike in 1980. I'd quit the NYPD and I was in the office looking for a job and I noticed that Cliff seemed to really like me. He just kept looking at me. It was almost kind of strange. I went home and told my then-wife, 'Hey, this guy, Cliff, really seems to like me. I think he might be gay.' As it turns out, Cliff and I have been friends ever since and I really do owe Cliff for every job I've gotten since. I think he was sizing me up. When I went back the next day, he gave me a job on the film, working with famed stuntman Dar Robinson. It was great. I thought I'd never stop working."

Dash was so enthused about his acting prospects that he sold his Long Island home and moved to Brooklyn. Soon after, in 1980, the Screen Actors Guild went on strike. "I paid the rent a year in advance and there was no work," says Dash. "I didn't work for six months and it was terrible." Dash had been keeping in touch with his new friend, Cudney, who mentioned a certain non-union film he was working on in Connecticut, entitled *Jason*. "Yeah, *Jason* was the name of the movie and Cliff told me that the guilds had allowed them to keep filming because they'd already started before the strike," recalls Dash. "I asked Cliff if there was any work and he just shrugged and said, 'No, man, there's nothing here.' I was desperate."

That all changed when, a short time later, Dash got a call from Cudney. "Cliff told me that the guy they had playing Jason was scared shitless and they were going to fire him," recalls Dash. "Cliff told me to get my ass up to Connecticut as soon as possible, but I had no money so I had to borrow twenty-five bucks from my brother for the gas it took to get up there." When Dash finally arrived, he found an anxious Miner and Murphy waiting for him, desperate to find a suitable replacement for Gillette.

movie." Miner and his partners had one concern about hiring Gillette: the difficult stunts that the Jason actor would be asked to perform during the making of the film. This was a particular requirement since Miner intended to do close-ups of Jason during some of the film's action scenes. "Warrington told us that he was a stuntman and that he could do the stunts at the time we started filming," recalls stunt co-ordinator Cliff Cudney, but there was trouble looming on the horizon.

Miner and his crew began filming in Kent, Connecticut, primarily in and around the lush Kent Falls State Park, a 295 acre piece of paradise located just off Route 7, which features a cascading waterfall that draws thousands of visitors every year. Very soon after filming was underway, Miner and crew became increasingly concerned about Gillette's ability to do the stunts that the film required. "Basically, Warrington quit the film - or was fired - early on because he said he didn't feel comfortable doing the stunts," recalls Cudney. "Steve wanted certain closeups for some of the scenes in order for the audience to see that it's Jason, but he just couldn't do it." Ironically, there had been another actor that Miner originally tabbed

Adding to the complications was the fact that a mould of Gillette's head - to be used in the film's finale - had already been made in Los Angeles, along with other related effects. "We would have to bring Warrington back to do the end of the film, so it was kind of tricky at that point," recalls Miner. Dennis Murphy adds, "Steve Daskawisz was like a godsend when he arrived because we weren't sure, at that point, just what we were going to do. We just took one look at him and asked him if he wanted the job."

There was one further hurdle to overcome however; the wardrobe department had already made a set of clothes to fit Gillette's specifications, meaning that the clothes would have to fit Dash as well. "They had to bring that guy back because they didn't have the money to redo the effects with my face," recalls Dash. "What was funny was that when I got there, Cliff looked at me and smiled and then told me that the clothes would have to fit me, no matter what. Everything. The shoes they gave me were about a nine-and-a-half and I'm a ten-and-a-half and they killed my feet. Then there was the cover Jason wore over his face, sort of like out of *The Elephant Man*. Steve, Dennis and I nicknamed it The Bag. I had to wear The Bag over my head for the whole film."

The inevitable necessity of bringing Gillette back for the film's ending was one of the reasons why Dash wouldn't receive final credit for playing Jason. Dash would have to settle for a mere stunt credit, leaving fans thinking that Gillette was the actor playing Jason for the duration of the film. The reality of the situation couldn't be further from the truth, but meanwhile, Miner and his crew - especially cinematographer Peter Stein - were busy crafting the film's prologue sequence which, at a length of eleven minutes and forty-four seconds, would turn out to be one of the longest pre-credit sequences in film history, eating a sizable chunk out of *Friday the 13th Part 2*'s sparse eighty-seven minute running time.

Filmed on a bleak rural street on the edge of Kent, the scene is a triumph of technical excellence - a real tour-de-force right up to its crude denouement, fundamentally a microcosm of the *Friday the 13th* series itself: tense setups - executed with style - leading up to a bloody impaling. The film opens with a girl walking around on a dark street, alone, singing *The Itsy Bitsy Spider* until her mother yells at her to come inside. The girl vanishes and then a second pair of sneakers appears, in a puddle on the street. It's Jason, played in the scene, dirty sneakers and all, by costume designer Ellen Lutter - the only woman ever to don the persona of Jason Voorhees. He walks down the street and looks up at a two-story parlour that belongs to none other than Alice. It's only been a few months since Alice, the last

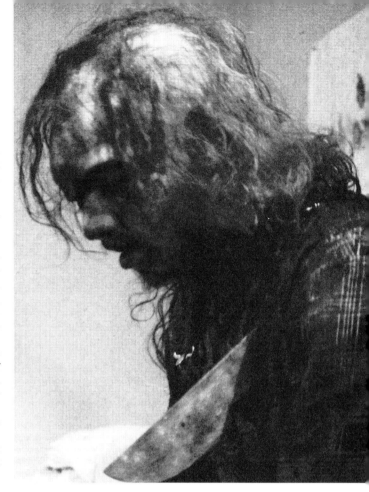

above:
The face of Jason Voorhees, as played by Warrington Gillette.

survivor of the Camp Crystal Lake Massacre, decapitated Jason's mother.

The obvious question is how did Jason find her, especially in this rather domestic setting? Kurz's script and Simon Hawke's stellar novelization provide the answer. It seems that Alice, trying to cope with her trauma - and the horrible deaths of Bill and Steve in particular - returned to the scene of the crime, near Crystal Lake, in an attempt to exorcise her demons. She also returned to the ominous lake itself where, logically, Jason observed and followed her back to her current home. Evidence of this is shown when a newly coiffured Alice, on the phone to her mother, says, "I just have to put my life back together and this is the only way I know how." Maybe not the smartest move, but on a psychological level somewhat understandable.

The scene inside Alice's house opens with a shot of the tormented girl twisting and turning on her bed - in the throes of a deep nightmare. Enter flashback clips from *Friday the 13th* as the audience gets a refresher course (though it's only been about nine months since the first film was released) as to what happened. "Alice was a very special character: she was the hero in the first film and indestructible in a

above:
Alice (Adrienne King) in the shower. These scenes were filmed at an apartment house in Kent, Connecticut. Production designer Virginia Field commissioned a graphic artist to design the artwork that appears in Alice's house.

way," says Miner. "It was important that she be killed off in a dramatic way, because this is Jason's film and avenging the death of his mother is what motivates him." The inside of Alice's house is filled with sketches, a nod to the artistic ability that she showed in *Friday the 13th*. "I wanted to have that little detail about Alice because you want to show that she's a real person," says production designer Virginia Field. "It didn't seem like a big deal at the time we were filming, but I knew that Alice liked to draw and I wanted to show evidence of that."

Following the flashbacks, Alice walks into her living room where she has the aforementioned phone conversation with her mother. She takes a shower as Peter Stein's camera slowly stalks behind her, ready to pounce at any second. "We really had fun doing the opening scene," recalls Miner. "I would tell Adrienne to walk a certain way and move at a certain pace and I just loved the way that the scene developed. It was scary because you know that something's going to happen, but it keeps getting dragged out and then the killer pounces." Recalls Stein, "I was doing a film in Canada, on the Queen Charlotte Islands, when Steve called me so I didn't have a lot of time to prepare, but Steve was prepared. I recall that he had that opening scene in the house all story-boarded out and that he was working with Marty Kitrosser, who was the script supervisor, to really plan it out."

After a nervous Alice gets out of the shower, the phone rings again. She picks up the phone, expecting to talk to her overbearing mother again, but the line goes dead. Alice is scared, thinking that someone is trying to kill her. She walks into the kitchen - armed with a knife - when her cat jumps through an open window, lightening Alice's tense mood. Her calm doesn't last long however when - while preparing some tea - she opens the fridge door and finds Pamela Voorhees's head glaring back at her in all of its ghastly glory. Needless to say, Betsy Palmer's return appearance in *Friday the 13th Part 2* was quite a surprise for the actress who ended up getting star billing, along with King, in the promotional posters for the film's release. "I couldn't believe it when Steve called and asked me to come to his office to do some dialogue for the film," recalls Palmer who, today, divides her time between Sedona, Arizona and Studio City, California. "I remember sitting in a booth and being asked to read six or seven lines with the camera on me. I thought to myself, 'Who's Jason? Isn't he supposed to be dead? How is this happening?' It's the same reaction I've had over the years when the fans come up to me and ask me about my son, Jason. I always tell them that Jason's dead, but they don't believe me."

Palmer's head was cast by Stan Winston in Los Angeles, but, strangely enough, the effect wasn't used for Palmer's second 'live appearance' towards

the end of the film. *Friday the 13th Part 2*'s limited budget forced makeup expert Fullerton to utilise lots of ingenuity. "The challenge with Pamela's head was that the producers said they wouldn't spend the money to fly Betsy Palmer over to Connecticut," recalls Fullerton. "That surprised me, so we just had to do the best we could. When I got the job, I told Steve that I needed X number of dollars to do the film and he gave that to me because I refuse to do cheap-looking effects that look terrible. They have to be done right. When I got Betsy's head, I just worked on the eyes because Betsy had shut her eyes when they did the mould of her. I also modified her nose and her lips - what was left of them."

As Alice screams at the horrible sight of Pamela Voorhees's disembodied head, a hand covers her mouth, rapidly followed by a sharp pick that is thrust right through the side of her head. Alice's seemingly endless run of luck has ended. But who was playing Jason in this scene? "I wasn't there for the opening scene and neither were the rest of the stunt crew," recalls Cudney who, as stunt coordinator, presided over not only Dash but also ace stuntmen Tony Farentino and Webster Whinery, who worked on all of the death scenes in the film. Neither Steve Dash nor Warrington Gillette were present for the scene either; the mystery man was in fact production assistant Jerry Wallace, credited as

The Prowler in the film. Ironically, Wallace and Richard Feury - Kevin Bacon's assailant in *Friday the 13th* - would later work together on the 1983 film *Enormous Changes at the Last Minute*, a film in which Kevin Bacon starred.

King felt that killing off Alice was a little unusual given everything that her character had lived through, and survived, in the first film. "I was told - with the way we did Alice's death scene - that the door was still left open if we wanted to bring Alice back," says King. "It didn't feel like we were killing her off permanently although I don't know how she could've survived getting an icepick through the head. It was a little strange coming back from London because I'd spent the whole year training at the London Royal Academy, but once I got back with Steve and some of the others it was easy to think like Alice again. London was one place where they'd let me do stuff that wasn't in the horror genre."

Cut to five years later at the heart of Crystal Lake. Things have changed a lot since we last saw the town (not in the least because it's actually Kent, Connecticut instead of Blairstown, New Jersey). On the other side of Crystal Lake - the opposite side from which the ghastly murders of half a decade ago took place - it's a new day. Paul Holt has opened a camp counselor training centre and, as we can see,

above:
Jeff and Sandra make the gruesome discovery of a dead animal.

below:
Alice finds the disfigured head of Pamela Voorhees (Betsy Palmer) in her refrigerator. Palmer recorded her dialogue for *Friday the 13th Part 2* in Los Angeles with Steve Miner but never appeared on set in Connecticut because the producers wouldn't pay her airfare.

above:
Crazy Ralph (Walt Gorney) prepares to meet his own prophetic doom.

there is plenty of interest: a lot of good-looking hard-bodied counselors have signed up for duty. Too many for a *Friday the 13th* film in fact. "One of the tricky things with the script was how we would isolate the core group of characters so we could kill them off," says Miner. "We had to get rid of the rest of them so we could focus on Jason stalking the main characters. Also, *Friday the 13th* took place over just one day and night while this film was going to take place over two nights, which was a bit of a challenge in terms of maintaining continuity and keeping everything in the film straight." Miner would further employ this 'divide and conquer' scary movie strategy in 1998's *Halloween: H20* where half the characters in that film - students at a boarding school - are sent on a field trip leaving psychopathic killer Michael Myers free to stalk the main cast. Can't let a bunch of extras get in the way of a good bloodbath.

The first night at the camp passes uneventfully at first, except for the mild distraction of a campfire huddle that briefly turns ominous when Paul Holt tells the gruesome tale of the Camp Crystal Lake legend. The tension is broken, however, when prankster Ted jumps into the fray, armed with a spear and a monster mask. "They told us not to ask questions about the script or the characters, but I was allowed to improvise with some of my jokes," recalls Charno.

The pleasant mood continues when Ginny and Paul go back to her cabin where they make love, off-screen. All seems well until Crazy Ralph appears on the edge of the track, watching them, no doubt feeling a certain sense of indestructibility given how long he's survived as a Camp Crystal Lake regular, but as Ralph backs up against a tree, Jason's hand swoops into view and strangles him to death with a piece of barbed wire. Ralph's death didn't mark the end of Gorney's involvement with the series, however, as he provided the opening narration for 1988's *Friday the 13th Part VII: The New Blood*. "Walt Gorney was a great man, very funny to have around," recalls Miner. "He was a very serious actor and I know that on *Part 2*, especially, he would often walk around and mumble to himself, which he'd done before. I knew we had to get him back for *Part 2* and Walt was one of my favourites."

Crazy Ralph's murder notwithstanding, the rest of that first night in *Friday the 13th Part 2* is pretty uneventful, with the multitude of camp counselors blissfully unaware of the terror, and for some the reprieve, that would be their fate the next day. The relaxed tone also extended to cast and crew. "In the first few weeks of filming, maybe just the first week, we shot day and night, and we all got to know each other very well," recalls Furey. "After that, it was almost all night shooting. It was weird because as the actors would be killed off in the film, they'd leave and it eventually got down to just Amy and I. We all got along very well. We were young, working on a major movie, having the time of our lives."

Originally scheduled for a painless thirty day shooting schedule, filming on *Friday the 13th Part 2* actually extended to last for nearly two months due to various logistical problems, not the least of which was the inclement weather. What's more, the sequel's modest $1.5 million budget didn't allow cast and crew, for the most part, to stay in motels. They were all living on the grounds of the Kent Falls State Park. "It was so cold in those Connecticut mountains when we were filming," recalls Stu Charno, who played Ted, *Part 2*'s requisite practical joker. "We were all staying in these little huts on the grounds. There was no heating at all, but, you know, we were all a bunch of young actors who were just happy to have jobs and be working." Dash recalls, "They put us all in rows of dormitories on the grounds and there was no insulation so Cliff had the bright idea of covering the walls with plastic which, finally, kept us warm."

Russell Todd was spooked by the place on more than one occasion: "After a day of filming, we'd all lurch back to our cabins at night," recalls Todd. "Every night, someone on the crew or one of the actors would hide and wait so they could jump out of the bushes and scare one of the unsuspecting actors. They'd either jump out of the bushes or you'd hear ki-ki-ki-ma-ma-ma in the darkness. Even though it was just a film, and we'd become friends, it was still a little scary walking back 'home' at night. On free nights, we'd go into town to a bar or restaurant and enjoy ourselves. We were all young, full of energy and having the time of our lives making a horror film. What could've been better?"

The Two Jasons

Up until the murder of Crazy old Ralph and the pre-credit 'icepicking' of Alice, *Friday the 13th Part 2* had been relatively bloodless. Not only were the main characters like Paul Holt and Ginny Field not introduced until well into the film's second reel, but none of the camp counselors had been murdered either. For years, *Friday the 13th* fans have considered *Part 2* to be the unloved bastard child of the series - a 'filler' film that's sandwiched between the classic original and the 3-D packed third instalment that arrived in 1982. "The MPAA forced us to cut out a lot of the great work that Carl and the guys did," explains Miner. "I was also concerned by the criticism of the first film in that the critics said it was just a bunch of mindless gore. I wanted the characters in *Part 2* to be a little more realistic and maybe that took away from some of the scares. I was worried about the MPAA; that we might get an X rating, which I think might've happened if we hadn't cut stuff. After *Friday the 13th*, the ratings boards really cracked down on all horror films and it had a chilling effect on all of the filmmakers." The MPAA notwithstanding, the gory business was about to pick up as the action moved to the second day, when Jason would begin his first murderous rampage, bag on his head and all. Still, the fact that *Friday the 13th Part 2* would exactly match its predecessor in terms of the bodycount

below:
The striking key artwork for Friday the 13th Part 2 that forms the basis for this book's cover design.

above:
Actor Tom McBride takes a drink during the filming of his death scene.

opposite:
Effects shot of Mark's (Tom McBride) demise.

below:
Ginny Field (Amy Steel) looks for a way to escape. The character of Ginny Field was named after production designer Virginia Field.

(ten) couldn't take away the feelings of many fans that the film would have been more exciting left fully intact; what was actually released was a compromised vision.

The carnage begins, off-screen at least, when the lovely Terry loses her dog. The animal's carcass is later discovered by Jeff (Bill Randolph) and Sandra (Marta Kober) when they sneak over to the old Camp Crystal Lake locale, site of the first film's murders in name only. Obviously, like Michael Myers in *Halloween*, Jason got hungry. Their gruesome sightseeing tour is abruptly interrupted by the local Sheriff (Jack Marks) who's not too happy to see kids prowling around the notorious area; in fact he's none too happy to see another group of campers, period, after what happened years ago. "We had a great time making this film," recalls Randolph. "We'd shoot for twelve hours a day, and then, at night, we'd have parties. Sometimes the parties would happen at seven in the morning because we were too wasted. It was cold, but I didn't want to leave." After the Sheriff reads them the riot act, Jeff and Sandra join the other counselors for a nice day at the beach. In a few hours, the night-time bloodbath would begin, but there was still time

for the daylight to claim a victim. "I took a real beating on that film," says Marks with a laugh. That's nothing compared to what happened to his character.

After the Sheriff berates a sarcastic Paul Holt about Jeff and Sandra's trespass, he gets in his car and heads back to town, but his ride is interrupted when a hooded figure jumps out in front of him and crosses the road, racing into the thick bush. For whatever reason, the obviously out-of-shape cop gets out of his car and gives chase. By this point in *Friday the 13th Part 2* the film has revealed just how imitative it is of the original *Friday the 13th*. The characters of Jeff and Sandra are clones of Jack and Marcie, while Ted is clearly inspired by Ned. The fact that Paul Holt steadfastly refuses to believe in the haunted legend of Camp Crystal Lake makes him just as stubborn as Steve Christy. To Paul Holt, it's almost as if the grisly events of five years ago are nothing more than an urban legend that's been blown way out of proportion.

Why the Sheriff races endlessly through the forest to catch this mystery man is a not entirely obvious, but for Jack Marks, the actor playing him, the whole ordeal was quite a workout. "I was

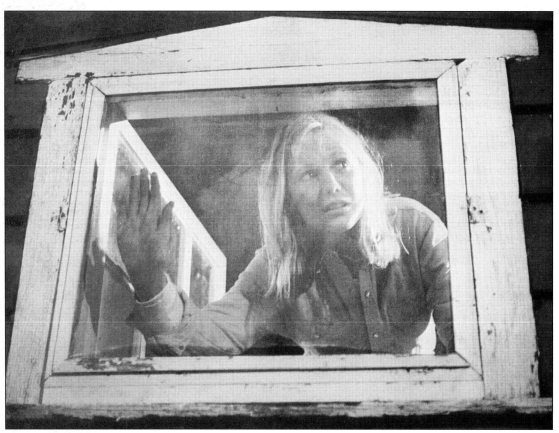

running all through those bushes, listening to instructions from Steve and the others," recalls Marks, a veteran of the East Coast theatre circuit. When the Sheriff finally arrives at a clearing, he spots a dilapidated and isolated shack: Jason's lair. The Pamela Voorhees shrine.

The audience can't see Pamela Voorhees's gruesome head as the Sheriff walks into the dusty cabin, but the cop surely can, as evidenced by the horrified reaction on his face. As he slowly turns around, feet appear behind him, and he swiftly meets his fate as Jason smashes the Sheriff's skull with a hammer. For Marks, the pain was real. "It was just a plastic rubber thing, but they kept hitting me in the head over and over again," recalls Marks. "After awhile it started to hurt. Finally, Steve and the makeup guys put me out of my misery and said 'that's enough.'" Was there more than made the final cut? Apparently so. "They had a blood-pack on me and when we started doing it, there was blood everywhere," recalls Marks. Says Fullerton, "We did several takes with the blood coming out of the head. It worked well, but I think the producers were nervous about the ratings board. We also didn't have much time to do corrections on effects and do multiple takes. It would've been a nice effect."

While the nosy Sheriff was dying, the rest of the campers were getting ready for their last night of rest and relaxation before the commencement of their gruelling camp counselor training. Paul Holt allows the would-be counselors to go into town for a night of boozing. Ginny and Paul head out, along with Ted and a bunch of extras, but a small group – destined to become victims of course - stay behind. How fortunate for Charno's Ted character that he, as the stereotypical practical joker victim, gets to leave the danger area. If only Steve Christy had been as generous as Paul Holt.

This leaves six: Wheelchair-bound Mark (Tom McBride), Scott, Terry, Vickie (Lauren-Marie Taylor) and, of course, lovebirds Jeff and Sandra. The first signs of impending mayhem appear when Terry (Kirsten Baker) goes down to the lake for some skinny-dipping. "When it was night out there," recalls Baker, "my movements were all carefully mapped out - where I walked, everything. That water was freezing." Terry's little swim is soon interrupted by slimeball Scott who decides to hold Terry's clothes hostage in return for a peek at her fair skin; somewhat understandable since Baker was a former model. A brief shot of Baker's breasts would turn out to be the only visible nudity in the entire film.

Scott's wicked ways are soon punished when, as he playfully jokes around with Terry, he accidentally steps into an animal trap lasso and is hoisted off the ground, to be left dangling helplessly. "I got

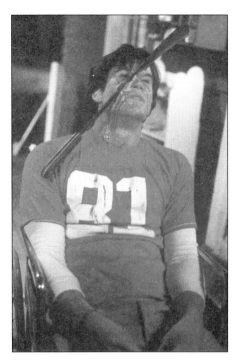

dizzy hanging up there," recalls Todd. "The blood was rushing to my head and I had to speak my lines, and it was torture." Stuntman Webster Whinery performed the actual lasso stunt. "Webster did that stunt and it was a very tricky and dangerous stunt with all of that whipping action," says Cudney. "If the rope hadn't been secure, Webster could've broken his neck, but he's one of the great stuntmen. We built a special rig for the stunt and the whole thing took a long time to design."

Thankfully for Scott, kind-hearted Terry agrees to go back to the camp and find a knife to cut him free. The camera stalks Terry mercilessly as she enters a storage shed. Eyes moving from side to side, she finally locates a blade. "Steve liked to plan out a lot of those Hitchcockian touches," recalls Stein. "I just shot the thing and it was just a job to me. It wasn't a film that did much for my career." Unfortunately for Scott, before Terry returns to help him down, Jason appears and slices his throat from ear to ear. "We had trouble getting the blood to seep out properly in that scene," recalls Fullerton. "The only good thing was that it was a close-up so we didn't have to worry about Russell dangling from the rope so much, but both the effect and stunt were tricky."

As scores of horror fans have noted over the years, blood - at least the grand and gushing kind that was so gleefully present in *Friday the 13th* - would be painfully scarce in *Friday the 13th Part 2*. Todd recalls the scene being, at first, especially

FRIDAY THE 13th PART 2
(1981)

Production Credits:
Georgetown Productions Inc., A Steve Miner Film
Executive Producers:
Tom Gruenberg,
Lisa Barsamian
Produced & Directed by:
Steve Miner
Co-Producer:
Dennis Murphy
Associate Producer:
Frank Mancuso, Jr.
Production Manager:
Lisa Barsamian
Location Unit Manager:
Roberta Presser
Written by:
Ron Kurz
Friday the 13th Part 1 Footage Script:
Victor Miller
Friday the 13th Part 1 Footage Director:
Sean S. Cunningham
1st Assistant Director:
Charles Layton
2nd Assistant Director:
Richard Feury
Director of Photography:
Peter Stein
Panaglide Operator:
Eric Van Haren Noman
Gaffer/2nd Camera Operator:
Steve Gerbson
Panaglide Assistant:
Jim Canatta
1st Assistant Camera:
Philip Holahan
Key Grip:
Sam Ewalt
Grip:
Phil Beard
2nd Grip:
Paul Volo
Gaffer/2nd Camera Operator:
Steve Gerbson
Best Boy:
John Newby
Electricians:
Bill Klayer,
Miguel Jimenez,
Tom Anderson
Still Photographer:
John Foster
Editor:
Susan E. Cunningham
1st Assistant Editor:
Jay Keuper
Editorial Assistant:
Guy Barresi

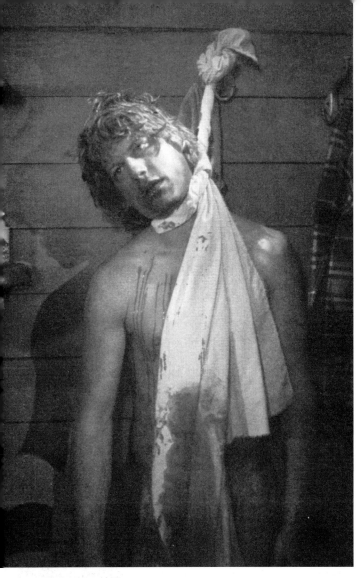

above:
Publicity still of Jeff's
(Bill Randolph) corpse.

opposite top:
Ginny tries not to pee her
pants as she hides from
Jason Voorhees.

opposite bottom:
Amy Steel brandishes a
chainsaw on the set of
Friday the 13th Part 2.

made it into the finished film, beyond a brief shot and quick cutaway. This scene - probably more than any other in *Friday the 13th Part 2* - elicited a spooked reaction from the crew. Jeffrey S. Delman was a production assistant on the film, having served as an art department production assistant on *Friday the 13th*, for which his sole contribution was giving the shelves of the pantry that Adrienne King hides in a coating of hunter-green paint. "It was very strange to watch Russell being hung up like that," recalls Delman, who wrote and directed the 1987 horror film *Deadtime Stories*. "We could see the tubes sticking out of Russell, but when the blood started coming out we all grew very still. It was a very creepy feeling. We knew it was just an effect, but it felt as if something bad was happening."

The subject of what did or didn't make it into the final cut of *Friday the 13th Part 2* is a difficult subject for Miner, who remains proud of his first directorial effort. "Look, it wasn't an option to release the film in un-rated form like *Dawn of the Dead* and *Last House*," he explains. "This was a film that had to play in lots of movie theaters and we also had to watch our negative pickup deal with Paramount because they sure weren't going to release a film that was un-rated and it would've been too expensive to go back and do tons of re-shoots. I'm sorry that fans feel there was too much stuff left out, but maybe, one day, Paramount will put together some kind of uncut version that will make everyone happy."

When Terry returns to release Scott from the snare, it does not take long for her to see that he's dead. She screams and - when she turns around and stares at an off-screen Jason - she screams again before she gets knifed to death, though this fact won't become clear until later in the film.

Friday the 13th Part 2 arguably marked Baker and Todd's most visible roles to date although both actors continued to work long after the release of the film. Following *Friday the 13th Part 2*, Baker pursued a career in modelling well into the 1990s. Aside from sporadic acting appearances in such films as *Sector 13* and *Weeds*, she has left acting, most recently being employed at an art gallery in Los Angeles. Todd's career trajectory was even more adventurous. In 1984, he seemed to have his big acting break when he was tapped by *Grease* producer Allan Carr to be the male lead in Carr's ill-fated remake of the 1960 beach comedy *Where the Boys Are*, decadently renamed *Where the Boys Are '84*. The film was a commercial and critical disaster that derailed the producer's budding career. Todd returned to the horror genre in 1986 when he starred in the Jim Wynorski-directed slasher film *Chopping Mall*. More roles followed, but Todd has since moved from actor to agent: he now works in

bloody. "It was done in sections and it was just spooky seeing everything from an upside down angle. It was hard to stay focused as an actor. There was a special effects makeup guy in the tree above me with a pressure tank, pumping the blood on cue when Jason slit my throat. I had tubing running down my clothing and behind a foam latex appliance on my neck. It all went well until the blood started flowing into my eyes. I tried to be professional and stay calm, but, at some point, I had to stop acting and let them know that it was stinging my eyes. Steve, a nice guy, finally cut at that point. If you look closely at that scene, you'll see a mistake. The blade of the knife is backwards. I think they did that for my own personal safety, but it seemed like a mistake to me when I saw the film."

Unfortunately, most of the intended bloodletting in this scene – as would be the case with almost every gory scene in *Part 2* – never

California running The Russell Todd Agency, which specializes in the representation of film technicians. "I've given up acting unless something good comes up," says Todd. "I'm really happy doing what I'm doing."

While Scott and Terry are dying, the other four counselors are cooling off back at the main cabin. Meanwhile, Ginny, Paul and prankster Ted are drinking the night away at a local bar. The bar scenes were filmed at a real-life casino bar located in nearby New Preston, Connecticut. It's here that psychology major Ginny relentlessly lectures an increasingly inebriated looking Paul and Ted about the possible existence and psychological motivation of Jason. Such psycho-babble wouldn't be worth mentioning except for the fact that Ginny questions aloud whether or not Jason is a "frightened retard." This is interesting since, in the first film, Savini and writer Kurz both conceptualized Jason as a mongoloid. This was a politically-incorrect description that Miner wanted to avoid in *Part 2*. "I don't believe the word mongoloid was ever used in either film," asserts Miner. "Other people used that description, but I guess that hurt some people's feelings, which I can understand. I would never make fun of anyone who's handicapped or deformed and I don't believe we did. Jason was a horrible monster." Says Fullerton, "Steve told me to just make Jason look horrible, no matter what, and that's what I tried to do. My only point of reference was to study the first film's ending and try and emulate and age that Jason accordingly. He also wasn't meant to be a ripoff of *The Elephant Man*."

Meanwhile back at the camp... while Mark and Vickie are playing computer games, Jeff and Sandra are starting to get mischievous looks in their eyes. It's time for the young lovers to have sex, not once, but twice. Whether or not they actually finish the

sexual act to completion is open to debate, but ultimately irrelevant since Jason finishes things off for them, for good. Jeff and Sandra did however get to enjoy each other's flesh for awhile because they would not be the first to die. That grisly honour was awarded to Mark who, being wheelchair-bound, obviously had the odds stacked against him. According to those around him, actor Tom McBride was more than suited to play the all-American Mark. "Tom was a great guy, a real good-looking kid with a bright future," recalls Miner. Says Stein, "I remember Tom very clearly because he was just a beautiful-looking man. He was so good-looking, so strong-looking, very much like Rock Hudson which, I guess, is kind of ironic given what happened to him."

After Vickie quizzes Mark on his sexual abilities, she leaves the cabin for what seems like an eternity to get some stuff from her car. Once Mark is alone in the cabin he immediately feels a strange presence in the room. Investigating further, he wheels over to a side exit when, suddenly, a blade appears and whacks him in the side of the face. Mark is propelled out the door and his dead corpse-in-a-wheelchair rockets to the bottom of a stair landing. "I think Tom's kill scene is probably the best scene in the film and my favourite," says Miner. "It was a scene that plays with the audience in the sense that they know he's going to get killed, but not when, and the scene just keeps going and going until it happens." In order to accomplish the effect, Miner had Fullerton build a mask that was draped over the side of McBride's head while the actual shot was done from a reverse angle, making the scene appear like it's really happening. "It was just a catcher's mask that we stuck to his head," explains Fullerton. "The machete that was used was made out of balsa wood and the catcher's mask was covered with Styrofoam. It was my idea to have it really happen on the screen like that and it worked great. The audience is seeing the real thing in the

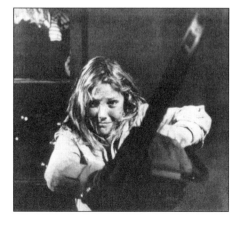

Music:
Harry Manfredini
Sound Recordist:
Richard Murphy
Boom Operator:
David Platt
Dialogue Editor:
Richard Howorth
Sound Effects:
Ross-Gaffney Inc.
Make-up & Hair Stylist:
Cecelia Verardi
Assistant Make-Up:
**Lisa Brozek,
Joanne Salarno**
Hair Styles by:
**Tina and Robert, Six Feet
Under, Westport,
Connecticut**
Costume Designer:
Ellen Lutter
Wardrobe Supervisor:
Susan Kaufman
Special Make-Up Effects:
Carl Fullerton
Make-Up Effects Assistants:
**David Smith,
John Caglione Jr.**
Special Effects:
Steve Kirshoff
Titles:
Modern Film Effects
Opticals:
**The Optical House, New
York**
Production Designer:
Virginia Field
Inside Property Master: **Tom
Walden**
Outside Property Master:
Chris Gardyasz
Assistant Property Masters:
**Sandy Hamilton,
Alice MaGuire**
Construction Coordinator:
Shaun Curran
Carpenters:
**Ed Cunningham,
Tom Allen,
Manuela Hartsuyker**
Scenics:
**Martha Gibson,
Jeff Glave**
Scenic Chargeman:
Duke Durfee
Script Supervisor:
Martin Kitrosser
Production Assistants:
**Ann Edgeworth, Jerry
Wallace, John Oshima,
Mitch Wood, Jeff Delman**
Location Auditor:
Pumpkin Payroll Service

opposite:
Ginny and Jason prepare for a final confrontation.

sense that there's really an object hitting Tom's head, which is nothing more than an appliance that's been covered over with a makeup wound."

The whole complex sequence was a challenge for everyone involved. "It had to be done before the sun came up and the schedule was crazy," recalls Fullerton. "I also had to design Tom's eyebrows, because of the appliance, and I was just too tired to do it again. I asked Steve to just give it a try and so Steve shot a take and it worked fine and Steve used that take." Then there's the matter of when Mark, wheelchair and all, falls down into the stair landing. "Tony Farentino did that stunt, which was tough because he's backwards," explains Cudney. "We had to build a special rig for that one so Tony wouldn't go off the rails. It wasn't a very nice ride for Tony, but he did it because he's a great stuntman."

For McBride himself, the death of his character Mark would be a grim harbinger of things to come. McBride died of AIDS in 1995. He was already a successful commercial and print model by the time *Friday the 13th Part 2* was released in 1981, whose career had including a stint as the Marlboro Man,

the ultimate symbol of male virility. McBride's good looks made him one of the hottest gay sex symbols in the wild New York party scene throughout the 1980s and early 1990s. Sadly, his self-destructiveness and sexual obsessions caused his health, and his life in general, to disintegrate as documented in the acclaimed 1996 documentary *Life and Death on the A-List*, a chronicle of McBride's life and death.

While Mark was jumping the rails and Vickie was still out at her car, Jason returned to stalk Jeff and Sandra, probably because they'd just had sex. Actually, Jeff and Sandra are going at it for a second time when we see Jason walking up the stairs, armed with Ted's spear, determined to make this a very sloppy-seconds. By this time, Dash had fully settled into the character of Jason. "People don't understand when I tell them that I played Jason because they always see Warrington Gillette's name on the credits," explains Dash. "I played Jason throughout the whole film except for the ending when Jason crashes through the window and a couple of the scenes where you see Jason's feet. Everything else is me. The reason I only got a stunt-

above:
Ginny enters Jason's secret cabin. Production designer Virginia Field bought the cabin from a local farmer in exchange for bottles of Scotch.

right:
Ginny stands in front of Jason Voorhees (Steve Dash) and impersonates the killer's mother, Pamela Voorhees. Steel came close to chopping off Dash's finger during the filming of this scene.

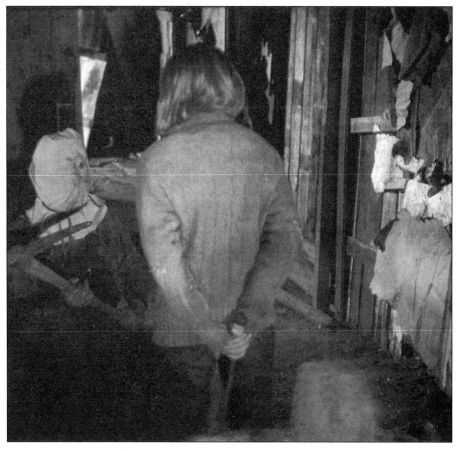

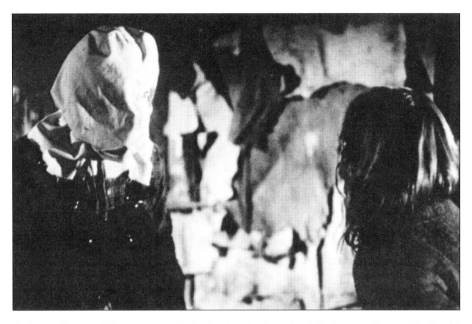

Animals Owned and
Trained by:
**Dawn Animal Agency, Inc.
of New York**
Production Office
Coordinator:
Denise Pinckley
Location Manager:
Mark Baker
Location Scout:
Randy Badger
Stunt Coordinator:
Cliff Cudney
Stuntmen:
**Webster Whinery,
Tony Farentino**
Casting:
Simon and Kumin
Extras Casting:
Denise Pinckley

CAST

Amy Steel
(Ginny)
John Furey
(Paul)
Adrienne King
(Alice)
Kirsten Baker
(Terry)
Stu Charno
(Ted)
Warrington Gillette
(Jason)
Walt Gorney
(Crazy Ralph)
Marta Kober
(Sandra)
Tom McBride
(Mark)
Bill Randolph
(Jeff)
Lauren-Marie Taylor
(Vickie)
Russell Todd
(Scott)
Betsy Palmer
(Mrs. Voorhees)
Cliff Cudney
(Max)
Jack Marks
(The Cop)
Jerry Wallace
(The Prowler)
**David Brand, China Chen,
Carolyn Louden,
Jaime Perry, Tom Shea,
Jill Voight**
(Extra Counselors)
Steve Daskawisz
(Jason Stunt Double)

double credit was all down to pure politics, but I should've gotten the credit because I was Jason."

As Jeff and Sandra are grinding away to orgasm, the door opens and Jason walks in, spear raised. Sandra sees her impending doom, but Jeff doesn't, and before Sandra can scream, Jason rams the spear through both of their bodies. It's unclear whether or not they had that orgasm. Fullerton and the actors had bigger worries. "It was a really uncomfortable scene for Bill and I to do," recalls Kober. "They made me lay on the floor, on my ass, with my shoulders on a couch support. Bill then moved on top of me on the couch." Recalls Fullerton, "It was supposed to be a very bloody scene because David Smith, Dick's son, had this air pressure tank that was rigged to shoot blood out. It was everywhere, but it all got cut. It was really gruesome. Basically, we had both of them on the couch and you could see the edges of their shoulders, which is the illusion because they're on a couch. We built an appliance for Bill, to simulate his back and his ass, and we put it on top of his shoulders. We tried it a couple times before we shot, without any blood, so we could fine-tune some stuff." Recalls Miner, "Carl and the guys used, I believe, two blood pumps to make the blood shoot out and it was really gory and gruesome." Adds Fullerton, "What we ended up doing was to combine a syringe with a garden pump that you can spray grass with. I severed the end and, after that, the blood just exploded everywhere. Even more impressive was - when the spear went in through their skin - that you could see the broken flesh with the blood which was all built out of gelatin. The

blood was just jelly. It was such a graphic piece of work. If it had made the finished film, the fans wouldn't have complained about anything that was missing from the film. It would've made the film."

This famous scene still stands as the most notorious moment of Kober and Randolph's respective careers, although both continue to work. Kober would return to the horror genre in *Slumber Party Massacre III* along with appearances in such films as *Neon Maniacs*, *Patty Hearst* and *Vendetta*. For his part, Randolph's output has been more sporadic, with appearances in films like *Guilty As Charged*, *Penn & Teller Get Killed* and *Switching Channels*.

After the double-impaling, Vickie finally arrives back inside the cabin; amazing considering that her car was parked just outside. Unable to find Mark - whose death her apparently deaf ears were completely oblivious to - Vickie decides to walk upstairs and check on Jeff and Sandra. She walks inside and spots Jeff, hanging from the door - although signs of his impalement are hard to notice. When Vickie turns around, Jason's hand lunges out at her, clutching a blade that moves right in front of the camera. The hand is believed to be, according to the memories of cast and crew, that of The Prowler Jerry Wallace, Adrienne King's assailant in the film's opening scene. "That wasn't me," says Dash. "That shot of the blade was one of the first scenes shot in the whole film. I think they shot that first so they could use it for a promotional trailer. One of the guys on the crew played the hand with the knife, not me." The scene unfolds not with Vickie running out the door like any sane person would do,

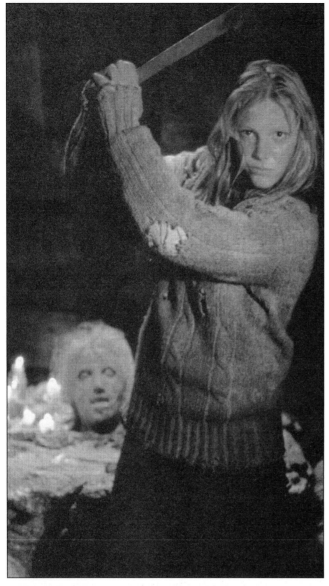

abovo:
Ginny wields a machete as the head of Pamela Voorhees (Connie Hogan) looks on. Hogan was originally supposed to open her eyes and smile in *Friday the 13th Part 2* but the scene was cut just prior to the film's release in 1981.

"but I remember that the waitress was very beautiful." Charno, a natural comedian, would go on to enjoy one of the more successful careers of the *Part 2* class, appearing in such films as *Christine*, *Once Bitten*, not to mention a memorable turn in the *Clyde Bruckman's Final Repose* episode of *The X-Files* for which Charno's wife, Sara Charno, was a former staff writer.

When Ginny and Paul enter the main cabin - much like Alice and Bill from *Friday the 13th* - they make a gruesome discovery in the form of a large pool of blood in Jeff and Sandra's bed. They walk back downstairs where Ginny senses something in the room. It's Jason. Jason and Paul grapple, vanishing out of sight. Ginny looks around for Paul when Jason jumps in her face. Ginny runs. "I really worked with the guy who was playing Jason to block out that scene," recalls Furey. "We really took some tumbles, but I thought it looked good on-screen." Dash remembers, "John and I got along really well and Steve Kirshoff did a great job with the special effects. I noticed on the film that Amy Steel was really getting the star treatment whereas John didn't seem to be getting the same amount of respect even though he was supposed to be one of the main stars. Then again, I think everyone was a little jealous because Amy was dating one of the stuntmen."

As Ginny tries to escape from Jason, she discovers Ralph's body, which almost falls right on top of her. She then tries to start her car but is attacked by a pitchfork-wielding Jason, who is now clearly visible wearing the bag on his head. "I really liked the one evil eye that you see," recalls Dash with a laugh. "I tried to add some nice touches like with the way I walked. I didn't want to talk to the other actors if I was supposed to be getting violent with them in a scene."

Ginny ended up hiding under a bunk in a cabin, where a mysterious puddle of 'fluid' would magically appear on the floor. What exactly was that? Did Ginny get so scared that she lost control of her bodily functions and literally relieved herself right on the floor? Actually, it turns out that it was a rat lurking in the cabin that provided the waterworks, not Steel's character, Ginny. "No, she didn't pee her pants," recalls Miner with a laugh. "That scene got people confused. We just wanted to show that Jason knew where she was and so the piss on the floor from the rat kind of gave her away."

Ginny and Jason declared war against each other, literally, when she tried to escape into the woods, all under the watchful eye of the full moon. "Amy Steel tried to kill me in that film," says Dash. "She tried to kill me twice, and she almost did, and she sent me to the hospital twice. We turned the local hospital in Kent into a zoo." When Ginny's

but instcad shc stupidly backs up against thc wall waving her hands in the air. Does she think she can reason with Jason? Appeal to his humanity? "I just waited for the stunt guy to press against me and then I gritted my teeth and screamed," says Taylor who - after a brief acting career that would include a memorable role in the under-rated 1984 slasher film *Girls Nite Out* – went on to carve out a niche as the host of the home decorating television program *Handmade by Design*.

That leaves Ginny and Paul, who return to the camp after leaving lucky Ted behind at the bar. Not only does Ted avoid horrible death, but, according to Simon Hawke's novelization, he got to spend the night with a beautiful waitress from the bar. "I don't remember reading that in any script," says Charno,

running through the woods, Jason appears out of nowhere and lunges at her feet, but the terrified girl just barely eludes Jason's outstretched hands. "That scene was set up so I'd run behind her and then I'd lunge and just miss her," recalls Dash. "In order for the scene to work, she couldn't be running too fast or else I wouldn't be able to catch her. I was holding a pick-axe too. Every time we did a take, she'd run too damn fast, every single time."

That wasn't the worst of it - not by a long shot - for Dash, however: "For that scene, we dug out a hole in the dirt that I could comfortably fall into," recalls the actor. "I had to do take after take where I dove into the dirt and the ground was like rock because of the cold. Well, for one of the takes it seems that someone left the pick-axe in the hole so, when I dove into the hole, I landed right on it and hurt myself. Hospital visit number one. I could've been maimed."

Miraculously, Ginny somehow navigates through the forest, ending up at Jason's secret lair, the aforementioned altar to Jason's dead mother which, apparently, is well within walking distance of the campsite even though we'd previously seen the Sheriff driving away from the camp to reach that spot. When Ginny goes inside, she spots Terry's seemingly pristine-looking body resting on the floor, almost like an offering to the head of Pamela Voorhees that rests on a stump, surrounded by candles. Was Jason transfixed by Terry's beauty? So much so that he didn't want to 'mark her up'? Why did he keep her as a souvenir? Is Jason a closet pervert? Perhaps Ginny would go on to write a paper on the subject for one of her psychology classes, but for the meantime, she has to worry about her very survival. As Jason storms the cabin, Ginny gets the bright idea to try and impersonate Pamela Voorhees in order to try and trick Jason and, ultimately, destroy him.

This is where Betsy Palmer once again re-enters the story with her aforementioned cameo narration, but that's not Palmer's head on the totem. The head belonged to an actress named Connie Hogan who Miner and the producers recruited locally as a 'head double' for the scene. "We were originally going to see Betsy's head with her opening her eyes and smiling, the whole bit," recalls Fullerton. "This wasn't possible for a number of reasons and, of course, Betsy couldn't be flown over so we could work with her. We then had to use Connie Hogan to occupy the head because we needed to build another head. It's not my favourite scene in the film and, in retrospect, I wish we'd used Betsy's mould from the opening. With Connie, we had to build a fake altar which forced us to cheat the neckline a bit. The way the film was cut made it look a bit silly but, again, we had a very rushed

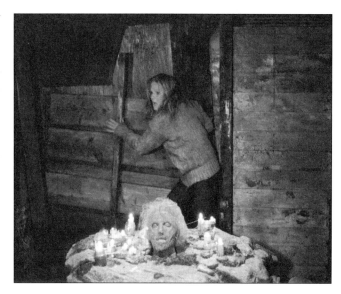

schedule. I wanted to make a mould of Connie's head out of urethane, but there was no time so we ended up using alginate which is tough because the alginate is designed to only work for one positive, but we were miraculously able to get three positives out of it. Ultimately, it was a good idea of Steve's not to include the smile because I don't think it would've looked very good."

Actually, Hogan wasn't an actress, but rather a registered nurse in Connecticut, and the sister of production manager Denise Pinckley, who also managed the production office on the set of *Friday the 13th*. "Denise called and told me they needed me to come in and play the part," says Hogan, today a scientist. "It was a non-union film, so I wasn't paid anything and they told me I wouldn't get credit in the film. I'd never acted before, but I had the blonde hair, the look they needed, and Denise recommended me. When we did the scene, it was basically me and Steve Miner, and Carl, in a dark hole. I was covered in the makeup, and I also had to wear contact lenses and dentures. I remember that one of the stunt performers cut his finger badly and I had to do a suture on the set. Other than that, it was basically just Steve and I. It was hard to move my eyes, or smile, because of the contact lenses. It was a fun experience to be in the film and Steve Miner was a perfect gentleman, as well as Carl Fullerton. Only my family and friends know I was even in the film."

Upon entering the shack, Jason is about to strike Ginny down, but is shocked into inaction when Ginny appears to him as a reincarnation of his dead mother, as Palmer's cackling face is superimposed, off and on, with Steel's image, for six lines of dialogue, beginning with "Come to Mommy... come on" and ending with "That's a good boy... good

above:
Ginny stands over Jason's shrine to his mother, the mass murderer Pamela Voorhees. Production designer Virginia Field constructed the cabin on the set of *Friday the 13th Part 2* in Kent, Connecticut.

above:
Ginny is taken by surprise when Jason Voorhees crashes through a window to attack her. Warrington Gillette hurt his head during the filming of this sequence.

she missed and hit my finger. There was blood everywhere and we were all looking around for my finger because we thought it was gone. It was barely hanging on. When I went to the hospital - and I'll never forget this - they gave me thirteen stitches."

After the clash of metal, Paul rushes in from out of nowhere and grapples with Jason. They crash into a wall that collapses and rains rubble down on them. Ginny picks up the machete and whacks the killer in the back of the head. Paul pulls off Jason's mask and he and Ginny stare at the unseen face in disgust. "John and I worked on that scene a lot," says Dash. "The effects crew did a great job of making that wall fall down on us. We just hit the spot and the whole thing fell down."

When Ginny and Paul return to the main camp area, it seems that the nightmare is over - although the rest of the counselors who were out partying have yet to return. Ginny and Paul have just started to relax in one of the cabins when they hear a suspicious bump. Terrified, Paul slowly opens the door while Ginny stands in the middle of the cabin, clutching a handy pitchfork. The tension ebbs when Muffin, the camp dog, believed dead, rushes in to greet them. "That's a classic red herring cue," says composer Harry Manfredini who composed a brand new score for *Friday the 13th Part 2*. "These aren't hard films to score because there's only four main musical cues: chase, kill, stalk and red herring. I did use a couple of cues from the first film in the second one, and I really just tried to elaborate on what had worked so well in the original."

Jason." At this point Jason starts to wise up when - out of the corner of his eye - he spots the head on the totem. "That was a horrible scene to do," recalls Steel. "I thought it was over with until, one day, Steve Miner and I were driving out in the country and he told me that we had to do it again. I had a feeling that something bad might happen." Recalls Dash, "I thought this was my best acting, the way I move my eyes and tilt my head. Everything went great until she brought the machete down upon me."

As a confused Jason cottons on to Ginny's trick, the heroine raises a machete over her head and swings it down towards Jason's head, but Jason blocks it with his pick-axe, or so it seemed. "She almost cut off my finger," recalls Dash. "I was supposed to block the machete with my weapon, but

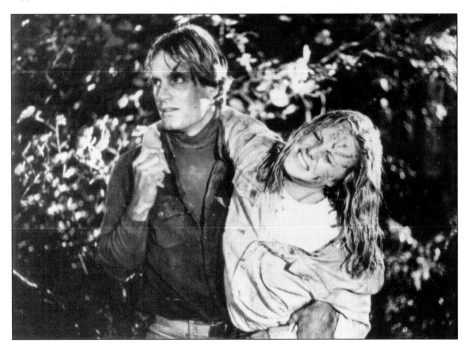

right:
Paul (John Furey) leads Ginny to safety.

Ginny and Paul's calm is short-lived when Jason crashes through the back window, an event that would result in the most controversy of any of the *Friday the 13th* films. Warrington Gillette returned to do the scene. "He'd told us he was able to do stunts, but he wasn't," recalls Cudney who also played a tow-truck operator in the first main scene of the film. "We designed a rig for that scene that was very easy for him. Basically, all he had to do was sit in a sling and allow the rig to break him through the wall, because he went through the wall, not the window. That was an effect." This is the first glimpse of Jason's mangled face. Recalls Miner, "Warrington was in that makeup for the whole day and he couldn't eat or do anything. We tried the scene once, but it didn't work so we had to do it over again." When Gillette tried to 'go through the window' the first time, he got quite a headache. "My head just smacked against the window because they hadn't altered the window properly," recalls Gillette, now an East Coast-based entrepreneur and aspiring horror film producer. Recalls Stein, "I remember when they did that scene the first time, the guy's head just smacked into the wall. I think it was supposed to have been rigged with balsa wood, or something to simulate the window, but his head just smacked against it."

Dash feels that Gillette's cameo reappearance only added insult to his injuries: "It's frustrating that everyone thinks that guy's Jason when he really didn't do anything," says Dash. "A few years later, one of those morning television shows, I think it was *Good Morning America*, did a segment on the guys who played Jason and they brought Warrington on the show. When Cliff heard they were doing the show, he called them up and explained that I was the one who really played Jason, but again, they see the other guy's name on the credits. The reason I didn't get credit was because the other guy's agent got him the credit. I didn't have an agent. I was just the guy in The Bag doing all of the stunts in the film, playing Jason."

Dash has spent the past twenty years doing stunts on such films as *F/X* and *Sweet Liberty* along with sporadic television appearances. "Something funny happened to me after I did the film," he recalls. "I got a job on that soap *The Guiding Light* playing a football coach. Guess who played one of the football players? Kevin Bacon. I walked into the dressing room and I saw Kevin and there was a *Friday the 13th* poster on the wall. I pointed at it and said, 'What's that?' He told me that he'd starred in the film and that he'd been killed with that arrow through the neck. I laughed and told him that I'd just finished playing Jason. We both laughed, but Kevin left the show soon after that so I was out of work because they didn't need a football coach anymore."

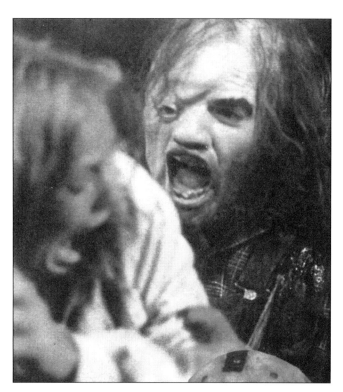

above:
Jason Voorhees's face is revealed at the end of *Friday the 13th Part 2*. *Friday the 13th* effects expert Tom Savini was unable to work on *Part 2* because he was working on the film *The Burning*. Carl Fullerton was given the make-up effects job on *Friday the 13th Part 2*.

Cudney, who went on to coordinate stunts for films like *Boogie Nights* and *October Sky* before retiring to his native Tennessee where he lives with his second wife and young son, says, "Steve was Jason and everyone should know that."

The main controversy surrounding *Friday the 13th Part 2* occurs with the ending, or rather the lack of one. When Ginny awakes the next morning, she's being carried out towards an ambulance, surrounded by cops. Paul is nowhere to be found. She calls out for Paul, but no one explains if Paul is dead or alive. "That was a case of the script not translating well to the screen, plain and simple," says Kurz. "Paul was killed, and what was supposed to happen was that Ginny would call out for Paul, and one of the State Troopers was supposed to say, 'We haven't found him yet.' We then cut to Mrs. Voorhees whose expression forms into a diabolical smile as if to say that she's proud of Jason for killing Paul and fooling everyone. He'd done well. What happened was that Phil forced Steve to stick to the script and so I think everything got muddled. Listen, in my opinion, I think if Steve had been given more control, the whole film would've been much better."

Friday the 13th Part 2 would, ultimately, have little bearing on the future career prospects of Furey and Steel, except for the fact that their roles in the film are still what each actor is probably best known for. The film would be Furey's first and last

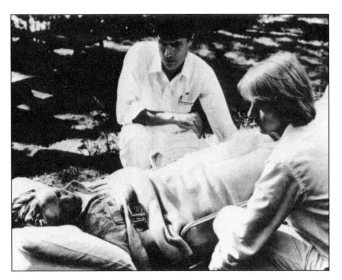

Paramedics prepare to take Ginny to the hospital while Ginny wonders about the fate of Paul. Paul Holt's ambiguous fate has been the cause of much conjecture over the years since *Friday the 13th Part 2*'s release.

theatrical feature in a career that has seen him work consistently on such television programs as *Remington Steele*, *L.A. Law* and *Queer As Folk*. In 1998, he had a recurring role on the soap opera *All My Children*, which is fitting since he's married to fellow soap opera actor Denise Galik-Furey. As for Steel, the twenty-plus years following *Friday the 13th Part 2* illustrate a career that's been somewhat star-crossed. She seemed poised for big things following a memorable appearance as Michael J. Fox's love interest in an episode of the hit television show *Family Ties*. Acclaimed roles in made-for-television films would follow, but when Steel's next two feature efforts - the 1986 horror-thriller *April Fool's Day* and the 1987 comedy *Walk Like a Man* – failed to set the box office on fire, Steel's bid for cinema stardom was over, although the actress has enjoyed a productive television career that has seen her appear on such series as *Chicago Hope*, *JAG* and *Millennium*.

The vagueness of the ending, and the fate of Paul Holt in particular, led to the long-standing and completely erroneous rumour that John Furey had, in fact, walked out on the film - in essence quitting the production before a proper ending could be completed and filmed. This is an untruth - since repeated in numerous online and print sources - that all parties are quick to denounce. "No, I was there for the whole production," asserts Furey. Says Miner, "John was a total professional and he did everything that was asked of him. If the ending was vague, that was the film's fault, not his." In fact, Furey and Miner have remained in friendly contact over the years. The making of *Friday the 13th Part 2* has been plagued with rumours of bitter feuds and actors quitting the production. "It was a very happy set, one big party," recalls Stein. "I remember that

Amy and I, and some of the others, used to drive into town to be with girlfriends and stuff. By this time, most of the main crew had had enough of the cold cabins and had moved into the local hotels. Other than that, the shoots went from seven in the morning to seven at night and there were parties every night."

Friday the 13th Part 2 was released on May 1, 1981 in 1,350 theatres where it grossed an impressive $6.4 million during its first weekend of release, more than *Friday the 13th* took during its first wide-release weekend. The film was released in Argentina on October 29 of that same year, followed by a release in Sweden on November 2. In France, the film wasn't released until January 13, 1982. The initially strong box office figures quickly declined, however, amidst withering critical barbs and nervous theatre chains eager to pull the film from their screens. The film finished with a final box office haul of $21.2 million, about half the amount earned by the original film less than a year earlier. This was still a profitable arrangement for Paramount, although the scathing reviews that *Friday the 13th Part 2* received - from critics like Gene Siskel and others - combined with shrinking totals, did nothing to convince anyone that this was the dawn of a slasher movie trend that had any sort of 'legs.' "It was a bit of a disappointment," says one former Paramount executive. That's Hollywood-speak, not for a failure to turn a profit but rather a failure to live up to unrealistic expectations.

It should also be noted that *Friday the 13th Part 2* was not the most commercially successful horror film of 1981, as *Halloween II* - which was released on Halloween no less - outperformed *Friday the 13th Part 2* by several million dollars (it grossed $25.5 million). "I was happy with the way the film turned out and I feel that it showed people that I could direct," says Miner. "The film did very well when you consider that it was released less than a year after the original film was released. If you combine both films into one, you've got a blockbuster kind of success. We were all happy with how it performed."

Typically, there is a diminishing return from sequels and, given that rationale, it seemed that the *Friday the 13th* series would be a rapidly dwindling, not expanding, enterprise. That was the safe bet. Still profitable? Certainly, but without much of a future, at least not in the mainstream where the films were still looked down upon from a lofty height. No one could predict the pulsing life that the *Friday the 13th* series would exhibit in the next couple of years. It was the dawn of a new era, a mini-revolution that would see Jason and the *Friday the 13th* series become bigger and stronger than ever before, or since. What exactly was this new era? It was the era of the hockey mask.

Terror in the Third Dimension

Following the slightly disappointing performance of *Friday the 13th Part 2*, the franchise was in need of a blood transfusion. It wasn't just that *Friday the 13th Part 2* had failed to live up to financial expectations, but also that many fans were left feeling cheated and underwhelmed by the film's trimmed-down effects and copycat storyline. Jason, it seemed, had been neutered by the MPAA and nervous studio executives. However, by early 1982, the playing field was about to change, in all sorts of weird directions. The *Friday the 13th* franchise was about to become stereoscopic.

The 3-D format had been virtually dormant since its last renaissance in the '50s with films like *Dial M for Murder* and *House of Wax*. Beginning in 1981 - and ending towards the fall of 1983 - 3-D made a brief but spectacular comeback. This was an attempt by gimmick-conscious Hollywood to try and tap into the *Star Wars* blockbuster market. This period would see the release of such 3-D films as *Comin' At Ya!*, *Parasite*, *Jaws 3-D*, *Amityville 3-D* and, not to be left out, *Friday the 13th Part 3: 3-D*. *Jaws 3-D* would turn out to be the most commercially successful of the whole bunch although, on a cost versus profit basis, *Friday the 13th Part 3* would later be considered the most profitable 3-D film of the era, even though the film would be one of the most costly horror films in history, at least in terms of blood, sweat and tears.

Steve Miner returned to handle directing chores, joined by Frank Mancuso, Jr. - now elevated to the status of producer. Lisa Barsamian also returned for the purpose of monitoring Stephen Minasian's asset, and she was joined by two new producers in Tony Bishop (now deceased), and Peter Schindler who would serve as an associate producer on the film. Bishop had served as a supervising producer on the acclaimed 1979 John Carpenter television film *Elvis* while Schindler had served as an assistant director on such films as *The Kentucky Fried Movie* and the made-for-television, dog-possessed-by-Satan film *Devil Dog: The Hound of Hell*. "I had a feeling, I was hoping, that this might be the last one," says Miner. "That's kind of what brought me back to direct *Friday the 13th Part 3* although I was very anxious to direct another film. I knew the experience could only help me."

The decision to go 3-D was not made by any of the above parties. Enter Martin Jay Sadoff, a true innovator in the world of film technology and a man who - along with Daniel Symmes (in charge of the 3-D effects for *Jaws 3-D*) - was most responsible for the '3-D birthquake' that briefly revisited movie screens in the early '80s. Prior to supervising the 3-D effects for *Friday the 13th Part 3*, Sadoff had served as an editor on the 1981 slasher film *Graduation Day* and had provided groundbreaking visual effects for the 1979 all-star comet disaster flop *Meteor*, one of Natalie Wood's

below:
American poster art for *Friday the 13th Part 3*. Paramount Pictures later ran Academy Award consideration ads in various trade papers for the purpose of getting nominations for members of the *Friday the 13th Part 3* technical crew.

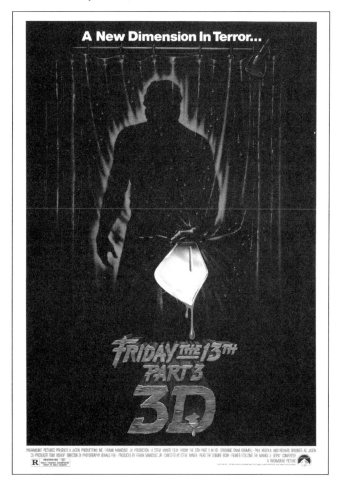

above and below:
Promotional admats for
Friday the 13th Part 3
emphasised the 3D
aspect of the film above
all else.

last films. Sadoff's modern experimentation with the wonders of 3-D coincided with the rise of Frank Mancuso, Sr. who, by 1982, was just settling into power at Paramount Pictures (Charles Bludhorn would die of a heart attack while disembarking from a private jet in 1983).

The relationship between Sadoff and the Mancuso family dated back to Sadoff's early professional days working in Toronto, when he was actively experimenting with 3-D technology. "I began testing 3-D when I was with Astral Bellevue Pathe in the '70s," recalls Sadoff, who would go on to work on the 3-D effects for the ill-fated 1983 film *Spacehunter: Adventures in the Forbidden Zone* before serving as an editor on *Friday the 13th Part VII: The New Blood.* He now works at Crest National, a full service editing and production facility in Los Angeles. "I became friends with Frank Sr. in Toronto and the Mancuso family treated me very well. When I was in Toronto, I began some early 3-D tests and that led to some of the big studios showing interest in the technology. Frank Sr. was the only one who was willing to step forward and *Friday the 13th Part 3* ended up being the final result, but that wasn't the original plan."

Frank Mancuso, Sr. was interested in creating a whole new cinematic landscape. "First of all, this was Frank Sr.'s passion," recalls Sadoff. "The 3-D effects were originally supposed to be used for *Star Trek III* and then who knows what might've happened. We spent something like $15 million

working on the technology and, most importantly, trying to outfit and reconfigure movie screens across North America so that they could handle the 3-D effects. The whole thing was very ambitious."

It was during this fifteen month process, leading up to and during the start of production on *Part 3,* that Sadoff and his associates sought to change the look of cinema forever. "We had to basically go around and rebuild about 2,500 movie screens," says Sadoff. "As far as wanting 3-D effects in *Part 3,* Frank Jr. and Steve Miner didn't give a shit about the 3-D because they were under such a tight schedule. They had to get this film made and, to make matters worse, Paramount told us that they wouldn't release the film if the 3-D effects looked stupid. It was a very stressful situation and the whole thing went on right up until the end of filming."

Finding a script for *Friday the 13th Part 3* was much less problematic. "We wanted a film that would deliver more on the visceral effects and, basically, combine the elements of the first two films," says Miner. "Again, like with *Part 2,* I wanted to take everything that worked and add lots of excitement." Martin Kitrosser - who had served as a script supervisor on the first two films - was commissioned, along with his wife, Carol Watson, to write the script. Of this infamy, Kitrosser is less than proud. "For Carol and me, *Friday the 13th* is a part of ancient history that we choose not to talk about. It's nothing personal against the good people we

right:
Cast and crew work on a
complicated camera set-
up in preparation for the
filming of a scene in a
muddy lake. *Friday the
13th Part 3* was afflicted
with volatile weather
patterns that included
heavy rain, snow, and
incredible heat.
(Photo courtesy of
Steve Susskind.)

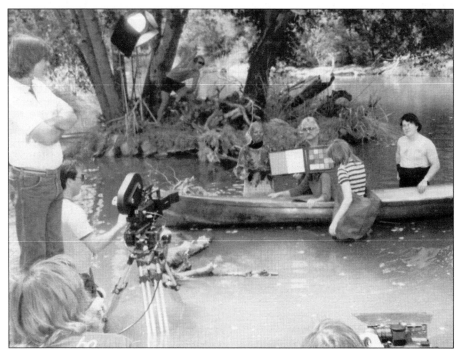

worked with on those films, but we just don't want to be associated with that stuff anymore," he says.

Regardless of their feelings today, Kitrosser and Watson would team up with producers Barsamian and Bishop a year later on the disastrous *Meatballs II* (originally titled *Space Kid* before the producers obtained the rights to use the *Meatballs* name), an in-name-only sequel whose manipulative title failed to make cash registers ring, certainly in comparison to the success that *Friday the 13th Part 3* would enjoy. This is notable because Barsamian and the production team made *Meatballs II* right after *Part 3*, at the same Veluzat Motion Picture Ranch location used for the filming of *Part 3*.

Before the hiring of Kitrosser and Watson, Phil Scuderi had approached *Friday the 13th Part 2* writer Ron Kurz but he wasn't interested: "I actually did one more movie with Phil a year later, which was some piece of junk called *Off the Wall*. Phil had a heart attack and turned that over to Frank on the West Coast." (This was Frank Mancuso, Jr.'s first full producing credit). "I never saw that film, but I heard it was a real mess despite a good cast. I had to go to arbitration with the Writers Guild to get a credit on the film. Basically, I didn't want to be typecast as a horror writer so I turned *Part 3* down and I really don't regret it."

Enter Petru Popescu, a name completely foreign to fans of the *Friday the 13th* series, unless they happened to stumble upon Michael Avallone's 1982 novelization of *Friday the 13th Part 3*, where Popescu is credited - along with Kitrosser and Watson - as one of *Part 3*'s writers. For the Romanian-born Popescu, the journey to America was just as arduous and challenging as anything he might face in Jason's domain. Popescu first came to the attention of Hollywood when he collaborated with respected director Peter Weir on the acclaimed 1977 Australian aboriginal drama *The Last Wave*. "Romania was under a dictatorship and I was a political refugee," says Popescu who's gone on to become a prolific novelist and screenwriter, mostly in artistically-driven subjects that are a million miles removed from the *Friday the 13th* universe. "They were burning my writings in Romania, I was tried in absentia, everything. I had to flee. I was in Australia where I started working with the Australian Film Institute and the success of *The Last Wave* brought me to America."

Popescu never dreamed that his trip to America would bring him face-to-face with Jason Voorhees. "I came to Los Angeles with nothing but a typewriter," he recalls. "Soon, I started meeting people. One day, I think I was walking the halls at ICM (International Creative Management agency) and I bumped into Steve Miner. He saw some of my writing and he liked it, and Frank Mancuso, Jr. also

above:
Steve Susskind, who played the part of general store owner Harold, and director Steve Miner joke around on the set of *Friday the 13th Part 3*. (Photo courtesy of Steve Susskind.)

liked my writing and they wanted me to work on the *Friday the 13th* script they had because they felt that it wasn't quite ready. It needed some darkness and tone and structure. I'd never even heard of the *Friday the 13th* films let alone seen them so I just had to learn as I was going. I'm a writer and I know how to tell stories. The *Friday the 13th* formula is a very simple formula for a writer to learn."

Another writer involved with *Part 3* was Michael Avallone, who was responsible for the film's novelization. This side-project is worth mentioning since Avallone's book would contain several scenes – particularly an alternate ending discussed in the next chapter – that never made it into the finished film. Michael Avallone was a veteran pulp novelist who'd barely even heard of the *Friday the 13th* films when he was assigned to write the official novelization for *Friday the 13th Part 3*, published in tandem with the release of the film in August of 1982. Avallone, who passed away in 1999, had over 200 works of fiction published over the course of his long career, including novelizations of such films as *Beneath the Planet of the Apes* and *Shock Treatment*. Avallone's son, David, recalls his father's fateful introduction to the world of Jason Voorhees. "It was a slow period in Dad's career and getting the *Friday the 13th* job wasn't exactly a confidence boost for Dad. The author rarely gets to see the film because it's usually still being edited so they send you a script to work from. Dad figured he'd skim through the script and write the book really fast. The script arrived and we both just stared at it for a minute. He handed it to me and said, 'I'm going out for coffee. When I get back, you can tell me how it is.' I sat on the couch and read about thirty pages. When Dad got back, he said 'So?' and I just told him, 'It's not what you'd call good.' He sighed, took the script out of my hands, and slumped towards his office. Soon, I heard the

below:
German pressbook cover art for *Friday the 13th Part 3*.

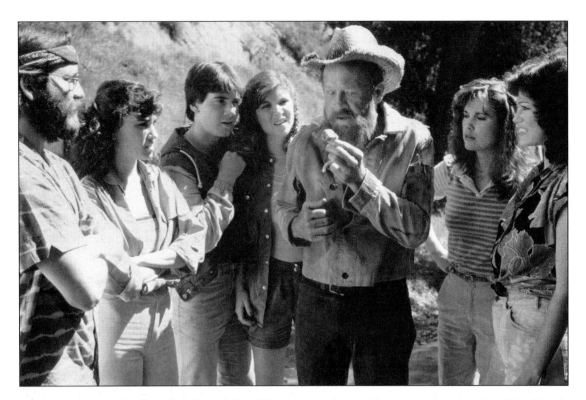

above:
Abel (David Wiley) brandishes an eyeball of unknown origin.

below:
Shelly (Larry Zerner) ponders his future as a practical joker.

familiar clattering of his Olympia manual typewriter. By the end of the day, my father came out of the office with some pages. I was watching TV and he had a grin on his face when he said, 'I want you to take a look at this.' I said, 'What, the *Friday the 13th* thing?' and he said, 'Yeah, I'm doing something really interesting with Jason.' I couldn't believe it. He started writing this book with low expectations, but a few pages in, he was already enjoying himself. He'd found a way to tell the story in his own interesting way - with his own imprint - and he wrote the book in less than a week. Dad never wrote a book that he didn't like."

Casting for *Friday the 13th Part 3* was very casual. Although Dave Eman and Bill Lytle were hired as casting directors, the actors that formed *Part 3*'s cast were taken, almost literally at times, from off the street, and while none of the actors that have ever appeared in a *Friday the 13th* film have exactly seemed like candidates for Stratford, the rag-tag bunch that would form *Part 3*'s cast would, ultimately, be responsible for some of the worst acting, not just in the context of the *Friday the 13th* films, but in film history, period. Film critic Leonard Maltin, in his otherwise complimentary review of *Friday the 13th Part 3*, labelled the performances as 'amateur night.' However, just because the actors in *Friday the 13th Part 3* couldn't act, that didn't mean that they wouldn't be memorable.

The most experienced member of *Part 3*'s main cast was probably Dana Kimmell, a devout Mormon who had previously appeared in such genre fare as *Sweet 16* and the 1981 television thriller *Midnight Offerings*. "It's hard to turn down a starring role in a major motion picture that's going to get a wide release," says Kimmell. "It was a paycheck, plain and simple. Personally, I've never been a fan of horror films, or anything that's really violent or gory, but I have been in quite a few of those movies, strangely enough. I remember that I'd just done *Sweet 16*, which a lot of people in the industry saw, and one of the producers of *Friday the 13th Part 3* saw the film and really liked my performance. The rest is history."

In the film, Kimmell's character, Chris, travels to an isolated farm compound named Higgins Haven with her friends for a weekend of relaxation. Chris is haunted by memories of a violent encounter with Jason Voorhees years earlier, but the main reason she's travelled to Higgins Haven, aside from wanting to confront these past demons, is to be with her boyfriend, Rick (known as Derek in the Avallone novelization), played by a previously-unknown actor named Paul Kratka. When Kratka got the lead role, he was thinking about a different form of slicing and dicing: he was attending college, a path that would eventually lead him to becoming Dr. Paul Kratka, a successful

chiropractor in Carlsbad, California. "I had the same agent as several of the other actors so we all kind of knew each other," says Kratka, whose agent at the time happened to be the mother of co-star Tracie Savage. "I'd done some theatre and so, at that time, I was really excited to have a starring role in this movie. I thought it was the beginning of a big film career."

The aforementioned Savage played Debbie, a pregnant teenager, adding more than a little dark sub-text to the rest of the film given her - and the unborn baby's - eventual fate. Savage had previously appeared on such television shows as *Happy Days* and *Little House on the Prairie*. "I'd been acting since I was a baby," says Savage who's now a successful news anchor in Los Angeles (and was incidentally called to testify in the criminal trial of O.J. Simpson). "When the film was being cast, I was taking classes at college. I wasn't even thinking about acting, but my arm was twisted into going to the *Friday the 13th* audition. There was a number of call-backs and, eventually, I got the part. I kind of liked the idea of doing a horror film." *Friday the 13th Part 3*'s requisite practical joker was Shelly. As played by Larry Zerner, Shelly may have been a goof, but he had a heart of gold. "I was walking on the streets near Westwood and I was handing out passes to *The Road Warrior*, which had just come out, when Marty Kitrosser and Carol Watson approached me and asked me if I'd be interested in being in their film," he recalls. "It was an amazing moment, like a bolt of lightning. I had an agent and I gave them the agent's number and I waited nervously. I auditioned about four or five times before they gave me the part." Zerner is now an entertainment lawyer in Los Angeles, his looks and physical appearance having changed dramatically over the past twenty years, with Shelly's podgy image a distant memory.

David Katims played Chuck, the '60s-throwback 'stoner dude' who only cares about his next joint. "I'd done quite a bit of theatre and my agent was Tracie's mother, just like Paul," recalls Katims, who's now a sales representative and stand-up comedian in Seattle. "Rachel Howard played Chili, my girlfriend, in the film, but when I auditioned, they had a different girl there to play Chili for like three or four call-backs. When we were all cast, Steve Miner took us all out to this park in Los Angeles to see how we'd photograph and how we'd work together as a group. That was when we all met each other."

As for the rest of the cast, Catherine Parks who played Vera in the film had been a runner-up in the 1977 *Miss America Pageant* after she'd held the title of Miss Tampa. Her first film appearance was in the 1981 Michael Crichton thriller *Looker*. Nick

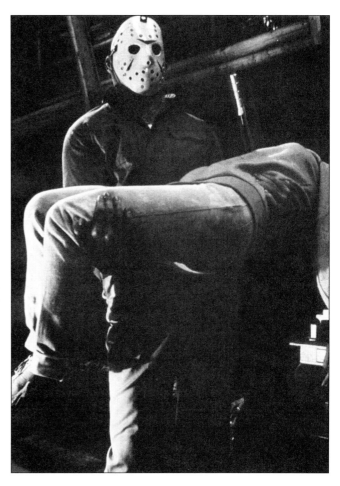

above:
Jason Voorhees (Richard Brooker) carries Chili (Rachel Howard) to her final destination.

Savage, who played Ali, the tough gang member who, along with his cohorts Fox (Gloria Charles) and Loco (Kevin O'Brien) form an unlucky trio in *Part 3*, had enjoyed a series of recurring appearances as a smooth-talking hood named Pickpocket on the hit television series *Hill Street Blues*. The veteran of the entire cast, in terms of years of acting experience, was David Wiley who played Abel, the "Crazy Ralph" clone: a wacky seer who tries to warn the characters against entering Jason's domain. Wiley has enjoyed a film and television career spanning almost forty years, including some memorable guest appearances on the cult '60s television show *Hogan's Heroes*.

Then there was the casting of Jason, always the source of much happenstance and humour, it seems, with every *Friday the 13th* production. "We wanted someone who was bigger and stronger-looking than we saw in *Part 2* - more athletic and powerful," says Miner. Enter Richard Brooker, a former trapeze artist - credentials that would make him, arguably, the most athletic Jason in history. "I answered an ad

right:
Effects expert Stan Winston, Steve Susskind, Richard Brooker, and Steve Miner on the set of *Friday the 13th Part 3*. Winston's original design of Jason Voorhees's face was eventually jettisoned in favour of effects expert Douglas J. White's design.
(Photo courtesy of Steve Susskind.)

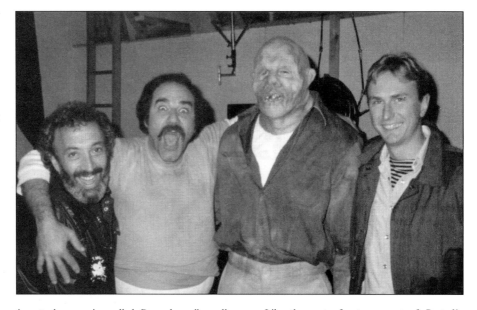

below:
Special effects prop being prepared for the filming of Rick's (Paul Kratka) eyeball-popping death effect.

in a trade magazine called *Dramalogue*," recalls Brooker, who today has become a successful director and producer of television specials as well as sports programs and special events. "They wanted a really large guy and I fit the bill, but I needed the job more than anything else because I was new in the country. I thought that playing a psychopathic killer seemed like the perfect entry-level job in the movie business." Prior to being the first actor to don Jason's trademark hockey mask, Brooker had worked in the European television industry in all areas of production which included a stint as 'technical manager' for a program entitled *Circus World Championships*, which aired on the BBC and ITV. He was ideally suited to this job, having spent many years touring Europe with some of the world's finest circuses.

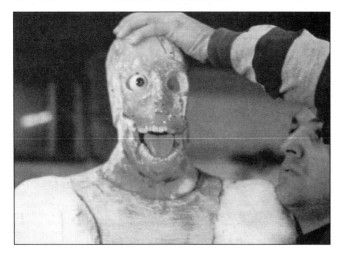

Like the cast of actors, most of *Part 3*'s technical crew were spanking new. Carl Fullerton, who'd worked on *Part 2*, was unable to work on *Part 3* due to scheduling conflicts and so Miner enlisted the services of Douglas J. White, a founding member of Makeup and Effects Laboratories, Inc. (MEL) and a former associate of Stan Winston's whose own contribution to *Part 3* would be, like his contribution to *Part 2*, peripheral. Along with White's involvement, the bulk of the film's effects chores would be achieved with the help of special visual makeup effects experts Allan A. Apone, Larry Carr, Louis Lazzara, Kenny Myers and Francisco X. Perez (who was then known as Frank Carrisosa). White would eventually handle most of the film's key effects when conflicting work commitments with simultaneous projects forced most of the other members of the effects team to leave the production at various stages. The budget for the film's makeup effects was substantially higher than that for *Part 2*, given *Part 3*'s overall $4 million budget, more than twice the amount spent on *Part 2*.

Makeup and Effects Laboratories, Inc. would receive credit for the film's effects, which were supervised by Martin Becker, who would go on to work on several more *Friday the 13th* sequels. "When we started the company, it was just a small 1,000-foot warehouse, but with *Friday the 13th*, and all of the projects we've done since, it's grown into a gigantic 10,000-foot facility," says Apone. The company was originally founded in 1978 by Apone and White; Perez later became a third partner after original third partner Peter Knowlton left the company. Both Perez and White would eventually

leave Makeup and Effects Laboratories, Inc. to start their own effects companies, leaving Apone, today, as the company's only remaining original founder.

Kenny Myers – recently credited with work on such films as *AI*, the Tom Cruise epic *The Last Samurai*, and *How the Grinch Stole Christmas* - recalls a bunch of talented kids having the time of their lives. "It was a group of young talent that came together to make a monster movie in the backwoods of Santa Clarita, now a city," recalls Myers. "The makeup effects we used were a collection of out-of-kit-makeups along with sculptures for the Jason makeup, given to us by Stan Winston, that Doug White and I got to put on. We laughed a lot. The hard part was working with the 3-D because the setups were laborious and we were working primarily at night, which is tough on your body and mind."

Sadoff's superhuman pre-production efforts notwithstanding, principal photography on *Friday the 13th Part 3* began in March of 1982 in California, in and around the storied Veluzat Motion Picture Ranch located near Saugus, California. Part of the Melody Ranch Motion Picture Studio, the famed location came to life in 1915, when it became the stage for endless movie westerns featuring such legends as Tom Mix, Roy Rogers and John Wayne. The ranch was severely damaged by fire a few years ago, but has rebounded and, with its 750 acres of barns, cabins and pine forest, the place is a living relic of a bygone era in cinema. For the purpose of making *Friday the 13th Part 3*, the ranch was ideal in that it offered excellent access by road. "It was great to film at the ranch because we were able to drive home when the day was done," says Miner. "The place had lots of great props and sets, and we kind of built the film around the place, altering parts of the story and certain scenes so we could maximize all of the great sets. As it turned out, there wasn't much time to go home." Additional exterior scenes were shot in and around Green Valley, California.

Composer Harry Manfredini was another *Friday the 13th* returnee, but, as the veteran composer explains, his musical contribution to *Friday the 13th Part 3* was largely symbolic. "The score for *Friday the 13th Part 3* was largely taken from the first two films. I worked on parts of the first reel and the last reel, but other than that, it was all taken from the stock they already had," says Manfredini, who incidentally claims to have never seen the film.

Enter Michael Zager, a songwriter and producer from New Jersey, best known for his work in the world of disco. Jason was about to boogie, well, at least for the opening credit sequence of *Friday the 13th Part 3* and for a few orchestral shades

afterwards. Throughout the 1970s, Zager worked on disco and R&B records with such performers as Peabo Bryson, Cissy Houston and, in a Kevin Bacon *Footloose* tie-in, Deniece Williams. "I knew Eddie Newmark who'd produced some of Harry's work and that's how I got the job on the film," recalls Zager, now a music professor at Florida Atlantic University in Boca Raton, where the dance music maestro also continues to produce and record music. "Disco was still hot and Harry, who was the only person on the film that I had contact with, suggested that I contribute a funky disco version of the traditional *Friday the 13th* riff. I did the opening and the closing and most of it was actually done in a bedroom. It was fun. I'd never seen a *Friday the 13th* film before or since, but the *Friday* score I did became a big club hit and I still get residuals from Europe. I think that, primarily, the makers of the

above:
The front of Veluzat Motion Picture Ranch as it appears today. The ranch has been around since 1915. (Photo courtesy of Sean Kearnes.)

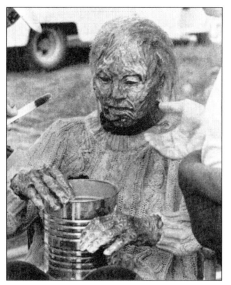

left:
Marilyn Poucher enjoys a last meal before jumping into a muddy lake in order to assume the persona of Pamela Voorhees for the final shock scene of *Friday the 13th Part 3.*

above:
Harold (Steve Susskind) and Edna (Cheri Maugans) argue over Harold's eating habits. Exteriors of the grocery store were filmed at a real store in the Angeles Crest Mountains. It snowed so much on the grocery store set that cast and crew were warned to leave or risk being stranded for days. Frequent rainstorms also played havoc with *Friday the 13th Part 3*'s production schedule.

below:
Harold's death scene. (Photo courtesy of Steve Susskind.)

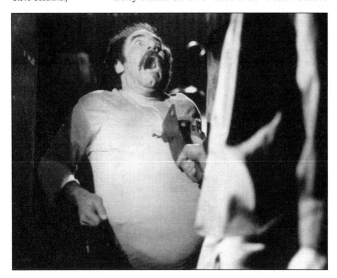

film wanted a record that they could sell from the film and the *Friday the 13th Part 3* music ended up doing very well. Other than that, I never met Steve Miner or anyone else who was associated with the film, just Harry."

As a matter of fact, the recording that Zager did, with the band Hot Ice, appeared on many music charts around the world. *Friday the 13th Part 3* proved, at least in a commercial sense, that disco definitely wasn't dead, at least not in 1982. "Disco never died," says Zager. "They just call it dance music today."

Despite the fact that less than 30 months separated the release dates of the first three *Friday the 13th* films, *Part 3*, just like *Part 2*, opened with a flashback to the previous film. The opening sequence shows Ginny Field plunging the machete into Steve Dash's Jason, a scene that's precluded by Betsy Palmer's *Part 2* voice-over. "I can't believe

that I was in the first four films," marvels Palmer. "I kept asking people, 'Didn't I die at the end of the first film?' I guess it just shows that Pamela's the fans' favourite monster." The flashback included one new insert: a back-angle shot of a wounded Jason - Steve Dash's Jason - reaching up to grab a blade off a ledge. The camera then zooms in on Connie Hogan's impression of Pamela Voorhees's rotted head stump. Then... funky disco music appears over the opening titles.

Filming began at the ranch, on the general store set which, outwardly, featured a gas station and authentic-looking Spanish buildings. The opening scenes of the film were filmed, at different times, over the period spanning March to May of 1982. It's been less than forty-eight hours since the bloodbath that occurred in *Friday the 13th Part 2*, a chronological device that would later handcuff the series. The carnage is being cleaned up by the authorities and Jason is still on the loose in Crystal Lake. The general store is owned by the odd husband-and-wife team of Harold (Steve Susskind) and Edna (Cheri Maugans). Unfortunately for Harold and Edna, Jason has decided to use their store as a temporary hideout prior to his next murderous rampage. "It was a great set, really realistic-looking," recalls Susskind. "I had a lot of fun playing a goof like Harold, and Cheri and I had a lot of fun calling each other names and acting like we hated each other, which we didn't." While Harold munches on chocolate donuts, he eventually makes a horrifying discovery in the form of a cage full of slaughtered rabbits. Before he can call the cops, Jason kills him with a meat cleaver. "I couldn't believe how large and powerful-looking Richard Brooker was when I met him. Richard was a really nice guy, but he really had a creepy presence when he was in Jason mode," recalls Susskind, who was hired through several mutual friends the actor shared with Miner, including Bud Fanton who was a friend of Miner's back in Connecticut in the late 1960s. He went on to become a highly successful character and voice actor, appearing in such films as *Osmosis Jones* and *Monsters, Inc.*

In fact, Brooker's Jason was such a terrifying presence that Susskind feared he might get killed for real: "They filmed my death scene at the Hollywood Stages in Santa Monica and it was a really dicey thing to film. When we did the cleaver scene, there was a bloodless version and a bloody version," he recalls.

Apone, White and the makeup crew designed a special chest cast and bloodline that, it was hoped, would pump copious amounts of blood out of the gaping wound in Susskind's torso. As with many horror film special effects, things didn't go exactly as planned. "That was a one-take shot," recalls

White. "We built a fibreglass chest and inserted a bloodline which would explode when the cleaver would make contact. That's the way it was supposed to work." For Susskind, the effect turned out to be a little more realistic than the actor bargained for: "We were going to do a take with a balsa-wood cleaver. They wanted to try it out because everyone thought that when the bloodline was cut with the metal that it would shoot blood everywhere. Everyone on the crew had bags over their heads." Brooker remembers: "I had to hit Steve at a certain side-angle so that just the wound was visible so the blood would shoot out at the camera for the 3-D effect."

Brooker stood tall on a riser for the rehearsal with the balsa cleaver, but Susskind was horrified when, "Richard did the side-saddle thing with the cleaver, but he accidentally smacked me on the chin with the cleaver! Then we had to do it with the real cleaver and I was scared out of my mind. I knew that when I opened the door that the cleaver was going to hit me again and what if Richard accidentally hit me in the face again? I was so scared that when Steve yelled 'action,' I totally froze up. I couldn't open that damn door because I was scared of the cleaver. Steve yelled 'cut' and walked over to me - and Steve's so understanding and sensitive - and I just told him that I was scared. Well, I calmed down and I opened the door and Richard did it perfectly. The cleaver hit me right in the chest, right on the wound, but the blood didn't shoot out." As it turned out, the

now infamous bloodline had been squished into a crevice inside of the chest model, thereby causing it not to respond to the strike. "It didn't bleed," says White. "It had taken too many hits, or something like that, and instead of shooting outward, the blood all formed inside the chest." Susskind remembers, "They only did one take, but I still have pictures of my chest drenched in all of that blood."

This left Harold's nagging wife Edna, who, oblivious to the death of her husband, was preoccupied with finding her lost knitting needle. Edna eventually did find her knitting needle... in the hands of Jason, who proceeded to plunge it through the back of her head. "That was a hard scene to do because they had to time the 3-D lenses and they had to get it just right," says Maugans. "It wasn't very comfortable having that needle thrust near my head, but everyone made it fun. I never felt like I was going to get hurt."

The 3-D effects for *Friday the 13th Part 3* were achieved using the ArriVision system, which was designed by the ArriFlex Camera Corporation and was also used in *Amityville 3-D* and *Jaws 3-D*. It served to give films, including *Friday the 13th Part 3*, an aspect ratio of 2:35:1, thus increasing the potential scope of the effects. "In terms of the script, I knew it was important to maximize the 3-D aspects," says Miner. "I specifically knew that we had to have things that fired out at the audience: jabbing, spearing type shocks like in the opening

above:
Steve Susskind prepares to be killed by Jason Voorhees on the set of *Friday the 13th Part 3*. Sadly, Susskind was killed in an automobile accident on the 21st of January 2005. (Photo courtesy of Steve Susskind.)

below:
Cinematographer Gerald Feil attempts to film a snake in 3-D. (Photo courtesy of Steve Susskind.)

above:
British quad poster for
double bill of *Friday the
13th Part 2* and *Friday
the 13th Part 3*.

scene when you see the snake jump out at the guy and when Jason puts the needle through the woman. I knew, at the very least, that the 3-D experience would be great and so, from that point-of-view, it was worth all of the time and effort."

Needless to say, the system was anything but an exact science, especially given how dormant 3-D had been since its popularity in the 1950s. Even today many wonder if 3-D will ever be perfected to anyone's true satisfaction. *Part 3*'s 3-D cameras were crafted by Mitchell Bogdanowicz, who passed away in 2004. Miner chose the Marks 3-D system, the Marks 3-Depix Converter system to be exact, as the basis for work on *Part 3*, a single-lens prism system that was adapted to work with ArriFlex cameras. Although difficult to use, Miner was happy with the set-up. "All of the 3-D systems we looked at were extremely difficult to use and the Marks system turned out to be the easiest to use," recalls Miner. "I was happy with the results. I actually wanted to do more 3-D films after *Part 3*, but the whole thing just kind of died. I think one of the biggest problems was the fact that most of these systems were built in backyards and they were very inexact."

Petru Popescu, *Part 3*'s uncredited writer, vividly recalls Miner's keen attention to detail. "Steve really wanted the script to have specific elements that would work well with the 3-D," recalls Popescu. "Even though I'd just arrived from Romania, I wasn't a neophyte; I'd known about 3-D. To show me what he wanted, Steve took me to a screening of *Dial M for Murder*, which was in 3-D, and he wanted me to work off of that. He wanted lots of spearing motions in the script."

Originally, Miner had wanted *Part 3* to take place immediately after *Part 2*, a plan that was scrapped when *Part 2*'s star, Amy Steel, declined to return for the follow-up. "I had an idea of putting

Ginny Field into a mental institution and having Jason strike there," recalls Miner. "I wanted to make it a little bit more psychological, but the producers didn't like the idea and it was decided that we'd go back to the typical setting and story that had been used in the first two films."

With the added difficulty of, in essence, setting-up the shooting of scenes in order to capture the action on camera twice, given the dual lenses that were required for the 3-D process, a filming schedule that was originally scheduled to run three or four weeks ultimately extended to ten weeks. Miner's director of photography was Gerald Feil, well respected for filming the 1963 classic *Lord of the Flies* and known to slasher movie fans for his work on the 1980 film *He Knows You're Alone*. "Yeah, I shot Tom Hanks's first film," says Feil jokingly, who met Miner at a Christmas party in New York in 1981. Feil had been researching different methods of 3-D because he was developing a 3-D version of *Peter Pan* with producer Lewis Allen. "I'd been doing some documentaries and had finished *He Knows You're Alone* when I got the job. Steve and I got along well from the first time we met." If the painstaking process of filming in 3-D was torture for the actors, for Sadoff, a comparative veteran of the process, it was business as usual. "There was nothing in the film that was really that difficult for me," he says. "The stuff that happened before and after the actual filming was more difficult. There was a lot of politics surrounding the film. The toughest part of the filming for me was that there was so much that I wanted to do that we never did. I wanted the 3-D effects in the film to be very avant-garde and revolutionary, but that's not what we ended up doing."

Filming scenes in sequence with the 3-D meant hours and hours of extra work for the actors. "It was really hard working with the 3-D because everything had to be just right," says Kimmell. Tracie Savage concurs: "Sometimes we'd just do take after take, because of the 3-D process, but none of us were really that upset because we were all just really happy to be starring in a movie. We knew it wasn't going to make any of us big stars, but it was a part of film history." Working on the other side of the lens was also a high-pressure job, according to Feil: "My biggest regret was that I wasn't able to start work on the film earlier in the production process because of scheduling commitments. I knew, going in, that the stuff we were going to do would be very experimental with a 3-D method, and camera system, that was largely unproven at the time, not to mention a Kodak emulsion that was also unproven." With all of the pieces in place for the filming of *Friday the 13th Part 3*, the 3-D bloodbath was ready to begin.

Jason Loses His Head

Despite its fresh 3-D perspective making the process of filming complex, the plot itself for *Friday 13th Part 3* was simple. Very simple. After the scene at the store, we cut to Chris and her friends, in Chris's van, driving to pick up their friend Vera (Catherine Parks) so they can head off to the Higgins Haven ranch to be slaughtered one by one. It's here that *Friday the 13th Part 3* reveals its most peculiar character detail by revealing that Andy (Jeffrey Rogers) and his girlfriend, Debbie (Tracie Savage), are expecting a child. The fact that both characters will ultimately die, along with their unborn child, raises the possibly silly question of whether or not *Friday the 13th Part 3* is representing a certain political viewpoint here. Not so, say the filmmakers. "The thing about her being pregnant wasn't meant to have any kind of hidden meaning except that it showed that Andy and Debbie loved each other," asserts Miner. For her part, Savage agrees that any such controversy is unwarranted. "The fact that she was pregnant wasn't played up that much in the film after the opening," says Savage. "I pretended to have morning-sickness and to always be hungry, but that's it. I think the pregnancy was just something that was thrown in."

The only other interesting character detail in the otherwise attractive group is embodied in Shelly (Larry Zerner), the well-meaning, but horribly awkward practical joker. Shelly's the film's only truly sympathetic character. "I have to say that, back in 1982, I was painfully similar to Shelly," says Zerner. "I just tried to give him some sense of dignity, but my hair back then was just horrible. Steve was a great director to work with, but we were told not to ask a lot of questions about character or the plot. We all knew, except for Dana, that we were going to die no matter what."

After luring Vera away from her overbearing mother who, in retrospect, is quite prophetic in not wanting Vera to go to Higgins Haven, Chris and the others get in the van where they join Chili (Rachel Howard) and Chuck (David Katims), two badly aging hippies with a serious marijuana addiction. The characters continue to smoke weed until a cop car threatens to stop them, forcing them to swallow the stuff whole. Was that real weed? "We had to swallow that stuff in the scene where the cops are approaching us and it was terrible," recalls Zerner. "They told us it was just oregano, but it really tasted like shit." Just what were they smoking? If there's one expert, it would have to be Chuck, the world's biggest stoner, as played by Katims. "It wasn't real pot," he asserts. "They went to a health food store and bought some herbal cigarettes and that's what we used, although it was kind of funky in that van." Katims was inspired in his performance, not surprisingly, by the work of the comedy team of Cheech Marin and Tommy Chong. "Yeah, Chuck was a real stoner dude and I tried to say 'dude' as often as I could to make it seem like Chuck had just fallen out of the 1960s."

As the van moves down a desolate road, Chris and the others pass the general store, where they witness the aftermath of Harold and Edna's massacre. It's around here that Chris and her friends stumble upon an old man standing in the middle of the road, the 'new Ralph' so to speak. His name was Abel and, as played by David Wiley, he had a warning to give Chris and her friends with the help of a certain prop: a human eyeball. "That was a tough scene to do because the two cameras that were side by side had to be just perfect," says Wiley. "I didn't try to copy Ralph from the previous films, but Steve wanted me to be the same kind of character in that Abel is crazy, but the stuff that he says is true."

Chris and her friends don't listen. Abel was to try one last time, later in the film, to warn Chris of the dangers facing her, but that was a scene that only ever existed on paper. Soon, Chris and her

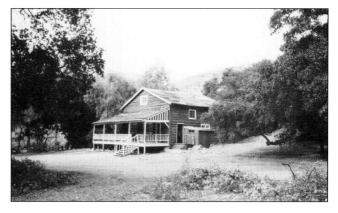

below:
The main cabin from *Friday the 13th Part 3* as it appears at Veluzat Motion Picture Ranch near Saugus, California today. The cabin was constructed by production designer Robb Wilson King. Production had to be shut down for one day when the cabin was infested by a swarm of bees intent on using it as a hive. (Photo courtesy of Sean Kearnes.)

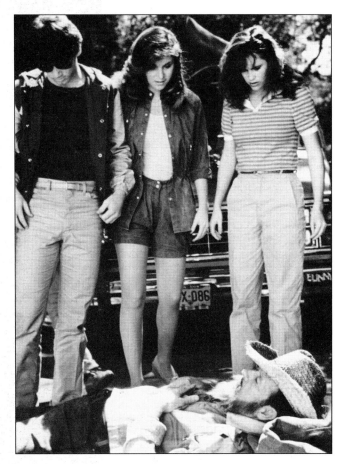

above:
Andy (Jeffrey Rogers), Debbie (Tracie Savage), and Chris (Dana Kimmell) survey the sleeping Abel (David Wiley). The Abel character was created as a take-off on Walt Gorney's Crazy Ralph character.

opposite top:
Loco (Kevin O'Brien) keeps watch while Ali (Nick Savage) siphons gas out of Chris's van.

right:
Vera (Catherine Parks) has a confrontation with Fox (Gloria Charles).

opposite bottom:
Andy and Shelly (Larry Zerner) juggle in 3-D. Today, Zerner works as an entertainment lawyer in Los Angeles. Rogers is a doctor in New York.

difficulties working with her. "I don't remember there being any problems with actors on the films," says Savage. Kratka, Kimmell's love interest in the film, agrees, "Dana and I got along very well. I knew she was nervous about being in the film, but so were all of us because, for most of us, it was our first movie. We've kept in touch over the years."

Once the characters have all been introduced, the action then starts to moves fast and furious when Shelly and Vera take Rick's Volkswagen and drive to the local grocery store for some goodies. It's here that Vera and Shelly meet up with Ali (Nick Savage), Fox (Gloria Charles) and Loco (Kevin O'Brien): three bikers looking to raise some serious hell. Unfortunately for them, they all eventually find it of course, in ways none of them had dared imagine. While Shelly and Vera are in the store, the bikers try to intimidate Shelly and Vera by holding Shelly's wallet hostage. However, Vera stands up to the bikers, particularly the tough-talking female, Fox, and all seems well until Shelly makes a big mistake outside the store when he accidentally backs up Rick's car, knocking over the gang's bikes. Ali's none too happy. "That was my favourite scene in the whole film to do because it had real tension," recalls Zerner.

After witnessing Shelly's crude disrespect for him, Ali leaps in front of the car and, after flashing a cool smile, he proceeds to smash the front of the vehicle with a chain. He continues his assault until Shelly and Vera get the hell out of there. "Smashing the front of the car was kind of scary, but freeing at the same time," says Savage. "It was fun playing Ali because I felt like he was one of Jason's most interesting opponents and every actor likes to play a bad guy and I got to play Ali as a bad guy who changes his ways at the end of the story."

When Shelly and Vera return, Rick is horrified to see his smashed-up car. None of them are aware that Ali and his friends tailed the vehicle back to the ranch. Meanwhile, Chris has begun to have visions of Jason all around her. Is it just her imagination? While Chris and Rick try to communicate with each other, Andy and Debbie go skinny-dipping down at the lake. It's then that Ali and his biker friends secretly arrive on the scene, anxious to make trouble. Ali starts by siphoning the gas from Chris's

friends arrive at Higgins Haven, moving over a creaky bridge that would come back to haunt Chris towards the end of the film. "It was nice being here for the actors because we weren't that far from LA," says Katims. "Maybe if we'd all been stuck in a hotel or some cabins somewhere the performances in the film would've been better, but we all got along well."

The first thing that Chris does upon arriving at the ranch - previously owned by her father - is to get together with Rick, her long-lost love. For years it's been rumoured that Kimmell was reluctant to do love scenes in the film due to her personal beliefs, and that the film had be altered to accommodate her. "No, once filming began, I did everything that was asked of me and I didn't have any problems with anyone," says the now happily married Kimmell, today known as Dana Kimmell-Anderson. "Before filming, when I'd read the script, I did ask Frank Mancuso, Jr. to trim down some of the really gory stuff, and some of the sexual stuff in the script, because I certainly wasn't going to take off my clothes. Before I took the job, I kind of agonized about whether or not to do the film. It was a tough decision, but I ended up having a good time." Kimmell's co-stars don't recall having any

van while Fox sneaks into the barn to roll in the hay. She soon appears outside the top window, swinging back and forth on a hoist while Ali yells at her to get down. She's there one moment, but then, mysteriously, she's gone. Loco walks inside the barn to find her. "This might've been the best executed scene in the film in terms of sheer excitement and pure suspense," says Miner. "It showed that you didn't have to have lots of gore and makeup to create a really suspenseful scene."

By this time, the 3-D effects have really begun to attack the senses of the audience, with objects - even the most innocuous forms - moving in and out on the eyes of the viewers. "My goal with *Friday the 13th Part 3* was to make things really bend and snap and fold in all sorts of exciting ways," says Sadoff. "As it turned out, the film wasn't as ground-breaking as I hoped that it would be because, like I said, I wanted to do an avant-garde type of film, but with a *Friday the 13th* film you're kind of boxed into a certain formula. I'm still very proud of the film and I feel that I was more or less responsible for the 3-D explosion that happened between 1982 and 1983. I've seen *Friday the 13th Part 3* about a million times and there's still a screening room at Paramount where you can go and screen the film. I love watching it."

When Loco climbs to the top of the barn landing, he spots Fox's corpse, mounted high above the floor, feet dangling. Too scared to even scream, Loco turns around and is immediately greeted by a pitchfork to the ribs. The disappearance of Fox and Loco disturbs Ali, who then enters the barn himself. Before Ali can climb up to the landing, Loco's bloody corpse falls on top of him, knocking him to the ground. Jason then appears up in the rafters, face obscured. He jumps down as Ali picks up a machete, intending to hack Jason to pieces. However, when the two men engage and Jason inevitably comes out on top, bludgeoning Ali with a wrench. Why doesn't Jason hack him to little pieces? "We were going for the more visceral type of effects and scares in this film as opposed to the really gory stuff," says Miner. "There's some bloody scenes and some gory 3-D effects, but we wanted some kills that happened off-screen too." The main reason why Jason didn't desecrate Ali further was probably because Andy and Debbie were just outside, heading towards the barn. They vanish out of sight and so does Ali, for a little while.

Night quickly falls upon the secluded ranch, the perfect time for the characters in *Friday the 13th Part 3* to have sex, do drugs and go off by themselves. "One of the biggest challenges in films like these is to find interesting ways to isolate the characters for when you kill them off," says Miner who would take a three year hiatus from filmmaking

following the production of *Friday the 13th Part 3*, not reappearing until 1986 when his next film *House* was released. Miner would also serve as second-unit director on the 1986 horror film *Night of the Creeps* which was directed by long-time friend Fred Dekker who was a co-writer on *House*. "After *Friday the 13th Part 3*, I actually optioned the rights to *Godzilla* from Toho to make an American film of *Godzilla*," recalls Miner, who hired Dekker to write a script for the project that never came to pass. "I was going to do *Godzilla* in 3-D too." Recalls Popescu, "I was only on the *Friday* set for four or five days, but I could tell that Steve was very ambitious. As a matter of fact, Steve showed me a script he'd written which was titled *Cats*. It was a very interesting and well-written psychological thriller about feline creatures."

The film's story continues back at the ranch where Andy and Debbie - the sexually active, expectant couple - are about to head upstairs for some sex-in-a-hammock, but not before Andy and Shelly engage in a little juggling one-upmanship. "That was a tough scene to film because they really had a tough time capturing it on the dual lenses," recalls Zerner. "Not only did Jeff and I have to juggle, but we had to do it in a way that the camera could capture. It was a great 3-D scene."

Elsewhere, Chris and Rick have taken off for a little stroll through the woods. With Andy and

FRIDAY THE 13th PART 3
(1982)

Production Credits:
**Paramount Pictures Presents. A Jason Inc./ Frank Mancuso Jr. Production.
A Steve Miner Film**
Executive Producer:
Lisa Barsamian
Producer:
Frank Mancuso Jr.
Co-Producer:
Tony Bishop
Associate Producer:
Peter Schindler
Production Manager:
Terry Collis
Production Co-ordinator:
Janet Lee Smith
Screenplay:
Martin Kitrosser, Carol Watson
Based upon characters created by:
Victor Miller & Ron Kurz
Director:
Steve Miner
1st Assistant Director:
Richard Davis
2nd Assistant Director:
Marilyn Poucher
Director of Photography:
Gerald Feil
Camera Operator:
Eric Van Haren Noman
1st Assistant Camera:
Steve Slocomb
2nd Assistant Camera:
Mako Koiwai
3-D Camera Technician:
Mitch Bogdanowicz
Louma Crane Technician:
George Michael Brown
Key Gaffer:
Tim Evans
Electric Best Boy:
J.B. Richner
Driver/Generator Operator:
Victor Kloster
Key Grip:
Steve Rez, III
Grip Best Boy:
Brian Smith
Dolly Grip:
Chico Anzures
Lamp Operator:
Gary Stark
Timer:
Bob Noland
Still Photographer:
Laurel Moore
Editor:
George Hively
Assistant Editor:
Larry Morrison

above:
Fox is mounted to a beam in the barn by Jason Voorhees (Richard Brooker).

opposite top:
Vera's spear-through-the-eye death scene. Cinematographer Gerald Feil built a fake moon on top of a crane for the night-time scenes in order to film the 3-D effects.

opposite bottom:
Debbie suffers a lethal abortion at the hands of Jason Voorhees.

Three Stooges mask? Would Jason have assumed those identifies? It's a point worth considering...

Vera angrily tells off Shelly who, totally dejected, heads back inside the compound where we see his hockey mask in all of its grim glory. Shelly's fate is sealed only moments later when Jason leaps out of the darkness and cuts his throat. Suddenly, Jason finds himself reborn, reinvented as the man behind the hockey mask, and in an instant a seemingly meaningless prop has become a significant piece of Americana that would endure over the following twenty years and beyond. "I asked them, after the film, if I could keep the hockey mask and I was told that it had been taken so I had an inkling that the mask might be used in the future," recalls Zerner. "I did get to keep the axe. It was freezing in that water."

Whose idea was the hockey mask anyway? Who deserves the credit, or blame, for this grisly icon of 1980s horror that has permeated pop culture like a machete through a skull? "It was an innocent thing, just something that looked really good," recalls Miner. "The script called for a mask and, obviously, we had to have Jason wear something."

The real story of the hockey mask involves Terry Ballard, *Part 3*'s technical advisor (Ballard played a State Trooper in both *Friday the 13th Part 3* and *Friday the 13th: The Final Chapter*, on which he also served as a creative consultant). Ballard had innocently brought along a hockey mask in order to joke around and play with some of the kids on the set. "It was an old leather hockey mask from the 1950s," says Ballard. "If I'd known what was going to happen, I'd probably have tried to copyright it." Enter Miner and Douglas J. White, who saw the hockey mask as the perfect face for Jason, with a few alterations. "Steve was looking for a mask as it was in the script, but when he saw Terry with the mask, Steve just flipped for it," recalls White. "We all thought it looked cool right from the beginning. The only problem was that it was too big for Richard's face so I had to take the leather mask and make an alginate copy of it along with a mould copy to make it fit."

Back at the water, a slightly remorseful Vera spots Shelly's wallet in the pond with a nice picture of Shelly and his elderly mother sticking out of it. Vera leans down to retrieve it when Jason walks out behind her. The new Jason. "It felt great with the mask on," says Brooker. "It just felt like I really was Jason because I didn't have anything to wear before that." Vera looks up, thinking that it's Shelly. When she calls out to him, Jason raises a spear-gun and fires a spear right into Vera's eye-socket. "We were told to make all of the effects so they came at you," says Apone. "The spear-in-the-eye scene was done with rods and wires and the spear was sent out

Debbie upstairs in their love hammock, Shelly is left alone with Vera, much too beautiful and sexy for him. Shelly has previously angered the group with a prank whereby he faked his own death by implanting a toy axe into his skull in a story point that, once again, could be traced back to the Ned character from *Friday the 13th* with the scene where he faked his own drowning in that film. For Shelly, just like Ned, the boy-who-cried-wolf joke would prove especially costly. Vera is outside the house, enjoying a quiet moment by the edge of the lake when Shelly plays another prank that would become a seminal event in horror film history, for more reasons than one. He gives Vera the fright of her life when when he suddenly and unexpectedly jumps out of the water, clad in a black scuba outfit. He's also wearing a mask - a hockey mask - a frightful omen of an era to come. What if Shelly had been wearing a Halloween pumpkin mask or a

along the rod and it was very hard, given the dual lenses, to make it look seamless, but it worked good. We used a guide-wire for the spear-in-the-eye scene. It was great 3-D."

In retrospect, the effect might not have been as spectacular as most fans think. According to makeup artist Kenny Myers, the spear-in-the-eye was a brilliant example of cinematic sleight-of-hand or, in this case, sleight-of-eyeball. "The young fans always come up to me and ask me how we shot the spear into her eye," says Myers with a laugh. "They're always surprised by the answer because we never shot anything into anything. It's just a great reaction shot with the spear already mounted into her eye. It's great when a simple gag works so well that it totally fools the audience, especially jaded audiences that have already seen so many special effects films before *Part 3*."

The scene caused Miner and the film's producers some problems with the MPAA. According to White, most of the power of the scene comes from actress Catherine Parks's believable reaction in the scene. "We filled the eye up with blood, and when she fell back, she fell right back, into the water," he says. "It worked too good because the blood was falling out. The 3-D shot was the spear coming towards her and everyone thought that the reaction shot would be too gory to keep in the film." White says that finding creative ways to kill off *Part 3*'s victims was an important aspect of the effect team's job description: "When I first met with Steve and the producers they asked me to come up with about ten great-looking kills that could take place on a farm. We were really able to be creative on *Part 3*."

Meanwhile, back at the main house, Andy and Debbie have finished having sex in the hammock and Debbie's about to take a shower while Andy goes for beer, and then proceeds to amuse himself by doing handstands in the hallway. "I had to do handstands to get the role in the film," says Rogers. "It was hard because it all had to be timed in with the 3-D, and my arms would be killing me, even though there were lots of cuts. It was really scary seeing Richard appear when I was upside down." Jason comes into view and, before Andy can say a

word, he is whacked to pieces with a machete. "We were going to use a mechanical doll for the scene with Jeffrey, but we changed it," recalls White. "We decided to use a dummy that was made of foam and that had already been split in two. The dummy was hanging from the ceiling and, when the blade struck it, the whole thing immediately split up. It worked very well." Recalls Martin Becker, "We had it rigged up so that when the blade would strike, the limbs would just crumple down - legs, hips, head. It was very effective. There were wires attached to the ceiling, forming a disconnect device that was triggered by the swinging action of the machete."

When the sexually-charged Debbie gets out of the shower, she has no idea that anything's wrong as she lies back down on the hammock and picks up a copy of *Fangoria*, reading an article on effects legend Tom Savini no less. Soon, much like Kevin Bacon before her, she is alerted to the grisly truth when drops of blood fall onto her from above. Debbie looks up and sees the corpse of Andy - the father of her unborn child - on a perch, lifelessly glaring back at her. Before she can fully comprehend what is happening, Jason ventilates her from beneath the hammock, shooting blood straight at the camera. "That scene took hours to film," recalls Savage. "They had to get everything just right and sometimes the blood wouldn't shoot out right. When it did, the blood went everywhere and we all laughed."

What to make of Andy and Debbie's unborn child? It's clear that the makers of *Friday the 13th Part 3* never intended for their film to stir debate about the issue. "I think the pregnancy was just a character detail," says Miner. "I think it was just put in there to show that they were in love and maybe it didn't belong there." Savage is similarly dismissive, "It was a little strange having to pretend like Debbie was pregnant and was suffering from morning sickness, but none of us took it very

Negative Cutter:
Holly Shadduck
Music:
Harry Manfredini
Title Theme:
**Harry Manfredini,
Michael Zager**
Title Theme Producers:
**Michael Zager,
Ed Newmark**
Music Editor:
Jack Tillar
Music, Post Production,
Creative Sound:
Newman Tillar Associates
Boom Operators:
**Earl Sampson,
David Kelson**
Production Mixer:
Bill Nelson
Re-Recording Mixers:
**William L. McCaughey,
Terry Porter,
Kevin F. Cleary**
Special Sound:
Nieman Tillar
Sound Effects Editor:
Clive Smith
Make-Up:
Cheri Minns
Assistant Make-Up:
**Kenny Myers, Lou Lazzara,
Larry Carr**
Hair Stylist:
Shannon Ely
Costume Supervisor:
Sandi Love
Assistant Costumer:
Gala Autumn
Special Make-Up Effects:
**Make-Up Effects Labs,
Douglas J. White, Allan
Apone, Frank Carrisosa**
Effects:
Martin Becker
3-D Supervisor:
Martin Jay Sadoff
Opticals:
Howard A. Anderson Co.
Main Titles:
Celestial Mechanix Inc.
Art Director:
Robb Wilson King
Set Decorator:
Dee Suddleson
Property Master:
Bonnie Ballard
Assistant Property Master:
Mike May
Script Supervisor:
Kathy Newport
Production Accountant:
Francine Mozurkevich
Production Auditor:
Constance Talley-Sherman
Production Payroll, Services,
and Facilities:
**Penny Lane Productions
Incorporated**

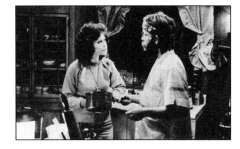

right:
Chili (Rachel Howard) and Chuck (David Katims) reminisce about the sixties.

opposite:
Jason Voorhees stalks Chris through the woods.

below:
Shelly's death scene. Jason steals the hockey mask that he uses to assume his new identity from Shelly after he kills the practical joker.

seriously. Nobody had any illusions about the kind of film that we were making."

That leaves Chili and Chuck, *Friday the 13th*'s most beloved hippies. When the power goes out in the compound, Chili sends Chuck down to the basement to check out the fuse-box. The main cottage is desolate and quiet since, obviously, everyone else inside is now dead. "I wanted to play Chuck as this really out-of-it stoner who somehow is totally impervious to everything around him," says Katims. "Originally, I think they wanted it to seem like - while the axes and knives were flying all around him - Chuck was able to avoid getting killed through pure luck and funny coincidence."

Chuck's luck doesn't last forever though. While down in the basement, Chuck has a rather jolting

confrontation with Jason, who electrocutes the hapless hippie by thrusting him into the live fuses. At least Chuck was able to die a quick and relatively bloodless death, or did he? "When we did the original scene, you saw Chuck's face melting all the way down," recalls Katims. "It was very gory, but I think they took it out because it didn't photograph well with the 3-D. It looked really disgusting."

Chili's waiting for Chuck upstairs when she hears a loud bump at the door. It's Shelly, hand clutching his gaping throat, gargling his own blood as his life seeps away. Chili thinks it's another one of Shelly's practical jokes, but it is not long until the horrific realisation dawns on her, and she tries to flee until Jason impales her with a fireplace poker.

That leaves Chris and Rick, the most sexless couple in slasher movie history. They're out in the woods, alone, oblivious to the fact that all of their friends are dead. "It was a really beautiful area once you were able to walk around," says Kratka who, today, enjoys camping in his spare time although, no doubt, not anywhere near the Veluzat ranch area. Rick's Volkswagen is not working so he and Chris decide to hike back to the ranch. Originally, this scene was supposed to include another confrontation with Abel. The first draft of Avallone's novelization included the would-be scene, which was supposed to show Abel pleading with Chris and Rick not to return to the ranch. The sequence never made the final cut, no pun intended. "I remember reading that scene," says Wiley. "We tried it once, but I guess they thought it didn't fit with the rest of the film." Recalls Miner, "I didn't feel that having Abel return a second time was really needed because he'd already warned the characters once. How many warnings can you give them?" Abel's nowhere to be found when the final massacre occurs.

Before they head back to the ranch, Chris and Rick talk about Chris's nightmare: the time, years earlier, when Chris was attacked in the woods by Jason, a detail that her parents seemed to later try and brush over. "My job, as a writer, wasn't to totally revise the script, but to add dimension," recalls Popescu. "I had the idea that everyone in the town might've been scared of Jason, so scared that they just wanted to leave him alone."

Chris's Jason flashback gives us our first serious glimpse of Jason's new face in *Friday the 13th Part 3* and reintroduces Stan Winston into the equation. "Stan just did a one-piece pullover mask of Jason's face and that was it," recalls Apone. Once again, scheduling conflicts had prevented Winston from taking control of a *Friday the 13th* film and, maybe more importantly, the design and look of Jason Voorhees. Although Winston had painted and sculpted a Jason face, it would be

White who would be eventually called on to create Jason's new look - in less than a week. *Friday the 13th Part 3* was already more than two months into filming when Miner and the film's producers called upon White to create Jason's makeup. "We ended up with three Jason makeups - Stan's, my first attempt, and my second attempt," recalls White. In the end, they chose mine."

For the look of Jason, Miner and White decided to seek their inspiration from Savini's original design in *Friday the 13th*, a choice that created a lot of work for the make-up artist, who was constantly altering Richard Brooker's face right up until the last day of filming. "Originally, Steve wanted a combination of Tom's and Carl Fullerton's design, but then we focused mainly on Tom's and tried to create a grownup version of the Jason that jumped out of the lake at the end of *Friday the 13th*." White's Jason design required the construction of a nine-part appliance piece, not to mention a new set of eyes for Jason. "In Stan's version, Jason's eyes were level and I had to make alterations because Jason has a droopy eye," says White. "We made a glass eye for Richard to wear to show the offset eye through the hockey mask. We did keep part of Stan's design in terms of the back of Jason's head so when I made my design, I had to be conscious that the back of Jason's head had to look exactly like Stan's. We just didn't have enough time to design an entirely new head."

For everyone on the effects crew, the most difficult part of working with 3-D was having to work around the light. "It's twice the light that you're dealing with because of the two cameras and it was very tricky," says Perez. "You're talking about a lot of arc-light that's unpredictable, not to mention being hot and uncomfortable. It all goes back to the fact that the 3-D technology just hadn't been perfected well enough to really pull things off as smoothly as we would've liked. Still, the 3-D effects turned out great." Says White, "The biggest problem the light causes is that it tends - at least back in 1982 - to make the actors' faces pale because of the fact that you need two, three times the light for the scenes. I used to work for Tom Burman and when Tom did *Spacehunter: Adventures in the Forbidden Zone*, you could see that Michael Ironside's face looked really pale and that's because 3-D used to really make scenes look washed out."

Chris and Rick hike back to the ranch where, like Alice and Bill, and Ginny and Paul before them, they find the place desolate and empty. While Chris searches around the cottage, Rick looks outside where he's accosted and pinned by Jason. Chris looks out the front door, but Rick's just out of sight. When she moves back inside, Jason performs some radical optical surgery on poor Rick. "Richard was so strong," recalls Kratka. "I'm a pretty big guy, pretty strong, but Richard was just huge." Recalls Brooker, "I couldn't believe what Jason was actually doing in this scene. You had to believe that Jason was so strong that he could press on someone's head hard enough so that the eyeballs would fly out. It was really wild."

Production Assistants:
Gary Dahl, David Miller
Assistant to Mr. Miner:
Terence McCorry
Assistant to the Producer:
**Mary Carroll Kaltenbach,
Jo Anne Cooper**
Caterers:
**Tony's Food Service,
Tony Kerum,
Angel Trujillo**
Craft Service:
Linn Zuckerman
Set Medic:
Bundy Chanock
First Aid:
Henry Humphreys
Technical Advisor:
Terry Ballard
Transportation
Co-ordinator:
Jim Lannen
Transportation Captain:
Jon Carpenter
Drivers:
**Dennis Yank,
Sharon Collis**
Insert Car Driver:
Lee Nashold
Stunt Co-ordinator:
John Sherrod
Stunts Performed by:
**Pam Bebermeyer, Tom
Elliott, Jimmy Medearis,
Mike Deluna, Marguerite
Happy, Steve Vandeman**
Casting:
Bill Lytle, Dave Emann

CAST

Dana Kimmell
(Chris)
Paul Kratka
(Rick)
Tracie Savage
(Debbie)
Jeffrey Rogers
(Andy)
Catherine Parks
(Vera)
Larry Zerner
(Shelly)
David Katims
(Chuck)
Rachel Howard
(Chili)
Richard Brooker
(Jason Voorhees)
Gloria Charles
(Fox)
Nick Savage
(Ali)
Kevin O'Brien
(Loco)
Steve Susskind
(Harold)

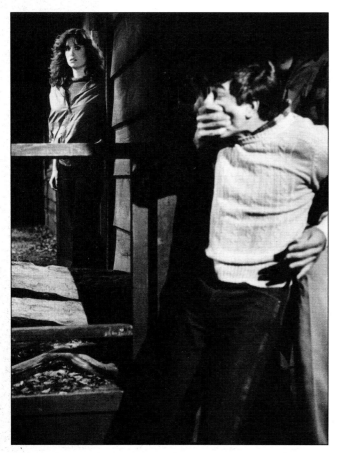

above:
Chris can't see Rick (Paul Kratka), who is about to get his eyes squeezed out by Jason Voorhees. Today, Kratka's a chiropractor in California.

opposite top:
Chris fights back against Jason Voorhees.

opposite bottom:
Whilst fleeing from Jason, Chris is shocked to discover Debbie's corpse.

Chris, the last survivor, will be the hardest to kill. "Those ending scenes were tough because I was being hit over the head with logs, attacked with knives, everything," recalls Brooker. "We also had to do the scenes over and over again because of the 3-D. Take after take; it was unbelievable." Jason does everything possible to kill Chris, who is confronted with the dead bodies of her friends, most especially the body of Rick which is crudely tossed through a window ostensibly, it seems, for the purpose of further terrifying the film's plucky heroine. "Those scenes were tough for me," says Kimmell. "I really don't like violence, and here I was in a position where I had to swing around all of these axes and knives."

During the stalk-and-slash romp, Chris, at various times, seriously wounds Jason, only to see him keep on coming back at her. She stabs him and then, as he's about to walk out the front door, she whacks him across the head with a log. Chris then gets in her van and starts to drive away, oblivious to the fact that Ali and his friends had siphoned away the gas earlier in the day. The van inevitably grinds to a halt on the creaky bridge. The action finally moves to the barn where Chris is seemingly trapped. There's nowhere to run, nowhere to hide. She climbs to the top landing of the barn, and hangs from a high beam as Jason walks inside. When her nemesis is directly beneath her she lets go and comes crashing down on top of him, and then runs up the barn steps again, shovel in hand. When Jason give chase up the stairs, Chris swings the shovel down on the back of the head, knocking him out. Seizing her only chance, Chris then ties a noose around his neck and throws him through the upper barn door, leaving him hanging several feet above the ground. Surely this is the end of her nightmare.

As Chris is about to walk out of the barn however, Jason comes back to life - pulling himself out of the noose and continuing his relentless pursuit. It's here that Chris receives salvation from a totally unexpected source: Ali the biker, it seems, still has some life left in him although - given his eventual fate - one has to wonder if he wouldn't have been better off playing dead until the ambulance crew arrived. "I thought it was cool that Ali came back from the dead and tried to save the girl," says Savage. "I just jumped on top of Richard and we fell to the ground and the floor was hard. I liked the fact that Ali got the chance to redeem himself."

The struggle between Jason and Ali buys time for Chris, who picks up an axe. As an enraged Jason slowly turns, having just quartered his unfortunate attacker, Chris drives the axe into his skull. Jason's arms twitch outward for a few beats until he falls to the ground. "I loved that little part where my hands stick straight out," recalls Brooker. "We rehearsed

The resulting sequence was the quintessential example of 3-D horror circa 1982. "We used a wire, a kind of monofilament wire, that extended from the socket inside the fake head that had been built, to a spot that was marked in between the two 3-D lenses," recalls White. "It was perfectly designed for the 3-D shot. The eyeball was thrust along the length of the wire and that achieved the effect and made it look somewhat real. We'd done it several times before that and it just didn't work because we'd tried to use compressed air to move the eyeball out of the socket." Recalls Apone, "The eye effect was very hard because it was on a rod and - since we were working with dual lenses with the 3-D - it was very difficult to send out the eye on a rod and keep the rod hidden." What did Miner think of this scene? "It looked good on paper, but it was a very silly scene," recalls Miner with a laugh. "The effects guys did a great job, but the idea itself of popping the guy's eyes out, it was just kind of goofy, but it was great 3-D and that was really our big challenge with the film: make great 3-D."

That left Chris and Jason. It is soon apparent that - as with every other *Friday the 13th* sequel -

those movements quite a bit and I really wanted to make sure that I played Jason as a monster who was constantly being fuelled by rage."

Lest anyone feel sorry for Brooker or Jason, it was White who, ultimately, took the brunt of Chris's axe attack. "The scene where Dana hits Richard in the head with the axe was basically done with a puppet that I operated," says White. "I basically took a steel sleeve and put my hand in there and that's what took the blow, not Richard's head."

Chris then stumbles - much like Alice from *Friday the 13th* - towards the lake where she hops in a small boat and drifts, hoping, no doubt, to wake up the next morning and discover that the horrific bloodbath was just one big extravagant nightmare. "We kind of got back to the formula of the first movie," says Miner. "There were scenes in *Part 3* that were very much like scenes from *Friday the 13th* and that wasn't an accident. The producers were very conscious of wanting to maintain the successful formula and so it seemed like a safe bet to have the film end in a similar way to the first one."

Chris wakes up, early the next morning, in the boat. She's perturbed as it seems she's been drifting in circles for hours. The cottage is in plain sight and Jason, now unmasked, is looking down at her from behind a window. Terrified, Chris tries to paddle backward, but the boat gets stuck against a stump, and then the rotted body of Pamela Voorhees rises from the swamp - disembodied head magically attached to her neck - and pulls Chris down into the dark abyss.

It was assistant director Marilyn Poucher inhabiting the reincarnated, and slime-drenched, body of Pamela Voorhees, but what is most interesting about this finale is the fact that it was just one of three endings that were shot. "We did a scene where Chris walks back to the cottage, opens the door, and Jason appears and decapitates her," recalls Miner. "We also did a scene where Jason gets his guts split open and you see them fall into the lens. They were great effects, great work by the guys but, from a commercial standpoint, we decided to go with a more conventional ending where the heroine lives at the end."

"The scene in the first film, when Jason jumps out of the lake, that was one of the best scenes I'd ever seen in a horror film," recalls Myers. "It was great to be able to recreate that scene in *Part 3*, to an extent. We did that makeup with Marilyn seven times before we put anything on film. We did one for testing purposes and the rest for just sitting around and waiting and Marilyn was very understanding. We'd get Marilyn all ready, but Steve wouldn't be ready to shoot that scene right then. Marilyn, who kept having to get into this, was very funny about the whole thing."

right:
Jason Voorhees attacks
Chris as she tries to
escape in her van.

For Poucher, the process of playing Jason's swamp-ravaged mother was just as gruesome as it looked in the finished film. Poucher was married, at the time, to assistant producer Peter Schindler. "Peter was hired by Tony Bishop and Steve Miner," recalls Poucher, a talented makeup artist in her own right. "It was originally an all non-union production and I was going to be a makeup assistant. As it turns out, I became the second, second assistant director and I also stood in for some of the stunt rigging. It was a wild shoot. One time, there were lots of rattlesnakes at the Veluzat Ranch and some of the guys would shoot the snakes. Steve Miner came up with the idea of Mrs. Voorhees coming out of the water in Dana's dream sequence. They decided that Mrs. Voorhees would've had to have been in the water for many years so Kenny Myers said that whoever played the part should have a thin face, like flesh on bone, and that's how I got the part. I had to go to a salon and have my face waxed so that the latex mask, that Kenny built, wouldn't stick to my facial hair and be impossible to remove. The worst part was having to go back into the water for the fifth or sixth time because that water was dirty and

below:
Made-up as Pamela
Voorhees, Marilyn
Poucher relaxes between
takes on the set of *Friday
the 13th Part 3*.

nasty, and full of living creatures. It had frogs, tadpoles, and mosquito larva. Nasty! I wore a wetsuit and Marty Becker loaded me down with extra weights to keep me down. When I jumped out of the water, and grabbed Dana, I was so laden with weight I couldn't really spring up. At the end of filming, Frank Mancuso sent me a nice letter, thanking me for being the Lady in the Lake."

As for the unseen spilling of Jason's guts, Apone recalls, "It was easy to make Jason fall, but the hardest part was just keeping the whole body together in one piece because it was fully loaded with the blood and all of Jason's guts. We had to keep the body looking good until Jason fell down and all of the guts split open." The would-be Jason body-splitting scene was a prime example of the entire effects team on *Friday the 13th Part 3* working together as a finely tuned unit. "The body split was my favourite scene to do and it would've looked great in the film," says Apone. "Every department had a hand in how good that scene looked."

The decapitation scene was much more tense. "We built a head that we chopped off for the scene and it looked really good," recalls White, who was primarily responsible for the decapitation. "I wasn't there for the decapitation scene, but I know that Doug and the guys did an awesome job," says Apone. The cast and crew were also impressed. "The door just opened and I flung the blade through the air and the head was just gone," recalls Brooker. "It looked amazing." Recalls Larry Zerner, "I watched them do the scene with the others and I thought it looked amazing. I definitely think they should've used that ending." To this charge, Miner merely accepts the rejection of the alternate ending as an unavoidable part of the *Friday the 13th* filmmaking process.

Why was the decapitation scene not used? There's no question that the film's producers were nervous about changing the formula that had been used in the previous two films - heroine survives to the end - but the real reason the scene was scrapped was blood. Lots and lots of blood. "Frank Mancuso,

Jr. was concerned about whether or not the blood would shoot out or not," recalls White. "The upside down scene worked really well, but this was tricky because we couldn't have too much blood or the scene would have to be cut for the ratings board." For this purpose, White designed a special rig to make the head fly off. "We built a rig for Dana that made it very easy for Richard who, basically, just had to swing the blade into the camera," says White. "We wanted the blood to be flowing blood, not spurting blood. The head was connected to stumps that were on a magnet and we had the blood-hose attached to the rig. Basically, it was set up so that Richard really just had to move forward and the head would fly off. It was easy for Dana too because she was wearing the whole rig and the head was on her so she just had to get out of the way and the head would fly off. But the blood spurted - I had the effect rigged to about 200 psi - and it was just too much blood for Frank and the other producers. They were just uncomfortable with it, but at least we got the chance to put it on film and it worked great." Ultimately though, the makers of *Friday the 13th Part 3* felt that the scene would be one decapitation too many – in light of the moment that Pamela Voorhees lost her head in *Friday the 13th* - for either the audience or the MPAA to handle.

By the beginning of July, principal photography had been completed, more or less, and a rough cut of *Friday the 13th Part 3* was assembled for the crew to watch. No-one was exactly overwhelmed by what they saw, not even in 3-D. "That's why I took my name off of the film," recalls Popescu, *Part 3*'s uncredited co-conspirator. "Steve showed us a rough cut and I thought it was really terrible. First of all, the performances were the worst that I'd ever seen in a movie, but even worse, the photography looked terrible. They had to go back and fix a lot of the photography. Eventually, they cleaned it up and then I saw the film again and, actually, I kind of enjoyed it for what it was. I don't regret taking my name off of the credits though because I didn't want to be typecast as a horror writer. I have enough good writing credits and I don't need *Friday the 13th* on my bio, thank you very much."

Miner was satisfied with his film, probably aware that the film would mark his *Friday the 13th* swan-song. "I think we accomplished what we wanted to with *Friday the 13th Part 3* and I loved seeing the film in theatres and hearing the reactions of the fans," says Miner, who would wait nearly five years before reappearing with the 1986 college comedy *Soul Man*, along with directing some episodes of the acclaimed television series *The Wonder Years* and the aforementioned *House*. "I learned the ropes of filmmaking with these films

and I'm very grateful. I'm also happy that I didn't get pigeonholed as the *Friday the 13th* director and that I've been given the opportunity to work on many different kinds of film and television projects, not just horror stuff."

Friday the 13th Part 3: 3-D was released on August 13, 1982 with Paramount having spent $3 million to market and promote the film. For whatever reason - whether it was curiosity about 3-D or the sight of a new and improved Jason Voorhees - audiences were both ready and energized for the film. Opening in 1,079 theatres, *Friday the 13th Part 3* grossed $9.4 million on its first weekend, averaging nearly $9,000 per screen and making it the number one grossing film of the weekend, beating out such films as *The Best Little Whorehouse in Texas* and *E.T. Friday the 13th Part 3* would end up grossing $34 million in its opening theatrical run, but that gross was increased to $36.6 million after Paramount took the step of re-releasing

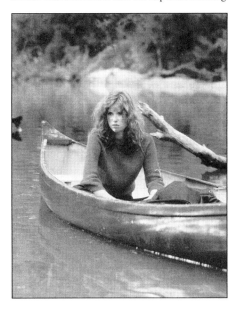

above:
Marilyn Poucher and
Dana Kimmell bond
between takes on the set
of *Friday the 13th Part 3*.
(Photo courtesy of
Steve Susskind.)

below:
Richard Brooker and
Steve Susskind at a
twentieth anniversary
screening of *Friday the
13th Part 3*.
(Photo courtesy of
Steve Susskind.)

promised - were they ready for a steady dose of 3-D? "There was lots of politics, and some lawsuits, and that basically killed it," says Sadoff who ended up overseeing all of the photographic work, as well as the post-production and animation, on *Friday the 13th Part 3*. Sadoff also supervised the post-production on the Molly Ringwald space film *Spacehunter: Adventures in the Forbidden Zone*, but according to him the results were a mess. "After that, I began to hate everything about 3-D." Still, he has never totally given up on 3-D, having produced projects for Paramount and New Line Cinema, as well as producing 3-D images for various thrill rides across America. Sadoff has also served as a 3-D consultant for Pixar and worked with the Society of Motion Picture and Television Engineers to try and standardize 3-D imaging.

The 3-D fad of the early 1980s failed because of greed and lousy movies, and the very practical fact that audiences soon got tired of the awkward, ill-fitting stereoscopic glasses and their attendant side-effects. What's more, when a rival 3-D techno-logical firm threatened to take legal action against Paramount over *Friday the 13th Part 3*, the movers and shakers in Hollywood decided that 3-D was more trouble than it was worth. "The 3-D fad just kind of ran out of energy and it vanished," says Sadoff. However, he has recently designed a new-and-improved 70mm 3-D lens that would, among its many innovations, give the viewer more autonomy and mobility of vision, and eliminate the need for the annoying glasses. "You'd wear polarized specs instead and you'd be able to move your head around and even walk around the theatre," he says. Furthermore, he hopes that a form of 3-D can be developed that wouldn't require the wearing of glasses at all. "It's possible and I think, one day, it'll be a reality. People don't want to get migraines watching 3-D films."

The box office success of *Friday the 13th Part 3* failed to earn it much credibility in Hollywood, where the films were still considered - certainly by executives within Paramount Pictures - a 'ghetto' fragment within the film industry. The franchise may have been invigorated on a commercial level, but, as they say, money can't buy love and it certainly doesn't buy respect within the corridors of highbrow Hollywood.

It would be nearly twenty months before another *Friday the 13th* film arrived in theatres and this time, all parties agreed, it would be the end. It was time to kill off Jason and the *Friday the 13th* franchise for good. If three films could be considered a trilogy, wouldn't a fourth film make for a fitting final chapter? Jason would die, to be sure, but not for long. In the *Friday the 13th* universe, there's no such thing as *The Final Chapter*.

the film in a handful of theatres towards the end of the year. This was the same strategy used by Fox with *Porky's*, but in this case its re-release pushed that film's gross well over the magical $100 million mark. *Friday the 13th Part 3* couldn't dream of those lofty heights, but the film was still a certified hit, certainly by the standards of the horror genre.

Today, with the benefit of takings adjusted for inflation, such a gross would translate to well over $70 million. *Friday the 13th Part 3* landed in the twenty-first spot on the year-end box office charts, besting out such higher brow offerings as *Blade Runner*, *The Road Warrior*, *Sophie's Choice*, and *Tron*, not to mention George A. Romero's Stephen King adaptation *Creepshow*. (Incidentally, *Friday the 13th Part 3* wasn't released in Canada until August 20, a week after the American opening, due to the technical considerations imposed on theatres in order to show the film. The film was released in Argentina on October 28, but took longer to reach Europe, opening in France and Sweden during February of 1983 and April of 1985, respectively.)

Fans, it seems, were willing to overlook what critics weren't willing to overlook: the wooden performances, silly dialogue and repetitive concepts. *Friday the 13th Part 3* was, in its 3-D form, a notable cinematic experience. So, why didn't this lead to more 3-D horror films and more *Friday the 13th* 3-D films in particular? If *Friday the 13th* fans were willing to embrace A New Dimension in Terror - as the ads for *Part 3* gleefully

A Final Chapter

By the end of October 1983 production had begun on *Friday the 13th: The Final Chapter* and never before, or since, had the pieces of a *Friday the 13th* film been assembled in such a leisurely fashion. This was the end, the last straw and, for all parties concerned, it was something of a relief. A bit sad, certainly, but welcome all the same. There would be no more rushed shooting schedules and no more tyrannical financiers imposing their wills. There was light at the end of the blood-soaked tunnel.

Stephen Minasian had seen Joseph Zito's 1981 slasher film *The Prowler* and was impressed enough to keep the director foremost in his thoughts whilst plotting the possibility of another *Friday the 13th* film. It didn't hurt Zito that Tom Savini had done the effects on *The Prowler*. Who could be better suited to working on the climax of the *Friday the 13th* series than Savini who, objectively speaking, can lay claim to being responsible for much of the success of 1980's *Friday the 13th*. "I'd gone to Cannes in 1980 with a reel that I was looking to show around to raise money to hopefully make a film," recalls Zito. "A lawyer approached me and he told me that, when we got back to New York, he wanted to introduce me to his clients. One of the clients was the producer of *The Prowler* and the other one was Stephen Minasian who owned the *Friday the 13th* franchise. I went to Cannes and I got two films out of it."

While filming *The Prowler*, Zito and Savini had established an excellent working relationship that would carry over to *Friday the 13th: The Final Chapter*. "Tom and I had an instant connection," recalls Zito. "What I like about Tom is the fact that he understands the camera so well. Tom's effects are best suited to certain camera setups and Tom likes to play around with the camera to make sure that the effects will look their best. I knew we'd work together again after *The Prowler*, but I didn't know on what."

Zito recalls of his fateful meeting with Minasian, still based out of Boston: "All I knew was that he was one of the owners of the *Friday the 13th* franchise. It was strange in the sense that all of our conversations took place over the phone. Anyway, he told me that he loved *The Prowler*, but that he

didn't think it was going to be a big hit. He said that it would've made a good *Friday the 13th* film."

It was the beginning of summer in 1982 and *Friday the 13th Part 3* was completed and about to be released. Minasian and his associates, unable to predict the massive box office success that their new film would enjoy, were unsure if the series would continue. "He told me that if *Part 3* did well that he'd be contacting me," recalls Zito. "Soon after, he called me back and told me that they were making part four and that he wanted me to direct the film. It all happened very fast. These were some really odd

below:
Jason Voorhees (Ted White) attacks Tommy Jarvis (Corey Feldman), his nemesis for many years to come.

above:
German lobby card shows dual shots of Rob (E. Erich Anderson) camping, and Trish Jarvis (Kimberly Beck) hunting for Jason Voorhees.

below:
German lobby card showing Axel (Bruce Mahler) mocking a corpse left over from the events of *Friday the 13th Part 3*. Axel's lewd comments about the unseen body indicate that it's likely either Tracie Savage's Debbie character or Catherine Parks's Vera character.

phone calls that we had. We started talking about the story because there wasn't a story or a script at that point."

Thus began a series of consultations between Zito, Minasian and Phil Scuderi, still recovering from the heart attack he suffered after the release of *Friday the 13th Part 2*. "We would have very long and intensive meetings, always by phone, because Mr. Minasian and Mr. Scuderi had very clear and strong ideas as to what the film should be about and what scenes should be in the film," recalls Zito. "I was in New York so we'd always be playing phone-tag. The owners would call me at night and we'd talk for an hour every night, exactly one hour, from eight to nine. This went on, every day, for months until a production script was finished to everyone's satisfaction."

By this time, Zito had contacted Barney Cohen, a former copywriter and print journalist whose previous screen-writing credits included such titles as *The Happy Hooker Goes to Washington*, *French*

Quarter and, most notably, the 1977 Mark Lester-directed thriller *Stunts*. "I had an interesting connection with the *Friday the 13th* series before I worked on *The Final Chapter*," says Cohen, who would go on to create the cult night-time television series *Forever Knight* as well as writing and producing *Sabrina, the Teenage Witch*. Zito made contact with the writer when he was scripting, of all things, a CBS after-school television special entitled *The Inside Out Clown*. "It was about a fat kid who dreams of becoming a clown," recalls Cohen with a laugh. "Joseph liked my writing and he knew I had some genre background. He liked the way I wrote kids and he said to me, 'Don't invent phoney kids. Create real kids.' That's what I tried to do when I wrote the script for *The Final Chapter*." Zito remembers, "I'd take the notes from the producers and then Barney and I would consult with each other and combine the notes with our own ideas." (Incidentally, Cohen and Zito would later re-team on the 1989 Dolph Lundgren action-programmer *Red Scorpion*.)

Another writer brought in during the early stages of pre-production was Bruce Hidemi Sakow, a former screen-writing fellow from the New York University Film School and an associate of the American Film Institute. Sakow made Zito's acquaintance when the director hired him to write a horror script entitled *Quarantine*, about the outbreak of a virulent disease that devastates a farm community. "I knew Joe through a friend of mine who was working for Joe in New York," recalls Sakow. "With *Quarantine*, we'd talked about the kinds of horror films we both liked and Joe raved about the atmospheric effects in *Alien* and how much he'd loved that film. Joe loved the story I came up with and then, after Frank Mancuso, Jr. hired Joe to direct *The Final Chapter*, Joe brought me onboard. I was excited, but I knew it would essentially be a formula slasher picture." Zito clarifies the extent of his input: "Bruce was mainly involved in the early stages of the story planning, and he did a great job, but the majority of the script was written by me and Barney."

The plot of *Friday the 13th: The Final Chapter* was much the same as the other *Friday the 13th* films. Jason comes back from the dead and finds a new locale and a new group of hot-blooded victims to stalk and slash. In common with the transition between *Part 2* and *Part 3*, the events in *The Final Chapter* would unfold within forty-eight hours of the previous film. Actually, the plot of *Friday the 13th: The Final Chapter* had an interesting similarity to the plot of *Friday the 13th Part 2* in that both films gave their would-be victims a night of reprieve before the bloodbath began. *The Final Chapter* did have some differences of course. Most

notably, Jason was going to be killed by a character who would become a recurring feature in the *Friday the 13th* legend: his nemesis, Tommy Jarvis. "The major contribution I made to the script was with the Tommy Jarvis character and the relationship he had with his mother and sister and Jason," recalls Sakow. "It was my idea to have this little kid kill off Jason, because we've seen Jason kill off loads of young adults so who else but a kid? I also came up with the *Final Chapter* title. The producers loved the concept, but they wanted there to be a house next door to hold a bunch of college students that Jason could kill off."

Cohen recalls that the producers behind the *Friday the 13th* series were less than thrilled with *Friday the 13th Part 3*, despite the fact that the film was a box office hit. "Oh yeah, I had the feeling that everyone felt that *Part 3* had been a big bomb," recalls Cohen. "It surprises me to hear how much money it made because I had the impression that the money-men hated it and that that's the reason why they wanted to end the series." Cohen, who'd never seen a *Friday the 13th* film prior to scripting *The Final Chapter*, recalls getting a crash course in the series's mythology and Cohen also has high praise for Sakow's largely uncredited contributions (Sakow only received a story credit on *The Final Chapter*). "Bruce had worked on a lot of the script before I'd arrived on the scene," recalls Cohen. "I mainly worked on creating the teenage characters and dealing with the relationship between Jason and Tommy because we were trying to end the series in an exciting way. I hadn't seen any of the *Friday* films prior to working on *The Final Chapter* until I caught a triple bill that was playing in Manhattan. Funny, because my favourite film is *Part 2*. I thought the first one was kind of cheap and I thought *Part 3* was silly, but I found *Part 2* to be really exciting."

For his part, Sakow recalls getting some rather direct instructions from Zito as to the tone of the *Final Chapter* script. "Joe told me, 'Look, I want there to be an exciting and gory death scene every seven or eight minutes.' I've worked on tons of projects over the years that haven't gotten made and slasher films aren't exactly something I'm really interested in, but it was great to be part of a hit film and a part of the *Friday the 13th* legend."

Once a script was completed to everyone's satisfaction, casting began under the supervision of Pamela Basker and Fern Champion. The duo would go on to cast several more *Friday the 13th* instalments. "We were looking for fresh looking, experienced actors who weren't totally unfamiliar with genre films," says Basker. "A lot of the actors in the film had either done some horror work before or had appeared in teenage films." Zito also played an

important role in the process, "In terms of casting, I actually did most of the casting for the film. The casting directors would round up a large pool of actors and then I would meet all of them and choose the actors that I wanted to be in the film. I think I did a good job because many of the actors in the film have gone on to have very successful careers."

For the lead role of Tommy Jarvis, the filmmakers selected Corey Feldman who had a small role in the 1979 Jack the Ripper time-travel thriller *Time After Time*, but who was destined to gain much prominence when - following the completion of *The Final Chapter* - the actor appeared in *Gremlins*, a role which would lead to a string of genre appearances in the course of his career, including *The Lost Boys*, *The 'Burbs* and *Bordello of Blood*. "I wasn't a big fan of the *Friday the 13th* films exactly, but I'd seen the previous film and liked it very much," says Feldman. "I quickly got into the series, and what it was all about. It was exciting to be doing a *Friday* film that was entirely

above:
German lobby card shows Tommy Jarvis wearing one of his homemade masks. Tommy was named after effects expert Tom Savini.

below:
Vacationers Samantha (Judie Aronson), Paul (Alan Hayes), Sara (Barbara Howard) and Doug (Peter Barton) enjoy a party at their vacation house. This building was constructed for the film under the supervision of co-producer Tony Bishop. The Jarvis house was a real log cabin.

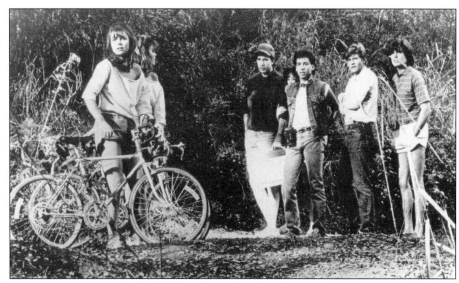

above:
Doug prepares to help Sara lose her virginity.

right:
Twin cyclists Terri (Carey More) and Tina (Camilla More) join the vacationers, including jokester Ted (Lawrence Monoson) and "dead fuck" Jimmy (Crispin Glover), for a party. *Friday the 13th: The Final Chapter* was filmed in and around Topanga Canyon, a few minutes away from the valley.

opposite top:
Axel gets the hacksaw from Jason Voorhees. White was offered the chance to reprise his role in *Friday the 13th Part V: A New Beginning* but declined due to his personal objections over the content of the *Friday the 13th* films.

opposite bottom:
Effects expert Tom Savini and his effects team joke around on the set of *Friday the 13th: The Final Chapter.* (Photo courtesy of Tom Savini.)

below:
Ted tries to impress Terri.

based upon my character and my sister and I knew that it would be seen by a lot of people. I had lots of fun working on *The Final Chapter* except that I came down with a bad fever during filming. Everyone treated me great."

Kimberly Beck, who played Trish Jarvis, Tommy's sister and *The Final Chapter*'s heroine, had appeared in the films *Massacre at Central High* and *Roller Boogie* (with *Exorcist* star Linda Blair). "I didn't know anything about the *Friday the 13th* series when I got the job," recalls Beck who has now married into the famed Hilton family, and continues to act. "They brought me back for four or five call-backs and I was just happy to have a job even though I didn't know anything about the story. I had no idea of the kind of notoriety I would gain from being in the film. If I had, I don't think I would've done it."

The part of Tommy and Trish's mother, Mrs. Jarvis, went to Joan Freeman (now known as Joan Kessler, having married veteran television producer Bruce Kessler), a genre veteran best remembered for her roles in the 1960s films *Panic in Year Zero!* and *Tower of London*, not to mention her television guest appearances on *Perry Mason* and *The Outer Limits.* "The *Friday the 13th* film was one of my last roles before I left acting," she says. "I liked the character and I liked the relationship between the mother and the daughter and the son. My death scene was really scary." As it turned out, the death of Mrs. Jarvis would end up being the film's greatest mystery.

The parts of 'the next door neighbours,' the young vacationers who move into the house across from the Jarvises only to be slaughtered one by one, went to actors with very colourful pasts. Peter Barton, who played the part of Doug, had appeared in the 1981 horror film *Hell Night*, which was

produced by Irwin Yablans of *Halloween* fame and which also co-starred Linda Blair. Barton, of all of the *Final Chapter* cast members, had the most interesting *Friday the 13th* connection as he had formerly starred with *Friday the 13th Part 2* heroine Amy Steel on the 1982 television series *The Powers of Matthew Star.* "I saw Amy Steel during one of the auditions and I fell in love with her, but she was with somebody and nothing happened," recalls Barton who's probably best known for his work on the long running soap opera *The Young and the Restless.* Barton met Kimberly Beck in 1979 when the actress was starring on the short-lived television series *Shirley* and Beck was filming a guest appearance on *Buck Rogers in the 25th Century.* Barton and Beck actually lived together, for a short time, in 1987.

The rest of the cast was filled with performers who were, at the time of filming in 1983, largely neophytes to the acting profession. They included E. Erich Anderson, Barbara Howard, Lawrence Monoson, Alan Hayes, Judie Aronson, Camilla and Carey More, and Bruce Mahler. Monoson had recently starred in the 1982 teen sex drama *The Last American Virgin* while Mahler had just completed the first of his many appearances in the long-running *Police Academy* film series. Identical twins, the More sisters had recently appeared in the television film *The Calendar Girl Murders* and would go on to become interior designers in California. Of all of these actors, it's Anderson who's had the most prolific career, earning scores of film and television roles in such projects as *NYPD Blue*, *Thirtysomething* and the films *Infinity* and *Unfaithful.*

The most interesting young actor to emerge from the *Final Chapter* cast would ultimately turn out to be Crispin Glover - son of veteran actor Bruce

Glover - whose performance as the sexually frustrated Jimmy is one of the comic highlights in the whole *Friday the 13th* series. Glover, who would go on to do some very interesting work in films like *Back to the Future*, *River's Edge* and, most recently, the remake rat-thriller *Willard*, had appeared, in small roles, on such television programs as *The Facts of Life* and *Family Ties* prior to his appearance in *The Final Chapter*. "I was very enthusiastic and excited about being in the film," recalls Glover. "I felt like it was a great opportunity because the films were very popular and I knew it would be something that I would look back on and laugh at, which I have, because these films have a long shelf-life."

Arguably the most important piece of the casting puzzle was the question of who would play Jason, always an interesting anecdote in every *Friday the 13th* production. Zito chose veteran performaer Ted White - a man with a list of acting and stunt credits dating back to such 1960s television programs as *Daniel Boone* and *The Andy Griffith Show* - to don Jason's hockey mask for the final time. "I wanted to get a real hardcore stuntman and Ted was perfect," recalls Zito. "Ted had great movements and, because he was experienced, we could use all kinds of weapons with him. I think he was a great Jason." For White, whose name was ultimately removed from *The Final Chapter*'s end credits, the film was a mercenary experience. "I did it for the work, for the money, plain and simple," he asserts. "Now, once I was on the set, I did get into the Jason psychology and I wouldn't talk to any of the other actors for long stretches. It was okay."

Then there was Savini, the man who many people associated with *Friday the 13th* and *Friday the 13th*: *The Final Chapter* have described as the real star of the series, a notion that was certainly true during the films' commercial purple period during the early 1980s. Savini's reasons for wanting to be a part of *The Final Chapter* were simple: kill Jason. "I

above:
Tom Savini jokes around with a prop head. Following his work on *Friday the 13th: The Final Chapter*, Savini travelled to Florida to work on the film *Day of the Dead*. (Photo courtesy of Tom Savini.)

top right:
Nurse Morgan (Lisa Freeman) is attacked by a re-animated Jason Voorhees in a hospital.

thought that, since I began the series, I should be the one to end it," he asserts. However, Savini was not actually hired until fellow makeup effects legend Greg Cannom quit the project due to 'personality differences.' Cannom had been hired by Frank Mancuso, Jr. This association created a minor conflict when Zito was brought onboard since Savini was the director's number one choice. "They were going to let me do a totally different and original-looking Jason," recalls Cannom. "After a while, I started having restrictions placed upon me which, combined with some other stuff that went on with the production office, forced me to quit."

With Cannom out of the picture, Zito had his man. "I wanted to finish what I'd created," recalls Savini who, during the *Final Chapter*'s filming, was making early preparations to work with old friend George Romero on the 1985 horror film *Day of the Dead*, another series-ending film. Savini had also been working on a haunted house project in North Carolina when Zito called and offered him the job. "I said yes, immediately, but it was awkward when I got out there because I found out that Greg Cannom was the first guy on the job," recalls Savini. "I didn't arrive until two weeks after Joe called me and they'd already done a week's worth of filming. Basically, I was excited about being able to design a Jason that was entirely related to the Jason I designed in *Friday the 13th*. I felt like I owed Jason, if no one else, to do the film."

For his part, composer Harry Manfredini, in common with *Part 3*, was very much an innocent bystander when it came to working on *The Final Chapter* as most of the film's music was recycled

music from earlier films. "Most of the music in *The Final Chapter* was recycled stuff and I haven't even seen the whole film," says Manfredini. "I did some stuff on the first and last reels, but that was it." According to Zito, Paramount didn't even want to pay for an original musical score. "I wanted Harry, but Paramount wanted to save money by recycling the music," recalls Zito. "I finally was able to get Harry to do some stuff and he did a great job, but the rest was done with the help of a music editor named Jack Tillar. I told Paramount what I needed in terms of music and, eventually, they gave it to me."

Finally Zito made sure he had the collaboration of his long-time cinematographer, João Fernandes, with whom Zito would work on the Chuck Norris hit *Missing in Action*. The duo also worked together on 1985's *Invasion U.S.A.*, also starring Norris. (Incidentally, this was a very successful era for Zito, as all three of his films released during 1984 and 1985 (*Friday the 13th: The Final Chapter*, *Invasion U.S.A.*, *Missing in Action*) went on to debut at number one at the North American box office.) With all of the pieces in place, filming on the $1.8 million film took place in and around Topanga Canyon in California.

The film itself opened with a flood of flashbacks – as with the pre-credit sequence that began *Friday the 13th Part 2*, the makers of *The Final Chapter* wanted to be sure that audiences knew where they were, chronologically, within the saga. This wasn't Zito's idea, but rather Frank Mancuso, Jr.'s: "I felt like, since this was the last film, it would be a good idea to see clips of all the action that happened before," he says. Zito doesn't think this was entirely

above:
Actor Bruce Mahler tries
out the stunt hacksaw
ready for the filming of
his character's murder.
(Photo courtesy of
Tom Savini.)

top left:
Special effects prop for
Axel's hacksaw death
scene.
(Photo courtesy of
Tom Savini.)

necessary: "I'm not sure if the flashbacks were a good idea. "I wanted the film to take place exactly after *Part 3* and I thought that it would've been best to open right there."

After the pre-credit sequence, *Friday the 13th: The Final Chapter* proper opens with the grisly aftermath at Higgins Haven as the bright strobe of a police helicopter burns into the camera. These scenes were filmed at the Veluzat Ranch. "I think Paramount wanted Jason to be alive right from the beginning, like the way *Part 3* started," says Zito. "I didn't think that was a good idea. I wanted Jason to be dead for a little while so the audience would feel anticipation. I wanted to film the opening scene at Veluzat, at the same spot, for the purpose of continuity because I know that the fans notice stuff like that."

Jason is zipped up into a bag and carried off in a morgue truck and taken to the local hospital, along with all of the other victims. Once inside the incredibly sparsely populated medical centre, we notice a young woman crying in the lobby. One of the victims' grieving relatives? Hasn't it just been a few hours since the bodies were discovered? "Yeah, she was supposed to be one of the relatives, but I'm not sure who," recalls Zito. "I think that was Frank's idea because it wasn't in the final script. We actually did a brief scene with her where she had some dialogue, but it was immediately scrapped."

Jason is taken to the hospital morgue, where he is stored away in a metal canister. It is not much of an obstacle for the masked one however, especially given the fact that his two caretakers Axel (Bruce Mahler) and Nurse Morgan (Lisa Freeman), are more interested in having sex than in looking after the dead. When Nurse Morgan, angry at Axel and his sick sense of humour, leaves the morgue, Jason appears behind the attendant with a surgical hacksaw, which he swiftly puts to use by slicing through Axel's neck, all with the help of Tom Savini. "We used a saw that was rigged with a neat little blood-tube," recalls the makeup effect wizard. Although Mahler was present for the close-up of the saw beginning its cut, a stand-in dummy was used for a proposed 'neck twist' sequence that was intended to show Axel's throat being sliced from ear to ear, causing his head to twist around. "I actually held the saw for some of the takes," recalls Mahler, who now runs a film production company in Florida. "That saw was pretty scary-looking and sharp and I was nervous about being cut even though Tom put this great cast over my throat."

That leaves Nurse Morgan who - conveniently enough for a newly reincarnated Jason - has taken refuge in an isolated storage room. When footsteps appear in the room, the nurse nitially thinks it's Axel, only to realise at the last moment what is actually going on when Jason guts her with a scalpel. So, without any trouble at all, Jason is free, but where will he go from here? It's not as if he can steal an ambulance and drive away, can he? With that face? Does Jason know how to drive anyway? "Our thought was that Jason, like any fugitive, would run away to the nearest safe haven," says Zito. "For Jason, that's the woods, his domain."

We cut to the deep woods of Crystal Lake where, apparently, the only living residents are the newly divorced Mrs. Jarvis and her two children,

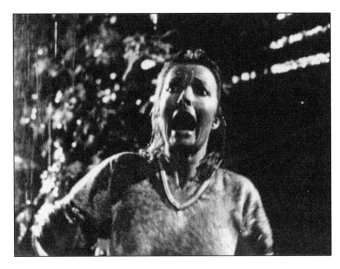

above:
Mrs. Jarvis (Joan Freeman) is spooked at the sight of an unseen assailant. Shots of Mrs. Jarvis's corpse were filmed by director Joseph Zito but deleted for narrative purposes. This footage is now thought to be lost in the Paramount Pictures vaults.

below:
Filming of the scene in which hitchhiker (Bonnie Hellman) is killed by Jason Voorhees whilst eating a banana. Tom Savini orchestrates the mayhem.

Tommy and Trish. Tommy, named after Tom Savini, is quite a talented young makeup artist in his own right, a detail that would feature heavily in *The Final Chapter*'s dénouement. "Tom Savini created all of these makeup monsters for Tommy's room and they looked great," recalls Feldman. "Again, it was kind of awe-inspiring knowing that I was going to be the one who would have to fight and kill Jason." Early on, it appears that the family is being stalked by the point-of-view of Jason, particularly during one of the opening scenes, where Mrs. Jarvis and Trish are jogging through the woods. For Beck, the fear of being watched was, in some ways, a frightening reality. "While I was making the film, I was being followed by a strange-looking man," she recalls. "When we were shooting the film, every day I went running in the park and that's when I started to notice that this man was watching me. One time, he got close to me and I screamed and he never said a word. It was so creepy. I would also get strange calls and all of this happened while I was making the film. I thought it was a *Friday the 13th* curse or something."

The Jarvis family's isolated existence is soon disrupted by the arrival of a group of vacationing party animals who move into the house across the street. This building was constructed especially for the film while the Jarvis house is, in fact, a real-life home. The new arrivals are typical teenage horror victim characters: shallow and obsessed with sex. According to writer Cohen, this wasn't the intention: "The script I wrote really had some good character stuff, but I don't think the actors they cast in the film were able to pull it off," he says. "The only actor I really liked in the film was Crispin Glover because he was really funny and interesting. I remember, when the film came out, reading a review by Janet Maslin or someone and the review

basically stated that the young actors were so good-looking and nice that it was a shame that they all had to be sliced and diced. I just don't think the actors did a good job of making the characters real, except for Crispin Glover."

Before the guests arrived, they had passed by an overweight female hitchhiker (Bonnie Hellman) who they refused to give a ride to. It was a very unlucky turn of events for the banana-loving hitchhiker, as she ended up getting stabbed through the neck by Jason. During their trip to the getaway house the youngsters, in a curious note, also passed by a dilapidated cemetery where we see, quite clearly, the rotted grave of Pamela Voorhees. Was she buried headless or was the head from *Friday the 13th Part 2* recovered and thrown in with the rest of the bones? Who paid for Pamela's burial? Maybe it was Elias Voorhees, the fictional character who would be created later on in the series. For his part, Zito feels that all such questions are unnecessary. "I thought that it would be creepy, given that this was to be the last film, to see a reminder of the mother," explains the director. "There was no thought of bringing back the mother, at least not on my part."

But was there any thought given to bringing back Adrienne King's Alice character, missing since the pre-credit sequence in *Friday the 13th Part 2*? Was the door open for Alice to return given the fact that her character's remains were never discovered? (This despite the fact that unused production stills from *Friday the 13th Part 2* clearly display graphic visual evidence of Alice's icepick-ravaged skeleton.) "I did have some conversations with Joe about a possible role in *The Final Chapter*, but it just didn't work out," recalls King. "I always believed that the door had been left open for Alice to return although I don't know how they would've done it. I would've been happy to return if there had been a really interesting part." To the question of Alice's possible return, Zito is adamant: "I don't think there was any idea to bring Alice back. I think that one of the producers might've made an attempt to bring her back, but I was involved with the project from the early stages and I don't recall anything like that." If Alice wasn't killed in *Part 2*, where was she during the five years after the prologue of *Part 2* and the events of *The Final Chapter*? Hiding out in a Witness Protection Program? Being held hostage by Jason as his own personal slave? If Alice had made a surprise reappearance in *The Final Chapter*, it would have been the first time that a dead human character, Mrs. Voorhees's disembodied head notwithstanding, had rejoined the living.

As the makers of *The Final Chapter* were about to discover however, death, in the context of the *Friday the 13th* universe, is just the beginning, not the final chapter.

The End of a Terror Era

One of the plot-points in *Friday the 13th: The Final Chapter* that stretches the film's credibility to breaking point is the painfully awkward introduction of Rob (E. Erich Anderson), a mountainous hiker who comes into contact with Tommy and Trish when their car stalls in the middle of a road. Rob, or Rob the Jason Hunter as he would become affectionately known by fans, was the brother of Marta Kober's Sandra character from *Friday the 13th Part 2*. What's going on here? Hasn't it just been a matter of three or four days between films? Did they have Sandra's funeral already and what about the way she died what with the after-sex impaling and all? "I wasn't too familiar with the story of the sister from the earlier film when we did the film," says Anderson. "I just remember thinking that it probably wasn't too smart to go hunting Jason in the woods. Rob later describes his dearly departed sister Sandra as "a good kid." Well, we all know know that – in terms of the twisted morality of the *Friday the 13th* universe - she wasn't a good kid, not that she deserved to be impaled with a spear, least of all with her lover sandwiched on top of her!

Aside from the death of the nasty-looking hitchhiker, the rest of the day and night is reasonably peaceful in the wooded area. Paul (Alan Hayes) and the ultra-sexy Samantha (Judie Aronson) have sex in the master bedroom while Jimmy (Crispin Glover) and Ted (Lawrence Monoson) debate about who's going to 'get laid' first. This subplot offers one of the film's main conflicts as Ted labels the sexually insecure Jimmy 'a dead fuck.' By the end of the film, Jimmy manages to spectacularly redeem himself; the only downside being that he - of course - ends up getting killed by Jason. Jimmy's sexual conquest would end up being Tina (Camilla More) who, along with her equally sexy identical twin, Terri (Carey More), meets up with Jimmy and his friends during a hike through the woods. "Originally, I think the producers wanted to film on the East Coast, someplace like Connecticut or New Jersey, but California was the perfect place because of all of the props and scenery we had to work with," says Zito. "I wanted the audience to think that we were in Crystal Lake, but, obviously, it's a different-looking Crystal Lake than we saw in the

first two films because we're filming in California not Connecticut. I made sure to have New Jersey plates on the cars because I recalled seeing that in the first film. Basically, it was a fictional Crystal Lake, but it could've been anywhere. The audience could use their imagination."

The young vacationers may have gotten a good first night's sleep, but the next day would be slaughter day. All of them were going to die. Zito liked the idea of having the two houses directly across from each other, with the intention that it

THREE TIMES BEFORE
YOU HAVE FELT
THE TERROR,
KNOWN THE MADNESS,
LIVED THE HORROR.
BUT THIS IS THE ONE
YOU'VE BEEN
SCREAMING FOR.

FRIDAY THE 13TH
-The Final Chapter

FRIDAY, APRIL 13TH IS JASON'S UNLUCKY DAY.

PARAMOUNT PICTURES PRESENTS FRIDAY THE 13TH–THE FINAL CHAPTER • MUSIC BY HARRY MANFREDINI
SCREENPLAY BY BARNEY COHEN • STORY BY BRUCE HIDEMI SAKOW • BASED UPON CHARACTERS CREATED BY VICTOR MILLER AND RON KURZ
PRODUCED BY FRANK MANCUSO, JR. • DIRECTED BY JOSEPH ZITO A PARAMOUNT PICTURE

above:
Samantha (Judie Aronson) gets knifed from beneath the water. This scene was shot at a man-made lake.

opposite:
Paul (Alan Hayes) is speared by an unseen assailant lurking beneath the water. The wires suspending Hayes in the air can be seen in this out-take shot.

would give *Friday the 13th: The Final Chapter* a suspenseful, tight-knit feel. "It's funny because you only see one linking shot of the two houses in the whole film and that's at the very end," recalls Zito. "Looking back, the other house could've been a hundred miles away and it wouldn't have affected the continuity. I liked having all of the characters in one place because there were a lot of characters to kill off in the film."

The mayhem begins in the afternoon, just as the sun's about to set. The youngsters are having a dance

party in their house and Samantha's upset at the sight of her lover, Paul, snuggling up with the sexy twins. Angry, she bolts to the nearby lake for a little skinny-dipping, where she swims out to a small inflatable raft. "That water was so cold and I was naked and it was just torture," recalls Aronson who's probably best known for her role in the 1985 John Hughes comedy *Weird Science*. The lake itself was, in some ways, an optical illusion as it was actually a film property set located up in Santa Barbara, miles away from the main Topanga location.

While Samantha is in the raft, Jason stabs her through the torso. Aronson's difficult filming conditions brought outraged yelps from Jason himself, White. "She was in the lake, and completely naked, and it was terrible," he recalls. "This was winter and it was freezing. I told Joe to get her out of there and get her warm or I'd stop working."

Samantha's lover, Paul - tail between his legs - soon walks out to the lake area to look for his favourite sexual partner. Upon swimming out to the raft moored in the lake, he very quickly makes the gruesome discovery. Bolting for the shore whilst screaming for help, he almost immediately

right:
Diagram showing how Samantha's death scene was achieved. (Illustration courtesy of Tom Savini.)

comes face to face with Jason who spears him in the groin area - yet again Jason deals out symbolic punishment to a sexually-active youngster. "We used cables to hold Alan up in the air while one of the set-persons, Jill Rockow, squeezed out the blood from under the water as Paul is getting killed," recalls Savini whose effects crew included such names as Alec Gillis, James Kagel and Larry Carr, who had worked on *Part 3*. "I inherited the crew from Greg Cannom's tenure, but they ended up being the greatest crew that I've ever worked with. James was mainly in charge of sculpting effects while Alec and Larry worked on the mechanical stuff. They're all brilliant sculptors in their own right."

An example of the makeup genius of Savini and his team can be seen earlier in the film when Tommy and Trish bring Rob home, and Rob is shown Tommy's bedroom full of masks and special effects. Originally, Rob was supposed to have been shown a bizarre device that had been built from the parts of a microwave oven. The instrument had a photo-reflector to focus waves of heat that would, in essence, fry objects that it came into contact with. This contraption was, originally, supposed to play a part in *The Final Chapter*'s ending, whereby Tommy would be able to melt Jason's face to the bone. "It was designed so you could turn it up a few notches, from one to ten," recalls Savini. "It was the ultimate weapon against Jason, but the money-men felt that it was too over-the-top and that Jason should be killed off with a knife or a machete, which is more a part of the *Friday the 13th* universe."

Back to the plot, Tommy and Trish have driven to town, apparently to buy a connector for one of Tommy's portable video games. At the vacationers' house, the youngsters are beginning to form pairs for the night, except for Ted who can't find anyone to sleep with and Terri who decides that she wants to go home, with or without her twin sister, Tina, who's decided to shack up with Jimmy, the 'dead fuck,' for the night. When Terri walks out the door, she immediately gets speared through the back by Jason. However, the most interesting action is about to happen over at the Jarvis house, for a variety of reasons.

Mrs. Jarvis is looking for Gordon, the family dog, when she hears an unfamiliar noise. She eventually wanders outside where she turns and shrieks at the sight of an off-screen Jason. We never see her again although it's later revealed, by default, that she's dead. What happened to her? The fate of Mrs. Jarvis would turn out to be *The Final Chapter*'s great mystery. As it turns out, a lot of things happened to Mrs. Jarvis, but none of them made it onto the big screen. "I liked the scene

when I walk out of the house and I stare up at Jason; it was very tense," says Kessler. "Even better was a scene we shot where my face rises out of the bathtub and my eyes are very nightmarish-looking. I remember doing another scene where Kimberly finds me and I'm still alive, but it turns out to be a nightmare because I'm really dead."

Zito claims that the omission of these scenes was done for the overall good of the film. "The scene with Mrs. Jarvis in the bathtub was something that was created by the series owners," recalls Zito. "I wasn't crazy about it, but Paramount agreed to pay for it. Her face explodes out like a monster and she's wearing these white contact lenses. It was a very scary scene, very effective, but I don't feel like it added anything to the film. The scene where Trish finds the mother was much the same. The mother was dead, we know that, so why do we need these things? They didn't make sense. I think the owners just wanted some kind of scene set in water because the water scene in *Friday the 13th* was so effective."

Meanwhile at the vacationers' house, Jimmy and Tina have just had sex, with Tina complimenting Jimmy on his spectacular performance. Jimmy walks downstairs, panties in hand, to

FRIDAY THE 13th: THE FINAL CHAPTER (1984)

Production Credits:
Paramount Pictures Presents.
© Friday Four, Inc.
Executive Producers:
Lisa Barsamian,
Robert M. Barsamian
Producer:
Frank Mancuso Jr.
Co-Producer, Production Manager/First Assistant Director:
Tony Bishop
Location Manager:
John G. Lytle
Screenplay:
Barney Cohen
Story:
Bruce Hidemi Sakow
Director:
Joseph Zito
Second Assistant Directors:
Sharon Mann, Paul Moen
Director of Photography:
João Fernandes
Camera Operator:
S. Phillip Sparks
1st Assistant Cameraman:
Larry Karman
2nd Assistant Cameraman:
Steve Barnes
Panaglide/Steadicam Operator:
Randy Nolen
Gaffer:
Bob Good
Still Photographer:
Larry Secrist
Electrical Best Boy:
Charlie Stephens
Lamp Operator:
John Vournas
Best Boy Grip:
Joseph Presson
Grip:
Adam Smith
Key Grip/Dolly Grip:
John Sayka
Editor:
Joel Goodman
Co-Editor:
Daniel Lowenthal
Music:
Harry Manfredini
Music Editor:
Jack Tillar
Sound Mixer:
Gary Rich
Boom Operator:
David Platt
Re-Recording Mixer/Music:
Charles Grenzbach
Cable:
Michael Chonos

above:
Jimmy (Crispin Glover) gets corkscrewed by Jason (Ted White).

opposite top:
Doug (Peter Barton) has his face crushed by the hands of Jason Voorhees.

opposite bottom:
The aftermath of Doug's murder.

below:
After being corkscrewed, Jimmy gets a cleaver in the face.

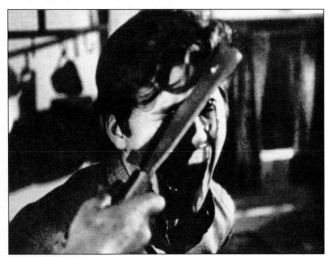

a window. Downstairs, the sexually starved Ted (is he actually a virgin himself who uses sexually graphic talk as a defence mechanism?) hears a noise in the living room. Spooked, Ted looks all around the room, when suddenly Jason plunges a knife into him, through the projector screen.

How is it possible for Jason to be in not just two, but sometimes three or four places at once? Isn't it hard for someone as big and ugly as Jason to move around with dexterity and stealth? "If you watch the scene very closely, you'll see that it was logically possible for Jason to move around like that," explains Zito. "What happened was that we used so many editing cuts in that scene that the time gets drastically condensed. You see close-ups of Ted, really fast, back and forth and, all the while, Jason's moving around the room. We actually did shots in the living room where you could see Jason moving around, but we just speeded it up in the editing room. It makes sense."

Jimmy and Tina weren't the only couple to get 'lucky' in the house. Doug (Peter Barton) and Sara (Barbara Howard) also hooked up - in their case in the shower - in one of *The Final Chapter*'s truly tender movements. After they have sex, Sara leaves the shower to wait for Doug in bed. Once Doug's alone in the shower, he gets a visit from Jason who doesn't want to have sex, but rather proceeds to crush Doug's face with his bare hands. "Ted put his hands right on my face and there was a rig of some kind attached to my face and it felt like my face was really being ripped to pieces," recalls Barton who appeared with co-star Judie Aronson in a 1983 episode of *The Powers of Matthew Star* that was entitled, appropriately enough, *Dead Man's Hand*. When Sara walks back into the bathroom, she discovers Doug's smashed-up corpse. Terrified, she tries to flee the now locked-up house only to be axed in the chest by Jason just as she's about to try and head out the front door.

That leaves Tommy, Trish and Rob. While Tommy's back home, Trish, for some reason (maybe she's trying to find her mother?), has ventured deep into the forest where she stumbles upon Rob's tent. Rob confronts a startled Trish as they both look inside the tent and see that Jason has destroyed all of Rob's weapons. How did Rob know where to go hunting for Jason, again, just a few days after the death of his sister? Regardless, Rob explains to Trish his revenge motive: his sister's murder. He also tells Trish about Jason's bloody history, through a series of neatly typed news clippings. "I remember reading a draft of the script where Rob was one of the heroes in the film and where he survived at the end," recalls Anderson who went on to appear in Zito's *Missing In Action* just a few months after *The Final*

confront Ted who's sitting on the couch, moping in front of a film projector, lonely as hell. A triumphant Jimmy goes into the kitchen where he searches for a corkscrew to open a bottle with. Jason, it turns out, has the corkscrew, which he promptly drills into Jimmy's hand while he smashes a cleaver into the defenceless youngster's face. "I'll never forget standing next to Tom Savini with that blade stuck in my head," recalls Glover. "I had a great time making that film and it was an honour to be killed by someone as great as Tom Savini. I don't regret any film that I've done because you learn from them all and *The Final Chapter* was a great learning experience for me."

Upstairs, Jimmy's new girlfriend Tina is waiting for Jimmy to come back for seconds. Any romantic thoughts she had are quickly dashed and slashed however, when she runs into Jason - seemingly able to be in all places at once - who grabs Tina and throws her pretty little head through

Chapter. Says cinematographer Fernandes, "One of the techniques we used in the film, if you can call it a technique, was darkness. Joe and I thought that as more and more of the characters were killed, the film should get darker and darker in terms of the look, and that's what we did in terms of the lighting. I think it was very effective because by the end of the film, there's a real grim look to the film that reflects the fact that everyone's dead."

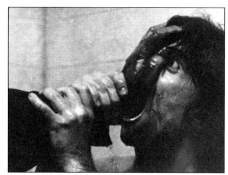

Rob and Trish race back to the two adjoining houses. They search the vacationers' house first where it seems, yet again, that Jason has done an immaculate job of clearing away his victims' corpses. Why does he care? Trish then goes upstairs however, where she does discover some bloody remnants, in the shape of Doug's body. She screams for Rob and the two of them, for no apparent good reason, find themselves at the top of the stairs leading down into the basement. There, Rob spots Jason and heads down, whereupon Jason lunges at him from the darkness. While Trish just stands at the top of the stairs, doing nothing, Jason and Rob fight each other. Much like Ali before him, Rob holds his own for a short while until Jason inevitably hacks him to pieces.

Trish races back to her house to get Tommy. "The shot of Jason and Trish moving between the two houses is the one shot where you see a single shot of the two houses," says Zito. "We also had to create the atmospheric effect of rain for that scene. We basically used a Steadicam shot to link the two houses together. When we were doing the shot of Jason moving from house to house in the single shot, the Steadicam operator slipped and fell and hurt himself, but we got it even though the machine was busted."

Once back in the house, Trish tries to fasten the front door, oblivious to the fact that Jason could easily smash through the front window, which he then does by using Rob's corpse as a projectile pass-key. Unable to call the cops, due to the fact that Jason had earlier ripped out the cables with his bare hands, Trish, like so many other *Friday the 13th* heroines, is forced to fight Jason to the death. As Jason tries to clamber into the house, he grabs hold of Tommy whilst Trish smacks the invader in the head with the hammer she had been using to try and board up the front door with. The action moves upstairs, to Tommy's room, where Trish immobilizes Jason by smashing a television set over his head. Moments later Jason comes back for more, and caught between chasing Tommy or Trish, he goes after Trish who, for reasons unknown, runs back across to the other house. Jason catches Trish upstairs and throws her out the window. According to Cohen, the relationship between Jason and Trish was originally supposed

Timer:
Bob Noland
Assistant Editors:
**Adam Fredericks,
Phillip Linson**
Re-Recording Mixer/
Dialogue:
John "Doc" Wilkinson
Re-Recording Mixer/
Effects:
Joseph Citarella
Sound Effects:
Blue Light Sound, Inc.
Production Sound Services:
Ryder Sound Services, Inc.
Make-Up:
Robin Neal
Hairstylist:
Kim Phillips
Wardrobe:
Steagall Designs
Special Make-Up Effects:
**Tom Savini, Alec Gillis,
Kevin Yeager, Jill Rockow,
Jim Kagel, Larry Carr,
Mike Maddi**
Special Effects:
REEL EFX Inc.
Special Effects
Co-ordinator:
Martin Becker
Special Effects Unit:
**John Godfroy, Frank Inez,
John Hartigan,
Dave Walton**
Music Title Design:
Modern Film Effects
Titles and Opticals:
Creative Film Arts
Production Designer:
Shelton H. Bishop III
Art Director:
Joe Hoffman
Set Costumer:
Debra Steagall
Script Supervisor:
Susan Malerstein
Production Supervisor:
Janet Lee Smith
Executive Consultant:
Terry Ballard
Production Co-ordinator:
Karen Altman
Production Accountant:
Constance Talley-Sherman
Assistant to Mr. Mancuso:
Mary Carroll Kaltenbach
Assistant Accountant:
Michael Goldberg
Stunt Co-ordinator:
John Sherrod
Stunts:
**Pamela Bebermeyer,
Sheryl Brown, Bob K.
Cummings, Mike De Luna,
Tracy Lyn Keehn**
Casting:
**Fern Champion,
Pamela Basker**

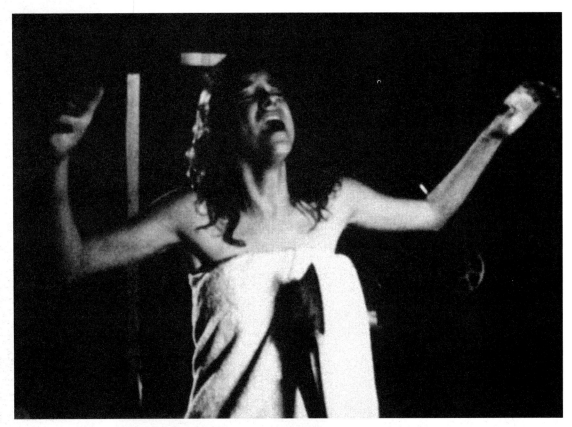

above:
After losing her virginity,
Sara (Barbara Howard)
gets axed by Jason
Voorhees.

opposite:
Trish Jarvis (Kimberly
Beck) and Jason battle
for the soul of Tommy
Jarvis (Corey Feldman).

right:
Trish tries to protect
Tommy from Jason while
Rob (E. Erich Anderson)
looks on.

to be much more tender. "I wrote a scene at the end where Jason sort of realizes the horror of his actions," he recalls. "He's still a monster, of course, but I wanted to show him having human feelings, instead of just being this masked monster, so I wrote a scene where Jason gently brushes his hand across Trish's breast and you see an emotional reaction from Jason. I think the producers probably felt that such a scene would be offensive given the fact that Jason had killed Trish's mother."

It was quite an ordeal for both performers, especially for Beck. "Ted was a real gentleman to work with, but I got lots of bruises on the film," she recalls. "The scene where Trish was thrown through the window was done with a stunt-woman, of course, but I had to go out there and lay in the mud with my panties sticking out and everything. For the scenes with Jason, Ted and I basically agreed to go for it, to not hold back." White remembers, "Kimberly got her stuntman's card from doing that film and the fight scenes were really tough on her. I was a little nervous when she was swinging the knife around because, obviously, she was tired and not that experienced with weapons, but we got through it."

Having survived her fall from the upstairs window, Trish regains her bearings and runs back to her house but when she gets there, she's immediately confronted by Jason. Armed with a machete, Trish tries to fight him off, but appears to be on the verge of defeat. While this battle has been raging, little Tommy has been studying the aforementioned news clippings that Rob left behind, inspiring him to attempt a remarkable deception. Suddenly and unexpectedly, the audience gets a special visitor: Mrs. Pamela Voorhees. "I'd seen the previous *Friday the 13th* film, and I know that Betsy Palmer gave a vivid portrayal of Jason's mother in the first film, and I wanted to give a performance as good as that," recalls Feldman whose character, Tommy, obviously went to school on Ginny's impersonation of Pamela Voorhees in *Part 2*. "I was a big

Halloween fan before working on *The Final Chapter*, but after working on the film, I became a *Friday the 13th* fan, especially since the character of Tommy Jarvis is so important to the series. How could you forget Betsy Palmer in *Friday the 13th*? I became familiar with what she looked like and sounded like. They matted down my hair, added the blonde tinges to the latex cover on top of my head and, slowly, I began to feel like I was that character. Tom and the makeup guys helped me a lot and I had a lot of fun doing the voice and I think I was believable; I think the audience believes that Jason would be fooled. I love doing voices. A few years later, I starred in a film called *Dream a Little Dream* and I basically switched bodies in that film and I had to pretend to be in another character's body. In *The Final Chapter*, I believe that Jason believes that he's seeing his mother."

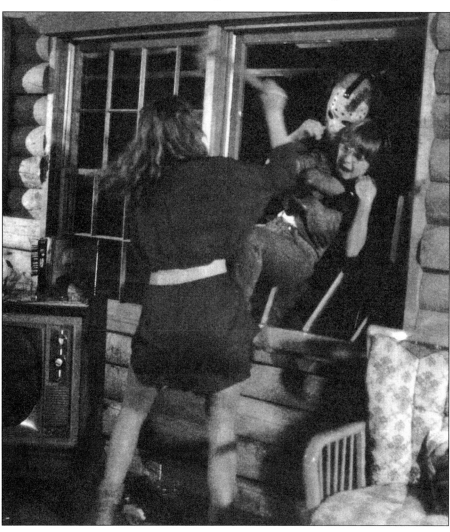

above:
Trish Jarvis plays dead. Kimberly Beck was bruised during the filming of this scene.

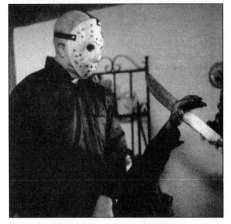

right:
This still shows exactly how simple some special make-up effects can be, as Ted White stares at a machete embedded in a prosthetic arm.

right:
Tommy Jarvis assumes the persona of Pamela Voorhees to trick Jason Voorhees.
(Photo courtesy of Tom Savini.)

Tommy's remarkable trick buys Trish enough time to pick up the machete and move behind Jason for the kill. She whacks the killer across his face, sending the hockey mask flying. Trish and the audience get a look at Jason's real face, and while the hideous visage of Pamela Voorhees's deranged little boy may not have been pretty to anyone but his mother, it was a groundbreaking image in the history of horror film effects. "That's why I came back to do *The Final Chapter*," says Savini. "I wanted to be the last one to show Jason because I really created his look in the first film and with *The Final Chapter*, you'd seen the full progression: from child to man."

Trish, understandably, shrieks at the sight of Jason, who promptly throws her to the ground. During the struggle, Tommy picks up the loose machete and rams it through the side of Jason's head. As Jason slumps to the ground, the machete sticks in the floor causing his head to slide messily down the length of the blade. "The original plan in the script was to cut Jason's head like an artichoke lengthwise," explains Cohen. Savini found inspiration from an old source in his quest to find a memorable way to kill Jason for good. "I really had my heart set on using the microwave scene that would eventually have caused Jason's head to explode into pieces," he explains. "With that gone, all I had left was a machete from my work on *Dawn of the Dead*. The machete was able to fold over the head of its victim. It was John Vulich who came up with the idea of that. He put the machete on and it looked really good. From there, we all decided that it would work well if Jason were to slide down into the blade as he falls. We built a mechanical Jason for that scene and the whole crew had to work the cables that made parts of the head move, and we had to check a monitor to see if we were doing it right or not. It worked good."

Jason's dead. Well, not quite. While Tommy and Trish are consoling each other, Tommy notices, out of the corner of his eye, that Jason's still moving. No doubt traumatized by the obvious fate of his mother - something he has in common with Jason of course - Tommy grabs the machete and strikes the monster over and over while Trish can only watch and scream. Later, we see Trish in a hospital room when Tommy enters the room and the two siblings embrace. As the camera closes in on Tommy's face, his eyes spring open, full of unmistakable menace. What's going on here? Was Jason really dead? Was Tommy going to be the new Jason? "We certainly felt that Jason was dead," explains Frank Mancuso, Jr. who was present during the filming of Jason's would-be death scene. "It was a very emotional scene to watch because we all thought that was the end. We couldn't believe it was over."

According to the filmmakers, the notion of presenting Tommy as a potential 'future Jason' was just an insurance policy should the franchise have continued, which it did. Jason was dead. If only for an instant, he was dead and so was the franchise. "It was my fault," says Zito with a laugh. "No one at Paramount had any interest in making more films and Frank Mancuso, Sr. told me as much during the difficult editing process. Basically, they were kind of embarrassed by the films even though they were very profitable. It was my idea to film the ending with Tommy because I wanted to leave the door slightly open just in case. I never imagined that there would be so many sequels made after that though. None of us had any idea." Cohen concurs, "I think the owners of the series really wanted to end it with *The Final Chapter* because, believe it or not, they cared about the

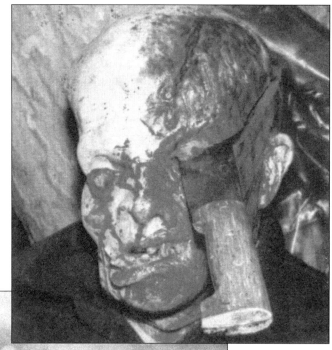

above:
The horrific wound that finally defeats Jason Voorhees in *Friday the 13th: The Final Chapter*. (Photo courtesy of Tom Savini.)

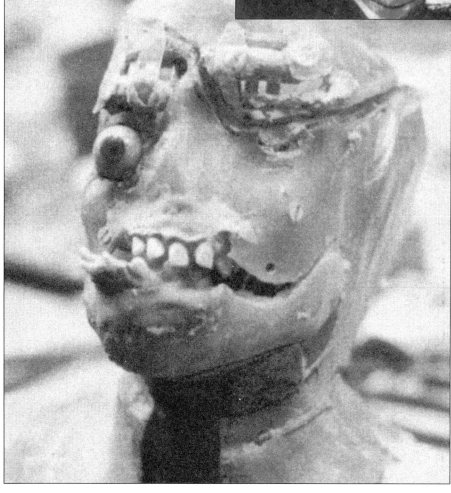

left:
The skull beneath the skin. Special make-up effects secrets revealed. (Photo courtesy of Tom Savini.)

above:
Behind the scenes shot of Tom Savini's effects crew with Jason's traumatised head. (Photo courtesy of Tom Savini.)

series and they didn't just want to milk it to death although money's always a consideration. I think what happened was that when the final dailies were shown, they got cold feet and felt that they needed some backup plan in case they wanted to make more films. I also think there was a lot of debate about whether or not the ending worked on a dramatic level. It was a difficult decision to make regarding Jason's future."

One person who was convinced that Jason was dead for good was Savini. "I didn't see how Jason could be brought back after what we'd done to him," he recalls. "This was the first film that I'd done in Los Angeles and that was a fun experience because I was able to work at Francis Ford Coppola's Zoetrope Studios where our shop was located and be around all of these Hollywood types. But no, I thought that was the end of Jason. Joe even said he was dead after we shot the final scene."

Zito and his production team had to rush to get *The Final Chapter* ready for its intended release date. "We only had a few weeks to edit the film," recalls Zito. "The film editor, Joel Goodman, had to work non-stop, along with several other editors, to get the film ready because the April 13 date was the only Friday the thirteenth on the foreseeable schedule and Paramount knew what a big marketing draw it was to debut the film on a Friday the thirteenth. Paramount rented out a house in Malibu and all of us just camped out around the clock until the film was finally cut and ready to ship. The biggest problem was with the MPAA because we had to cut Jason's death and we weren't able to show everything that we wanted to, but we still had to make it clear that Jason was dead for

right:
The crew staged a mock funeral for Jason Voorhees on the set of *Friday the 13th: The Final Chapter.* (Photo courtesy of Tom Savini.)

good because, again, Paramount wanted Jason dead. Paramount really wanted to end the series."

Regardless of Paramount's stance in early 1984, the old 'never say never' adage could have been custom made for Hollywood, especially when it comes to milking profits from a certain disreputable horror franchise. When *Friday the 13th: The Final Chapter* made its debut on April 13, 1984, its performance exceeded everyone's expectations. "No one expected it to do as well as it did," says Zito. "It was, at that time, the biggest opening box office weekend in Paramount's history for that time of the year. It was quite a shock." Playing in 1,594 theatres, *The Final Chapter* grossed a whopping $11.1 million in its first three days of release, remaining the highest opening of any *Friday the 13th* film right up until the teaming of Freddy and Jason in 2003's *Freddy Vs. Jason.*

Who said Jason was dead? "There was something about it being *The Final Chapter* that really energized the fans," recalls Mancuso, Jr. "One of the things that happened with the later films is that the fans felt a little confused about why we were making more films after we called that film *The Final Chapter.*" Although *The Final Chapter*'s $32.8 million final box office tally would fall several million dollars short of *Part 3*'s total, one thing was clear: Jason was more alive than ever. There was a problem with this: since the makers of *The Final Chapter* had done such a good job of 'killing Jason' in the film, how was it possible to 'resuscitate' Jason in a believable and exciting way?

It was a dilemma that would haunt the *Friday the 13th* franchise for the rest of its years, and although *The Final Chapter* most certainly wasn't, things would never be the same again. It was, in many ways, the end of an era and the beginning of the end.

The Beginning of the End

Whether or not Jason was in fact dead at the end of *The Final Chapter* was a moot point by the time that film's box office figures were tallied. By the summer of 1984, the box office gods had determined that Jason Voorhees was to be quickly resurrected. Well, in a way. In September of 1984, filming began on *Friday the 13th Part V: A New Beginning* on the outskirts of Los Angeles, Oxnard to be exact, but it would turn out to be a classic example of greed-inspired motives overwhelming all narrative logic and objectivity. How could Jason come back? Where was Tommy and, more importantly, what was he? *A New Beginning* would certainly provide answers to these questions, but the tortured explanations weren't very convincing, certainly not to the paying customers who'd so faithfully flocked to see *The Final Chapter*.

To add to the franchise's problems, it would not be long before Jason would be far from the only monster in town, as Freddy Krueger was about to energize moviegoers in a visceral manner that the later *Friday the 13th* sequels couldn't match. Admittedly, at the time *A New Beginning* was in production, *A Nightmare on Elm Street* had yet to debut. However, by the time *A New Beginning* was released in March of 1985, Jason would be well on the path towards conceding to Freddy Krueger the mantle of film's number one monster. *A Nightmare on Elm Street* grossed $25.5 million upon its release in November of 1984, and the dark seed had been planted.

However, that was all yet to come, and Freddy Krueger would not have even registered in the minds of Stephen Minasian and Phil Scuderi when, shortly after the release of *The Final Chapter*, they began scouting possible directors for *A New Beginning*. The person given the job was right in their midst and his name was Danny Steinmann, a man who retains the title of being the most mysterious director associated with the *Friday the 13th* series. In 1983, Minasian and Scuderi had viewed an early rough cut of Steinmann's 1984 release *Savage Streets* and were impressed enough to offer him a salaried position, as well as signing him to direct two films for them.

The second of these would-be projects was to be a sequel to *Last House on the Left*, pragmatically

called *Beyond the Last House on the Left*, that Steinmann was supposed to film in Wisconsin, beginning work in April of 1985. *Beyond the Last House on the Left* obviously never happened - for a variety of reasons - but Steinmann did get to direct the first of the two proposed projects for Minasian and Scuderi: the sequel to *The Final Chapter*. "I'd always wanted to direct horror films because I grew up loving horror films," says Steinmann, whose prior work consisted of producing commercials for companies in New York as well as making exploitation films; aside from *Savage Streets*, Steinmann had directed the 1981 horror film *The Unseen*. "I didn't start out making exploitation films," he recalls however. "I worked as one of the producers on a Gene Roddenberry television film called *Spectre* and I also worked on *The Man in the Glass Booth* which was a movie made from the award-winning play of the same name. I'd done other stuff besides horror."

below:
Jason Voorhees (Tom Morga) attacks an isolated halfway house in *Friday the 13th Part V: A New Beginning.*

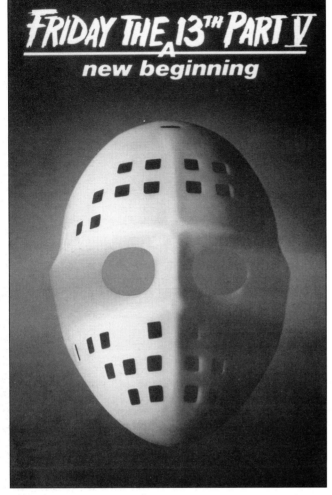

FRIDAY THE 13TH PART V
new beginning

above:
Promotional artwork for the *Friday the 13th* films had always been simple and striking, but with this video cover artwork for *Part V*, the minimalist ethic reached its logical conclusion.

opposite:
Pam (Melanie Kinnaman) and Reggie (Shavar Ross) make a gruesome discovery.

Feldman's work on *The Goonies* forced Steinmann to film the nightmare scene at the end of principal photography, which lasted for thirty-three days. The scene was actually filmed in the backyard of Feldman's neighbour's house. "I was already cutting and editing the film when I found out that Corey was available and we went back and shot the scene in the cemetery in about two days," recalls the director, whose original concept for *A New Beginning*'s prologue was very different to what was eventually filmed. "Originally, we were going to follow Tommy right after *The Final Chapter* when he goes to the hospital where they've taken Jason's body," says Steinmann. "What happens is that Tommy kills the hospital staff and then Jason rises from a hospital slab and they confront each other, and then we cut to the older Tommy at the mental institution."

Casting for *A New Beginning* was - in common with most of the other instalments - a fairly casual process, with Pamela Basker and Fern Champion returning to oversee the task. John Shepherd was cast as the adult Tommy, marking the actor's first starring role after a few minor television appearances. "I really felt like it was a great opportunity and a great learning experience in more ways than one," recalls Shepherd, who actually co-wrote some of the scenes in the film. "I thought Tommy was an interesting character and I was able to do some interesting things with him in the film in terms of us not knowing if he's a killer or not. As an independent filmmaker, there's no better training than working on a *Friday the 13th* film." In later years Shepherd, a devout Christian, would go on to produce and write Christian films through his production company, Dean River Productions. Steinmann has high praise for Shepherd's contribution. "I wrote the final shooting script in about three weeks, but my biggest worry was finding someone to play Tommy because that was the key to the film," he says. "We must've looked at a hundred actors and we actually cast this one guy who wasn't very good. John was cast right before we started filming and he was perfect."

For his part, Shepherd recalls having lots of time to develop the character of the adult Tommy Jarvis, a challenge for the actor since Tommy is a virtual mute in the film. "I had lots of time to prepare for the role," recalls Shepherd. "In fact, I volunteered, before we started filming, at the Camarillo State Mental Hospital for a few weeks and worked with the kids out there just to get a feel for the life in an institution. As for the knowledge of the character of Tommy Jarvis, and what happened in the previous film, I hadn't seen any of the previous *Friday the 13th* films, but Paramount set up a private screening for me so I could see Corey

A New Beginning takes place eight years after the events of *The Final Chapter*. Tommy Jarvis is now twenty years old and a veteran of the psychiatric system, which has placed him in an isolated halfway house named Pinehurst as part of his rehabilitation programme. The film's pre-credit sequence however, opens with a younger Tommy from *The Final Chapter* as he witnesses - in the context of the older Tommy's nightmare - the attempted cremation of Jason Voorhees. Jason kills the two unlucky attendants who have been given the task of disinterring his body, and the scene immediately cuts to the adult Tommy as he wakes up from his horrible dream. Actor Corey Feldman was originally scheduled to star in *A New Beginning*, but had to beg off due to the fact that he was filming *The Goonies*. "They told me that they needed me to come back so they could link the two stories," recalls Feldman who, prior to his work on *The Goonies*, had appeared in *Gremlins*. "I wanted to do justice to Tommy and I thought it was a great scene and I made some very good friends." Actually,

Feldman's work in *The Final Chapter*. I sat in this huge theatre by myself and even though it was the middle of the afternoon, the cavernous and empty auditorium blasting out Harry Manfredini's chilling score really scared me."

Shepherd's two main co-stars in the film were Shavar Ross, who played the part of Reggie - this film's heroic youngster role - and Melanie Kinnaman who played Pam, *A New Beginning*'s requisite scream queen heroine. While this was Kinnaman's first film role, Ross was - at the age of thirteen - already a long-established acting veteran, well known for his role as Gary Coleman's best friend on the popular NBC television series *Diff'rent Strokes*. "I was looking to possibly move into doing feature films and getting to play the hero in something as popular as a *Friday the 13th* film seemed like a great idea," recalls Ross who, much like co-star John Shepherd, is also a born-again Christian and currently active in producing feature films for the Christian marketplace.

For her part, Kinnaman found the requirements for playing a *Friday the 13th* scream queen very basic: "I was a blonde who could run and scream very well and I got the part," says Kinnaman with a laugh. "The whole experience was fun and silly. I went to school on these kinds of films before we started to work, but there were so many ridiculous things that we did in the film that it was hard not to break into laughter. I wanted to make sure that my performance was good because I didn't want this to be known as one of the worst of the *Friday the 13th* films. I knew that everyone in the industry was going to see the film so I wanted to make a good impression."

Of the rest of the actors, Carol Locatell and Marco St. John, who played Ethel Hubbard and Sheriff Tucker, respectively, were both veterans, having already accumulated many film and television credits. Another veteran in the cast was Vernon Washington who played Reggie's grandfather, George. Washington died in 1988. "He was a really sweet man," says Ross. "It really felt like we were family while we were working together." Actually, at the time of writing, *A New Beginning* earns the rather ominous distinction of having the most deceased cast and crew members of any of the *Friday the 13th* films. Washington is joined in the afterlife by screenwriter David Cohen, production designer Robert Howland and actor Mark Venturini, whose 1996 death is ironic in more ways than one given the role he would play in *A New Beginning*.

The rest of the cast - portraying the resident victims of Pinehurst - was largely composed of newcomers including Juliette Cummins, John Robert Dixon, Tiffany Helm, Jerry Pavlon, Richard

Young and the aptly named Debi Sue Voorhees. Miguel Nunez, Jr., who had a small role in the film - as Reggie's delinquent brother, Demon - has gone on to have a successful career including a starring role on the 1987 CBS television series *Tour of Duty* and parts in such films as *Juwanna Mann* and *Scooby Doo*. Young has also enjoyed a prolific career since *A New Beginning* including a small role in 1989's *Indiana Jones and the Last Crusade*. Then there was the casting of Jason which, in common with other films in the series, would lead to much controversy.

There are two Jasons in the film which, itself, isn't half as confusing as the way in which Steinmann and the *A New Beginning* production team would reintroduce the spectre of the killing machine. Although Steinmann shared writing credit on *A New Beginning* with Cohen and *Part 3*'s co-writer Martin Kitrosser, it was left to Steinmann to conceptualize just how Jason would, and could, return from the dead. "It was a tough challenge, given the way they'd seemingly killed Jason in *The Final Chapter* so I decided that we had to make a left turn," says Steinmann. "I wanted the film to be about Tommy: his fears, his hallucinations, and I wanted Jason to spring out of that. The twist was that it was going to be a whodunit because I didn't want the audience to necessarily like Tommy. Tommy could be Jason, especially after the hospital scene at the end of *The Final Chapter*, and I wanted the audience to feel like they really couldn't trust him." Actually, Kitrosser received a writing credit on *A New Beginning* largely because his proposed storyline for *Friday the 13th Part 3* - where Amy Steel was to have been stalked by Jason in a mental institution - was incorporated into the storyline for *A New Beginning*'s script.

Speaking of trust, when *A New Beginning* first went into production, no one - not actors or any proposed production personnel - was told that it was a *Friday the 13th* film. The name of the production was listed as *Repetition*. This was done

above:
Vinnie (Anthony Barrile)
eats a flare.

right:
Duke Johnson (Caskey
Swaim) examines Joey
Burns's (Dominick
Brascia) corpse.

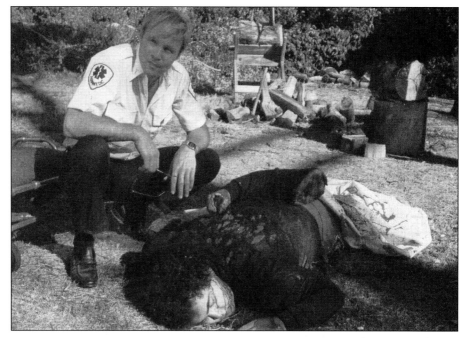

opposite:
Pete (Corey Parker) gets
his throat slashed.

below:
Dr. Matt Peters (Richard
Young) and the residents
of Pinehurst survey a
massacre.

to avoid any of the rampant controversy and negative stigma that had begun to spring up in the oppressively conservative Reagan-era, a dismal time that saw anti-horror protests daily. "I didn't know it was a *Friday the 13th* film until later in the production," recalls actor Ron Sloan who played the character of Junior Hubbard in the film. "I'm not sure, but I think a lot of the people in the film had no idea what film this was. After a while, it became pretty obvious, especially when they wanted to do a mould of my head."

The first appearance of Jason in *A New Beginning*, or 'Pseudo Jason' as fans would later call him, happens early in the film. The events of *A New Beginning* take place over the course of three days and nights, but the vital incident that leads to Jason's return occurs on the first day. With Tommy watching ominously, overweight and insecure Joey Burns (Dominick Brascia) walks in the grounds of the halfway house, holding his prized chocolate bars and looking for some company.

After being rebuffed by some of the girls, Joey walks over to where the ultra-intense Vic Faden (Mark Venturini) is chopping some wood. Vic and Joey have a disagreement, which turns decidedly nasty when Joey persists in taunting Vic until, overcome by psychotic rage, Vic slaughters Joey with his axe. For Brascia, it was an honour to die so violently in a *Friday the 13th* film, especially given the eventual significance of Joey's death. Dick Warlock, who played Michael Myers in *Halloween II*, was the stunt coordinator on *A New Beginning*, with Martin Becker, Louis Lazzara and David Miller handling the bulk of the effects duties. "Dick Warlock and I worked a lot on my death scene," recalls Brascia who, today, is a radio talk show host as well as an independent filmmaker in his own right. "First of all, Mark Venturini was a really great guy and a very good actor, nothing like Vic Faden. I was a little nervous about the axe he was using because there was a fake one and a real one and they both looked the same. When they did the effect, they bloodied me all up and I would walk around everybody with an

arm hanging off. What I liked about Joey was that the director, Danny Steinmann, let me change the character and make Joey much more human."

According to makeup expert Miller (who incidentally would go on to work on several instalments of the *Nightmare on Elm Street* film franchise), Joey's death scene was a case of do now and ask questions later. "That effect was very rushed and it didn't turn out very well," he recalls. "The casting for that was done by different members of the makeup team, not me, and it just didn't come off right. His head was made using gelatin which is almost impossible to paint over well and make it look really believable. It was hard because there was no time." There was also no money as the total effects budget for *A New Beginning* was less than $60,000.

As Pam (Melanie Kinnaman) and Dr. Matt (Richard Young) look on in horror, Sheriff Tucker (Marco St. John) arrives on the scene with the medical staff, including a strange-looking paramedic named Roy who has a rather startled reaction when he sees Joey's body because, as it turns out, Joey was his long-lost son. This inspires Roy to assume Jason's mantle and continue his murderous spree. Roy was played by Dick Wieand. "I was kind of told that Roy had become possessed by the spirit of Jason and that the shock of seeing his dead son had made Roy vulnerable to Jason's suggestion," says the actor, who spent years trying to forget his role in the film. "It was a nightmare for awhile because that's all people would see me as, but, over the years, I've learned to have a sense of humour about it. I'll never forget the day I auditioned for the director. Danny told me to stare down at a blank table and imagine that I was looking at my murdered son. It was very disturbing, and I did a good job, but I'm the last person on earth you'd expect to play a killer in a *Friday the 13th* film. I'm a nice guy."

Roy's rampage begins on that first night when he kills Pete (Corey Parker) and Vinnie (Anthony Barrile), two motorists parked in the wrong part of the woods at the wrong time; Pete gets his throat slashed and Vinnie gets a distress flare inserted into his mouth. "The flare-in-the-mouth scene was something that I worked on with Dave Nelson, who was in charge of the film's mechanical effects and who did a great job in the film," says Miller. "We made this great-looking head and inserted the flare which was perfectly rigged to blow up. The eyes looked terrific."

It's here that Jason makes his appearance, hockey mask and all, but it wasn't Wieand under the mask, but rather veteran stuntman Tom Morga who, like Steve Dash from *Part 2*, would play Jason for the film's entirety - with the exception of an insert shot near the end of the film - without receiving due credit. "I was Jason," asserts Morga, who also played - in another uncredited appearance - Michael Myers during much of 1988's *Halloween 4: The Return of Michael Myers*. "Dick Warlock and I have been friends for years and he knew I'd do a good job of playing Jason, especially since I have a ton of acting credits. I really got into the character, so much so that some of the actors would get scared. The stunts were tough, but really exciting." Ted White, who had played Jason in *The Final Chapter*, turned down the role.

The next morning sees Sheriff Tucker survey the bodies of the murdered motorists while - in one of the film's most comical moments - paramedic

Re-Recording Mixer/Dialogue:
Ray West
Re-Recording Mixer/Effects:
Chris Carpenter
Re-Recording Mixer/Music:
Bob Minkler
Boom Operator:
Patrushka Mierzwa
Production Mixer:
Mark Ulano
Color Timer:
Stephen R. Sheridan
Production Sound Services:
Glen Glenn Sound
Sound Effects:
Blue Light Sound, Inc.
Make-Up:
Kathryn Miles Logan
Hairstylist:
Enid Arias
Wardrobe Designers:
Image Makers
Wardrobe Supervisor:
Camile Schroeder
Wardrobe Assistants:
Janis Larkham, Nola Sharp
Special Make-Up Effects:
Martin Becker
Special Make-Up Effects Unit:
Earl C. Ellis Jr., David B. Miller, Anton Ruprecht, Wm. Scott Strong, Larry S. Carr, Louis Lazzara, David Nelson
Special Effects:
REEL EFX Inc.
Special Effects Co-ordinator:
Frankie Inez
Special Effects Unit:
Thomas K. Hartigan, Frank Munoz, Mark A. Sparks, Tom Del Genio, Victor D. Lupica, Duncan J. Simpson
Titles:
Modern Film Effects
Opticals:
MGM Opticals
Production Designer:
Robert Howland
Set Decorator:
Pamela Warner
Set Dressers:
Sara Lee Wade, Michael Gastaldo
Scenic Artists:
Jeanine Lambeth, Robert Rosenbaum
Property Master:
Barbara Benz

by the cops? What about the fact that Roy hadn't even seen Joey since running out on the boy when Joey was born? Isn't Roy nothing more than a role-model for deadbeat fathers across the world? Regardless, Roy, or Jason, attacks Billy and Lana, killing them both with an axe.

Actually, the murder scene in the diner was a reinterpretation of a cut scene that had been filmed by *The Final Chapter* director Joseph Zito with the intention that it would appear in that film. "We were lucky that we had some really great footage that never made it into *The Final Chapter*, but which we could've used had we needed it," recalls Zito who, in 1989, had preliminary meetings with producer Frank Mancuso, Jr. about a proposed *Freddy Vs. Jason* project that never came to pass at that time. "We did the scene at the diner and it was a great scene - very atmospheric and suspenseful. You saw the girl, alone in the diner, and you saw that there were railroad tracks outside the diner. Jason ends up killing her in the diner and it was a great-looking scene. That scene was in earlier versions of the *Final Chapter* script and I guess the powers-that-be liked it so much that they decided to file it away and use it again."

Finally the third day in the story arrives, the day and night when the film's bloodbath occurs. By this time, Tommy's been acting very strangely - constantly watching everyone - and exhibiting tremendous strength for example in a scene where he body-slams Eddie (John Robert Dixon) when Eddie teases him. Eddie and his lover, Tina (Debisue Voorhees), are a couple of sex maniacs. They decide to sneak off into the woods to have sex; safe sex at least, since Eddie has a roll of condoms. For Voorhees (now a newspaper reporter in Dallas), a starring role in *A New Beginning* meant having to reveal more than she had bargained for. "We were totally naked for that scene," she recalls. "It took about fifteen hours to do our naked love scene. One of the reasons I think I was cast was because the producers freaked out when they saw that my last name was Voorhees. They couldn't believe it. What was weird was that there was another actress up for my role and she just happened to be the girlfriend of the actor I did the scene with and she wasn't too happy that I was going to be doing the scene with him. What happened was that the producers had wanted her, but then Danny Steinmann picked me because I'd done a really good read for him and he was impressed. I called the guy up and suggested that we meet and get to know each other because we were going to be naked. It was cold and very uncomfortable."

The scene between Eddie and Tina was originally filmed to include graphic nudity, not surprising since Steinmann's background includes

above:
Lana (Rebecca Wood-Sharkey) gets axed in the chest.

opposite:
Tina (Debisue Voorhees) is fatally blinded.

below:
Eddie (John Robert Dixon) has his head crushed.

Roy carries the bodies into the ambulance truck. Tucker has begun to believe that the murders might be the work of Jason Voorhees despite previously being led to believe that his killer had died years ago. "When I read the script, I didn't want to do the film," says St. John who's best known for his memorable roles in such films as *Thelma & Louise* and *Tightrope*. "It was just the same thing over and over again with the killings, but I did find it interesting that my character thought that Jason was alive."

There are two more murders on that second day - at a rundown diner where sanitarium worker Billy (Bob DeSimone) arrives to pick up sexy waitress Lana (Rebecca Wood-Sharkey). For some reason, it appears that Roy holds Billy and Lana, along with the other characters in the film, responsible for Joey's murder. This of course makes no logical sense; what about Vic Faden, who was taken away

the 1973 X-rated film *High Rise*, which he wrote and directed under the name Danny Stone. This scene would mark just one of many cuts that Steinmann was forced to make in the course of preparing nine different edits of the film before gaining the MPAA's eventual approval. This obviously meant that editors Bruce Green and Armen Minasian (no relation to Stephen Minasian) were kept busy. "The nude scene was very graphic and shocking and there's no way that was going to make it past the censors," says Minasian. "Later, word got out that the director had a porn background. It turned out to be a very gory film, but most of it ended up being cut out and I don't know why they even filmed that stuff."

While Eddie and Tina are having safe sex, they're being watched, from behind some trees, by a pervert named Raymond (Sonny Shields), a vagrant whom the crazed Ethel Hubbard (Carol Locatell) had hired to clean the manure out of her barn in exchange for a plate of food. Raymond soon gets his comeuppance for being a peeping tom when he turns around - looking into the camera - and gets stabbed with a hunting knife. After Eddie and Tina finish having sex, Eddie heads for the lake to wash while a clearly energized Tina stares up at the sky. Her happy mood is soon shattered however when Jason appears and pops her eyeballs with a pair of garden shears. "It was freezing cold when I went in to have the face mould done," recalls Voorhees. "They covered my whole face with the mould and all I had was this straw sticking out of my mouth and my face was freezing. Then they put the blood into my eyes and it burned my eyes like crazy so I

was blind. The worst part was being totally naked and being surrounded by a bunch of strangers."

When Eddie returns for seconds, he turns Tina over and stares into her violated eye sockets. Obviously shocked and scared, he backs up against a tree which, of course, turns out to be manned by Jason who pins Eddie's head against the trunk with a leather strap. Jason weilds the strap in a garrotting motion, crushing Eddie's skull. "The scene with the strap was one of the best effects in the film," asserts effects expert Louis Lazzara who also worked on *Part 3*. Another member of *A New Beginning*'s effects team was Larry Carr - another veteran from *Part 3*. "The strap scene worked so well because Larry Carr built a great appliance for it. Everything fell into place."

Nighttime soon intrudes upon the isolated halfway house as Matt, Pam and the others wonder where Eddie and Tina could possibly be. Pam decides to take Reggie to see his estranged brother, Demon (Miguel Nunez, Jr.) at a nearby trailer park, taking Tommy along with them. By this point in the film, it's obvious that Tommy couldn't possibly be responsible for the previous murders given the simple fact that he would have needed to be in two places at once. Still, the dark suggestion that follows Tommy's character does, in some respect, elevate *A New Beginning* above the cardboard storylines that preceded this entry in the series. At least Steinmann was trying to do something interesting, a task made extremely difficult since the writer-director was so obviously hamstrung by *The Final Chapter*, a film that had done everything it possibly could to convince fans that the series

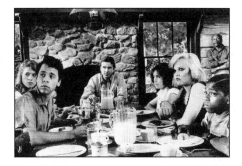

was over. "I was given a lot of creative freedom on *A New Beginning*," recalls Steinmann. "Frank Mancuso gave me what I needed, more or less, to make the film I wanted to make. He brought Corey Feldman back for me and he let me alter and radically change scenes that I didn't feel were going to work. When I did *The Unseen*, the film was basically taken out of my hands, but with *A New Beginning*, I was given a lot of control."

While Reggie happily reunites with his brother Demon, and his foxy girlfriend Anita (Jere Fields), Tommy has a violent confrontation with Junior Hubbard (Ron Sloan) that almost turns deadly. "Junior was a total idiot, but I had so much fun playing that character," recalls Sloan. Pam stops Tommy, just as he was about to put his fist through Junior's head, and then she takes Reggie back to the compound. Meanwhile Tommy runs off, presumably in another attempt by the filmmakers to keep him as a possible murder suspect. Back at the trailer park, Demon, feeling the effects of some nasty enchiladas, races towards the nearest outhouse to take a monster dump. While inside, the room starts to shake when Anita decides to have some rather juvenile fun with Demon. Suddenly Anita falls silent. When Demon opens the door a crack, he looks down and spots Anita, throat slashed. "That

place was a dark and disgusting hole and I had to be in there for hours while they were doing the spear effects," recalls Nunez, Jr. "I also had to wear those awful curls and wear that Michael Jackson outfit, but it was fun to be in a *Friday the 13th* movie and people always mention it to me, even though I've done lots of movies and television programs since."

Demon backs up inside the outhouse when, suddenly, a sharp spear is thrust through the wall, just missing him. The attacks continue until the spear fatally impales Demon, who can only gaze down at his mortal wound in stunned awe. There's something interesting in that outhouse and that's the obscure piece of graffiti that's been scrawled on the back wall. The message reads 'Fadden was here,' a reference, improperly spelled, to Joey's demented, axe-wielding killer. Was this a further attempt by the makers of *A New Beginning* to raise the spectre of another murder suspect, this time an escaped Vic Faden? "That was a bit of an in-joke but, as you're watching the film, I think you really get the idea that the killer could be a number of people," says Steinmann. "One of the tough parts of the story was the logic of how somebody assuming Jason's identity would be so powerful and strong but, again, we kind of went with the idea that the murderous spirit of Jason was inside of the killer, whoever it was."

A New Beginning's dark character shadings, and the film's whodunit subplot, gave Harry Manfredini the scope to compose a full original score for the film, his first since *Part 2*. "I used a lot of rhythms in that score to suggest insanity throughout the film," says the composer. "I wanted to focus the music on all of the characters, not just Tommy, because the audience had to feel that the killer could've been anyone. Aside from Tommy, I tried to focus on Roy and the creepy farm worker. Basically, I crafted the music to try and fool with the expectations of the fans because the ending's supposed to be a surprise."

Elsewhere, a maddened Junior has crawled back home to his mother, Ethel. As Junior rides around the house on his bike, Jason unexpectedly appears and decapitates him with a cleaver. "We built a great-looking head for that scene and then added the hair," recalls Miller who assumed primary effects duties on *A New Beginning* only after effects expert Larry Carr left the production. "Changing effects personnel in the middle of production was somewhat problematic, but we still had lots of talented people working on the film. Earl Ellis was invaluable in terms of his sculpting work." While Junior loses his head, crazy Ethel stands inside her kitchen, obliviously staring over a disgusting bowl of stew when Jason whacks her in the head with a cleaver. "Ethel was one of the craziest characters

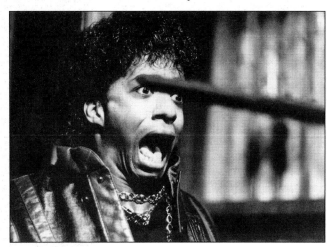

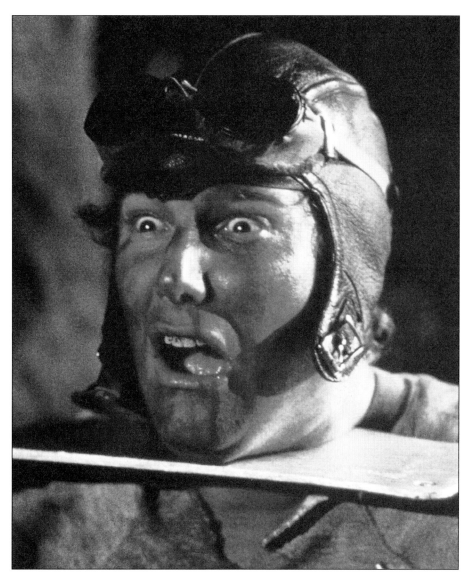

I've ever played," recalls Locatell who, today, is a respected acting instructor and character actress. "I didn't know anything about the *Friday the 13th* movies, or what the film was really about, so I just played Ethel totally crazy and the cast and crew were very encouraging with me. I thought I had some funny lines in the film."

When Pam and Reggie arrive back at the compound, without Tommy, they discover that George and Matt are gone too, having headed out to search for Eddie and Tina. Pam leaves Reggie behind while she drives off to search for George, Matt and Tommy. The bloodbath is now fully under way.

It's here, late in the film, that Kinnaman rises above the thin *A New Beginning* script to become

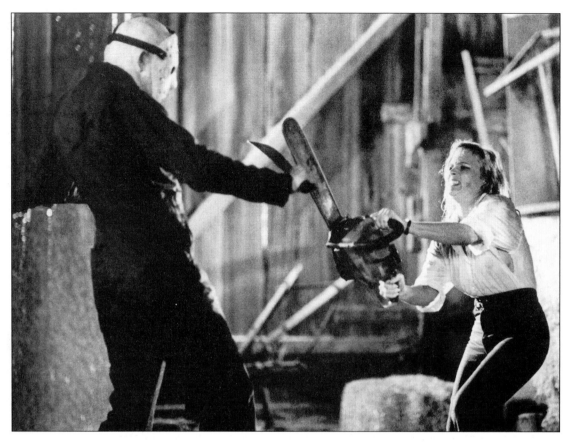

above:
Pam battles Jason with a chainsaw.

one of the all-time great *Friday the 13th* heroines. It's a shame that she didn't become a big star after *A New Beginning*, as in the role of Pam, Kinnaman displayed the ingenuity of Alice, the beauty of Ginny and a sheer physical toughness that none of the heroines, before or since, have possessed. "I love the fact that I'm a part of the *Friday the 13th* history," says Kinnaman.

With Pam gone and Reggie trying to get some sleep, that leaves the stuttering Jake (Jerry Pavlon), who's trying to proposition Robin (Juliette Cummins) while they're watching an old movie on television. Robin rejects the ultra-sensitive Jake, who then wanders upstairs where he peeks in on the gothic Violet (Tiffany Helm) who's too busy perfecting her new-wave dance moves to notice anyone or anything around her. While Violet continues to dance, Jake turns away from the door, only to get a cleaver in the face, compliments of Jason.

Originally, the effect called for the cleaver to actually slice right down Jake's face. "That was a really good-looking effect that ended up being more of a reveal kill where you only see the corpse afterwards," says Lazzara. "There were a lot of good effects in the film that were cut out because

everyone knew they'd never make it past the MPAA. For us, the reveal effects weren't that hard because all we had to do was to make wounds and use lots of blood."

No would-be effect was more gruesome than that created for the death of Helm's character, Violet. "One of the creepy things about making the film was that the guy who played Jason would sometimes follow me around on the set, near the groves," recalls Helm. "My death scene was totally different than what was originally intended. I was dancing to music from a band called Pseudo Echo, which was good, and I was hoping that I'd get to be seen dying next to a Sex Pistols poster, but there were some rights issues. My death scene was hilarious." When Jason enters Violet's room, he calmly plunges a machete into her stomach in what is one of the more mundane and unspectacular effects in the film. The original version of Violet's death was to have been much more controversial and shocking. "The original script had me getting a machete right between the legs," recalls Helm of the menstrual flow from hell. "I still have pictures of that scene and it's so funny because the director just couldn't believe what he was seeing."

The graphic scene - and the inspired work of the effects crew - elicited a nervous reaction from Steinmann. "I freaked out when I saw the scene because I knew it would never get past the censors," he recalls. "I had to do a quick rewrite right then and there. It was a very powerful scene, but what's the point if you know there's no chance of it getting into the final cut?"

That leaves Robin who, totally unaware, walks into her room and climbs up onto her top bunk bed to sleep, breasts fully exposed. When she rolls over on her side, she comes face to face with poor wide-eyed Jake, whose bloody demise is finally revealed on camera. Robin then gets impaled by a machete that is thrust up from beneath the bunk. At least poor, sympathetic Jake achieved his dream of going to bed with Robin, albeit in bloody death.

According to Cummins, there was - like all of the other effects in *A New Beginning* - more than made the final cut. Cummins, who was good friends with Helm, spent two weeks at the film's makeup shop preparing for her grisly demise that, ultimately, never made it into the finished film. "They did a cast of my body and made several fake chests that were used for the scene," she recalls. "There was a hole in the top of the bunk so I just had to stick my head through where the fake chest was. It was my head, but a fake chest. I just watched while they started pumping blood out of the chest. It was about four in the morning, near Halloween, and raining like hell outside. They couldn't get the blood to come out in a way that looked good on camera and I think that's one of the reasons why the scene wasn't used." A year later, Cummins appeared in *Psycho III* where her character met a similarly gruesome death, in a phone booth. Says the actress, "I worked on *A New Beginning* for maybe two weeks and it's stayed with me for almost twenty years."

It is not long before Reggie wakes up and discovers all of the dead bodies, piled up in Tommy's room. Pam arrives back at the house at the same time and very quickly both of them, shocked and distraught, race to leave the house, only to find Jason kicking through the front door. The idea of putting the dead bodies in Tommy's room, his lair, was yet another attempt by Steinmann to raise his profile as a prime suspect. Another clue that appears to suggest that Tommy is the killer is that this Jason seems to be wearing a head-mask, and of course the audience knows that Tommy is an aspiring makeup artist on the side. "We based the head-mask more or less on what Tom Savini had used in *The Final Chapter*," explains Lazzara. "I re-sculpted it myself and it looks almost identical to the one in *The Final Chapter*, which is fitting since *A New Beginning* was, more or less, a direct sequel."

above:
Bloodbath at Pinehurst.

Pam and Reggie race out of the house with Jason (or, more accurately, Roy), in hot pursuit. They stumble through the bushes until they discover a road with Roy's ambulance, lights flashing, parked at the side of the road. When Pam investigates the vehicle she discovers Roy's partner, Duke, in the backseat; the same paramedic who'd mocked Joey's remains when he and Roy were putting Joey into the meat-truck. Duke's corpse is notably much more bloody and butchered than most of the other victims. A possible sign of Roy's grief and rage?

Pam and Reggie head back through the bushes where they discover Matt - his head spiked into a tree - and poor, sweet George whose eyes have been crudely gouged out. For Kinnaman and Morga, these scenes meant lots of stalking and slashing, especially when the action moves to a barn where Pam tries to fight Jason off with a chainsaw, a shining example of scream queen feminine independence. "Sometimes I'd be running, and I'd fall down, and the director would tell me to just keep rolling around in the mud," recalls Kinnaman, who later appeared in the 1989 Eric Roberts karate thriller *Best of the Best*. "They wouldn't cut a scene for anything. I'd just keep running with the camera rolling. The scene where I'm attacking Jason with the chainsaw was my favourite scene. After a while, the saw became piping hot and I was just staring at it and laughing and the crew was laughing too. My whole performance in *A New Beginning* basically consisted of me running, nothing but running, while rain machines were being poured over me," says Kinnaman, an accomplished stage actress and dancer. These outdoor scenes were accomplished with the help of gigantic water towers - strategically placed around the set on forty-foot tall mounts - that were used to simulate the rainstorm. Kinnaman continues, "The scenes where I fight Jason were so much fun to do because Jason was so much bigger than me and the thought of me fighting him off was ridiculous."

below:
Original American theatrical poster art for *Friday the 13th Part V: A New Beginning*. This uninspired generic design marked the lowest point in the marketing of the film series.

above:
Violet (Tiffany Helm) is grabbed by Jason Voorhees. Helm's character was originally supposed to have been killed by a machete thrust between her legs, but the sequence was deemed too graphic for release.

right:
Pam pulls Reggie to safety.

below:
Friday the 13th Part V: The New Beginning had the most kills of the first eight films in the *Friday the 13th* film series.

Jason does indeed manage to fight off the chainsaw, which loses power. Just as Jason is about to kill Pam and Reggie with his machete, Tommy appears near the barn entrance, ready to face his demons once and for all. "One of the hardest parts of playing Tommy was that I had little dialogue in the film so I had to project Tommy's emotions," says Shepherd. "I just thought about everything that happened to Tommy in the previous film, especially with the death of his mother, and I just tried to bring it into my performance." Jason whacks Tommy in the chest with his machete, sending him reeling on the floor. Just as Jason is about to pounce on him, Tommy rises up and drives a switchblade into his assailant's leg. Tommy then climbs up to the top landing where Pam and Reggie are hiding, as Jason - for once actually vulnerable to injury - hobbles after them.

Seeing that Tommy is seemingly out of commission, Jason turns his murderous attention to Pam and Reggie. "I remember an earlier scene - maybe the scene where I look up at Tommy who's staring down from a window - where I had to look straight up at the camera and I was laughing my head off," recalls Morga. "Well, Dick Warlock, the stunt coordinator, was standing there and he was mooning me so it was hard to stay inside the Jason character because I was laughing so hard. I had a lot of fun playing Jason and I think the other actors fed off of that except when we were doing the kill scenes. The biggest challenge in playing Jason in *A New Beginning* was the fact that it really wasn't Jason, but a real guy, so I tried to move normally,

limp a little because, in the barn scene especially, he's really hurt and, unlike the real Jason, I had to show that he's not indestructible. I got the job because Danny Steinmann liked the way I walked."

Morga - in what is surely one of the best performances of any of the Jason actors - beautifully displays Roy's frailties in the scene where Reggie uses a tractor to plough into Jason. Stuntman Ray Woodford filled in for Ross, but it was Morga who felt the impact, something he wanted to impart upon the pseudo-Jason. "That was the most physically tough scene because the tractor really ran into me," recalls the actor. "As far as who I was playing behind the mask, I really felt like it could've been anyone. Obviously, it was Roy, but what if Roy had secretly gone off and dug up Jason from his grave and, somehow, they were working together at different times in the story? You don't know. Maybe it really was Jason in some of those scenes."

Once Jason reaches Pam and Reggie, Pam tries to defend herself with a pipe, to no avail, and it looks like Jason is about to drive his machete through her skull until Reggie, out of nowhere, leaps out at Jason, the sheer momentum of his attack pushing Jason into clear air. When Pam and Reggie peer over the edge of the landing, Jason reaches out his hand and grabs Reggie's leg, trying to pull him down. It's at this point that Tommy finally assumes the mantle of hero as he rises up, machete in hand, and lashes out at Jason's exposed hand, causing the killer - whose mask has fallen off - to fall over the side and onto a row of spikes that lay, quite conveniently, on the floor of the barn. "We carried Jason's dummy-

above:
Tommy Jarvis (John
Shepherd) ponders a
career as Jason.

body along on a track," recalls mechanical expert Dave Nelson. "The body was carried about fifteen or twenty feet above the sharp spikes and, every time we tried it, the body landed on the spikes just perfect." Recalls Miller, "The body was rigged with blood packs, but it was dark in the barn when they filmed the scene and, as a result, the scene didn't turn out that bloody in the final cut."

Jason is dead. But as Pam, Tommy and Reggie look down at the corpse laying below, they see that the face belongs to Roy, the psychotic paramedic - driven over the edge by the sight of his dead, long-lost son, Joey. The irony of all of this, as ridiculous as it may seem, is that if Vic Faden hadn't axed Joey to death, no one else would've died. Too bad for the residents and staff at Pinehurst that Vic wasn't taking his medication.

Later that night, Pam and Reggie are at the county hospital, waiting on Tommy, while Sheriff Tucker calmly, and with a straight face, explains Roy's devilish motives. Pam then gets to visit Tommy in his room. As he opens his eyes, Tommy's calm expression rapidly darkens and, quite suddenly, he plunges a blade into Pam's chest. It was all a nightmare. Tommy wakes up, startled, and looks up to see a vision of Jason standing over him. Defiant, Tommy shakes off the hallucination and the image vanishes.

Or does it? When Pam enters the hospital room for real, the film ends with a shot of Jason's face, moving behind Pam, blade extended. The window has been broken open. Has Tommy finally assumed the identity of Jason for real? Not exactly. "Again, we had to leave the door open at the end of the film in case Jason was going to be brought back," says Steinmann. "Since *A New Beginning* really didn't have anything to do with the main *Friday the 13th* legend, as it related to Jason being the killer, we wanted to leave a few possibilities open. One of those was the idea of Tommy finally becoming Jason once and for all and another was the idea that Jason was still living from beneath his grave and that he could rise from his grave. There was also a bit of an idea of having Reggie's character being the killer because his brother and grandfather had been murdered, but I don't know how serious of an idea that was. Basically, we tried to leave all options open."

It's interesting to note that Shepherd himself contributed to the writing of the film's climactic scene. "Danny told me he hadn't settled on an ending for the film and he wanted my input," recalls Shepherd. "Michael Hitchcock, a fraternity brother of mine, and I came up with the cool idea of throwing the chair through the window to make it look like Tommy had busted out. I typed up a

scene, gave myself dialogue, and gave it to Danny who liked the idea, but not the dialogue, which he cut out. But he liked the scene and used it. I thought Tommy was possessed at the end of the film. I wasn't crazy about putting on the mask at the end, and was relieved when I saw the script for *Jason Lives* and saw that Tommy wasn't going to be the villain."

When *Friday the 13th Part V: A New Beginning* was released on March 22, 1985, it was greeted with an enthusiastic box office take of $8.0 million, but business rapidly fell off in the following weeks and *A New Beginning* ended up with a final haul of $21.9 million, the lowest total since *Friday the 13th Part 2*. *A New Beginning* would be the last *Friday the 13th* film to break the $20 million barrier, a clear sign of the rapidly diminishing popularity of the series. "*A New Beginning* was a turning point in the series in that we found out that the *Friday the 13th* films had a core audience that would go see the films, no matter what," says Mancuso, Jr. "Parts three and four did so well financially that I don't know if it's fair to compare the later sequels to them. Those films perfectly suited the mood of the public at the time that they were released. Again, I think one of the problems was with going from *The Final Chapter* to *A New Beginning* because it seemed to the audience - people who weren't a part of the *Friday* core audience - that the films were just going on and on."

It is worth noting that *A New Beginning* was the last instalment to be produced, officially, by Georgetown Productions, Inc. Aside from the first five *Friday the 13th* films, the company's only other official credit was the 1981 slasher film *Eyes of a Stranger*, which starred Jennifer Jason Leigh and Lauren Tewes of *The Love Boat* television infamy, and whose effects were handled by none other than Tom Savini. It should also be noted that *A New Beginning* was far from the most commercially successful horror film of 1985, as *A Nightmare on Elm Street Part 2: Freddy's Revenge*, released in November of 1985, grossed $30 million. Even the critically acclaimed comedy-horror film *Fright Night* made more money than *A New Beginning*. The message was obvious: It was either time to kill off the *Friday the 13th* franchise for good or bring back Jason in a new and exciting way, if that was possible.

A conclusion was rapidly reached: the makers of the *Friday the 13th* series would have to find a way to bring Jason Voorhees, the real Jason Voorhees, back from the dead, even if it meant going straight to hell.

Jason's Waking Life

If *Friday the 13th Part V: A New Beginning* marked the beginning of the slow but steady decline of the *Friday the 13th* series then 1986's *Friday the 13th Part VI: Jason Lives* was, at the very least, an enjoyable speed-bump in the downward spiral. Made and written with a tongue-in-cheek sensibility not present in any *Friday the 13th* film before or since, *Jason Lives* would, like *A New Beginning*, turn out to be an anomaly, but in a good way. To be sure, *Jason Lives* was, in general plot terms, cut from the same predictable cloth as all of the other tired *Friday the 13th* sequels, but it was all done in the spirit of good fun.

It didn't start out that way. Originally, the next film in the series was - according to Mancuso, Jr. and the other members of the production team - going to follow on directly from *A New Beginning*, with Melanie Kinnaman and Shavar Ross returning in their roles. "After *A New Beginning*, I was signed to be in *Part VI*, but the producers changed their minds," recalls Kinnaman. For his part, Ross had a better reason for expressly declining to make a return to the series, as he explains: "They asked me if I wanted to come back for another film, and I wasn't really against it, but then I found out that they were going to kill off Reggie. Even worse, he was going to be killed in the opening scene. I didn't want to be a part of that."

John Shepherd was also approached to reprise the role of Tommy Jarvis, but declined for personal reasons. "I actually thought the script was pretty good. I thought about doing the film for about thirty seconds until it became clear that we wouldn't be able to come to terms on the money issue. Honestly, I felt that one *Friday* was enough for me. I was working with Junior High kids up at Bel Air Presbyterian Church at the time and a couple of the mothers weren't nearly as impressed as the kids were that my picture was in the *Los Angeles Times* holding a machete," recalls Shepherd. "Soon after, I left acting and decided to go to seminary."

Friday the 13th Part VI: Jason Lives would end up going in a whole new direction, with one exception: Tommy Jarvis was going to return - an older, tougher and much less catatonic Tommy Jarvis. It's five years after the events of *A New Beginning*. Tommy Jarvis is free from the trappings of mental institutions and is fully determined to kill off Jason for good by burning Jason's bones into ashes.

Enter writer-director Tom McLoughlin, the man who would be responsible for steering *Jason Lives* into slightly more cheeky and irreverent waters. The then thirty-ish filmmaker had, more or less, grown up around the entertainment business, becoming an accomplished writer on various stage productions. In 1983, McLoughlin really gained the attention of Hollywood, and the owners of the *Friday the 13th* series, with *One Dark Night*, a thriller about a group of teenagers who spend a night in a spooky mausoleum. The film starred Meg Tilly, in one of her first roles. McLoughlin's debut as a feature film writer-director impressed Mancuso, Jr. who, along with all of the other parties, agreed that McLoughlin was the perfect director for the job. "They saw the film and really felt like I would bring something fresh and interesting to the *Friday the 13th* series," recalls McLoughlin. "I was a big fan of the *Friday the 13th* films and I was thrilled. Even more exciting was being able to script the film as well and, more than that, be able to put a different twist on the films. Aside from *A New Beginning*, which was co-written by the director, none of the other films had ever been written and directed by one person. It was an amazing opportunity."

below:
Jason Voorhees (C.J. Graham) rises from the bowels of the earth with a decayed new look in *Friday the 13th Part VI: Jason Lives.*

right:
Jason Voorhees wields
paint-baller Burt's
(Wallace Merck)
severed arm.

right:
Jason Voorhees wields
paint-baller Burt's
(Wallace Merck)
severed arm.

opposite:
Sheriff Garris (David
Kagen) takes Tommy
Jarvis (Thom Mathews)
into custody.

below:
Jason escapes from
his grave.

By this time, Don Behrns, a film industry veteran best known to horror fans for being a production manager on *Halloween*, was assigned the task of producing *Jason Lives*, which began filming in early 1986 in the peaceful surroundings of Covington, Georgia, a setting that would give McLoughlin and the *Jason Lives* production team an opportunity to create a unique-looking *Friday the 13th* film. "I wanted *Jason Lives* to have a very post-modern look and filming in Georgia allowed us to do that because it looks so different from the East Coast or California where they shot the other films," says McLoughlin. "I wanted to totally demystify Camp Crystal Lake and the legend of Jason." It's interesting to note that during production, *Jason Lives* operated under the name *Aladdin Sane* - McLoughlin's in-joke reference to a David Bowie album of the same name - for the purpose of avoiding unwanted publicity on the set.

Casting chores were handled, once again, by the team of Basker and Champion who, with the help of Mancuso, Jr. and McLoughlin, found a few

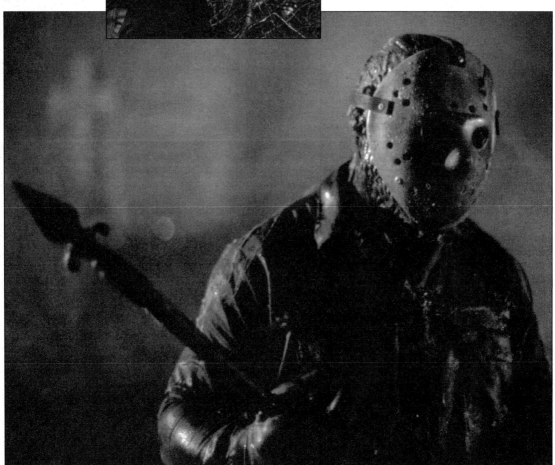

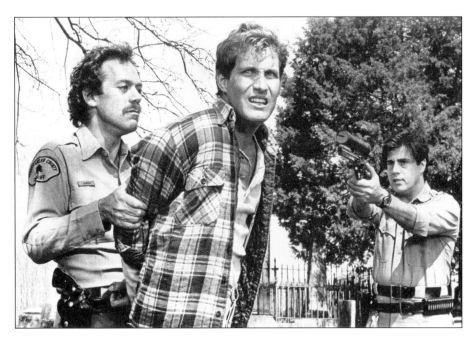

**FRIDAY THE 13th
PART VI:
JASON LIVES**
(1986)

Production Credits:
**Paramount Pictures
Presents. A Terror, Inc.
Production.**
Producer:
Don Behrns
Production Manager:
Iya Labunka
Production Co-ordinator:
Vikki Williams
Production Associate:
Ian McVey
Script:
Tom McLoughlin
Director:
Tom McLoughlin
First Assistant Director:
Martin Walters
Second Assistant Director:
Cathy Gesualdo
Second Second Assistant
Director:
Anthony Smoller
Director of Photography:
Jon Kranhouse
Additional Photography:
J. Patrick Daily
Underwater Photography:
Barry Herron
First Assistant Camera:
John Allen
Second Assistant Camera:
Lane Russell
Steadicam Operator:
Randy Nolen
Still Photographer:
James H. Armfield
Gaffer:
Jim Tynes
Rigging Gaffer:
Hugh Esco
Best Boy Electric:
John "Fest" Sandau
Electricians:
**Ronald J. Pure, John
Demps, Chuck McIntyre,
Brett Laumann, Irl Dixon,
David Pence**
Camera Equipment:
Otto Nemenz International
Editor:
Bruce Green
Assistant Editor:
Jonas Thaler
Apprentice Editor:
Susan Kurtz
Dialogue Editors:
**Greg Jacobs,
Barbara Barnaby**

interesting names to be in *Jason Lives*. Thom Mathews was cast in the role of Tommy Jarvis, having just scored a triumph in Dan O'Bannon's acclaimed 1985 horror-comedy film *The Return of the Living Dead*. "Thom was the perfect actor to play Tommy Jarvis in *Jason Lives* because he'd shown that he could do comedy and horror really well," recalls McLoughlin. For Mathews, a veteran of numerous B movies, being part of a second horror franchise was an offer he could not afford to pass up. "I knew it was something that, years later, people would remember me from," he says.

Jennifer Cooke was cast in the role of Megan Garris, a fact that would later fill the actress with some feelings of regret. "I hate horror films, but I thought that Megan was a hip and interesting character and it was a good paying job and I took it," says Cooke whose previous acting experience had included a recurring stint on the soap opera *The Guiding Light* and a supporting role on the cult science-fiction television series *V*, which also starred Robert Englund of *A Nightmare on Elm Street* infamy. "It was just a lot of me running around and screaming but, all in all, it was kind of fun in a goofy way and I just tried to act like a professional since I knew it was a film that was going to get a wide release." Cooke has since turned her attentions away from acting as, together with her husband, she founded the Celestial Seasons Tea Company. She has also written a book entitled *Cooking with Tea*, which was published in 1995.

In an inspired bit of horror casting the part of Tommy's institutionalized best friend, Allen Hawes,

was given to Ron Palillo who is best known to legions of pop culture addicts for playing the character Horshack on the cult television series *Welcome Back, Kotter*. "The 1980s were a nightmare for me," says Palillo, who has since gone on to become an accomplished stage performer and artist. "It was just one of those things where, after *Kotter*, it became impossible to break out of that until the whole retro thing made a comeback in the '90s. As for *Jason Lives*, it was just a job, but I was happy to be in a movie. I really felt a lot of sympathy for my character, Allen, because he was so desperate to belong and Tommy's his only friend and he's willing to die for him. The scene at the graveyard took a long time to film."

It's interesting to note that John Travolta is a godfather to one of Palillo's children and that Travolta's nephew, Tom Fridley, was cast in *Jason Lives* in the role of Cort. David Kagen, who has gone on to become one of the most respected acting instructors in Los Angeles, was cast as Sheriff Garris, Megan's constantly worried father and a continually disbelieving foil for Tommy Jarvis. "It was fun to play a strong character like Sheriff Garris," says Kagen. "I got to shoot Jason, fight Jason and get killed by Jason. I actually think that Sheriff Garris was, in a way, the hero of the story because he's willing to give up his life for his daughter."

When casting Jason, the makers of the film continuing to show faith in the 'size matters' adage. A then-unknown actor named C.J. Graham was chosen for the part, eventually. Early on, Graham thought that he had been given the job only to find

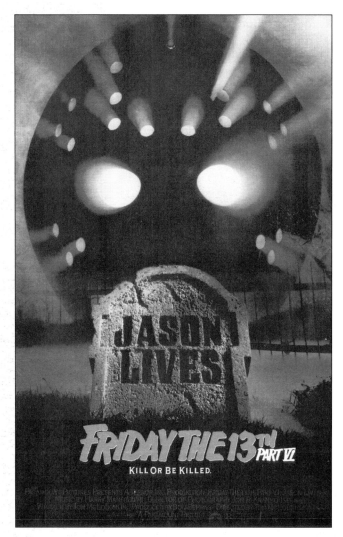

above:
American poster art.

opposite top:
Jason Voorhees studies
a severed appendage.

opposite bottom:
Effects experts Gabe
Bartalos oversees the
film's mask props.
(Photo courtesy of
Gabe Bartalos.)

overleaf:
Tommy Jarvis attempts to
cremate Jason Voorhees.

friend from the institution days, Allen Hawes. They arrive at a cemetery - Jason's cemetery - although in McLoughlin's original script, Pamela Voorhees's tombstone was also visible there. (Was someone supposed to have paid to have her body exhumed and moved to another cemetery?) With Allen watching in stunned horror, Tommy digs up Jason's grave, armed with a gas canister which he plans to use in order to cremate Jason. Once Tommy eyes Jason's rancid corpse, a dark rage wells up inside of him. Overcome with hatred, he tears a spiked rail from the front gate and uses it to impale Jason over and over.

Just as Tommy is about to incinerate Jason's corpse and turn him into a pile of ashes once and for all, Jason's maggot-covered eyes spring open. He's alive! Why didn't Tommy just leave him buried in the ground? Why hadn't Sheriff Garris or the Mayor of Forest Green (Crystal Lake has been renamed Forest Green by the spooked residents) ordered his body to be cremated years ago?

While Jason was being reborn, once again, it was up to the effects team - this time led by Jim Gill and Christopher Swift - to give Jason a new bloody look and provide the monster with some exciting targets. Bill Foertsch and Brian Wade also provided key makeup effects for the film while special effects expert Martin Becker looked on through the auspices of his company, Reel EFX, Inc. "The ratings board played havoc with *Jason Lives* in terms of what we could show," recalls Becker. "We didn't know what we could get away with and what would be cut. Eventually, Frank Mancuso would have to meet with us and we'd all have to go through the whole script, scene by scene, and figure out what we were going to do."

One of the most problematic scenes occurred within the graveyard sequence when Jason tries to perform a heart operation, without anaesthetic, on poor Allen Hawes. Although Jason, from a narrative standpoint, appears to rip out Hawes's beating heart, the visual evidence is scant. "The hand was supposed to blow right through the chest, holding the heart which Jason just tosses into the dirt," recalls Swift. "It was a very visceral scene because you see the heart, still warm, laying on the ground. The way it turned out, it's hard to see what Jason actually did to him."

Concerns over the MPAA's reaction to the film forced McLoughlin to shoot around most of the gory scenes. Even though the writer-director wanted to infuse *Jason Lives* with hip humour and numerous in-jokes, he was under no illusions about what *Friday the 13th* fans were expecting the film to deliver on a visceral level, especially given the cuts that had been made in the past few instalments. "I'm surprised that there was never an X-rated

out, much to his horror, that his position had been usurped. Stuntman Dan Bradley was originally cast as Jason in the film until executives at Paramount decided, after viewing initial dallies, that Bradley didn't have the right "body type" to play Jason in the film. "They'd cast someone else and I was really disappointed because I'd thought that I was the clear favourite," recalls Graham who, at six-foot-three and 218 pounds, certainly had the physical requirements to don the hockey mask. "They called me back a few days later because the guy that they'd hired just wasn't working out. He wasn't scary or physically commanding enough. I wasn't really an actor; I'd been managing a club when I decided to give acting a try. They offered me the job on a Friday and I had to be there by Monday to start filming."

Jason Lives opens with Tommy Jarvis frantically driving along an empty country road with his

version of the film released on video because the fans would've loved it," says McLoughlin. "I would often have to film scenes in two or three different ways because of ratings concerns. I wanted the film to be bloody and gory, but often times we'd shoot a great-looking effect and then Frank and the producers would shake their heads because we all knew it wouldn't get past the censors. We shot all of the killings in different levels of gore, just in case."

The opening sequence, set at the graveyard, was however actually shot by Frank Mancuso, Jr. due to some last minute scheduling conflicts with McLoughlin and his team. "It was great to get back in the field and get my hands dirty," recalls Mancuso, Jr. "It was no big deal. Tom and the others could've easily done it, but we were on such a tight schedule that it had to be shot then and there. Prior to that, I'd basically been involved with casting and choosing directors and scripts so it was great fun to get out of the office and shoot that scene."

Once Jason rises up from his grave, Tommy finds himself running for his life as a mysterious rainstorm further dashes any possibility of finding a way to cremate Jason. Tommy drives to the local Sheriff's office where he warns Sheriff Garris (David Kagen) that Jason's alive. Garris thinks he's crazy and locks Tommy up as we find out about the new town name of Forest Green.

Jason Lives is set over two nights with the only murder on the first night occurring when dazed and confused motorists Darren (Tony Goldwyn) and

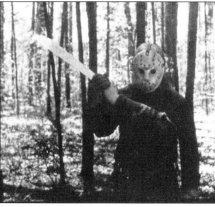

Lizbeth (Nancy McLoughlin, who is married to Tom McLoughlin) find themselves stuck in a ditch on a desolate road with Jason standing right in front of them. The scene represents the clearest example of the tongue-in-cheek humour that the director tried to inject into *Jason Lives*, as Lizbeth cracks a joke about the symbolism of a man in a hockey mask. Darren reacts in his own way, by pulling a gun out of the glove compartment, obviously feeling that the job of a camp counselor near the old Camp Crystal Lake grounds isn't to be taken lightly. "The scene where she says it's a bad sign when you see a guy in a hockey mask standing in the woods got a big laugh, along with the shot of an American Express card floating in the water which just cries out for the audience to say "Don't leave home

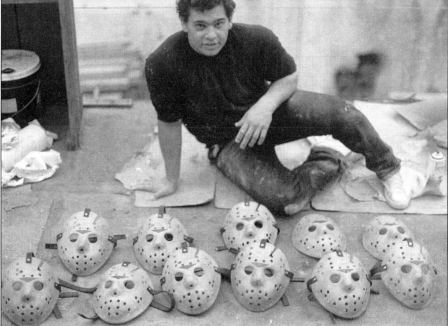

Foley Editor:
Margaret Carlton
Music:
Harry Manfredini
Sound Mixer:
James Thornton
Boom Operator:
Steve Halbert
Supervising Sound Editors:
Dane Davis, Blake Leyh
Assistant Sound Editor:
Laura Graham
Costume Designer:
Maria Mancuso
Costumer:
Danna O'Neal
Assistant Costumer:
Melissa Gleason
Hair/Make-Up:
Denise Van Arsdale
Hair/Make-Up Assistant:
Phyliss Temple
Special Effects:
Martin Becker,
REEL EFX, Inc.
Special Effects Make-Up:
Chris Swift, Brian Wade
Special Effects Make-Up
Assistants:
Gabriel Bartalos, Chris
Biggs, John Blake,
Barbara Bock, Thomas
Flountz, Bill Foertsch,
Jim Gill, Jim McLoughlin,
Richard Mayone, Steve
Sommerfield, William
Stoneham, Gail Taylor
Special Effects Mechanical:
David Wells, Ken Sher
Special Effects Mechanical
Assistants:
Gary Crawford, Thomas
Hartigan, Steve Jordon
Special Lighting Effects:
William Wysock
Titles:
Cinema Research
Corporation
Opticals:
MGM
Production Designer:
Joseph T. Garrity
Art Director:
Pat Tagliaferro
Set Decorator:
Jerie Kelter
Lead Man:
Robert Lucas
Set Dresser:
Wayne Frost
Seamstress:
Shari Griffin
Property Master:
Guy H. Tuttle

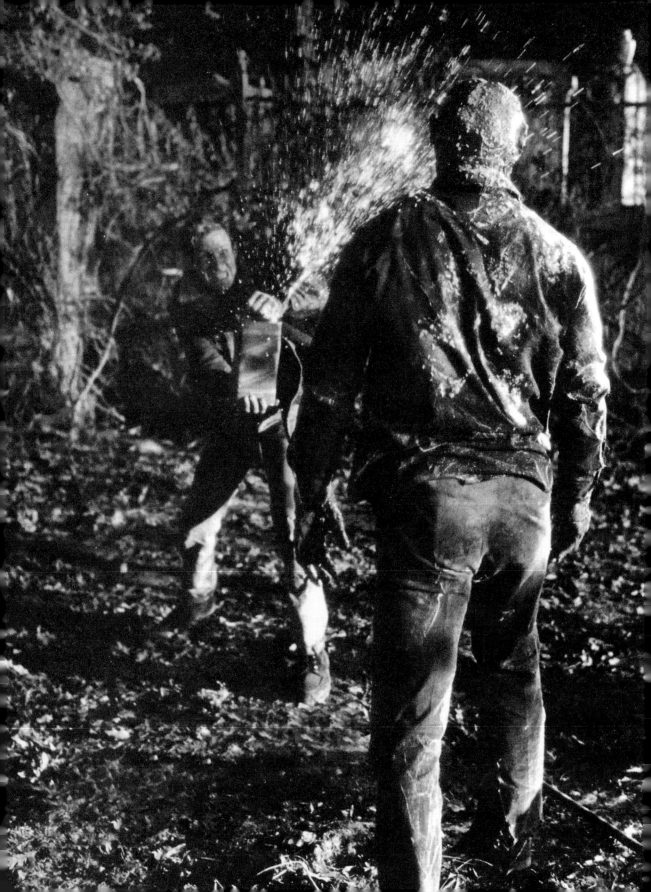

without it" and that got big laughs," says McLoughlin. "I loved doing that and it just seemed like the logical thing to do because, at that point, everyone knew who Jason was so why wouldn't the characters?" Jason impales Darren with a spear which he then turns on Lizbeth, although not before she tries to offer Jason her wallet. Apparently, Jason doesn't have much of a sense of humour.

The next day is filled with killings - virtually non-stop - as we move to the grounds of Camp Forest Green, which bears little resemblance to the original Camp Crystal Lake that *Friday the 13th* fans remember so fondly. "I wanted to come up with a new concept and look for everything associated with the *Friday the 13th* legend," says McLoughlin. "We shot the forest with interesting lighting, and lots of smoke, and we made the camp look really colourful. The films had become really formulaic and they all looked the same so I wanted this film to be set in its own time and place because Jason's story began here, at Camp Crystal Lake, and that was a long time ago. I wanted to let fans know that this was a new era."

Although much of the film was shot in and around Covington, Georgia, the actual Camp Forest Green scenes were filmed at Hard Labor Creek State Park which is located near Rutledge, Georgia. Amazingly, Rutledge only has a population of 700, give or take a few dozen slaughtered camp counselors. A lovely mosaic of pine and hardwood forest, the 5,800 acre-park area is the perfect setting for a *Friday the 13th* film with its man-made lakes and serpentine trails that move, circuitously, through twenty-four miles of pristine wildlife. "It was a lovely setting," recalls McLoughlin. "It had the perfect look for the new and updated Crystal Lake." The crew would eventually head back to Los Angeles, towards the end of the shoot, to film some watery closeups in a swimming pool for the film's finale.

One of the most curious plot-points in *Jason Lives* is Jason's burial, and just who exactly buried him. When Tommy returns to the cemetery the next day, he finds that Jason's dug-up grave has been filled over by - unbeknownst to Tommy - the shifty-eyed caretaker, Martin (Bob Larkin). As it turns out, Martin's working for Mr. Elias Voorhees, Jason's father and Pamela Voorhees's husband. How is this possible since we know, from the original *Friday the 13th* legend, that Pamela was a single mother? "I wrote a scene where Elias visits the graves and Martin's so scared because he's filled over the graves after Jason left," recalls McLoughlin. "I wrote Elias as this really evil-looking man with evil eyes who knows everything that's going on. He looks down at the grave and he knows that Jason's no longer buried there. We just

didn't use the scene. I don't think the producers felt comfortable about changing the course of the story that much because the basic formula of Jason just killing teenagers was so successful, but it would've been interesting." Novelist Simon Hawke included the appearance of Elias Voorhees in his official novelization of *Jason Lives* that was published in tandem with the film's release.

The sneaky caretaker, Martin, eventually gets a broken bottle driven through his throat by Jason in yet another scene that was crudely trimmed by the censors, along with a would-be mass decapitation of a trio of paint-ball players. It's interesting to note that Jason was played in this scene by Dan Bradley, the only scene he played as Jason in the film before being jettisoned in favor of Graham. "The effects guy had set up three bodies in a row with moveable heads," says McLoughlin. "It was a great setup. The blade moved along the track and hit the trips which causes the bodies to fall down and the heads to fly right off, but it never made the final cut. That was one of the scenes that was most robbed of its impact and power because of the cuts, but that's the way it was and we didn't make any excuses. A good horror film doesn't rise or fail solely on its effects, and I felt like we had an interesting enough story with which to make up for the lack of really gory effects shots."

One of the most interesting things about the character of Jason in *Jason Lives* is the fact that, unlike in the previous sequels, this time around the killer was virtually indestructible. It didn't seem like he felt any pain. "I wanted Jason to be a much more formidable monster in the film," says McLoughlin. "He's been reborn and it was kind of silly in the previous films the way he would always get beaten up and knocked down by the heroine at the end when before he'd been killing everyone in sight. I didn't want Jason to just be a guy in a mask. I wanted him to be an unstoppable monster and then have Tommy try and figure out how to kill Jason which, of course, ties in with Jason's original resting place: the bottom of the lake."

Unfortunately, C.J. Graham, the man behind the mask, wasn't so impervious to pain. "I don't know if you've ever been shot before, but there's an amazing amount of impact," says Graham. "I would get shot in the film and the crew would hook me up with jerk cables that would hit me with hundreds of pounds of pressure. The impact was powerful, so much so that I had to get my body used to it over the course of time because it can knock you out."

What *Jason Lives* lacks in gory effects, it tries to make up for in body count as the numerous action scenes and kills occur in and around Camp Forest Green. In a classic example of the new-and-improved powers and strength possessed by this

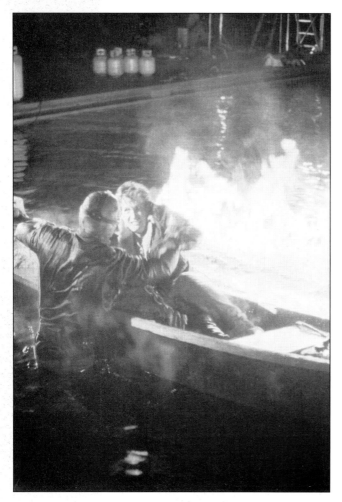

above:
Tommy Jarvis and Jason Voorhees battle in the waters of Crystal Lake.

opposite top:
Megan Garris (Jennifer Cooke) tries to rescue Tommy Jarvis from Jason.

opposite bottom:
Allen Hawes (Ron Palillo) gets his heart ripped out by Jason.

right:
Lizbeth (Nancy McLoughlin) attempts to negotiate with Jason for her survival.

from the ratings board that awaited the film. Basically, McLoughlin would film three different versions: a PG-13 version, an R version and a no-holds-barred X rated version obviously intended for some future uncut release of the film. One of the most humorous examples of the war between the MPAA and *Jason Lives* occurred in a scene featuring a cabin literally drenched in blood. "Tom wanted that cabin to be very bloody, the walls covered with blood," recalls Swift. "By this time, we were starting to have fun with the effects even though we know most of it wasn't going to make it into the finished film. Tom would let us shoot scenes that were really bloody, just to have them on camera. Anyway, I went into the cabin, looked around, and then I just started spraying body parts everywhere along with bloody chunks. It was too gross so, in the finished film, we don't really see a clear shot of the cabin."

Regardless of its trimmed scenes and would-be versions, the central conflict in *Jason Lives* is between Tommy Jarvis and Jason Voorhees, and that's how the film would end: a fight to the death between Jason and Tommy for which the symbolic lake is a fitting battlefield. Jason is lured to the lake where Tommy awaits in a boat. The killer is on the verge of throttling Megan to death when Tommy's image appears in the water. The mere sight of Tommy, in that setting, totally enrages Jason who, instinctively, marches through the lake to get Tommy, who has used combustible material to set fire to the water around the boat. "I was just worried about the boat not tipping over," says Mathews. "I was also worried about the health of the guy playing Jason because he was really on fire." When Jason springs up from the watery depths, he's covered with fire and so was Graham. "That scene was done in one take," recalls the actor. "They set my back on fire, but it wasn't too dangerous because of the water. If it ever became too much, I'd just go under the water. There were a lot of tough stunts, and I was shot and thrown through doors and walls. The good part was that the filmmakers would always talk about the stunts with me before we did them so I was never really that scared."

Jason, we see him crash and burn a large van whose occupants, the young lovers Cort (Tom Fridley) and Nikki (Darcy DeMoss), have already been crudely dispatched by Jason via a hunting knife in the head and a face-through-the-wall, respectively. As the burning van hurtles along the road, Jason triumphantly appears out of the flames. Jason's message is clear: I am Jason. Feel my wrath.

Back at Camp Forest Green - while Megan and Tommy are trying to figure out how to destroy Jason - Sheriff Garris arrives, trying to stop Jason and, more importantly, save his beloved daughter, Megan. It eventually costs the brave Sheriff his life when Jason literally breaks Garris in half. Originally, Garris's fate was going to be much worse. "You were supposed to see the Sheriff's legs thrashing back and forth," recalls McLoughlin. "Then we were going to have Jason bend his spine right back so the Sheriff's face touches his feet. It was really horrific, but it was cut out."

As previously mentioned, McLoughlin would often film different versions of key scenes featuring effects sequences, to prepare for the inevitable cuts

When *Friday the 13th Part VI: Jason Lives* was released on August 1, 1986, it received a bruising reception from the paying customers who obviously felt that - despite new tongue-in-cheek promotional campaign - *Jason Lives* was just another tired stalk-and-slash festival, and worse yet, one that had been castrated by the MPAA. That's not to say that *Jason Lives* was a failure, although it was the first *Friday the 13th* film to fail to surpass the $20 million barrier at the box office. *Jason Lives* made $6.7 million on its opening weekend and, unlike its most recent predecessors, was able to hang on to its audience for a few weeks on its way to a final gross of $19.4 million.

Perhaps the person who benefitted most from *Jason Lives* was McLoughlin who, along with Steve Miner, has been able to carve out a prolific career for himself in and out of horror. Following *Jason Lives*, McLoughlin wrote and directed the 1987 fantasy film *Date with an Angel*, which starred Phoebe Cates and French screen icon Emmanuelle Béart. Though the film was a box office flop, it has since become a minor cult classic and McLoughlin has enjoyed a varied directing career, in film and television, that includes such diverse efforts as the 2001 Andy Garcia thriller *The Unsaid* and the 2002 made-for-television film *Murder in Greenwich*, which was based on the much discussed Martha Moxley murder case. "*Jason Lives* was a great opportunity to show what

As the protagonists continue their battle, Tommy's makeshift boat splits open and the two mortal enemies sink into the water with Tommy trying to fasten a boulder-leaden, chain-noose around Jason's sturdy neck. The boulder pulls Jason down, but he still won't let go of Tommy. Finally, Jason's grip seems to weaken and Tommy appears at the surface of the lake, unconscious, while a terrified Megan watches from the shore. "The scenes in the water were just horrible to do," recalls Cooke. "All I had on was a coat and my pants, and we were filming in a cold lake in Georgia at two or three in the morning and then we went back to Los Angeles, up at the pool at USC, to do more water scenes in a swimming pool." Recalls McLoughlin, "When I ran out of time, and I needed a few more close-ups, we went to my parents' house and used their pool to finish the scene."

Megan swims out to Tommy, not knowing if he's dead or alive, but before she can find out, Jason grabs her leg, pulling her down into the murky depths. Desperate, Megan makes a grab for the boat's hull, yanking on the boat's motor, causing a now-spinning propeller blade to slice into Jason, ripping through him. Megan is free and Jason has been defeated, left to rot in his proper burial place. "The bottom of the lake was where it all began for Jason and that's where I felt it should end," says McLoughlin. "It was the only fitting place for Jason and Tommy to have their final confrontation and for Tommy to exorcise his demons once and for all." Megan drags Tommy back to shore where she applies mouth-to-mouth, which causes Tommy to slowly reawaken. For Tommy, the nightmare was over, but for fans of the *Friday the 13th* series, the legend of Camp Blood was far from over.

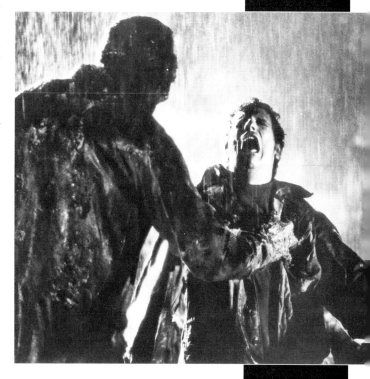

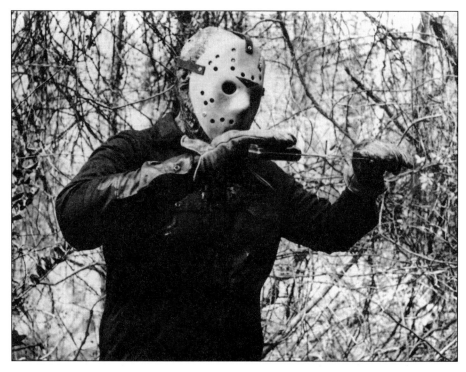

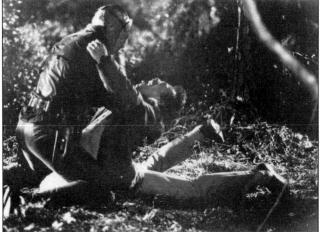

I could do and I'll always be very grateful to it," says McLoughlin. "Even though I like working in lots of different genres, I'll always love horror and I'll always be a *Friday the 13th* fan." Recently, McLoughlin - who also co-scripted the 1997 children's fantasy film *FairyTale: A True Story* - was slated to direct *Exorcist: Dominion*, a 'prequel' in the *Exorcist* film series that was, ultimately, turned over to director Paul Schrader.

One person who was suitably impressed with McLoughlin's take on the *Friday the 13th* series was composer Harry Manfredini. "Tom brought a certain wit and intelligence to *Part VI* that I found very enjoyable," says the composer who tried to capture, with his music, some of McLoughlin's campy, no pun intended, humour. "I know that Tom had a test screening and the results weren't good and the entire film was changed from its original concept. I think what happened was that the test audiences didn't particularly like the film and so Tom went back and added some kills to beef-up the body count. It was tough because I think that Tom wanted to add a lot of character and story to the film, but that's really not what they're about in terms of making the audience happy. Musically, I just tried to go along with what Tom was doing which was tough because scenes were constantly being changed or rewritten. Still, it's one of my favourite *Friday the 13th* sequels and I thought Tom did a really good job under difficult circumstances."

What of the *Friday the 13th* franchise, following *Jason Lives*? There would be more movies, certainly, but with dwindling box office figures, and ebbing fan interest, Jason was in dire need of a cinematic resurrection. At the dawn of 1987, Freddy Krueger was in full command of the horror landscape, both commercially and critically. Jason, it seemed, was in danger of drowning, but not without a fight. For the next sequel, the makers of the *Friday the 13th* film series decided to create a new opponent for Jason in the form of a psychic. Jason Vs. Carrie? Sort of.

Jason vs. Tina

By the end of 1987, the *Friday the 13th* franchise seemed to be in good shape. There was, however, some serious competition. In February of 1987, *A Nightmare on Elm Street 3: The Dream Warriors*, directed by Chuck (*The Mask*) Russell, had been released, taking in an astounding $44.8 million at the American box office - far more than any *Friday the 13th* film had ever earned. While the *Nightmare on Elm Street* franchise was about to propel a then minor-league New Line Cinema to major status, it was a sobering fact that the box office receipts for the *Friday the 13th* films had been declining year after year.

Still, there was nothing to deter Frank Mancuso, Jr. and Paramount from making another film in what was still, after all, a profitable franchise (comparisons to the lofty heights being attained by the *Nightmare* franchise notwithstanding) and so, in December of 1987, production began on *Friday the 13th Part VII: The New Blood*. Were the makers of the film scared of Freddy and his newfound commercial muscle? Hardly. If anything, the makers of *The New Blood* sought, early on, to take a unique approach to fighting Freddy Krueger: If you can't beat 'em, join 'em. *A New Blood* was originally supposed to be *Freddy Vs. Jason*, fifteen years early. Such is the nature of the movie business however that back in 1987 Freddy and Jason just wouldn't be able to get along.

"We couldn't come to terms with New Line about how to proceed with a *Freddy Vs. Jason* film," says Mancuso, Jr. "It just couldn't get worked out because both sides felt possessive of the series and the money that the films had made for the companies. Both companies wanted to distribute it and own it and it just fell apart. There were no hard feelings. I think both sides wanted it to happen, but that's the way it goes." As a result, the development work started to head in a new direction, and instead of a proposed *Freddy Vs. Jason* film, a *Jason Vs. Carrie* film began to shape up, more or less. *Jason Vs. Tina* would be more accurate.

In choosing a director for *The New Blood*, Mancuso, Jr. was undecided until he screened *Troll*, a low-budget horror film that was given a theatrical release in 1986 where it performed surprisingly well given its origins. The film had been directed by John

Carl Buechler who was also a respected makeup effects expert. At around the time Mancuso, Jr. was made aware of Buechler's work in *Troll*, Buechler had been in Rome, finishing up *Cellar Dweller*, a turgid horror film that was released in 1987. *Cellar Dweller*, *Troll* and another Buechler-directed effort, the unspeakably awful *The Dungeonmaster*, were dishevelled remnants of Charles Band's crumbling Empire Pictures outfit. Nevertheless Mancuso, Jr. was impressed with Buechler's track record, especially *Troll*'s box office success, so he called Buechler's agent and offered the director a job on *The New Blood*.

Initially, Buechler was a little sceptical about directing 'another' *Friday the 13th* sequel. "I asked Frank for a meeting and I told Frank that I wasn't at all interested in doing a sequel that was nothing more than a rehash of the other *Friday the 13th* sequels," he recalls. "My agent almost had a heart attack and I thought I'd lose the job right there, but Frank liked what I had to say and he was open to the idea of taking the franchise in a different direction. I think the main reason I got the job was because of my strong effects background. They knew I could direct and handle lots of effects."

below:
Maddy (Diana Barrows) is attacked by Jason Voorhees (Kane Hodder) in *Friday the 13th Part VII: The New Blood*.

above:
Director John Buechler instructs actors Susan Blu and Lar Park Lincoln on the set of Friday the 13th Part VII: The New Blood.

opposite:
Jason feels Tina Shepard's rage.

Although the idea of introducing a psychic heroine to face Jason might have seemed like a fresh approach for the *Friday the 13th* franchise, the sad fact is that *The New Blood* is nothing more than a cinematic sheep in wolf's clothing. Aside from briefly exploring the psychic angle in the storyline, the basic plot of *The New Blood* was more of the same: a group of vacationing teenagers arrive in Crystal Lake for some fun and sex, unaware of Crystal Lake's bloody history. (Why haven't the characters in the *Friday the 13th* sequels seen the other *Friday the 13th* films since, demographically, they're the franchise's target audience?)

To be fair, there were a few new wrinkles in the structure of *The New Blood*, and they all centre around the character of Tina Shepard. Lar Park Lincoln was cast as the heroine, and the Dallas-born actress was no stranger to the horror genre having appeared in 1987's *House II: The Second Story*. When Lincoln read the script for *The New Blood*, she wasn't even sure what it was. "I'd done some auditions, but I hadn't heard anything so I'd gone back home to be with my husband and family in Dallas," she says. (Sadly, Lincoln's husband passed away in the mid-1990s from cancer.) "I got the script and I just gave it to my husband. It was called *Birthday Bash* so I didn't know what it was about, but my husband read it and said, 'Yeah, this is definitely the *Friday the 13th* movie.' They liked to use different names so the fans wouldn't find out and storm the set."

By the time Buechler had joined the team, the storyline was being re-worked into screenplay form by writer Daryl Haney. "The result of the *Freddy Vs. Jason* project was to turn Freddy into Carrie who became Tina," says Buechler. "It's ironic that I also worked on *A Nightmare on Elm Street 4: The Dream Master* because I could compare the similarities of the films in terms of the story. Both films are about heroines who take on special powers which they use to fight the monster. In *The New Blood*, Tina's able to fully harness her telekinetic powers by the end of the film and she uses the powers to defeat Jason which is what happened, more or less, in *The Dream Master*." Another proposed outline had Jason mysteriously attacking a condominium complex, an odd premise that, thankfully, never made it past the talking stages.

above:
Tina Shepard (Lar Park Lincoln) and Nick (Kevin Blair) plot their strategy against Jason Voorhees.

right:
Michael (William Butler) gets spiked by Jason.

Lincoln was intrigued that her character, Tina Shepard, was a departure from the typical *Friday the 13th* heroines, particularly in regards to her telekinetic powers, an aspect that prompted Lincoln to carry out some research on the topic of psychic phenomena. "That was the most interesting part - getting to learn about psychics," she says. "I knew how important Tina's telekinetic powers were to the character so I went out and met with real psychics and learned about psychic visions and the way that psychics can relate their visions because it's one thing to have a vision and another to be able to explain it. The people I met, I don't know if they were really psychics, but it was an interesting experience just to be around them."

Other major roles went to Susan Blu, who was cast as Tina's doting mother Amanda Shepard, and Terry Kiser who was cast in the villainous role of Dr. Crews, a scheming shrink who wants to harness Tina's powers for his own diabolical purposes. Blu's role in *The New Blood* marked a rare live-action appearance for the actress who's best known as an acclaimed director and voice-over artist on numerous animated television series including *Spider-Man: The Animated* Series and *Teenage Mutant Ninja Turtles*. Kiser on the other hand was a veteran character actor, *The New Blood* marking his second straight genre appearance after appearing in the 1987 horror film *The Offspring* (which notably starred Vincent Price and was directed by Jeff Burr of *Leatherface: Texas Chainsaw Massacre III* infamy). Kiser would become most well known for his role in the 1989 comedy film *Weekend at Bernie's*, in which Kiser played the titular corpse. "I liked playing the villain in the film because Dr. Crews was really depraved," says the actor. "Before, I was primarily known for my comedy roles, but ever since *Friday the 13th*, I've played more and more villains."

The rest of the *New Blood* cast was comprised of young actors who, for the most part, had some genre experience. Kevin Spirtas was cast as Nick, *The New Blood*'s young male lead who - like the male heroes from the previous two entries in the series - would ultimately live to fight another day. Spirtas was credited as Kevin Blair in the film as the actor's birth-name is Kevin Blair-Spirtas, but the actor dropped the Blair part of his name, professionally, as of the early '90s.

Prior to his appearing in *The New Blood*, Spirtas, a St. Louis native, had appeared on Broadway, eventually becoming a stunt performer before appearing in Wes Craven's disappointing 1985 sequel *The Hills Have Eyes Part II*, widely regarded as one of the worst horror films of the revered director's career. "I'd done stunts before and I think they liked that," says the actor who,

today, is best known for his work on the long-running NBC soap opera *Days of Our Lives*. "It was a very physically demanding shoot, especially being in the woods of Alabama. I'm glad I'd done so much theatre before doing the film because the film really hasn't typecast me like so many of the other actors even though I've done more horror films since. It was a starring role in a feature film."

The members of the *The New Blood* cast who could claim to be horror veterans were William Butler and Heidi Kozak who played, respectively, the characters of Michael and Sandra. For her part, Kozak, a striking blonde in the grand tradition of slasher movie victims, had starred in 1987's *Slumber Party Massacre II* alongside *A New Beginning*'s Juliette Cummins. Kozak retains a few bad memories about her *Friday the 13th* experience: "I almost caught pneumonia," she recalls. "I came down with a bad case of hypothermia when I swam in that lake because it was freezing. I didn't have any problem screaming when it came time for my character to die." As for Butler, he had appeared in *Prison* with fellow *New Blood* co-star Kane Hodder. He also had prior experience in the industry as a makeup artist, and he knew Buechler from time spent with the director at his MMI (Mechanical and Makeup Imageries) which, today, is now known as Magical Media Industries) Studios, the company that handled *The New Blood*'s effects.

Butler found *The New Blood* a nice way to make the transition from effects expert to actor. He has gone on to appear in such films as *Leatherface:*

FRIDAY THE 13th PART VII: THE NEW BLOOD (1988)

Production Credits:
Paramount Pictures Presents. A Friday Four, Inc. Production. A John Carl Buechler Film.
Producer:
Iain Paterson
Production Manager:
Rebecca Greeley
Associate Producer:
Barbara Sachs
Production Associate:
Thomas Irvine
Script:
Daryl Haney, Manuel Fidello
Director:
John Carl Buechler
1st Assistant Director:
Francis R. "Sam" Mahoney
2nd Assistant Director:
Todd Amateau
Director of Photography:
Paul Elliott
1st Assistant Camera:
Edward Giovanni
2nd Assistant Camera:
Giles Dunning
Still Photographer:
Michael Ansell
Second Unit Camera Operator:
Thomas L. Callaway
Second Unit 1st Assistant Camera:
Harry K. Garvin
Gaffer:
John Drake
Key Grip:
Curtiss Bradford
Best Boy Grip:
Anthony Caldwell
Grips:
Renton-Paul Medcalf, Christopher Kiperman, Monte Bass, Henry De Bardeleben, Kevin Whitlow
Best Boy Electric:
Don Cely
Electricians:
Oliver Peale, Ali Farboud, Carl Johnson, Nick Nelson, Robert Pugh
Editors:
Barry Zetlin, Maureen O'Connell, Martin Jay Sadoff
Music:
Harry Manfredini, Fred Mollin
Boom Operator:
Gail Dalton Brodin
Recordist:
Mark "Frito" Long

Texas Chainsaw Massacre III and Tom Savini's 1990 *Night of the Living Dead* remake. "I'd been helping out John Buechler at his shop, and John knew about my acting aspirations," he says. "When John got the movie, he agreed to give me an audition and so I read for Frank Mancuso, Jr., and the casting director, and I got the job. It was funny because, when I auditioned, I had to pretend that Jason was killing me, a big part of the role, and it was so hard to stop from laughing because there were all of these suits surrounding me. They weren't exactly scary."

When Butler appeared with Kane Hodder in *Prison*, neither of them, could have imagined that Hodder would be destined to wear the hockey mask of Jason Voorhees. Casting Jason for *The New Blood* was probably less traumatic on this occasion than any of the previous attempts. What no one could have predicted is the way that Hodder would transform the role, or indeed what an impact it would have on the actor's career, as he would go on to appear in three more *Friday the 13th* films after *The New Blood* before being supplanted by Ken Kirzinger who would don the hockey mask for 2003's *Freddy Vs. Jason.*

Playing Jason was just a case of the veteran actor-stuntman discovering the monster inside of himself - the inner Kane Hodder. It helps that he is six-foot-three and weighs 210 pounds. Not the largest man ever to play Jason, but certainly the fiercest. "I tried to get in touch with Jason's thirst for revenge, the motive behind his need to kill everyone in sight," says Hodder. "When I read the script for *The New Blood*, I knew this was going to be a little different than me just doing a bunch of stunts. In this film, Jason's in a real battle with this girl psychic and he's kind of met his match."

Hodder put into practice some of the tough lessons he had forced himself to learn whilst working with Buechler on *Prison*. "I played a dead monster in that one and John did the makeup and he was impressed with how I acted inside the makeup because John and his team put me through hell in that film," he recalls. "They covered me with dirt and worms in that one because my character was rising up out of the ground. Having worms come out of my mouth was really my idea and I think everyone on that film was sick to their stomach when I did that, but I wanted it to look as disgusting as possible because that's who the character was. I took the same approach when I played Jason. I think John and the producers were looking for a Jason who could, first and foremost, do his own stunts. I was the right size and shape they were looking for, but I'd also had a reputation as someone who could do any kind of stunts, especially dangerous fire stunts. I watched the other films to see what I liked and didn't like about the other Jasons. I wanted my Jason to be much more agile and quick on his feet than the previous Jasons."

Buechler feels that Hodder had a natural affinity for the role. "We couldn't have had all of the fire and psychic projection stuff if we hadn't had a guy like Kane playing Jason," asserts the director. "I wanted to go over-the-top with the effects sequences and I needed a Jason who was like a man of steel, able to do all of the physical stuff.

When Hodder put on Jason's hockey mask, it sometimes caused a tangible change to take place inside the otherwise kind-hearted actor-stuntman - a creepy presence that scared everyone on *The New Blood* set, not just the cast and crew. "I tried to be scary, but sometimes people would stumble onto the set and they'd be terrified of me, only when I had the mask on," recalls Hodder. "There's a famous story from *The New Blood* when I had to walk along this dirt road to get back to my trailer. One night, instead of using the road, I walked through a trail in the woods, wanting to stay in character. Well, a man approached me while I was walking along in my Jason outfit and he asked me if I was in the movie. He was scared. I didn't say a word and all I did was tilt my head like Jason would do. Finally, he asked me another stupid question and I just lunged for him and he took off screaming. I don't know who the hell he was, but the next day, Buechler told me that the local Sheriff was supposed to come by for a set visit, but he hadn't shown. Was that guy the Sheriff? I don't know."

Another interesting casting note is that Marta Kober, *Part 2*'s after-sex impaling princess, was initially offered a part in *The New Blood*, the casting directors oblivious to the fact that she had starred and been killed in *Friday the 13th Part 2*. "Yes, my agent actually sent me out to read for *The New Blood*, and they liked me, and I had the job," recalls Kober. "They didn't know I'd been in the previous film, and I felt bad about not telling them so I told them because I knew they would've been upset if they'd found out later."

Musically, Harry Manfredini's unbroken run of scoring *Friday the 13th* films was interrupted, in a sense, in that Manfredini shared credit with composer Fred Mollin, who would later serve as composer for *Friday the 13th: The Series*, and, in 1989, would go on to compose the score - without Manfredini's input - for *Friday the 13th Part VIII: Jason Takes Manhattan*. "They told me they wanted a bigger, more explosive-sounding score," says Mollin. "I tried to come up with a theme for Tina because she was a psychic and I felt like she'd project a certain aura since there had never been a character like her before in a *Friday the 13th* film. For the rest of the score, we mixed in Harry Manfredini's tracks from parts one, two, four and six and the score was kind of a mix of all of the *Friday the 13th* sounds."

Once again, the story opens with rapid-fire clips and echoes from the previous *Friday the 13th* films, which is odd since one wonders how many people watching *The New Blood* would not already be very familiar with the thin and well-known

Re-Recording Mixers:
Wayne Heitman,
Stanley Kastner
A.D.R. Foley Mixers:
Gary Gegan,
Matt Patterson
Make-Up/Hair:
Jerrie Werkman
Costume Designer:
Jacqueline Johnson
Wardrobe Supervisors:
Marcy Craig,
Debra L. Wright
Special Make-Up Effects by:
Magical Media Industries
Incorporated
Mechanical Effects:
Image Engineering Inc.
Mechanical Effects
Co-ordinator:
Lou Carlucci
Titles:
Precision Image
Titles and Opticals:
Motion Opticals Inc.
Production Designer:
Richard Lawrence
Visual Consultant:
Pamela O'Har
Assistant Set Decorators:
Albert Cummings,
Terry Tubbs
Swing Gang:
Gene Bishop, Barton
Hilliker, Les Godwin,
Sylvia Lawrence
Construction Co-ordinators:
Jaime Bird, James Beggs
Paint Foreman:
Larry Clark
Construction Painter:
Frank Costello
Property Master:
Batia Grafka
Prop Man:
Cesar Alava
Key Costumer:
Donna Barrish
Set Construction:
Scene Docks Unlimited,
Bayshore Construction
Stunt Co-ordinator:
Kane Hodder
Stunts:
Alan Marcus, Bobby
Bragg, Karen Garrett,
Steve Hulin, Maria Kelly,
John Sistrunk, Jeannie
Malahni, Tod Keller, Tracy
Hutchinson, Paul Short,
Paula Marie Moody
Script Supervisor:
Susan Lowitz
Assistant to the Director:
David Ronan
Set Production Assistant:
Franklin Vallette
Production Co-ordinator:
Shalini Waran

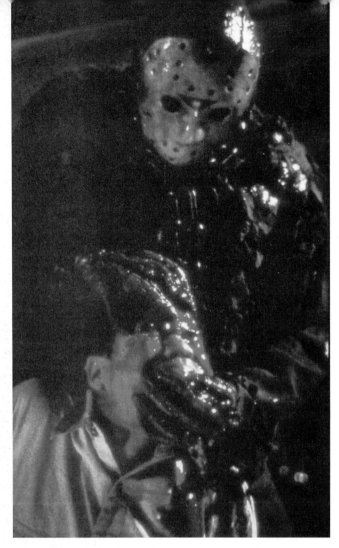

above:
Ben (Craig Thomas) gets
his head crushed by
Jason Voorhees.

opposite:
Jason displays a grisly
souvenir.

premise of the series. All the same, the opening narration is an interesting *Friday the 13th* footnote since the voice belonged to none other than Walt Gorney or, as the actor would forever be known until his death in 2004, Crazy Ralph: Crystal Lake's Prophet of Doom.

Preliminaries aside, *The New Blood*'s opening scenes are set approximately eight years before the events of *Jason Lives* although, with all of the leaps through time in the *Friday the 13th* series, it's hard to believe that the makers gave any serious thought to the chronological relationship between the various films. "I think there are mistakes in the films, particularly with time, and I think that's because the films were often rushed," says Buechler. "The script for *The New Blood* was written very quickly and I was constantly having to rework it because there was stuff that I didn't think made sense. A lot of the writers who work on these kinds of scripts feel that they're too good for the genre so you need directors who really care about

the material to steer the films in the right direction because, sometimes, no one cares." It's interesting to note that writer Daryl Haney shared screenplay credit on *The New Blood* with a writer named Manuel Fidello, a ghostlike pseudonym. Haney wrote virtually all of *The New Blood*'s script with Buechler making changes and revisions up to and including the start of filming.

The film starts, allegedly, at Crystal Lake in 1989, where the drunk and unruly John Shepard (named after *A New Beginning*'s John Shepherd) lives with his wife, Amanda, and their seven-year-old daughter, Tina. When John becomes abusive, an angry Tina - already showing signs of awesome telekinetic abilities - causes a fatal accident when she uses her powers to collapse the dock that John is standing on, sending him plummeting into the watery abyss. The aftermath of the tragedy finds a traumatized Tina being shuttled between various mental hospitals for treatment, the girl forever blaming herself for her father's death.

A full ten years pass before seventeen-year-old Tina returns to the old family house next to Crystal Lake, with her mother and the sinister Dr. Crews. Soon, a group of teens converge on a nearby house and the scene is set for another round of carnage as, unbeknownst to everyone including the Crystal Lake police department, Jason's body is still trapped at the bottom of the lake, a result of the killer's confrontation with Megan and Tommy during the finale of *Jason Lives*. Unfortunately for Tina (and all of the victims that would ultimately pile up in *The New Blood*), she tries to purge her guilt by using her powers in an attempt to resurrect her dead father from the bottom of the lake. Instead of resurrecting her father however, she resurrects Jason, who has another bountiful assortment of victims to choose from, but soon discovers that Tina is a lot more dangerous than she looks. "The idea of Tina's guilt about her father was very interesting," says Lincoln. "It gets even worse by the end of the story because so many people die, including her mother, and it's really her fault because she brought Jason back."

Filming took place in and around Point Clear, Alabama, although all of the interior shots were done when the crew eventually returned to Los Angeles in early March. Why Alabama? "It would've been easier to shoot in Los Angeles, but I wanted that feel and look of mother nature," says Buechler. "I also needed a lake and I needed to do some big stunts, blowing stuff up, so it was much easier to find some quiet place in the woods. That wouldn't have been possible in Los Angeles given the fact that we only had $3 million to make the film. I wanted a nice-looking lake and I wanted real woods. Frank Mancuso backed me up on that. Of course, since all of the interiors were going to be

filmed in Los Angeles, and everything else was done in Alabama, it would drive us crazy in terms of trying to maintain the film's continuity. We didn't know where we were sometimes."

Once all of the characters arrive at the lake, it's time for Jason to begin his usual rampage. Buechler's effects expertise was backed up by a team of talented technicians including John Foster and Greg Johnson, both from MMI. Also involved were Heidi Snyder, who worked on head sculptures, Joe Podnar, responsible for the moulds of the heads, and John Criswell, the film's animatronics expert. Lou Carlucci was responsible for the non-makeup effects in the film.

One of the biggest challenges for the crew was to figure out exactly how Jason would look in *The New Blood*, especially considering that Jason had his face cut open by a boat propeller before sinking to the bottom of the lake. "We wanted Jason to have a very marked and shocking change in his facial appearance because of what happened in *Jason Lives*," recalls Foster. "We thought of him as this great classic monster along the lines of Frankenstein." Johnson is more specific about their approach: "He was under the water so we knew that he was going to be rotted somewhat. We mainly wanted to show his bones and ribs, make his features very defined. We did a full prosthetic makeup for Jason's face. Unfortunately, many of our best effects were left on the cutting room floor."

One thing Buechler wanted to accomplish with *The New Blood* was to have Jason kill his victims in exotic and imaginative ways. Some of the film's more unusual kills include a character being smashed into a tree while still in a sleeping bag and a particularly outrageous scene - much of which was cut out - where the nefarious Dr. Crews gets disembowelled with a tree-trimming saw. "The Weed Whacker kill with Dr. Crews," recalls Johnson. "It was an X-Rated scene, really gory - a great effects moment. We stuck it into Terry Kiser's stomach and Terry had a bag of blood attached to him which the saw would hit. Our Weed Whacker had a really sharp saw blade on it in the story. When we did the effect, we hit the bag which was full of chunks and guts and, when it hit, it sent chunks flying a hundred feet away. Even more disgusting was that you could see pieces of the guts hanging off of the blade."

While conscious of *The New Blood*'s essential killing mandate, Buechler tried to retain some focus on the film's real story, that of Tina, her realisation of the great powers she possesses, and her clash with Jason. "I was kind of disappointed that we didn't do as much with Tina as we could've," says the director. "I wanted to really get into the clairvoyant stuff and have Tina experience all of these surreal nightmares because I'd really done a lot of homework about the paranormal and the way that clairvoyants use their powers. The producers didn't like the idea."

Buechler's would-be vision for *The New Blood* included the return, in a very bizarre way, of Pamela Voorhees or, to be more exact, her head. "Tina has a psychic vision in the film where she drives a car off the road and totals the car and I wanted to see Tina's mother standing in the road with Betsy Palmer's head in her hands, something weird like that," explains Buechler. "Then, Betsy Palmer's head would've cried out, in a child's voice, 'Help me, help me,' something like that, like the voice we heard in the first film. I remember telling that to Frank and the other producers and I remember Barbara Sachs - who was one of the associate producers - just laughing and telling me that I was crazy and that the idea was too 'out there.' I thought the film wasn't wild enough. It needed to be really over-the-top, shocking."

Once Jason is done with dispatching the nubile victims that populate *The New Blood*, it's time for Jason and Tina to fight, with Nick watching from the sidelines. Tina's mother has already been killed by Jason after the slimy Dr. Crews used her as a human shield, throwing her in front of the killer whilst being chased by him. With both of her parents dead, Tina has only one thought in mind - she wants Jason to die, too. Of course, unlike past heroines in the series, Tina has her telepathic powers, which she uses variously to hurl projectiles at Jason, set him on fire, and even to electrocute him. Poor Jason just can't seem to figure Tina out.

Hodder was no stranger to fire before appearing in *The New Blood*, but by the end of filming he

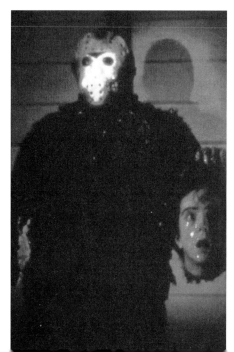

Assistant Production
Co-ordinator:
Pat Frazier
Los Angeles Office
Co-ordinator:
Pamela Solomon
Assistant Editors:
**Lori Ball, Marcy Stoeven,
Lauri Brown**
Captain-Los Angeles:
Ella Blakey
Captain-Alabama:
Shelba Travis
Drivers:
**Kim Larsen, Michael
Locke, Janice Phelps, Tim
Wright, Marvin Dials, Pam
Hart, Arthur Smith**
Casting:
Anthony Barnao
Location Casting:
Mary Gaffney

CAST

Jennifer Banko
(Young Tina)
John Otrin
(Mr. Shepard)
Susan Blu
(Mrs. Shepard)
Lar Park Lincoln
(Tina)
Terry Kiser
(Dr. Crews)
Kevin Blair
(Nick)
Susan Jennifer Sullivan
(Melissa)
Heidi Kozak
(Sandra)
Kane Hodder
(Jason)
William Butler
(Michael)
Staci Greason
(Jane)
Larry Cox
(Russell)
Jeff Bennett
(Eddie)
Diana Barrows
(Maddy)
Elizabeth Kaitan
(Robin)
Jon Renfield
(David)
Michael Schroeder
(Dan)
Debora Kessler
(Judy)
Diane Almeida
(Kate)
Craig Thomas
(Ben)
Delano Palughi
(Rescue Worker)

right:
The evil Dr. Crews (Terry Kiser) uses Amanda Shepard (Susan Blu) as a shield against Jason Voorhees.

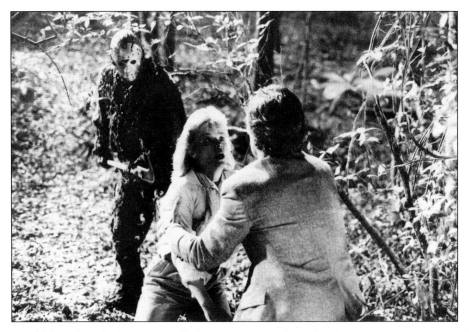

below:
Jason goes up in flames.

could lay claim to being something of an expert in the dangerous art of pyrotechnics. "I've done a lot of fire stunts in my career and they're always dangerous and this one was especially dangerous because it was a really, really big burn," explains Hodder. "In the film, I was totally smothered with flames, but you could still see my face and you can see that it's still Jason. I burned for twenty seconds in that scene which is very unsafe, but I wanted it to look good because I love what I do."

Even more dangerous for Hodder was a scene where Tina brings the house down, literally, on Jason. "When the house was blown up, it knocked some of the crew members out," he recalls. "The front of the house was rigged with light materials - mostly balsa - which the effects guy put into the core of the roof. The thing was rigged so, when a button was pressed, the whole thing would come down and it sure did. Even though it was filled with balsa, there was still lots of wood and, when it fell on top of me, it really knocked me out."

Lincoln feels that Tina's telekinetic war against Jason was *The New Blood*'s highlight: "Tina's powers really throw Jason out of whack, out of his comfort zone, because he's never seen anything like that before. It was Jason against Carrie, more or less, and I think Tina was the bravest, strongest and most interesting heroine of all of the films. I think Kane did a great job in making Jason a real living, breathing character as opposed to the guy-in-a-suit thing that you'd seen in the previous films. There was chemistry between us and, when Jason and Tina locked eyes, you could feel that they wanted to kill each other."

The confrontation reaches its climax when, after setting Jason on fire and causing a house collapse on him, Tina and Nick are seemingly free from danger. But this is a *Friday the 13th* movie... suddenly Jason appears out of the fire and the action moves towards the dock on the shore of the creepy lake, for a final dramatic showdown at the very spot where the story began. It's there that Tina uses her powers in a most creative way, willing her father to rise up from the dead, out of his watery tomb, to pull Jason back down into the water, to his

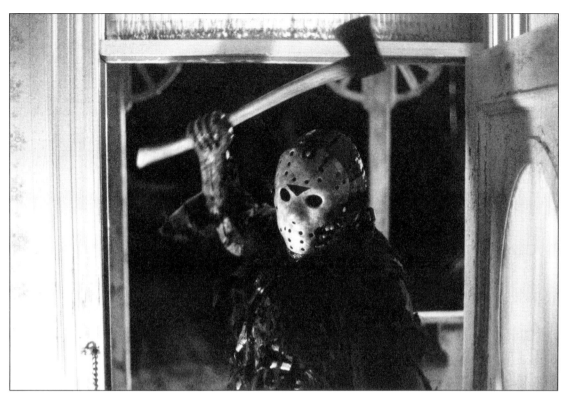

rightful resting place in the watery bowels of Camp Crystal Lake. "I loved the ending because it showed how Tina was able to outsmart Jason," says Lincoln. "It was a neat ending that had a lot of interesting twists. When you think about it, it was my character who not only brings Jason back from the dead, but defeats him too."

It's all over. Not exactly. It seems that Jason was originally intended to make one more appearance from beyond his watery grave, much as he did in the original 1980 *Friday the 13th*. "There was an alternate ending that was filmed, but never used in the film," claims Hodder. The would-be ending features an obviously stupid fisherman who is seen relaxing on the lake in his boat, when suddenly Jason leaps out of the water and pulls him under. Fade out. The fisherman was played by stuntman Alan Marcus, a good friend of Hodder's. "You see Jason jump out and grab him by the neck and pull him under," says the actor. "I still have the tape and it does look a lot like the scene from the first film which is why it wasn't used, but it's a really good scene."

So at the end of *The New Blood* Jason was back where he started - trapped at the bottom of Crystal Lake. However, some people were determined to continue the battle fought in *The New Blood*. It seems that both Lar Park Lincoln

and Kevin Spirtas wrote their own scripts for a proposed sequel to *The New Blood*. "I wrote a *Tina Vs. Jason* script that I was really hoping Paramount would want to make," says Lincoln. "It was about Tina who had become a psychiatrist and was once again confronted by Jason. People liked the script a lot, but it just didn't happen."

The reality was that Tina Shepard's future as a nemesis for Jason was entirely at the mercy of the box office performance of *Friday the 13th Part VII: The New Blood* and, on that front, the news

above:
Jason Voorhees at his terrifying best.

below:
Tina Shepard calls upon her telekinetic powers.

ON FRIDAY,
MAY 13TH,
JASON
IS BACK.

BUT
THIS TIME
SOMEONE'S
WAITING.

FRIDAY THE 13TH
PART VII - THE NEW BLOOD

above:
Original American
theatrical poster art.

below:
Another victim meets
his doom at the edge of
Jason's machete blade.
*Friday the 13th Part VII:
The New Blood* marked
the first of four appear-
ances by Kane Hodder
in the role of Jason
Voorhees.

earliest stages of development, the *Freddy Vs. Jason* and *Jason Vs. Carrie* concepts. "I had six weeks to make *The New Blood*," asserts Buechler. "That was the bottom line and, I think, given the limitations we had, we made a pretty good film. I was never a big *Friday the 13th* fan to begin with and the only reason I wanted to direct *The New Blood* was to take the series in another direction, and I think we did."

Despite *The New Blood*'s relative profitability, the dark spectre of the *Elm Street* franchise was impossible to ignore, especially when, just three months after the debut of *The New Blood*, *A Nightmare on Elm Street 4: The Dream Master* was released on August 19, 1988. The timing of this release was significant since *The Dream Master* would go on to gross an astounding $49.3 million during its theatrical run, making it the most commercially successful horror film of its era. "It was a historic moment for New Line Cinema," says New Line Cinema CEO Robert Shaye. "We never dreamed that an *Elm Street* film could be that successful and cross over to a mainstream audience like that. It was an exceptionally well-made film as well. The success of the film really helped to put New Line on the map."

Indeed, there was an ominous tone of doom in the writings of film critics and journalists when it came to comparing the relative strengths of the *Elm Street* and *Friday the 13th* franchises. *Elm Street* had, for a brief and shining moment, broken through into the mainstream while *Friday the 13th* was stuck in a retroactive quagmire with no new cards to play. Most importantly, both franchises deserved these fates, as would be noted by these same critics and journalists. It was all about reputation and street credibility and, in that aspect, the *Elm Street* films were known as the smarter, more technically impressive and visually innovative cousin while the *Friday the 13th* films were now considered to be the awkward, somewhat embarrassing step-child of the horror universe. While the picture may have been clear enough at the end of 1988, the biggest surprise was yet to come, something no one could predict...

By the end of the summer of 1989, both the *Friday the 13th* and *Elm Street* series would be laid to rest. They were not dead - certainly not - for nothing can ever really kill Freddy Krueger or Jason Voorhees. However, just as Jason Voorhees had spent much of his recent cinematic existence trapped in a watery grave, the *Friday the 13th* film series was about to be placed into an indefinite coma from which even Jason couldn't escape, at least not for a few years. But before any of that came to pass, Jason was headed in the direction of The Big Apple.

was not good. The Jason Vs. Tina concept explored in *The New Blood* had, seemingly, failed to stir up any fresh interest in the genre marketplace beyond the core *Friday the 13th* audience, on which the franchise was now increasingly dependent. *The New Blood* may have had a slightly new look, but the blood was the same colour, and the victims' IQs hadn't risen much.

That's not to say that *The New Blood* was a flop, far from it. When *Friday the 13th Part VII: The New Blood* was released on May 13, 1988, it grossed a robust $8.2 million during its opening weekend, a much stronger debut than *Jason Lives*. However, business dropped rapidly in the weeks to follow and *The New Blood* would end up with a final take of $19.1 million, marginally less than the $19.4 million taken by *Jason Lives*. It was a respectable performance, certainly given the film's meagre $3.5 million budget, not to mention the film's incredibly rushed schedule which - as previously mentioned - had included, at the

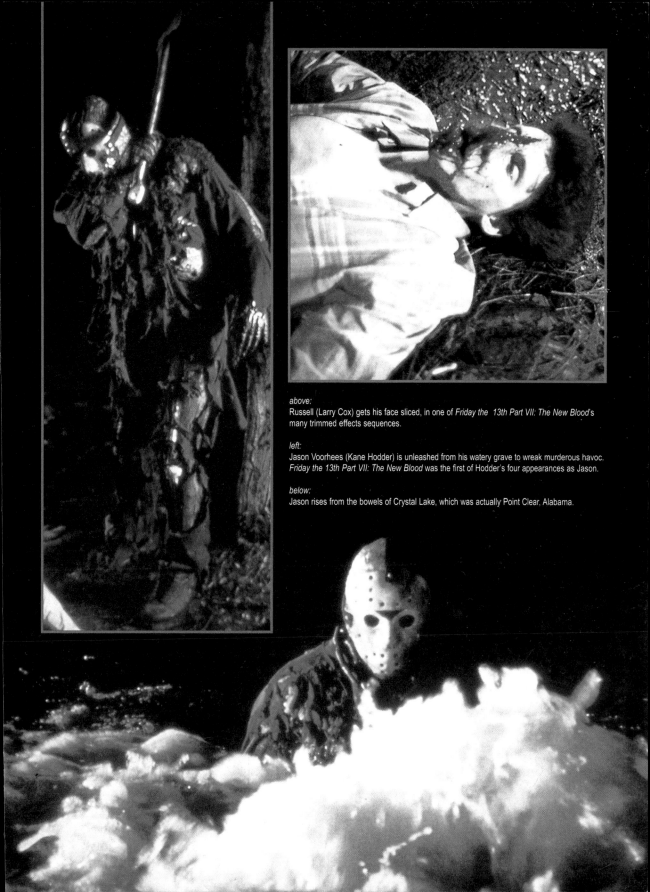

above:
Russell (Larry Cox) gets his face sliced, in one of *Friday the 13th Part VII: The New Blood*'s many trimmed effects sequences.

left:
Jason Voorhees (Kane Hodder) is unleashed from his watery grave to wreak murderous havoc. *Friday the 13th Part VII: The New Blood* was the first of Hodder's four appearances as Jason.

below:
Jason rises from the bowels of Crystal Lake, which was actually Point Clear, Alabama.

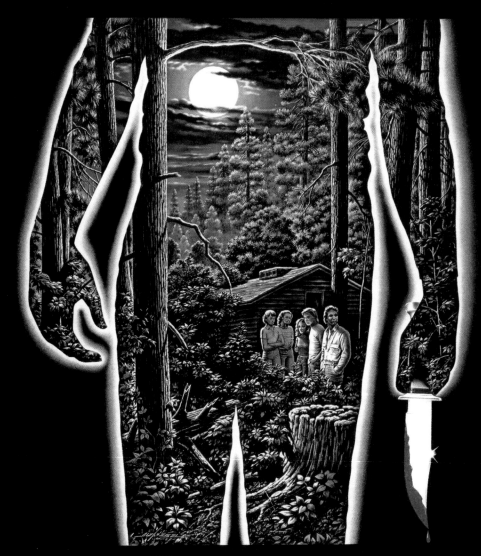

They were warned...They are doomed...
And on Friday the 13th, nothing will save them.

FRIDAY THE 13TH

A 24 hour nightmare of terror.

PARAMOUNT PICTURES PRESENTS FRIDAY THE 13TH A SEAN S. CUNNINGHAM FILM STARRING BETSY PALMER ADRIENNE KING HARRY CROSBY LAURIE BARTRAM MARK NELSON JEANNINE TAYLOR ROBBI MORGAN KEVIN BACON DIRECTOR OF PHOTOGRAPHY BARRY ABRAMS MUSIC BY HARRY MANFREDINI ASSOCIATE PRODUCER STEPHEN MINER EXECUTIVE PRODUCER ALVIN GEILER WRITTEN BY VICTOR MILLER PRODUCED AND DIRECTED BY SEAN S. CUNNINGHAM A GEORGETOWN PRODUCTIONS INC. PRODUCTION

A PARAMOUNT RELEASE

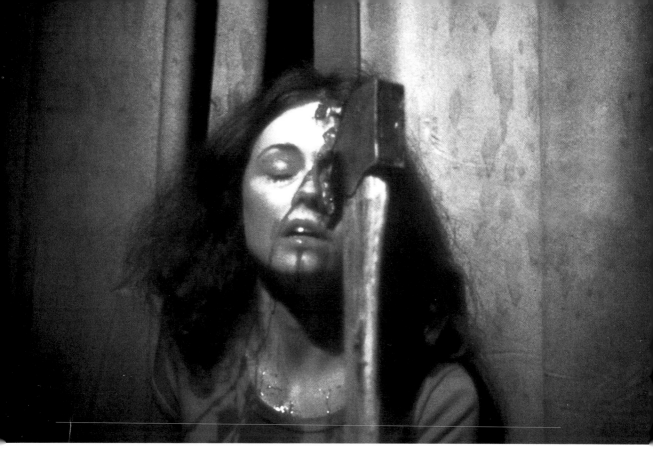

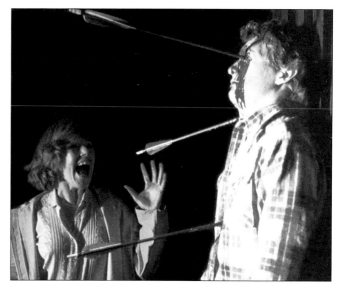

above: Alice (Adrienne King) makes the gruesome discovery of Bill's (Harry Crosby) defiled corpse. Tom Savini wasn't present for the filming of the scene, which damaged Crosby's corneas.

top: Marcie's (Jeannine Taylor) death premonition came true when she was axed in the skull. Tom Savini built a mould of Taylor's face for a planned axe-sliding-down-the-skull sequence but the effect didn't work.

left: European promotional artwork for *Friday the 13th* features the Warner Bros. logo and a painting based on the bloody axe-on-the-pillow scene.

opposite: Original American poster art for *Friday the 13th*.

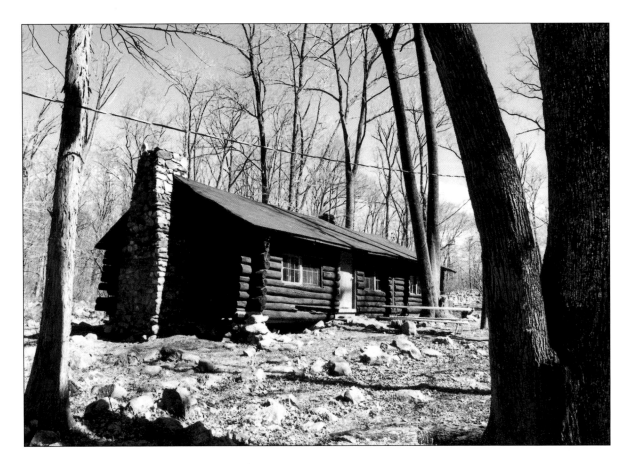

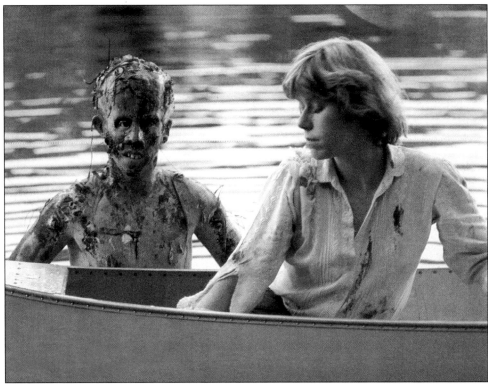

above:
The main 'strip monopoly' cabin as it appears at Camp No-Be-Bo-Sco in Blairstown, New Jersey today. (Photo courtesy of Dean A. Orewiler/Orewiler Photography.)

right:
Jason Voorhees (Ari Lehman) makes his first screen appearance in *Friday the 13th*'s shock ending, constructed by writer Ron Kurz and effects expert Tom Savini. The scene was not completed until three months after the end of principal photography.

opposite top:
Original British quad poster design for the uncut theatrical release of *Friday the 13th*.

opposite bottom:
Two-colour British double-bill quad poster for *Friday the 13th* and *Friday the 13th Part 2*.

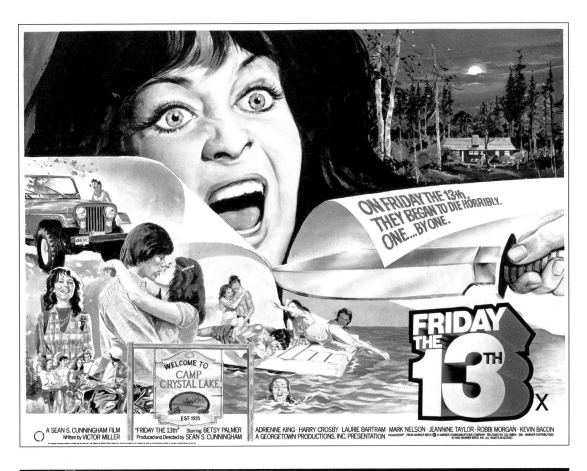

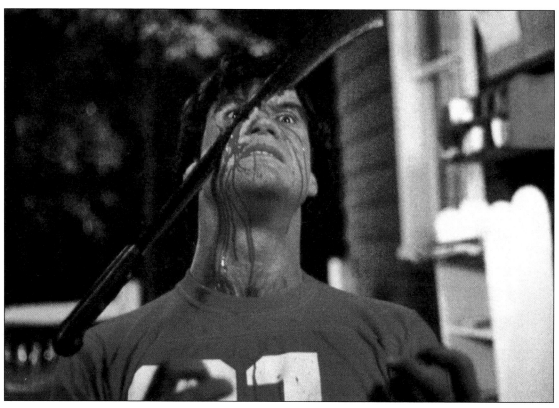

above: Wheelchair-bound Mark (Tom McBride) gets sliced by a machete in *Friday the 13th Part 2*. McBride died young, in 1995.

below: Ginny Field (Amy Steel) defends herself during the film's climactic scene.

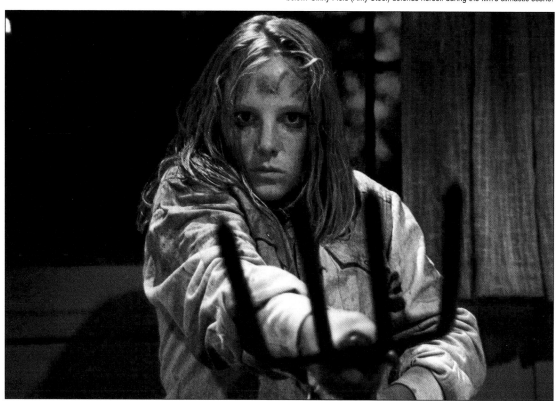

above:
Sandra (Marta Kober) witnesses the after-sex impaling of herself and her lover Jeff (Bill Randolph) at the hands of Jason Voorhees (Steve Dash). This was one of many effects on *Friday the 13th Part 2* to be severely-trimmed prior to theatrical release.

left:
Jason Voorhees stalks his prey, face covered by The Bag. Although Warrington Gillette received screen credit as Jason, Steve Dash played the killer in most of the scenes.

background image:
Steve Dash was almost impaled on this pick-axe during the filming of *Friday the 13th Part 2.*

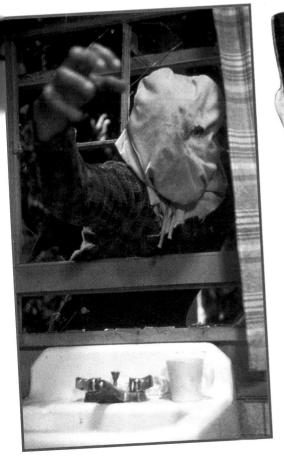

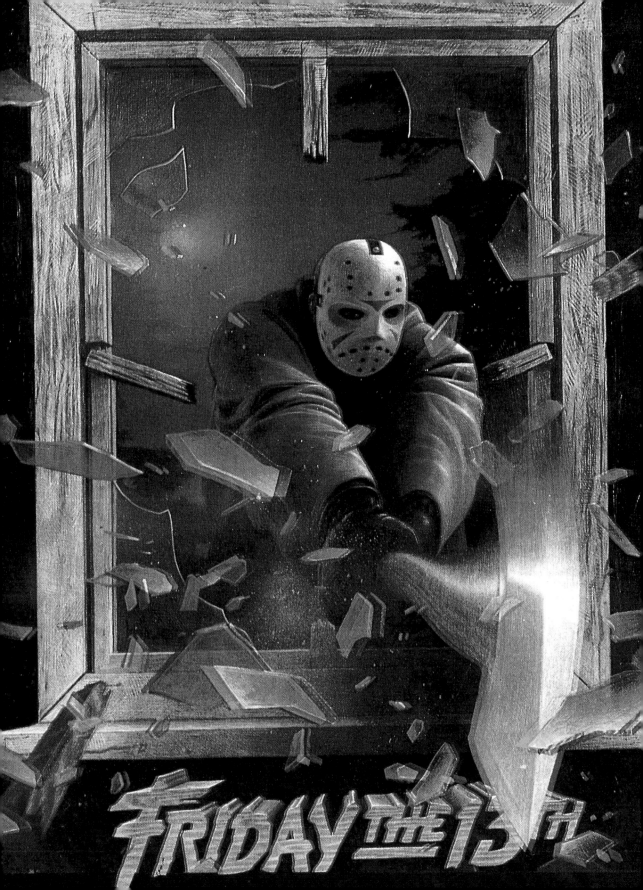

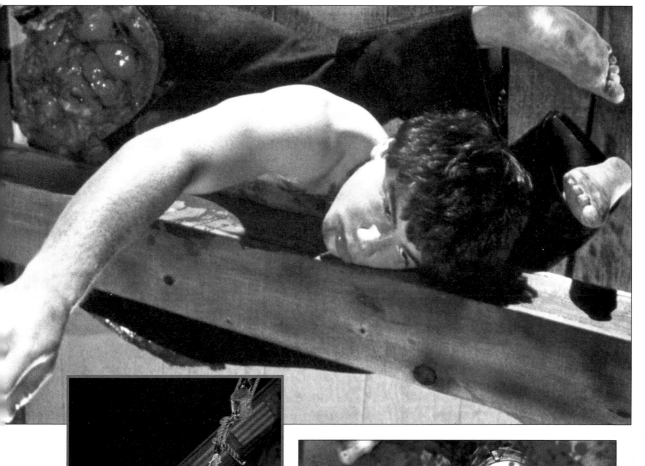

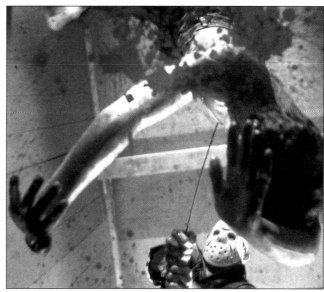

above:
Upside down view of Andy's (Jeffrey Rogers) 3-D bisection.

top:
Andy's horribly mutilated body is left by Jason to drip-dry.

left::
Jason Voorhees (Richard Brooker) hanging from the rafters.

opposite:
3-D Japanese pressbook art for *Friday the 13th Part 3*.

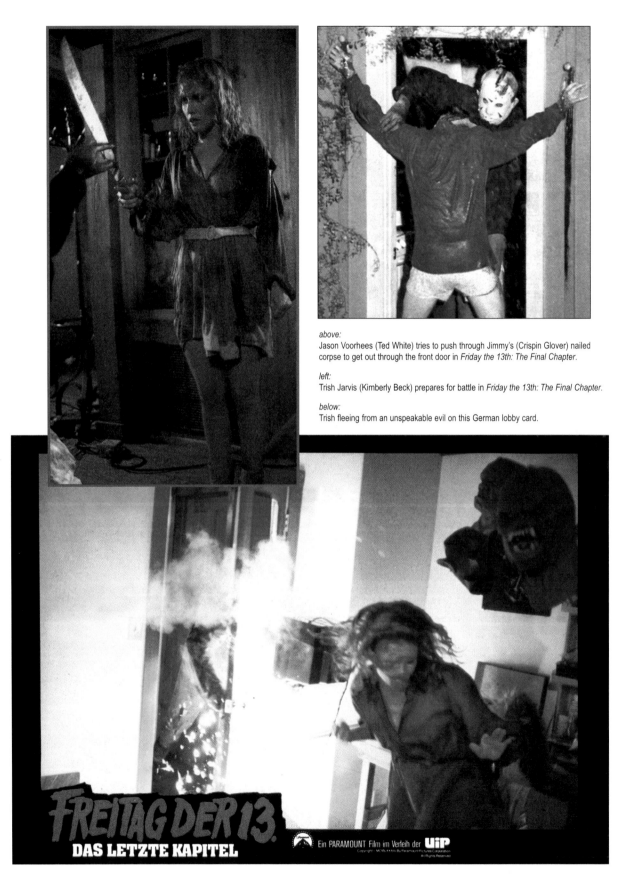

above:
Jason Voorhees (Ted White) tries to push through Jimmy's (Crispin Glover) nailed corpse to get out through the front door in *Friday the 13th: The Final Chapter.*

left:
Trish Jarvis (Kimberly Beck) prepares for battle in *Friday the 13th: The Final Chapter.*

below:
Trish fleeing from an unspeakable evil on this German lobby card.

FREITAG DER 13.
DAS LETZTE KAPITEL

Ein PARAMOUNT Film im Verleih der UiP
Copyright © MCMLXXXIV By Paramount Pictures Corporation
All Rights Reserved

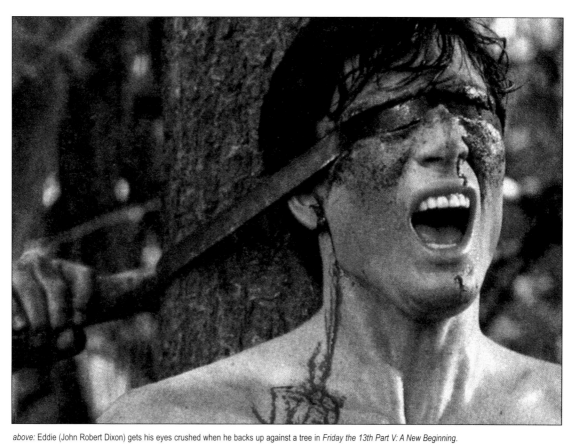

above: Eddie (John Robert Dixon) gets his eyes crushed when he backs up against a tree in *Friday the 13th Part V: A New Beginning.*

below: Uncensored image of Joey Burns's (Dominick Brascia) corpse, which inspires a new series of murders in *Friday the 13th Part V: A New Beginning.*

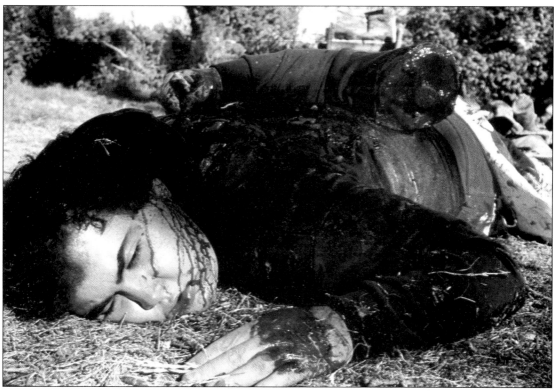

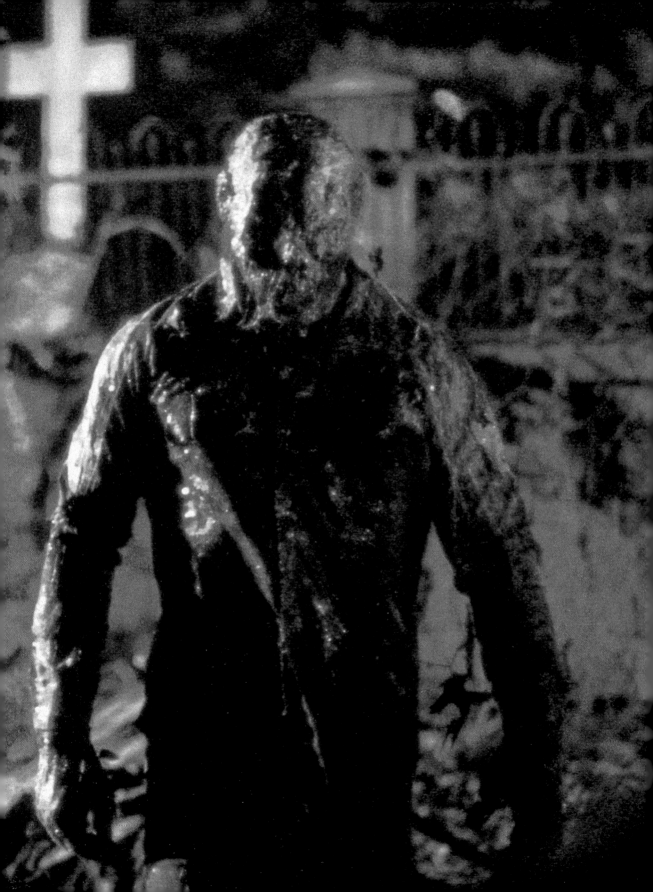

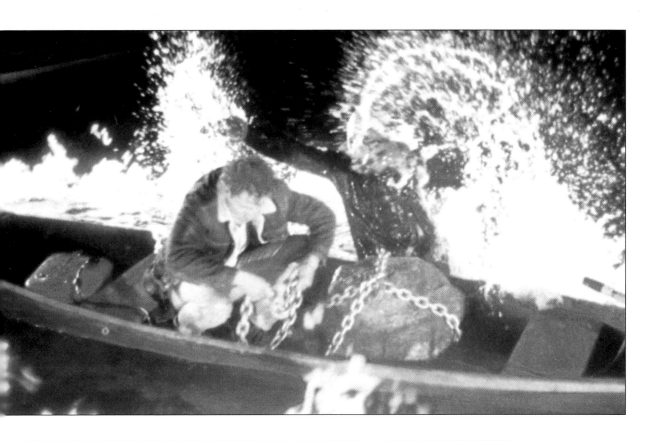

above:
Jason Voorhees (Kane Hodder) admires his reflection in a New York City stall, in *Friday the 13th Part VIII: Jason Takes Manhattan*.

right:
Jason prepares to take a slice out of the Big Apple. *Friday the 13th Part VIII: Jason Takes Manhattan* was criticised for spending too much time on a cruise ship and too little time on location in New York City. With the expection of a few specific location shots, Vancouver doubled for New York in the film.

opposite:
Jason was given a new and monstrous look in *Friday the 13th Part VII: The New Blood* under the guidance of director and effects expert John Buechler.

Terror in Times Square

In March of 1989, production began on *Friday the 13th Part VIII: Jason Takes Manhattan* and, although none of the parties involved in the *Friday the 13th* series knew it at the time, this eighth instalment would prove to be, in many important ways, Jason's swansong. It was the end of the *Friday the 13th* moniker for one thing, as the title would never be used again. In that sense, *Friday the 13th* really is dead. After *Jason Takes Manhattan*, it would be four years until 1993's *Jason Goes to Hell: The Final Friday* would arrive, but by then the series was fractured, the magic spell broken.

From the inception of the series in 1980 and continuing, virtually unchecked, until 1989, there had always been a *Friday the 13th* film in some stage of development, but after the release of *Jason Takes Manhattan*, and it's relative commercial failure, the winning streak was over. In that respect, the film, whatever its glaring flaws, marked the end of a bygone era. Although the *Jason Takes Manhattan* tag seemed to promise that the eighth instalment in the series would take place in New York, this was somewhat deceptive, as the bulk of the film was made in Vancouver which - with its sparkling streets and underground tunnels - served as a passable copy of the Big Apple. It's also interesting to note that, with a budget of $5 million, *Jason Takes Manhattan* was at that point in the series the most expensive *Friday the 13th* film to date.

When choosing a director for *Jason Takes Manhattan*, Frank Mancuso, Jr. decided to stay in-house with his choice of Rob Hedden, who was also given the task of writing the film's script. Hedden had previously directed and written episodes of *Friday the 13th: The Series* (the full story of which is covered in the next chapter of this book) - he had been on the Paramount lot, developing his own projects, when the producers of the series called and asked for his help: "They really didn't even have a pilot at that point. In

opposite:
Poster art for the original American theatrical release of **Friday the 13th Part VIII: Jason Takes Manhattan**.

below:
Despite its title, *Friday the 13th Part VIII: Jason Takes Manhattan* spends most of its running time onboard the *S.S. Lazarus.*

above:
Jason Voorhees (Kane Hodder) in New York City.

opposite:
Jason attacks heroine Rennie (Jensen Daggett) on the *S.S. Lazarus.*

below:
Jason at sea.

exchange, I asked them to let me direct some episodes and they reluctantly agreed to give me a chance." Hedden had previously written episodes of the television series *MacGyver.* "The only directing experience I had, prior to *Friday the 13th: The Series*, was some Making of documentaries for movies that had been recently released like Terry Gilliam's *Brazil*," he says.

Hedden actually re-wrote the first four episodes of the series, without credit, and the first episode that he directed was *The Electrocutioner.* His work immediately impressed the *Friday the 13th* production team, especially Mancuso, Jr. "They wanted me to do another one, just to see if it wasn't some fluke, and so I did *13 O'Clock* and that turned out great as well," recalls Hedden. "I kept on working on the series until, one day, the producers came to me and asked if I was interested in writing and directing the next *Friday the 13th* movie. I was stunned. I couldn't believe that I was getting this opportunity."

When it came to scripting *Jason Takes Manhattan*, Hedden was largely free from the constraints of the previous films, in particular with regard to the increasingly ridiculous timeline discrepancies. "I'd studied all of the previous films in one big marathon viewing session and I was left kind of confused in terms of how we were going to continue after *Part VII* because Jason was dead," recalls Hedden, who was only thirty-five years old

at the time. "I was told that I didn't have to worry about the previous stuff, to feel free to branch off in a totally different direction. Looking back, I was given a lot of creative freedom with *Jason Takes Manhattan*, maybe too much. I asked about killing Jason and they said yes, I could kill Jason if I wanted to."

The plot that Hedden eventually concocted would, in essence, bring Jason full-circle - back to the roots that were laid down in *Friday the 13th*. "Yeah, I definitely wanted to explore the child inside Jason because the whole series goes back to the story of Jason Voorhees, the young boy, drowning in Crystal Lake," he explains. "I wanted Jason, after we killed him off at the end, to transform back into the child he was when he first drowned in Crystal Lake. Basically, I wanted to end the series where it truly began."

Mancuso, Jr. was supportive of Hedden's concept for *Jason Takes Manhattan*, saying: "I felt, at the time, that it was a great idea to have *Jason Takes Manhattan* take place in a different place and time. The Camp Crystal Lake thing was tired. Ultimately, I wasn't intimately involved in the making of *Jason Takes Manhattan* in terms of the actual filming and the editing, although I did view several cuts of the film when it was completed and I gave suggestions on what to change. My job on this film was to deal with any problems that Rob and his team faced and come up with solutions."

**FRIDAY THE 13th
PART VIII:
JASON TAKES
MANHATTAN**
(1989)

Production Credits:
**Paramount Pictures
Presents. A Horror, Inc.
Production.**
Producer:
Randolph Cheveldave
Associate Producer:
Barbara Sachs
Unit Production Manager:
Mary Guilfoyle
Location Manager:
Gordon Hardwick
Script:
Rob Hedden
Based on characters
created by:
Victor Miller
Director:
Rob Hedden
First Assistant Director:
Jeffrey Authors
Second Assistant Director:
Tom Quinn
Director of Photography:
Bryan England
Underwater Photography:
Pete Romano
1st Assistant Camera:
Brian Murphy
2nd Assistant Camera:
John Seale Jr.
Steadicam Operator:
Robert Crone
Camera Operator:
Paul Birkett
Still Photographer:
Ron Grover
Camera Trainee:
Mike Wrinch
Gaffer:
Don Saari
Best Boy Electric:
Mal Kibblewhite
Electricians:
Rick Dean, Vince Laxton
Key Grip:
Jim Hurford
Best Boy Grip:
Gordon Tait
Dolly Grip:
Brian Kuchera
Grips:
Rob Bojeck, Ken Young
Editor:
Steve Mirkovich
Los Angeles Auditor:
Vicki Ellis
Music:
Fred Mollin

Although, as has already been discussed, the timelines of the *Friday the 13th* saga have become somewhat tangled and confused over the years, the events of *Jason Takes Manhattan* should in theory be taking place in 1999, i.e., just after the ending of *The New Blood*. Of course, back in 1989, the year 1999 seemed like the distant future, and setting the film then would have meant a great deal of extra effort in terms of production design. Largely to avoid such complexities, Hedden and his crew decided to pretty much ignore the previous timelines in the *Friday the 13th* series. "We wanted the film to take place in the present day - 1989 or a few years after," asserts the director. "I mean, there had already been so many jumps in time within the series that it seemed ridiculous to set the film in the distant future. We couldn't make a futuristic film because we would've had to change the look of everything. Ultimately, I think the *Friday the 13th* series made a few mistakes in regards to the timelines and I don't think it was something that anyone who came before me ever gave any serious thought about in terms of what year we were in because every sequel kept on taking place five or ten years in the future. I don't think the fans care about stuff like that because they know how silly it is."

When it came to choosing the acting talent for the film, casting directors David Cohn and Fiona Jackson wanted to find fresh faces that weren't necessarily scarred by appearances in previous slasher films. The film's two young leads, Sean and Rennie, were played by Scott Reeves and Jensen Daggett (birth name Jennifer Daggett), both completely unknown at the time. Reeves had some prior acting experience, having appeared on the soap opera *Days of Our Lives* in 1988. "I was in my early twenties when I got the part so I was a little old to be playing a high school senior, but I was thrilled to get a starring role in a feature," says Reeves, who would later appear in the underrated 1991 thriller *Edge of Honor* with Corey Feldman before achieving his greatest fame on the soap opera *The Young and the Restless*.

Daggett wasn't the first choice to play Rennie, as Hedden and the producers had seriously considered casting then-unknown actresses Elizabeth Berkeley and Dedee Pfeiffer (the sister of Michelle Pfeiffer). For her part, Daggett was happy to snag the heroine part in *Jason Takes Manhattan*, as this was her first professional role, but the actress was a little nervous about one thing: being asked to take off her clothes. Strangely enough, had Daggett seen the seven previous *Friday the 13th* films, she would have known that *Friday the 13th* heroines never ever take off their clothes. "I think they liked me because I had a fresh face," says the actress who's gone on to appear on such television fare as *Home Improvement* and *Will & Grace*. "Yeah, I was a little nervous that they'd ask me to take off my clothes, which isn't something I wanted to do so I

above:
Boxer Julius (V.C. Dupree) tries to dial 911 with Jason Voorhees in hot pursuit.

opposite top:
Peter Mark Richman as evil Charles McCulloch.

opposite next to top:
Jensen Daggett as Rennie.

opposite next to bottom:
Scott Reeves as Sean Robertson.

opposite bottom:
Barbara Bingham as Colleen Van Deusen.

had my agent just clear up exactly what I was going to have to do. There were no problems and everyone treated me great."

Most of the rest of the cast was filled with virtual unknowns, including never-to-be-remembered names such as Vincent Craig (V.C.) Dupree, Saffron Henderson, Sharlene Martin, Warren Munson, Tiffany Paulsen and Todd Shaffer. This is not meant as an indictment of these actors or their skills, which may well be sound, but rather a testament to how appearing in a *Friday the 13th* film can arguably curse a young actor's long-term career prospects. But there are rare exceptions to any rule, and so it is with this film. Aside from Martin Cummins, who went on to star in the James Cameron-produced television series *Dark Angel*, and veteran character actor Peter Mark Richman, who played the sinister chaperone Charles

McCulloch in *Jason Takes the Manhattan*, there is also Kelly Hu, one of the biggest stars to come out of the *Friday the 13th* films. The female Kevin Bacon? Time will tell - Hu's career is still young.

It's ironic that Hu - a Hawaiian native who's gone on to star in such films as *Cradle 2 the Grave*, *The Scorpion King* and *X2* - played such a forgettable character in *Jason Takes Manhattan* given the beauty and charisma displayed by the actress almost fifteen years later; she is a testament to the fallacy of overnight success in the film business. Hu's character, Eva Watanabe, is killed by Jason fairly early in the film, strangled no less. Prior to her turn as one of Jason's victims, Hu was best known for her turn as Kirk Cameron's love interest on the '80s television series *Growing Pains*, not to mention her reign as Miss Teen USA in 1985. However, it was an appearance on the Vancouver-filmed television series *21 Jump Street* that led to her role in *Jason Takes Manhattan*. Hu looks back on the job with somewhat mixed feelings: "I remember being excited at the prospect of being able to go to New York, but I was killed off early in the film so I stayed in Vancouver. That's all I really remember about the film: getting killed off before Jason gets to Manhattan."

Jason Takes Manhattan represented a landmark of sorts for Kane Hodder, since no actor had ever played Jason more than once in the series. Another interesting Jason-related anecdote is the fact that Ken Kirzinger, the stunt co-ordinator on the film, would go on - almost fifteen years later - to play Jason in *Freddy Vs. Jason*. Kirzinger also played a New York cook in the film, his character being assaulted by Jason in a bar and tossed through a mirror. Hodder and Kirzinger both find this more than a little ironic. "Yeah, Kane and I have been friends for a long time," says Kirzinger, a veteran of the Vancouver film scene. "I never imagined that I'd be playing Jason fifteen years later, but that's just the way it goes. I'm sure that Kane understands that it's just business. He's a great guy and a great performer."

Hodder has similarly fond memories of Kirzinger, and of Hedden's fresh approach and new ideas for the development of Jason in *Jason Takes Manhattan*. The actor believed that, for as long as the *Friday the 13th* films would continue to be made, he would be playing Jason. "I know that a lot of people didn't like *Jason Takes Manhattan*, but I thought the film had some really cool and interesting moments even though the ending was terrible," he says. "Everyone knows I loved *The New Blood* the most because I really felt that it had the best action sequences and the best concept. All of the directors I worked with had different strengths and I think Rob's strength was writing because the

script for *Jason Takes Manhattan* was really creative and full of great dialogue. I loved, for instance, going to Times Square in Manhattan, in full costume, and being out in the open while hundreds of people would just walk by and stare at me."

Another *Friday the 13th* veteran to return for *Jason Takes Manhattan* was special effects expert Martin Becker who had been involved with the series in various capacities since *Part 3*. Along with fellow effects experts Jamie Brown, Tibor Farkas and William Terezakis, Becker was looking forward to fulfilling Hedden's prophecy of bringing the look of Jason full-circle. "I believe there were more kills in *Jason Takes Manhattan* than any previous *Friday* film at that time," says Becker. "There was obviously the chance to turn Jason into a child which was very interesting, but I think a lot of us felt, deep down, that *Jason Takes Manhattan* was going to be the last film, at least for a while. You could just feel it in the air that interest in the films was starting to fade. As far as the film goes, Rob wanted to film several scenes, bloodless and bloody, to deal with the MPAA so Jamie and the guys were able to be creative, but what I liked about Rob's approach was that some of the kills in the film were off-screen, which I think makes for a lot more suspense in a *Friday the 13th* film." Sadly, Becker died in 2004 after a long battle with cancer.

In addition to one week of filming in New York, the crew spent five weeks in Vancouver, with a couple of days spent back in Los Angeles. For Hedden and the film's producer, Vancouver-based Randolph Cheveldave (who'd previously worked on *April Fool's Day*), the decision to film in British Columbia wasn't made purely for economic reasons, though admittedly the production budget could not have stretched to six weeks on location in New York. "Cost is always a factor for films shooting in Vancouver, but the main reason we chose Vancouver was because the city had all of the locations we needed," says Cheveldave. "Most of the film was going to take place over water as well as taking place at Camp Crystal Lake and in the forest, and so we had to find one place that could supply all of those locations. Where else but British Columbia?" For the purpose of handling the day-to-day costs of production, Cheveldave, like many *Friday the 13th* producers before him - dating back to *Part 3* - set up a production company, Horror Films, Inc. During production, *Jason Takes Manhattan* existed under the title *Ashes to Ashes*, a title used, as was the case with several previous sequels, to avoid unwanted attention and controversy on the set.

Hedden feels that the Vancouver setting served the film well: "The main thing I liked about Vancouver were its beautiful lakes. I wanted to be

Supervising Sound Designer:
Jeffrey L. Sandler
Recordist/Sound Effects:
Steve Woods, Gary Blufer
Recordist/Engineer:
Rick Maclane
Sound Mixer:
Lars Ekstrom
Production Designer:
David Fischer
Set Decorator:
Linda Vipond
Set Dresser:
Lawrence Redfern
Assistant Set Decorators:
**Ignacio McBurney,
Patrick Kearns**
Storyboard Artist:
Brent Harron
Construction Co-ordinator:
Geoff Hilliard
Construction Foreman:
Doug Hardwick
Paint Foreman:
Grace Rourke
Construction Painter:
John Hamilton
Lead Greensman:
Phillip Lunt
Greensman:
James H. Green
Property Master:
J. Graham Coutts
Prop Man:
Andreas Nieman
Props Buyer:
Max Matsouka
Make-Up Artist:
Laurie Finstad
Hairstylist:
Malcolm Tanner
Costume Designer:
Carla Hetland
Costume Supervisor:
David Lisle
Assistant Special Effects Make-Up:
**Tibor Farkas,
William Terezakis**
Special Make-Up Effects:
Jamie Brown
Mechanical Effects Co-ordinated by:
Martin Becker
Special Photographic Effects:
**Effects Associates Inc.,
Jim Danforth**
Titles and Optical Effects:
Cinema Research Corporation
Miniature Effects:
Light and Motion Corp.

true to the image of Camp Crystal Lake from the first film. We found a lake that matched pretty well and then, for the New York scenes, downtown Vancouver was perfect because it had lots of cool alleys and streets and there was even a dock that fitted the cruise ship perfectly. The Boy Scouts Camp that we filmed in at the start of the film had everything that the camp in *Friday the 13th* had: cabins, docks, thick forest. Probably the most important thing about filming in Vancouver was the fact that there were underground subway tunnels because we didn't have the money to film in the subways of New York. We had to go to New York, obviously, to film Times Square because that's not something you can duplicate."

One major point of interest surrounding *Jason Takes Manhattan* is that it was the first instalment of the series not to be composed, in terms of screen credit, by Harry Manfredini who had been, up to that point, the only constant remaining from the very first film. Fred Mollin, who'd worked with Hedden on *Friday the 13th: The Series,* the television series that aired between 1987 and 1990, was tapped to score *Jason Takes Manhattan.* According to Hedden, the decision to use Mollin was a case of a director wanting to continue what had been an excellent working relationship, and he meant no disrespect to Manfredini whose work he had always admired: "I loved the old music, but I didn't have a relationship with Harry whereas I'd

worked with Fred and loved his work. It really wasn't my decision because if the producers had insisted on Harry, I wouldn't have argued. I was the writer and director and they let me hire who I wanted and I picked Fred who did a great job."

Jason Takes Manhattan opens in very familiar territory: on the dark waters of Crystal Lake, where we meet two lovebirds, Jim (Todd Shaffer) and Suzi (Tiffany Paulsen). The young couple are all set to enjoy a romantic interlude when the wayward anchor on the lovers' boat accidentally triggers a surge through an underwater power cable, inadvertently enlivening the submerged corpse of Jason Voorhees whose bones, for some reason, weren't pulled out of the water after *The New Blood* and cremated once and for all. Anyway, Jason then climbs onto the boat where he impales Jim with a spear gun before he lingeringly stabs Suzi. Back and ready to cause havoc in the land of the living once again, Jason boards a ship, the *S.S. Lazarus,* which is bound for New York. On board is a group of graduating high school seniors planning to celebrate their freedom in the Big Apple. Unfortunately, before they have a chance to arrive in the city that never sleeps, Jason, the monster that never sleeps, will end up killing virtually all of Crystal Lake High School's graduation class, along with some really sleazy adults who are thrown on board for added texture. A few of the students do however manage to escape

Visual Effects Supervisor:
Dale Fay
Special Effects
Co-ordinators:
**REEL EFX Inc.,
Gary Paller, Jim Gill,
Bettie Kauffman**
Visual Consultant:
Pam O'Har
Stunt Co-ordinator:
Ken Kirzinger
Stunts:
**Gary Chessman, Jim
Dunn, Dorathy Fehr, Reg
Glass, Ted Hickman, Ernie
Jackson, David Jacox,
Michael Langlois, John
Nash, Dawn Stofer Rupp,
Jacob Rupp, Melissa
Stubbs, Danny Virtue,
John Wardlow**
Production Supervisor:
Vikki Williams
Production Co-ordinator:
Roberta Slade
Assistant Production
Co-ordinator:
Joanne Barry
Co-ordinator Trainee:
Lesley Fransvaag
Production Assistant:
Wendy Mentiply
Assistant to the Producer:
Liz Huggins
Casting:
**David Cohn, Fiona
Jackson**
Locations:
**Vancouver, BC, Canada;
New York City, NY, USA**

CAST

Todd Shaffer
(Jim)
Tiffany Paulsen
(Suzi)
Timothy Burr Mirkovich
(Young Jason)
Kane Hodder
(Jason)
Jensen Daggett
(Rennie)
Barbara Bingham
(Colleen Van Deusen)
Alex Diakun
(Deck Hand)
Peter Mark Richman
(Charles McCulloch)
Ace
(Toby)
Warren Munson
(Admiral Robertson)

to New York where, for reasons unexplained, they're mercilessly stalked by Jason who seems to be able to monitor all of their movements.

One of the few character subplots in *Jason Takes Manhattan* is that of the relationship between Reeves's character, Sean, and his father, the strict but loving Admiral Robertson (Warren Munson). "I liked how they had that detail in the script about Sean not feeling like he can ever impress his father and I wish there had been more of that in the script," says Reeves. "It's kind of a shock when Sean finds that his father's been murdered because the relationship seemed to have been building. I think you expect the father to live, so it was a big

surprise." Admiral Robertson gets his throat slit in the film, but his fate could have been a lot more graphic: "I filmed a scene where you saw the blood seeping out of the throat and it was very gruesome," recalls Hedden. "As with most of the kill scenes, I'd filmed another take where you just see the cut and no blood, and that's what ended up making the film. The cuts were really tough on our film and I didn't think the cut stuff was that gruesome by today's standards."

Jason's reign of terror onboard the *S.S. Lazarus* sees the passengers variously get burned to death, brain-bashed, stabbed, harpooned, axed and electrocuted. During the rampage, Hedden

introduced a minor subplot, and a potential secondary villain in Richman's character, Charles McCulloch, the sinister chaperone who's attracted to teenage girls. McCulloch's predilection leads to him being caught in a compromising position with Tamara (Sharlene Martin), who tries to blackmail the degenerate before she gets stabbed to death with a shard of glass.

It's about here that *Jason Takes Manhattan* starts to squander the moderate amount of excitement and tension that had no doubt built up for fans looking forward to the prospect of Jason roaming the streets of Broadway and, no doubt, cutting up The Rockettes. Unfortunately, it soon becomes clear that the New York action is not going to kick in until very late in the film. In the meantime, what the viewers get is just more of the same tired old stuff with the only difference being that the killing spree takes place on a boat as opposed to the grounds of Crystal Lake.

Still, some of the kills are interesting, particularly the shower death of Martin's character, Tamara. According to Hedden, the scene was, more or less, a tribute to *Psycho*: "That's where Sharlene gets slashed in the shower and, yes, it was sort of inspired by *Psycho*. Originally, you were going to see Jason bring the shard of glass right through her body, very bloody, which was too much for the MPAA. It was more like *Psycho* in that you see the

blood splatter the walls and fall down into the drain, but we'd wanted to use more blood." Like Daggett, Martin was a little nervous about taking off her clothes, even if just to take a shower. "I didn't want to get naked and I was very nervous about being in the shower," she recalls. "Then Rob calmed me down and explained to me that the shot was going to be mostly steamed over and he did it

in a very tasteful way. Actually, before we filmed the shower scene, Rob got undressed and actually stepped into the shower to show me that it wasn't so hard, so that really relaxed me."

As the rampage on the boat continues, Sean and Rennie, and a few other survivors, search the ship for the elusive killer, eventually discovering the psychotic stowaway, Jason. One of the film's other interesting ideas is that Rennie, in common with some of the heroines from previous sequels, has been experiencing hallucinations of Jason ever since she had a chance encounter with the masked monster when she was just a young girl. The story went that Rennie's uncle had, years ago, taken her out to Crystal Lake on his boat, where he threw her in the water in an effort to teach her how to swim. It was there that the terrified girl experienced her first vision of Jason.

Hedden feels that Rennie's visions allowed *Jason Takes Manhattan* to explore more of Jason's past than any of the prior sequels. "I think I was trying a *2001: A Space Odyssey* thing with Rennie's character in terms of trying to have Jason see the child in himself," says Hedden. "With Rennie, I wanted her flashbacks to allow the audience to see into Jason's past, to give the story an added dimension in terms of it not just being a slasher film, especially in the scene where Rennie looks into a mirror and sees Jason who crashes through the mirror and attacks her. You're not sure if it's real or just in Rennie's mind. I think that the *Nightmare on Elm Street* films were certainly an influence on the story. As a matter of fact, after *Jason Takes Manhattan* came out, I was actually approached by New Line Cinema about writing and directing an *Elm Street* film but I turned it down because I was so tired from working on *Jason Takes Manhattan*."

Back on the *S.S. Lazarus*, the graduating class has been sliced and diced down to just a handful, and so the remaining survivors - including Julius (V.C. Dupree), Rennie, Sean, Miss Van Deusen (Barbara Bingham) and the sinister Charles McCulloch - try to escape on a lifeboat. Not forgetting Rennie's dog who, in an earlier version of the *Jason Takes Manhattan* script, was almost mauled by Jason. "We were going to do a great scene where the kids arrive in New York with the dog and Jason kicks the hell out of the dog," recalls Hodder. "It would've been a really good scene, but I told Rob that even Jason wouldn't hurt a dog. He would rip out someone's heart, but hurting a dog was too much for him. Even Jason has his limits."

When the group makes it to shore, *Jason Takes Manhattan* finally serves up the New York locale that is so prominent in the film's title. Unfortunately, many *Friday the 13th* fans felt

cheated; they had been looking forward to the spectacle of Jason stalking through the streets of New York, but the film had so far failed to deliver upon the premise. In short, fans wanted to know why it took so damn long for Jason to get to Manhattan.

Of course, for the most part, this wasn't Manhattan, it was Vancouver. "It was so expensive to film in New York and that's why most of the film takes place on the boat," explains Hedden. "I was hoping to create enough suspense and tension on the boat that the boat location would stand on its own, but I guess fans were expecting more scenes in Manhattan and maybe more of the film should've been set there. Vancouver was such a great match for New York, in terms of its look, that I think we could've done more because I think the ads for the film seemed to promise that the film would spend more time in Manhattan than it did."

Once in Manhattan, Jason stalks Sean, Rennie and the others while taking time to slice a bloody chunk out of the Big Apple. He kills a couple of gang members who kidnap Rennie, and in the film's most memorable scene, Jason gets into an impromptu rumble with Julius on a rooftop. Julius lands a few good punches until an impatient Jason

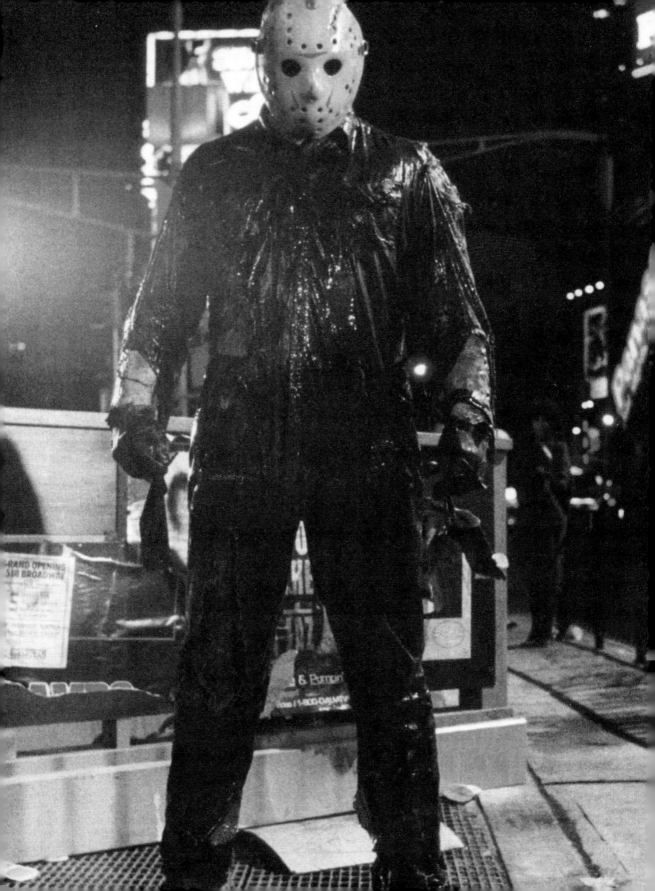

decapitates him with one bloody punch. "That scene was both fun and exhausting," recalls Dupree. "I kept punching and punching and we'd do take after take, and I'd get so tired that I didn't have to act when Julius is too tired to throw more punches. Then, I had to pull my punches, of course, although Kane was so big and strong that I don't think I could've hurt him. Sometimes I'd hit the mask and it hurt. I loved how they killed off my character and people still remember that scene to this day."

Once Jason dispatches Miss Van Deusen - who gets immolated inside a car - and a local cop, the stage is set for the climactic confrontation between Jason, Rennie and Sean. That is, after Jason drowns the depraved Charles McCulloch in a barrel of raw, toxic sewage. And sewage is the order of the day in the film's finale as Rennie and Sean find that the only way to escape the seemingly-omniscient Jason is to run down into the bowels of the local drainage system. Bizarrely, what they find down there is poisonous sewage, the perfect potion to solve their problems; as Jason tries to kill the two survivors, Rennie turns on a valve that releases the sewer's poisonous contents onto Jason's ravaged body. Crystal Lake's Crimson Toxic Avenger is transformed into the scared little boy who drowned at Camp Crystal Lake on that fateful day in 1957. "I wanted to take Jason back to where he started and I feel like the ending definitely accomplished that," says Hedden. "I think, in the script, I described him as being seven or eight when I think, according to some of the timelines, he was really eleven or twelve. In the original script, he was talking a lot more, crying out for help, crying out for his mother, but it was decided that a lot of that should be trimmed for the finished film. I wanted to go farther - in terms of dealing with the origin of Jason and the supernatural aspects of the character - than any of the other films."

The scene in the sewer was physically demanding for Hodder as special effects expert Martin Becker rigged 2,000 gallons of water to flow over the actor inside the sewer set. One of the requirements of the scene was that Jason should have water and toxic slime gushing out of his mouth, an easy task for Hodder who lists projectile vomiting among his many skills. "Oh yeah, I can puke on command," he boasts. "That's what they wanted and I did it, no problem. I just drink some water and I can vomit anything. Actually, the rush of water almost knocked me unconscious, but the puking part was easy."

The unusual ending brought largely negative reactions from fans, who felt it was illogical and silly. As it turns out, Jason himself isn't exactly a big fan of the film's ending. "No, I really hated the

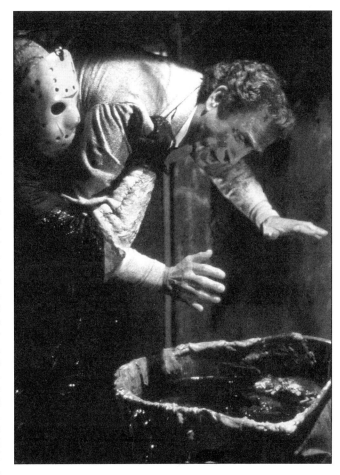

ending," says Hodder. "I fought to try and get it changed, but that's the way it turned out. I think it just confused the fans in terms of what had happened to Jason before *Jason Takes Manhattan*. It didn't make sense and I'm glad that, in the later films, we just ignored that ending all together." If Hodder had an angry reaction to the ending of *Jason Takes Manhattan* during the making of the film, it's news to Hedden. "Kane never said a word to me about the ending," he recalls. "If he had, I would've talked to him about it and possibly changed it but he never said anything to me. All parties involved agreed to shoot that ending so it wasn't just a case of me going out on a crazy limb. It was agreed upon. I'm sorry Kane feels that way because I thought we had a great working relationship. The ending, like the film, certainly got mixed reviews. Some people liked it, and understood what I was trying to do, and some people just hated it."

It seemed that nothing could be done to forestall the bruising reception that *Jason Takes Manhattan* received from the paying customers when the film was released on July 28, 1989, just two weeks before the equally doomed release of *A*

above:
Jason Voorhees dunks Charles McCulloch in a vat of toxic sewage.

opposite:
Jason prepares for a slaughter at sea.

below:
Dummy Julius head.

FRIDAY THE 13TH PART VIII
JASON TAKES MANHATTAN
JULY 28TH AT THEATRES EVERYWHERE

above:
Alternate North American poster art for *Friday the 13th Part VIII: Jason Takes Manhattan.*

Nightmare on Elm Street 5: The Dream Child. Maybe Paramount executives knew something when they let Hedden dispose of Jason in the matter that he did; either the climate had changed irrevocably or *Friday the 13th* fans had moved on. Whatever the reason, *Jason Takes Manhattan* was, at the time, the least commercially successful film in the *Friday the 13th* film series. Of course, the same could've been said of *Jason Lives* and *The New Blood* at the times of their relative releases, but the negative reception that greeted *Jason Takes Manhattan* was downright ominous. *Jason Takes Manhattan* grossed $6.2 million during its opening weekend, leading to an eventual final gross of $14.3 million domestically. The only solace, it seemed, was the fact that *The Dream Child* also fared poorly at the box office, although that film's $22.1 million take seemed strong in comparison to that of *Jason Takes Manhattan.*

Times had changed. Paramount pulled the plug on Jason. Could it have been that simple? "I think,

after *Jason Takes Manhattan*, everyone looked back and said, 'We had a really good run, the films were very successful, and maybe this is the end,'" says Mancuso, Jr. "It was kind of strange - when 1990 rolled around - to not have a *Friday* film in development, but it felt like maybe it was time to end the series although I wasn't against the possibility of doing another *Friday* film had a really great story idea came along."

As a matter of fact, Mancuso, Jr. renewed his efforts - following the release of *Jason Takes Manhattan* - to once again make the *Freddy Vs. Jason* concept a reality, even organising meetings with prospective directors, including *The Final Chapter*'s Joseph Zito. "There was talk about *Freddy Vs. Jason* after *Jason Takes Manhattan*, but it didn't come together despite everybody's best efforts," he says. "I'm happy that *Freddy Vs. Jason* has finally been made because I always thought it was a great project. I'm not sure what the impact of the *Friday the 13th* films was in terms of how they'll be remembered. I think they were a specific kind of film made in a certain era, and the fans loved to watch them. We all had fun working on them. I don't know how long they'll be remembered or what they'll be remembered for."

That was it, although one could argue that the franchise had, from a commercial and cultural perspective, started to lose its influence as of the mid '80s. For the fans who'd grown up with the series in the '80s, waiting year after year for the arrival of the newest *Friday the 13th* film had seemed like a tribal ritual that was, like death and taxes, always going to be a part of life. But it had ended. It was 1990 and the '80s were gone, and so was the excitement and visceral power of those days. The days when an independently-made horror film with gory, raw effects, could take a nation by storm were over. By 1990, theatres were beginning to become shackled to the blockbuster mentality created by corporate film events such as the release of *Batman* in 1989. Theatres were becoming computerised, the independents were being shut out and *Friday the 13th* was no longer cool.

It was 1990 and Vanilla Ice was the biggest star in America. The battle between Freddy and Jason was on indefinite hiatus, and even though Jason would return a few years later, Fridays would never be the same again... not like they were back in the good old days. By 1990, the only remnant of the *Friday the 13th* franchise still alive was *Friday the 13th: The Series*, a syndicated television series that debuted in 1987 - when the film series was still seemingly healthy. *Friday the 13th: The Series* marked an interesting diversion in the history of the franchise, most notably because Jason was nowhere to be found.

The Hockey Mask Vanishes

In order to fully complete the picture of the whole *Friday the 13th* story, it is necessary to back-track a few years at this point, to 1987, when the makers of the *Friday the 13th* film series decided to take the franchise in a radically different direction. *Friday the 13th: The Series* aired from 1987 to 1990 (the year after Paramount had released what would be their last *Friday the 13th* film, and the last film to ever carry the *Friday the 13th* insignia). If the ultimate flattery for a film is for it to be endlessly copied and sequelized, maybe the ultimate tribute to the success of a series is to bring it to television. Whatever the crazed logic behind Paramount's decision to do just that, one thing was clear: the films had, by the late 1980s, become so deeply entrenched as part of mainstream pop culture that the series would never be able to return to its blood-soaked and pure roots. *Friday the 13th* was a brand, a stamp that could be put on anything and everything in the pursuit of profits, but *Friday the 13th: The Series* would stand on its own two feet - without Jason.

Created by Frank Mancuso, Jr. and Larry B. Williams, *Friday the 13th: The Series* - which made its debut in September of 1987 - told the story of two cousins, Ryan Dallion (John D. LeMay) and Michelle 'Micki' Foster (Robey), who, following the mysterious and sudden death of their estranged uncle, Lewis Vendredi (R.G. Armstrong), a man they never met, are bequeathed his old antique shop. Vendredi's Antiques is a creepy den full of unusual odds and ends. It turns out that these sundry items were created with the help of black magic and that Vendredi's landlord was, more or less, the Devil himself. (A quick aside... for those without a grounding in foreign languages it is worth pointing out that the word 'vendredi' is French for 'Friday'!)

All of this was immediately revealed in the premiere episode of the series, *The Inheritance* (directed by genre veteran William (*Death Weekend*, *Spasms*) Fruet and featuring a young Sarah Polley in one of the principal roles), in which we find out that Uncle Lewis had made a deal with the devil whereby he would trade cursed antiques that would have disastrous consequences for their owners. Vendredi had hoped to become immensely wealthy, but, alas, he's sent to the bowels of hell instead.

Enter Ryan and Micki, who arrive at the shop and immediately begin selling off the cursed inventory, completely oblivious to the hell that they are unleashing upon the world.

Fortunately Jack Marshak (Chris Wiggins), an old associate of Lewis, passes by, and immediately discerns that the large number of antiques that Ryan and Micki have sold off are about to wreak unholy terror upon the world. Appraised of the full details of Vendredi's alliance with the Devil, the two cousins swiftly realise that everyone in possession of the sold antiques is destined to die before their time unless Ryan and Micki, with the invaluable help of Jack Marshak, can recover the cursed items.

That was the premise for the show, that eventually ran for an impressive seventy-two episodes before its cancellation in 1990. One by one Jack, Micki and Ryan would document the cursed items and then, in each episode, we would be witness to the tragic effects of the cursed antiques along with the frantic and heroic attempts of the trio to recover the items before too many people are killed.

below:
Ryan Dallion (John D. LeMay) has reason to believe that time is running out for him in the episode *13 0'Clock.*

above:
Ryan Dallion and Micki Foster (Robey) are attacked by a dead violinist in the episode *Symphony in B Flat.*

below:
Second season press advertisement.

The premise was as far away from the world of Camp Crystal Lake as fans could imagine, which begs the question, why? Why not simply capitalise on the success of the *Friday the 13th* films by making a show that revolved around a slasher storyline? Why risk turning off *Friday the 13th* fans by naming the show *Friday the 13th: The Series*, since audience expectations were bound to be skewed by the entirely different premise of the series? Why make a television series and risk overexposure, a fate that arguably did eventually cripple both the *Friday the 13th* franchise and the *Nightmare on Elm Street* franchise? (A rival television series, *Freddy's Nightmares*, was launched in 1988 to directly compete with *Friday the 13th: The Series*.)

According to Mancuso, Jr., who was originally going to call the series *The 13th Hour*, it was never anyone's intention to link the series with the films. "I remember that I didn't do any interviews for the first year or two because the questions were always the same: Where's Jason?" he recalls. "The basic concept was to take the idea of *Friday the 13th*, which is that it symbolizes bad luck and curses. We were going to find some way to tie the hockey mask into the show, but we just scrapped it because we knew that the show had to stand on its own two feet. If we had even referenced the films once, it would've totally taken the viewers out of the new world that we were trying to create." Another proposed title for the series was *Friday's Curse*, which was indeed the name under which the series was known when it debuted in the United Kingdom.

The decision to entitle the series *Friday the 13th: The Series* was, according to Mancuso, Jr., just a matter of name recognition. "I felt that it would've been a lot easier to sell a *Friday the 13th* show than something called *The 13th Hour*," he says. "Still, it wasn't as cut-and-dried as people might think because when I first started pitching a *Friday the 13th* television show, people would cringe because the films had such a negative connotation to them. But yeah, from a commercial standpoint, it was a no-brainer to call the show *Friday the 13th*."

Since *Friday the 13th: The Series* was filmed entirely in Toronto, Canada, filming requirements, not to mention politics, stated that roughly half of the talent employed on the series had to be Canadian, which is fortunate for series stars Robey (sometimes billed as Louise Robey) and Chris Wiggins, both of whom had ties to Canada. Robey was born there, the daughter of a decorated Air Force major and a London stage actress, the former model and singer travelled widely in her youth, attending schools in England and Italy. An accomplished dancer, Robey was offered a scholarship at the prestigious Royal Academy of Ballet in London, which she turned down to pursue a modelling and recording career in Paris. "I'd done some demos and then I came into contact with this famous French photographer, Jacques Henri Lartigue, who took pictures of me that got me lots of modelling work," she recalls. "I called my parents in Canada and told them I wasn't coming back." While modelling, Robey found time to record the single *One Night in Bangkok*, that went on to became a top ten hit all over the world, and she also had a small part in the 1986 Arnold Schwarzenegger thriller *Raw Deal*, though apparently most of Robey's role ended up being left on the cutting room floor.

Auditioning for *Friday the 13th: The Series* was almost a cursed experience in itself for Robey. "I heard the title and I didn't know anything about the *Friday the 13th* films, but I assumed that the show was going to be about Jason and I really wasn't that interested," she says. "It wasn't until I read the first couple of scripts that I saw that it was something completely different. Still, when I went in to read, I wasn't that enthused. I almost didn't care. I read for one of the casting assistants and they ended up bringing me back for another read the next day. I never could've predicted how much fun the show would turn out to be and the impact it would have upon my career."

For Wiggins, a wily veteran of film and television who has spent most of his working years in Canada, *Friday the 13th: The Series* was just another job, a professional obligation, with a bit of a strange twist. Wiggins's other notable genre appearance was a supporting turn in Bob Clark's 1980 Jack the Ripper thriller *Murder by Decree*. "I'd never played an expert in the occult before," recalls Wiggins with a laugh. "That was interesting, and I was also intrigued by the idea of having to recover all of these cursed items which I thought would make for interesting television and, hopefully, a long-running series."

Wiggins, who has won numerous Canadian acting awards, remembers *Friday the 13th: The Series* as being a labour of love, and certainly a lot of work. "The hardest part of making the show, aside from the budgetary constraints, was the fact that it wasn't normal hours," recalls Wiggins who was born in Lancashire, England. "Most of the scenes were shot at night and if you have a family, a life, it's very tough to work and live under those conditions. What made us all get through it was the fact that the cast and crew were very much like a team, which was a real asset because there would be times when we wouldn't be sure if we'd be able to get through an episode or not."

John D. LeMay, a native of St. Paul Minnesota, was given the starring role of Ryan Dallion in *Friday the 13th: The Series*. For him it was, in a tenuous way, a return to the *Friday the 13th* family as LeMay had appeared in Sean S. Cunningham's 1985 teenage delinquent thriller *The New Kids*. Prior to his role in *Friday the 13th: The Series*, LeMay had obtained a Music degree from Illinois State University in 1984 and had appeared on such television series as *The Facts of the Life* and in several episodes of the '80s revival of *The Twilight Zone*. Getting the part of Ryan Dallion was a psychic experience for LeMay. "I was a young actor in Hollywood and I was very nervous about my career and my future," recalls the performer, who would go on to star in 1993's *Jason Goes to Hell: The Final Friday*. "I went to see this medium who told me, quite mysteriously, that there was an acting job for me somewhere back East. Well, I thought she meant New York, but I had no idea that it would end up being in Toronto. Shortly after that, I got the call for the *Friday* audition that was shooting in Toronto. I think it was the last of, like, five auditions and I went in and I read with Robey. It's funny because I always prepare for my auditions, but I hadn't even been thinking about *Friday the 13th*."

The need for the series to have Canadian input turned out to be somewhat of a blessing in that some very interesting directors would work on episodes of the series. Aside from Fruet, who directed nine episodes, the show was graced by notable professionals such as David (*The Fly*, *Scanners*) Cronenberg, Atom (*Felicia's Journey*) Egoyan, Rob (*Friday the 13th Part VIII: Jason Takes Manhattan*) Hedden, Armand (*He Knows You're Alone*) Mastroianni, Tom (*Friday the 13th Part VI: Jason Lives*) McLoughlin, Bruce (*Hello, Mary Lou: Prom Night II*) Pittman, and David Winning.

The low budgets and ten-day production schedules proved to be an interesting challenge for the directors. "It was a great chance to learn all about directing television," says McLoughlin, who's spent much of his subsequent career dong just that. "I was basically trying to make a feature on a fast schedule and a low budget. Most of the time I think we pulled it off."

The most critically acclaimed episode of the whole series was 1988's *Faith Healer*, directed by Cronenberg. In the episode, Jack is asked by a friend to help investigate an unscrupulous mystic who uses a cursed glove to heal people by transferring their wounds and ailments to another person. While Jack tries to recover the cursed glove, he must also come to terms with the fact that

above:
First season press advertisement.

below:
A cursed World Series ring punishes a compulsive gambler in the episode *The Mephisto Ring*.

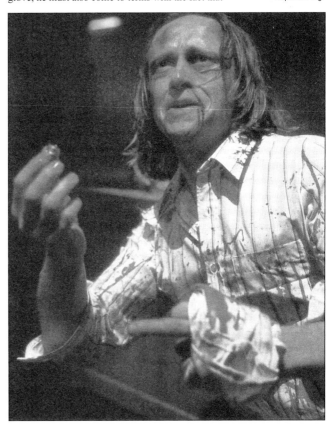

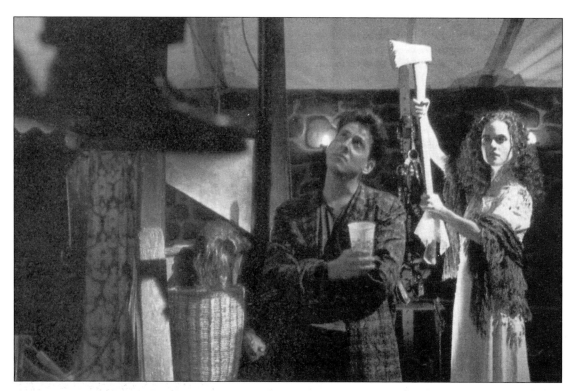

above:
A wax figure comes to life and prepares to attack an unaware Ryan in the episode *Wax Magic.*

below:
Despite solid ratings, *Friday the 13th: The Series* was strangled by studio politics and protests from religious groups.

his friend (Robert Silverman) is dying of cancer. "I always loved watching anthology horror programs on television when I was a kid," says Cronenberg. "I was asked to direct an episode because I was friends with several of the people involved with the show and, since I hadn't done a feature since *The Fly* in 1986, I thought it would be a good opportunity to stay sharp because I'd been working on *Dead Ringers*. I was very happy with how the episode turned out and the fans really loved it."

According to Fruet, directing episodes of *Friday the 13th: The Series* was often a hellish experience. "We would start a week and not know how we were going to get an episode done, but by the end of the week, we'd find a way to do it," he recalls. "I think the real saving grace of the show was Rodney Charters, the director of photography, who's a great friend and one of the best in the business. The hardest part of the show was how mean the local producers were because they were always slashing the budgets and screaming at us to work faster. I felt that Frank Mancuso, Jr. really wanted to do a great show, but the producers in Toronto just wanted it done fast and cheap."

Fruet's personal favourite episode, and also one of the most challenging for him, was 1988's *Wax Magic,* which told the tale of an eccentric wax sculptor and his wife. The sculptor uses a cursed handkerchief to reanimate the wife, who has

previously been turned into a wax statue. As they tour carnivals, the woman finds herself in the position of having to kill in order to maintain the curse, something she detests. "I loved that script, but the producers didn't want to do it because they said we'd never find a carnival, but there was one right in the city," recalls Fruet. "It looked like it cost a lot more than it did and the actors were great and it's the episode that I'm most proud of. The stress of the show eventually got to be so much that, one night, I came home and just told my wife that I was quitting."

Luckily, for all parties involved, the first season of *Friday the 13th: The Series* was a rousing ratings success, with the show often ranking just behind *Star Trek: The Next Generation* in the hostile world of syndicated television. The initial ratings success of the series was great vindication for co-creator Mancuso, Jr., who maintains that talk of puny production budgets and hellish schedules was largely overblown. "The show was very hot and cold in a lot of ways," he says. "Some of the shows worked very well and some didn't. After the first season, I felt very comfortable talking about the show because it seemed like the fans had embraced the show's concept and they'd accepted that it wasn't about Jason. I think we learned a lot from the first season in terms of creating stronger characters and using directors who would bring a

more cinematic approach to the show. I made a point of hiring directors who'd made films because I felt like veteran TV directors were too stale. We always had good directors working on the show. As for the effects, the effects budget was never as low as some people claimed. What happened was that we went through several effects people because some of the effects weren't ready when they were supposed to have been ready."

LeMay believes that becoming Ryan Dallion was a great chance to bring out different parts of his personality, although the limiting nature of the show, combined with the gruelling schedule, ultimately provoked the actor to leave the series in 1989. "I remember that the first episode we actually filmed was *Cupid's Quiver*," recalls LeMay of the Atom Egoyan-directed episode about a cursed Cupid statue (though shot first it was actually the third episode to air during the first season). "I took different parts of myself and put them in Ryan and vice versa. I've never really been a fan of comic books, like Ryan, but I love great art."

LeMay formed a close bond with his fellow cast members and the city of Toronto. "Doing the show, I got to know every inch of Toronto and I feel like an honorary Canadian," says the actor, who lists *Read My Lips*, *Root of All Evil* and *Tattoo* as his favourite episodes. "It was one of the greatest experiences and I was working for two years and learning every single day, and it's hard to believe that it's been over fifteen years now. Chris Wiggins was a very valuable mentor for me and we still keep in touch every once in awhile. He was very important to me as an actor and a person. As for Robey, I saw her at an art gallery in Los Angeles a few years ago. Looking back, I always thought they should've kept the *Friday's Curse* title because I think the *Friday the 13th* title really angered all of those political and religious groups when the show became a hit."

A great many exciting and talented actors worked on the series, including such guest stars as Keye Luke, Ray Walston and Fritz Weaver. In the episode *Tales of the Undead*, Walston played Ryan Dallion's idol, comic book artist Jay Star who - in an oblique reference to the plight of real-life comic legend Jack Kirby - uses a cursed comic book that allows him to take vengeance on those in his industry that ripped him off. "Walston was such a clever, sly actor to be around," recalls LeMay. "Working with R.G. Armstrong was a great surprise because he plays all of these villains, but he's really such a gentle man. Working with Keye Luke in *Tattoo* was really quite an honour."

Wiggins, a classically trained actor from the stage, considered the increased gore and violence that appeared in *Friday the 13th: The Series*

following the successful first season - and a subsequently increased effects budget - to be a bit of a turnoff. What's more, the actor believes it may have been a possible cause for the eventual demise of the series. "I thought the violence got to be a bit much, especially in the second season," says Wiggins. "I would sometimes complain about the gory scenes, but those would be the same scenes that the fans would enjoy the most." LeMay feels that complaints about the violence in the series were overblown. "There were a couple of shows, *Face of Evil* and *Vanity's Mirror* in particular, that I felt pushed the boundaries of violence," he says. "Still, I don't think the show should've been singled out. The fans loved those shows and I don't believe in censorship."

Friday the 13th: The Series changed irrevocably when, in 1989, LeMay made the decision to leave the show in order to pursue other acting opportunities. In a two-part instalment entitled *The Prophecies* that began the third season, LeMay's

above:
A deadly ventriloquist's dummy in the episode *Read My Lips.*

below:
Ryan Dallion, Micki Foster and Jack Marshak (Chris Wiggins) study a cursed antique. The actors have remained friends since the series was cancelled in 1990.

above:
A cursed silver compact prevents ageing at a horrible price in the episode *Face of Evil*.

included roles on such television series as *Providence* and *Tour of Duty*) liked the way that Ryan Dallion - under the direction of Tom McLoughlin - was given a second chance in life, something the actor was looking for himself when he made the decision to walk away from the show. "Everyone I talked to thought it was weird, but I thought it was a really clever way to get rid of me," says the actor. "I liked the idea that, instead of dying, Ryan got to live his life over again. I don't think I was ever really the Ryan Dallion that the producers were looking for because I wasn't macho and tough. I tried to make Ryan intelligent. I was getting tired of the character and the guerrilla-style filming we did because there was a lot of pressure on me to be there even if I was sick. *Friday the 13th: The Series* gave me an incredible opportunity to be a working actor, someone that people still recognise and, as an actor, you like to try different things and I certainly don't think my leaving had any effect, one way or the other, on the show's cancellation."

To say that fans of the series had a mixed reaction to Ryan's 'reincarnation' would be a severe understatement as LeMay was replaced by actor Steve Monarque whose character, the street-tough Johnny Ventura, had already been introduced in the second season episode, *Wedding Bell Blues*, in which he was seeking a mysterious pool-cue, a search that led to a trail of dead bodies and a fateful pairing with Jack and Micki. Filled with personal demons from his youth, Johnny agrees to help track down the remaining cursed items. Furthermore, since Johnny and Micki aren't cousins, there was nothing stopping them from starting a romance. For Monarque, a native of Passaic, New Jersey, entering an established series wasn't easy. "I was nervous, but Chris and Robey immediately embraced me," recalls the actor, who had previously appeared in 1984's *Sixteen Candles*.

Robey and Wiggins believe that LeMay's sudden departure did cause problems, despite their fondness for Monarque. "We loved John and I think the change upset the rhythm and timing of the show," says Robey. "John was a very good actor, but I sensed that he wasn't happy. It was a very stressful time because the show's future was very uncertain. Steve Monarque was a great guy, very sweet to work with, but the chemistry that had already been established must've been very hard for him to deal with. It's so hard for another actor to come in and join an established show and replace an established character that the fans love."

Ironically, the makers of *Friday the 13th: The Series* made an attempt to create a fourth lead when the character Rashid, a Middle Eastern mystic played by Elias Zarou, was introduced in the

character, Ryan Dallion, was killed off in a very unusual and controversial way, after he became an unwitting pawn of Satan's fallen angel, Astaroth. Eventually Ryan was forced to sacrifice himself in order to save the life of a young girl in a wheelchair, in the process preventing the fulfilment of the last of the six prophecies that would have allowed Satan to dominate the world. As a result of Ryan's sacrifice he was transported back into the body of a school-aged child, thereby giving him a second life!

LeMay (whose subsequent acting output, aside from *Jason Goes to Hell: The Final Friday*, has

episodes *Bottle of Dreams* and *Doorway to Hell*. However, the idea was scrapped following tepid audience reaction.

Of all the characters in *Friday the 13th: The Series*, the one that grew the most as the episodes progressed was Micki, largely due to improved writing. What began as a stilted character eventually transformed into a brave and likable heroine. "We had two days off between the filming of episodes and I was always burned out, especially since I was often flying to Paris to promote the show or promote my music," says Robey who would eventually become Lady Burford when, in 1994, the actress married The Earl of Burford, Charles de Vere Beauclerk. Now divorced, the former 'royal couple' share a son. "I think Micki started out as just another pretty girl, but I think she became very intelligent and useful. You know, I don't think *Friday the 13th: The Series* was horror at all. I think it was a suspense show that just happened to have elements of horror."

Robey lists her favourite episode as 1990's *The Charnel Pit* - the last ever episode as it happens - during which she came face to face with none other than the Marquis de Sade. "I did a lot of work in that episode. I got to ride around and I got to dress up in all kinds of period costumes. It was like being a kid and playing dress-up," she says, adding: "None of us had any idea that was going to be the last one because we'd been virtually guaranteed that this show was going to be brought back for a fourth year,"

By the end of the third season, ratings had begun to slip, not to mention the fact that the two *Friday the 13th* films that had been made during the time that the series was in production - 1988's *Friday the 13th Part VII: The New Blood* and 1989's *Friday the 13th Part VIII: Jason Takes Manhattan* - had been box office disappointments. The ratings were still respectable, but with the cancellation of *Freddy's Nightmares* in 1990 and the equally disastrous performance of the most recent entry in that film series - 1989's *A Nightmare on Elm Street 5: The Dream Child* - the writing was on the wall. But the question still remains; why, if *Friday the 13th: The Series* itself was still a profitable, cheaply produced show, was it cancelled? "The show was killed because of greed," asserts Fruet. "The show was doing very well when it was on in late-night and then the producers decided to move it into the evening and it just killed the show. All of a sudden, all of these religious groups started attacking the show and it just died."

According to the members of the cast, the cancellation of the series was a surprise. "One day we were making plans for a fourth season and a couple of days later it was over," recalls Robey. "It was a real shock for everyone, like losing a member of your family. All of a sudden, our family was being taken away and there weren't really any reasons given other than the fact that the most recent *Friday the 13th* film had bombed and the religious groups were causing trouble with Paramount. We were together for three years, seven days a week, and it was all gone in a flash. It's ironic because our ratings, at that time, had never been better."

Wiggins feels that the backlash from family and religious groups was the final impetus that convinced an already skittish Paramount to pull the plug on anything that was associated with *Friday the 13th*. "The religious groups were threatening to boycott some of the sponsors and they were accusing us of being Satanists," he recalls. "I found that charge utterly ridiculous since the show was

above:
Second season press advertisement.

below:
Ryan is tortured by an evil psychiatrist in the episode *And Now the News*.

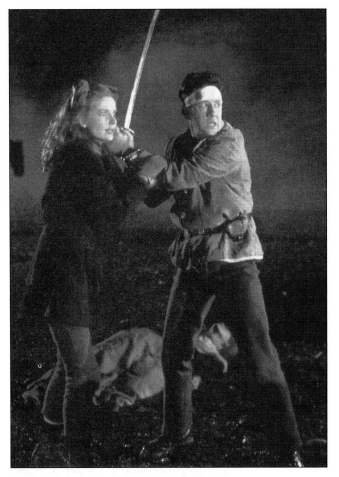

turned Freddy Krueger into a cartoon figure and overexposed the character. We didn't have Jason on our show, but I think the fans might've been tired, at that point, of anything that was *Friday the 13th*. Still, I'm very proud of *Friday the 13th*: *The Series* and the wonderful people who contributed to the show. It was fun and I know the show still has a cult audience because I still hear from fans."

Enough of a cult audience to fuel the prospects of a reunion show that might tie-up the series' storyline? Never say never. "I'd love to do a reunion show if they could get Chris and John back," says Robey. "You know, the two-hour, third season opener was released as a feature in Europe so there's still lots of fans around the world. We're all still friends. I think we owe it to the fans to track down all of the remaining cursed objects. One of the other things that really killed our show was bad luck, ironically enough. Frank Mancuso, Jr. was trying to take over *War of the Worlds*, another syndicated show that was filming at our studio. When that show died, Paramount decided to get rid of the studio which meant killing the show." Wiggins would also love to be involved in a reunion, mostly for nostalgic reasons. "A few years ago, John, Robey and myself were invited to attend a television spectacular in Spain and it was just like old times," he recalls. "I'd love to do a reunion movie if only to meet Robey and Steve again and, of course, John, if he would come back. Jack is one of my favourite characters that I've ever played as an actor."

While *Friday the 13th*: *The Series* wasn't a classic piece of genre television in the vein of *The Outer Limits* or *The Twilight Zone* it was a colourful and welcome addition to the world of horror television during its three year life. It's ironic that, through endless reruns, *Friday the 13th*: *The Series* is more fondly regarded than many of the entries in the film series. Even more ironic is that the cancellation of the series in 1990 coincided with the ominous fact that, for the first time since the shocking and stunning theatrical debut of *Friday the 13th* in 1980, there were no more *Friday the 13th* films in development.

During the early eighties, at the height of the *Friday the 13th* films' popularity and pop culture relevance, it seemed like these movies were coming from a ruthlessly determined production-line that, just like Jason, was never going to stop. Before 1990 had drawn to a close however, *Friday the 13th*: *The Series* was gone, and Paramount had no intention of making more films. For millions of fans around the world to whom the *Friday the 13th* films had seemed akin to death and taxes, it was as if Jason, and the *Friday the 13th* franchise, had been banished to hell.

about our characters fighting the forces of Satan, not embracing those ideas. It's frustrating when these kinds of groups, in a democratic society, can decide what kinds of programs we can watch on television, but they have a lot of power."

For his part, Mancuso, Jr. feels that the cancellation of the series was, more or less, just the natural end of a popular cycle. "The *Elm Street* and *Friday* franchises were probably over-saturated at that point," concedes the producer. "Who's to say that three years wasn't enough for the show? You know, from a creative standpoint, I felt like the show might've become a bit stale, although there were still some good episodes and good people associated with the show. I think the failure of *Jason Takes Manhattan* was a big factor in Paramount's decision to pull the plug because, all of a sudden, the *Friday the 13th* franchise wasn't profitable for them anymore and they didn't have to be involved anymore. I don't think it was a coincidence that *Freddy's Nightmares* was cancelled the same year. I felt like the makers of that show had

A Franchise Goes to Hell

By the summer of 1992, both Jason and the *Friday the 13th* film series had been dead for three long years. Paramount, the company that had housed the franchise for a decade, seemed to have no further interest in it. Enter Michael De Luca who was, at the time, the head of production at New Line Cinema and a big fan of the horror genre having even helped in the scripting of 1991's *Freddy's Dead: The Final Nightmare*, a *Nightmare on Elm Street* sequel that performed surprisingly well at the box office.

With the rights to the *Friday the 13th* series hanging in the air, De Luca decided that he wanted to give the series a shot. "It was a simple situation where Paramount clearly had no intention of making another *Friday film* and we stepped in," says De Luca who, at the time of writing, is a production executive at DreamWorks. "*Freddy's Dead* had done very well and it seemed like the fans were interested in exploring the origins of characters like Freddy. I felt that it was important to start over with the *Friday* films instead of calling it *Part 9*. The key to the whole thing was getting Sean Cunningham, who was the creator of the original film. I wanted Sean involved if we were going to do another film."

It had been more than a decade since Sean S. Cunningham had been directly involved with the franchise, his last contribution being the nurturing of director Steve Miner during the making of *Parts 2* and *3*. The intervening years had not been a particularly prolific or successful period for Cunningham, either commercially or professionally. His last directorial effort, prior to his association with *Jason Goes to Hell: The Final Friday*, had been the poorly received 1989 underwater horror film *DeepStar Six*. The producing end of things didn't seem to be going any better as 1989 also saw the release of his production *The Horror Show*. Directed by James Isaac (who would later direct *Jason X*), the film was intended to create a new horror franchise with the introduction of a monster named Max Jenke, played by Brion James. In fact, *The Horror Show* was originally intended to be a second sequel to 1986's *House*, and was to have been entitled *House 3*, but *House II: The Second Story* had been a relative commercial disappointment and the decision was made to try

and establish *The Horror Show* as a new film series. It didn't work. *The Horror Show* bombed. Cunningham's career appeared to be stalled.

Given this recent history, what prompted Cunningham to accept De Luca's offer? According to Cunningham, he was attracted to the project because he simply wanted to finish what he had started: "People must think I've seen all of the other sequels, but I really never did," he says. "I was interested when I heard that New Line Cinema was involved because I think they're a great company and I wanted to have a relationship with them not just in terms of the *Friday the 13th* franchise, but other projects as well. I wanted to end the series and I wanted to be in control of that."

New Line's acquisition of the *Friday the 13th* franchise caused some to speculate whether, in fact, New Line was able to use the *Friday the 13th* name in the title of any future films the company might make, or if the name itself was still owned by Paramount. Cunningham maintains that the answer

below:
Visual effects test shot from *Jason Goes to Hell: The Final Friday*. (Photo courtesy of Al Magliochetti/Eye Candy Visual FX.)

is simple and pragmatic: "New Line bought the franchise and the franchise was *Friday the 13th*. The fact that *Friday the 13th* wasn't used any more had nothing to do with contractual issues. It was marketing, pure and simple. It just seemed ridiculous to call a film *Friday Part 10* or something like that. It just sounds stupid and the fans had let us know that they were tired of it."

The key elements of *Jason Goes to Hell: The Final Friday* fell into place via a complex web of associations between mutual acquaintances of Cunningham. Dean Lorey, the man who would eventually be signed up as the film's writer, had attended NYU Film School in the late 1980s, where first he made the acquaintance of Adam Marcus, who was destined to become the film's director. Marcus had a long-term attachment to the film series, having worked, as a young boy, on the original *Friday the 13th* film, pouring coffee and running errands. During his time on that production he became a very good friend of Cunningham's son, Noel. Marcus (whose brother Kipp also hailed from NYU Film School, and who took a role in *Jason Goes to Hell: The Final Friday*) ended up working for Cunningham in Los Angeles.

In 1989, Lorey developed a project entitled *Johnny Zombie*, a dark horror-comedy script inspired, initially, by his own comic book sketches about a love-struck teenager who finds himself transformed into a zombie. "I sent the script to Adam, who was working for Sean," recalls Lorey. "Adam loved the script and he passed it on to Sean who also loved the script and wanted to make a film out of it."

With the project renamed *My Boyfriend's Back*, Cunningham was able to make a deal with Touchstone Pictures and production on the film began in late 1992, with Cunningham producing and Bob (*Parents*) Balaban directing (Though interestingly enough Lorey and Marcus had been developing *Johnny Zombie* with the intention that Marcus would be its director. What's more, at one stage *Jason Takes Manhattan* writer-director Rob Hedden had also been tapped as a possible director on the project.) In the event, the film was a commercial and critical failure, but Lorey - who would later become most well-known for his comedic work with Damon Wayans on the film *Major Payne* and Wayans's television series *My Wife and Kids* - had nevertheless made a good impression on Cunningham.

Before Lorey and Marcus were signed on, respectively, as writer and director of the project that would eventually become *Jason Goes to Hell: The Final Friday*, Cunningham had initially assigned a writer named Jay Huguely to develop a script. Huguely was a long-time friend of Cunningham's and, as a matter of fact, Cunningham, Huguely and Harry Manfredini had been working together on a musical project for years. Unfortunately however it never came to fruition. Prior to his scripting chores on *Jason Goes to Hell: The Final Friday*, Huguely spent much of his career working as television writer, having written several episodes of the popular CBS detective series *Magnum P.I.* Huguely would eventually receive a co-writing credit on *The Final Friday*, but the first draft of his script did not meet the approval of Cunningham, Marcus or executives

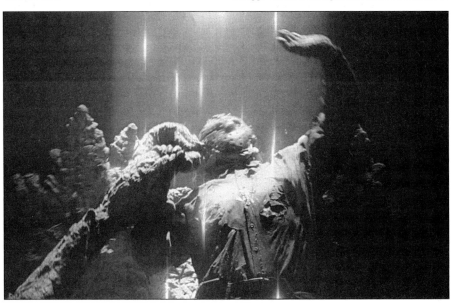

at New Line Cinema. "Jay wrote a really good script, but it had a lot of really different concepts that didn't fit with everyone's idea of what a *Friday* film should be," explains Cunningham. According to Marcus, it was just a case of all parties involved wanting to move in a different direction to that proposed by Huguely: "The script really had very little to do with Jason himself; it was really mostly about Jason's family. Jason really wasn't in the script. We just felt that it didn't quite work."

When Cunningham and Marcus began discussing story ideas, it became clear that neither wanted the film to have anything to do with the other *Friday the 13th* sequels, or at least nothing beyond *Part 2*. "One of the first decisions made was to completely ignore *Jason Takes Manhattan*," recalls Marcus. "No one liked that film. It had a great idea, but it was all on a boat. I kind of liked *The New Blood* because it tried to be something with the *Jason Vs. Carrie* angle, but we wanted to forget everything that happened previously except for the original film and parts of *Part 2*. I didn't want *The Final Friday* to be tied to anything besides what happened in the first film."

Enter the director's long-time friend, Lorey, for whom the biggest challenge in the scripting of *The Final Friday* was to create something that was simultaneously new and familiar. "One of the first things we talked about was that we wanted to start out with the idea that Jason was a real killer who was known across America," says the writer. "In a way, we were doing something that predated *Scream* and other films because we were assuming that the characters in the film knew Jason and knew the rules, and knew not to do stupid things like walking into a house alone."

Production on *Jason Goes to Hell: The Final Friday* began in July of 1992 in Los Angeles, and for Kane Hodder who was, at that point, fully entrenched as the permanent Jason Voorhees, the new film was a great relief after the nightmare of the previous few years. "After *Jason Takes Manhattan*, I knew it wasn't dead, but it was strange when two or three years rolled by and there was no *Friday* film," he says. "I felt totally energized and I even decided to gain about twenty pounds for *The Final Friday*, just to make Jason look even more fearsome. I really liked the script although I was caught off-guard by the whole body-switching thing which meant that I wasn't in the film that much. I really did think that *The Final Friday* had a chance to be the best of the sequels."

The presence of New Line Cinema overseeing the $7 million production was most keenly felt in terms of casting and effects, and if nothing else, the company knew how to distribute and market

horror movies. What were New Line's real motives for wanting to acquire the *Friday the 13th* franchise? Did they really want to revitalize it or were they just clearing the way for *Freddy Vs. Jason*? Cunningham thinks it was a little bit of both. "Part of the reason for making *The Final Friday* was to keep the series active," he asserts. "We were, of course, always talking about *Freddy Vs. Jason*. In 1992, it seemed like it might happen, but the script didn't work. Of course, we all wanted Wes Craven to be involved, but he didn't care for the scripts and stories we had so it was kind of stalled. In the meantime, I've got to protect my property and the way to do that is to keep Jason active by doing a film and letting fans know that the franchise is still viable. That's not to say that *The Final Friday* was just a pawn in a grand marketing scheme because we all worked hard and I was happy with the way the film turned out."

The casting of *The Final Friday* yielded the most eclectic and unorthodox group of actors ever to appear in a *Friday the 13th* sequel. Certainly, in terms of merit and prestige, the cast that signed up would have to be considered the most distinguished group to date.

Steven Williams was given the pivotal role of Creighton Duke, the ruthless bounty hunter who makes it his life's mission to destroy Jason Voorhees. Williams was best known for his work on the Fox television series *21 Jump Street*. Erin Gray, a former model and a star on such television series' as *Buck Rogers in the 25th Century* and *Silver Spoons*, was cast as Diana Kimble, the woman who would eventually turn out to be Jason's sister. Another respected acting veteran to be cast in *The Final Friday* was Billy Green Bush, who had appeared in the 1986 horror film *Critters* but had a solid Hollywood background, including appearances in acclaimed titles like *Alice Doesn't Live Here Anymore* and *Five Easy Pieces*.

Casting chores on the film were handled by Julie Hughes and Barry Moss, veterans from the 1980 original. Casting director David Giella also greatly assisted in the process. According to Moss, the passing of thirteen years had not make it any easier to find good actors who would agree to appear in a *Friday the 13th* film. "When *The Final Friday* was made, it was a very bad climate in terms of trying to get good actors to agree to be in films like this," he says. "Most of the characters in the films were adults and even the two leads, Kari Keegan and John D. LeMay, were a little more mature-looking so we were looking for different kinds of actors. We were very lucky to get actors like Erin Gray and Steven Williams because they brought a lot of credibility to the film. It also helped that *Friday the 13th* wasn't in the title and

JASON GOES TO HELL: THE FINAL FRIDAY (1993)

Production Credits:
New Line Cinema Presents. A Sean S. Cunningham Production.
Producer:
Sean S. Cunningham
Line Producer:
Deborah Hayn-Cass
Unit Production Manager:
Deborah Hayn-Cass
Location Manager:
John Grant
Script:
Dean Lorey, Jay Huguely
Story:
Jay Huguely, Adam Marcus
Director:
Adam Marcus
First Assistant Director:
Francis R. 'Sam' Mahony III
Second Assistant Director:
Kelly Kiernan
Director of Photography:
William Dill
First Camera Assistant:
Rudy Harbon
Second Camera Assistant:
Benjamin Lehmann
Gaffer:
John Aronson
Steadicam Operator:
David Emmerichs
Best Boy Electric:
Katie Nilson
Electricians:
Alan Stewart, Greg Hewett, Andrew Glover
Key Grip:
Joseph Dianda
Best Boy Grip:
Linden Troupe
Dolly Grip:
Klaus Hoch-Guinn
Grips:
William McDevitt, Scott Patten
Editor:
David Handman
Assistant Editors:
Noel Cunningham, Melissa Kent
Additional Editing:
Geoffrey Rowland
Music:
Harry Manfredini
Sound Mixer:
Oliver L. Moss
Boom Operator:
Brian Moss

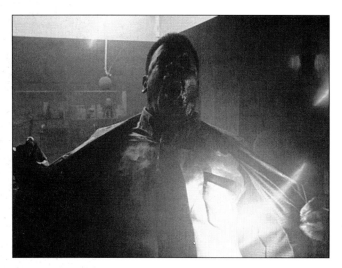

above:
A Coroner (Richard Gant) is possessed by the spirit of Jason after he devours the killer's heart. (Photo courtesy of Al Magliochetti/Eye Candy Visual FX.)

below:
CG-created dagger used by Jessica Kimble (Kari Keegan) to banish Jason Voorhees to hell. (Photo courtesy of Al Magliochetti/Eye Candy Visual FX.)

the New Line association also made a lot of actors want to be involved with the film."

The most interesting role in *The Final Friday* was that of the lead, Steven Freeman - a deadbeat who refuses to grow up and take responsibility for his actions, but who, nonetheless, eventually summons the courage to fight Jason. This part was initially offered to Blair Underwood, star of the television series *L.A. Law* and such films as *Just Cause* and *Set It Off*, but he dropped out for 'personal reasons', which raises the question of whether a strong African-American presence might have added something to *The Final Friday*, or any of the previous sequels for that matter. It might be a moot point however since Jason has always seemed to be an equal opportunity killing machine. Just ask Nick Savage's Ali character from *Part 3*, who was given not one, but two chances to die. In the end John D. LeMay, just a few years removed from *Friday the 13th: The Series*, was cast in the lead role opposite Kari Keegan who played Jessica, Diana Kimble's daughter and a key figure in the film's complicated story since she is, technically, Jason's niece. (Keegan, a Pittsburgh native, had previously appeared with Keanu Reeves in the little-seen 1988 film *Prince of Pennsylvania*.) Returning to the *Friday the 13th* universe was a very difficult decision for LeMay, full of pros and cons. "It's hard to say, looking back, if it was a good move or a bad move, career-wise," he says. "I left *Friday the 13th: The Series* to kind of avoid being typecast and here I was being offered a part in a *Friday the 13th* film so I was a bit nervous about doing it. When I was doing the series, the press would always ask me about the films and the truth was that I'd never seen a *Friday the 13th* film. I decided to take the part in *The Final Friday* because it was a lead role and I liked the character

and, with New Line involved, it seemed like the series was going in a whole other direction."

Jason Goes to Hell: The Final Friday also marked the welcome return of long-time composer Harry Manfredini after his abrupt and awkward absence from *Jason Takes Manhattan*. "I loved working on *Jason Goes to Hell*, especially since I got to work on a new sound rather than the typical ki-ki-ki-ma-ma-ma stuff," he says. "I didn't have any hard feelings about coming back. It was a brand new chapter and there were new people running the series and, most importantly, Sean was back. The sound for the *Jason Goes to Hell* score was great and I actually played all of the music in the film by myself inside my studio. The score for *Jason Goes to Hell* was practically all done with the use of synthesizers. The only complaint I have about *Jason Goes to Hell* was that we came out with a CD and it didn't sound very good at all. The tracks just weren't transferred properly."

Another key addition to *The Final Friday* production team was of course its effects crew, which included legendary trio Howard Berger, Robert Kurtzman and Greg Nicotero of the famed KNB EFX Group. The men were thrilled to finally get a chance to work on a *Friday the 13th* film, even if it wasn't being labelled as a such. That was part of the appeal. "We never would've done one of the previous sequels because that would've been too boring for us because the effects in those films were all the same," says Kurtzman who went on to direct his own horror film, 1997's *Wishmaster*. "The other *Friday* films basically just showed a bunch of slashed up bodies, but *The Final Friday* had a lot of different supernatural elements and it was a chance, at the time, to be involved with what was going to be the last *Friday* film." Berger, credited as the film's special effects supervisor, says the team was also drawn to the idea of working with the originator of the *Friday the 13th* series; KNB had previously worked with Cunningham on *The Horror Show*. "We loved Sean's work and we knew that he wanted *The Final Friday* to end the series in an interesting way. With Sean involved, we were anxious to work on the film."

Although Jason, in his traditional image, wouldn't be as heavily featured as usual in *The Final Friday* given the film's body-switching storyline, the effects team was determined to give the iconic killer a special look, especially since, yet again, *The Final Friday* was supposed to be the end of the series. "We carefully studied the previous films to come up with a great look for Jason," says Kurtzman. "We wanted this to be the ultimate Jason and we wanted the trademark hockey mask to look like it had become a part of him, a part of his face. We really liked what Carl Fullerton and his team

had done with the look of Jason in *Part 2* and we also liked what John Buechler had done in *The New Blood*, and we took those as our inspirations. We liked the idea of giving Jason's body and face a very defined look."

Marcus's primary aim was to try and make an entertaining film, even if the story didn't adhere to the overall logic of the entire series. According to the strictest interpretation of the *Friday the 13th* timelines, *The Final Friday* should logically be taking place in the year 2000. Does it matter? Not according to the director, who when asked about the subject laughs, "It's ridiculous, and that's why we made a point not to adhere to any of the logic from the previous films. Our point was that *The Final Friday* took place after the first two films, so why is that so hard to understand? As for Connecticut, it was a fact that the town of Crystal Lake was located somewhere in Connecticut and that's why I made a point in the film about having signs and license plates that read as being from Connecticut." (A small but important detail, because the film was shot in the vicinity of Los Angeles.)

The plot and treatment for *Jason Goes to Hell: The Final Friday* was a notable departure from the previous films. Events open with a beautiful would-be camper, Elizabeth Marcus (Julie Michaels), who arrives at Camp Crystal Lake where she immediately starts doing all of the stupid things that inevitably lead to a character like hers being horribly murdered: She takes off her clothes, makes jokes into the camera, etc. - actions pretty much expected of a typical *Friday the 13th* victim! Then, Jason appears. At this point the film reveals its tongue-in-cheek premise as the young woman turns out to be an FBI agent, working with a heavily armed unit that's trying to lure Jason out of hiding so they can utterly destroy him, which is what appears to happen when Jason chases Agent Marcus into a clearing where a horde of FBI agents open fire, relentlessly shooting him until, finally, the agents launch an explosive at Jason which literally blows him to pieces, leaving his enlarged, pulsing heart on the ground. The ambush was one of the most complicated scenes Marcus has ever done as a director. "The explosions in the ambush scene were overwhelming," he says. "Kane was full of squibs and there was gunfire everywhere. It was such a complicated series of shots because the agents come out of nowhere and they had to be in perfect position, and we had to see Jason getting blown to pieces at the right angles."

As Jason's remains, primarily his still-living heart, are scooped up for shipment to FBI headquarters in Youngstown, Ohio, we get our first glimpse of Steven Williams's bounty-hunter

character, Creighton Duke, the only man, it seems, who knows that Jason is still alive and, more importantly, how he can be destroyed. Williams, who has played morally ambiguous characters on the television series *The X-Files* and in films like *Missing In Action 2: The Beginning*, believes that Duke represented the ultimate anti-hero: "He was a great enemy for Jason while, at the same time, showing some psychotic tendencies in his own personality. He was a great enemy for Jason."

Duke was an inspired creation of Lorey's. A scene set at the Voorhees house was filmed, in which Duke explains that, years ago, his girlfriend was attacked and killed by Jason when they were out on Crystal Lake, thus fuelling his desire to destroy Jason once and for all. "It was a funny, but silly scene that just didn't make the final cut," says Lorey. "There were a lot of scenes that were cut for the purpose of time, and knowing that they'd never make it past the MPAA." Marcus concurs: "There's a reason why most horror films run about ninety minutes and that's because they seem to flow well at that length. I really felt like a lot of the extra scenes, usually scenes with a lot of exposition, slowed down the film. It's also a fact that a ninety minute film can get more screenings in a theatre than a two hour film."

Once Jason's parts are taken back to Youngstown, Ohio for an autopsy, *The Final Friday*'s body-switching plot begins to take shape as an overworked coroner (Richard Gant) prods Jason's misshapen heart in awe. Transfixed, he picks up the organ and, inexplicably, takes a big bite out of it, eventually devouring the whole heart. "It was like being a zombie," says Gant. "I had to imagine that I was possessed by Jason." And indeed, the coroner is possessed by Jason, whose spirit now inhabits his body. The viewer is left in doubt about this, as Kane Hodder's Jason reflection can be seen every time he walks in front of a mirror, inside his host body. It seems that Jason is able to transfer from one body to another via a snakelike monster - essentially representing the chewed remnants of Jason's heart, his being - that is ingested by a would-be victim.

Is this plot point familiar? When *Jason Goes to Hell: The Final Friday* was released in 1993, Lorey and Marcus were criticised for liberally borrowing ideas from the superb 1987 horror film *The Hidden*. The New Line film boasted a story about an alien killer who transferred bodies by causing his victims to ingest an eel-like creature, which was passed from mouth-to-mouth. To this charge, Lorey and Marcus plead ignorance. "We heard that when the film came about and, frankly, we were shocked," claims Marcus. "I wasn't familiar with *The Hidden* at all when we were planning *The Final Friday* and

Key Make-Up/Hair:
Kimberly Green
Costume Designer:
Julie Rae Engelsman
Wardrobe Supervisor:
Maria Grieco
Seamstress:
Cynthia Black
Assistant Make-Up/Hair:
Cheryl Hamby
Special Make-Up Effects:
KNB Effects Group
Mechanical Effects:
Bellisimo, Bellardinelli, Tom Bellisimo
KNB Supervisors:
Robert Kurtzman, Greg Nicotero, Howard Berger
Mechanical Designer:
Scott Oshita
Special Visual Effects:
Al Magliochetti
Titles and Opticals:
Howard Anderson Company
Set Decorator:
Natali K. Pope
Art Department Assistant:
Elizabeth Hill
Property Master:
Steven B. Melton
Property Assistants:
Randolph W. Andell, Manuel John Baca
Construction Co-ordinator:
Robert Maisto
Stunt Co-ordinator:
Kane Hodder
Stunt Players:
Kane Hodder, Conrad Palmisano, Alan Marcus, Keith Campbell, Kiante Elam, Gary Guercio, Paul Barbour, Ken Bates, Rick Blackwell, Steve Santosusso, Tom Bellissimo, Kate Gianopulos, Sandy Beruman, Tom Huff, Barbara Klein, Dick Hancock, Charles Picerni Sr., Charles Picerni Jr.
Script Supervisor:
Harri James
Production Co-ordinator:
Anna-Lisa Nilsson
Assistant to Mr. Cunningham:
Jennifer Matney
Casting Associate:
Jennifer Gilburne
Production Secretary:
Cheryl Cain
Casting:
Hughes/Moss, David Giella

it's really just pure coincidence that the plots are so similar in terms of the possession angle. Other than that, the two films are totally different."

Somehow, Jason - in his new body - travels from Ohio all the way back to Crystal Lake after taking time out to destroy a few FBI agents, including Kane Hodder as a foul-mouthed character who gets his grisly comeuppance when he disparages Jason and questions his manhood. (Lorey also had his cameo moment, playing an obnoxious assistant coroner who has an autopsy probe shoved into the back of his neck.) Back at Crystal Lake we meet Diana Kimble (Erin Gray) who, despite her beauty and obvious sophistication, works at the local diner. In a perfect example of the way this film ignores the previous sequels, it's revealed that Diana is the sister of Jason Voorhees, presumably shamed by the murderous actions of her mother, Pamela Voorhees. Diana has a daughter - Jason's niece - named Jessica (Kari Keegan) who herself has a child by a young man named Steven Freeman (John D. LeMay) who has presumably abandoned her, because Jessica just happens to be dating a tabloid journalist named Robert Campbell (Steven Culp) who hosts a reality show called *American Casefile*, and who has offered Creighton Duke $500,000 if he can kill Jason. Duke travels to Crystal Lake where he confronts Diana about her dark family secret and warns her that Jason is still alive.

If this painfully convoluted premise sounds like it would baffle most *Friday the 13th* fans (If nothing else, didn't Pamela Voorhees mention, in *Friday the 13th*, that Jason was her only child?), it left the production team with more than a few headaches. "There was so much exposition in the story and, frankly, there was a point where none of us could really understand it all," admits Marcus. "It was very confusing so we tried to trim scenes and shoot additional scenes that would explain things in a simpler way." (Additional filming was also undertaken in response to a test screening of *Jason Goes to Hell: The Final Friday*, after which the fans let Marcus and his team know that they wanted to see Jason kill someone in a summer camp setting. Marcus had no choice but to comply. "The test audience kept asking to see a scene at Camp Crystal Lake," he says. "They wanted to see Jason kill someone at a camp so we shot several additional scenes that were written and filmed in a week. It was tough because the additional scenes forced us to rethink the plotting in terms of the film's logic.")

Despite Duke's best efforts to warn her of the impending danger, Diana is soon killed by Jason, now in the form of another body - a deputy named Josh. At this point, Jason's motives become crystal clear: He wants to destroy the last of his relatives, driven by rage and the fact that, according to Duke, Jason can only be finished off by one of his

relatives. The death of Diana leaves only Jessica and her young daughter, Stephanie. What's more, Jason needs a blood relative in order to be reborn back into his own body. For her part, Keegan found *The Final Friday*'s wacky storyline, by and large, a refreshing change from the prior *Friday the 13th* sequels. "I started to read the script and I saw that the opening scene took place at Camp Crystal Lake and I thought it was going to be another summer camp horror film," says Keegan who, in 1996, had a memorable role as one of Tom Cruise's ex-girlfriends in the film *Jerry Maguire*. "It was nothing like that. It was crazy. I couldn't believe all of the stuff that happened in the script."

In order to show Jason's body-switching, Marcus needed, aside from good actors, some supernatural highlights to drive the whole possession angle home to audiences in a suitably creepy fashion. Enter visual effects expert Al Magliochetti - a veteran of such films as *The Addams Family* and *Brain Damage* - to create the necessary illusions. Magliochetti knew Greg Nicotero from their past collaboration on the 1985 George Romero zombie epic *Day of the Dead*. "Sean Cunningham was a little nervous, at first, about using optical effects, but my work eventually won him over," says Magliochetti. "Originally, I was just brought in to give the guys at KNB some support, but then I ended up doing about forty shots for the film." Some people might be surprised that Magliochetti would want to return to the *Friday* fold considering what he had endured when he was briefly employed on *Friday the 13th: The Series*. "I was visual effects supervisor on that show and it was hell," he says. "There was no money and no resources to work with, and I would be asked to deliver elaborate mechanical effects in just a few days. I just couldn't take it anymore and I left."

On *Jason Goes to Hell: The Final Friday*, Magliochetti devoted most of his energy to Jason. "I began by working on a flash vest for Kane Hodder and then I just did more and more," he says. "In some ways, I was going back to a stop-motion, Ray Harryhausen approach with the film. There's a magical dagger that can kill Jason in the film and I used animation to show a knife morphing into this magical dagger. Jason also had to have a magical essence in the story so I created lots of beams to light Jason up. I tried to add lots of swirling electricity to show the supernatural tone of the story. When I worked on the film, I was basically by myself, which I like, and I was able to do all of the drawings for the film. The hardest part of working on the film was having to work with the raw footage because the optical effects had to match the story."

Eventually, all of the action leads to the old Voorhees family home which, despite its horrific legacy, has been incredibly well-maintained over the years, save for a few cobwebs. It's here that Jason plans to return to his old form by killing one of his family members and switching bodies. When Steven (who had been framed from Diana's murder) breaks out of prison, he tries to convince Jessica of Jason's plot, but she only really believes him when they discover that Duke has abducted young Stephanie, using the child as bait to draw all of the parties back to the Voorhees house - the place, it seems, where Jason must be destroyed. "There were a few character things that were left out of the film that I think the fans would've really enjoyed seeing," says Marcus. "There was a lot of flashback stuff with Jason, Elias and their parents that would've really tied up the Jason story. Jason's brother, Elias, was actually even more evil than Jason." (Elias was the name of Jason's brother in Marcus's version, but in the history of the *Friday the 13th* series Elias Voorhees is generally considered to be the name of Jason's long-lost father.)

So the stage is set for film's climax occurs at the Voorhees house. Creighton Duke gives Stephanie back to Jessica along with the magical dagger that Jessica can use to destroy Jason. It's here that the body-switching plot gets really crazy when Sheriff Landis arrives at the house with a sick look on his face. Torn, Landis impales himself on the knife. That leaves Officer Randy Parker (Kipp Marcus) who, it turns out, is now possessed by Jason. He makes a grab for Stephanie but Steven attacks him with a machete. Unfortunately, Jason's diseased heart crawls out of Randy's gaping wounds, sliming its way down to the cellar where, incredibly, Diana's body - the ideal vessel for Jason to be transformed back to his good old self - has been stored. How on earth did Diana's body end up at the house? It seems that the slimy Robert Campbell stole Diana's corpse and brought it there to use it as a prop for his would-be television spectacular! (Happily for all, by the end of the film, the by-then-possessed Campbell gets shot in the head and run over by a car.) The convenient appearance of Diana's corpse allows Jason to reappear inside his old body, setting the stage for the final confrontation between himself, Jessica, and Jason, not to mention little Stephanie, but Jason wouldn't murder a child... would he?

The fight rages outside the house as Jessica and Steven try to kill Jason with the magical dagger, but first the once mighty Creighton Duke id disposed of, as Jason bear-hugs him to death. If Jason kills Jessica and young Stephanie, there will be no more relatives left, leaving Jason free to terrorize mankind for all eternity.

CAST

Kane Hodder
(Jason Voorhees)
John D. LeMay
(Steven Freeman)
Kari Keegan
(Jessica Kimble)
Steven Williams
(Creighton Duke)
Steven Culp
(Robert Campbell)
Erin Gray
(Diana Kimble)
Rusty Schwimmer
(Joey B.)
Richard Gant
(Coroner)
Leslie Jordan
(Shelby)
Billy Green Bush
(Sheriff Landis)
Kipp Marcus
(Randy)
Andrew Bloch
(Josh)
Adam Cranner
(Ward)
Allison Smith
(Vicki)
Julie Michaels
(Elizabeth Marcus F.B.I.)
James Gleason
(Agent Abernathy)
Dean Lorey
(Assistant Coroner)
Tony Ervolina
(FBI Agent)
Diana Georger
(Edna, Josh's girlfriend)
Adam Marcus
(Officer Bish)
Mark Thompson
(Officer Mark)
Brian Phelps
(Officer Brian)
Blake Conway
(Officer Andell)
Medelon Curtis
(Officer Ryan)
Michelle Clunie
(Deborah, the dark-haired camper)
Michael Silver
(Luke, the boy camper)
Kathryn Atwood
(Alexis)
Jonathan Penner
(David) [not credited, scenes deleted]

above:
Jason Voorhees in the bowels of hell.
(Photo courtesy of Al Magliochetti/Eye Candy Visual FX.)

below:
Jason Voorhees joins Freddy Krueger in hell. Krueger's bladed glove makes a surprise appearance at the end of *Jason Goes to Hell: The Final Friday.*
(Photo courtesy of Al Magliochetti/Eye Candy Visual FX.)

Finally, Jessica manages to plunge the dagger into Jason who still clings to life until she leaps forward and kicks the dagger deep into his body, triggering the magical weapon's powers. As the magical dagger slices into Jason's body - his soul - the heavens open with searing lights that pound through his body as the ground opens and demon-like monsters pull a weakened Jason down into hell, leaving only the tattered hockey mask.

Hodder considers *The Final Friday*'s action-packed ending and Jason's down-and-dirty fight with Steven Freeman to be the highlights of the film. "I thought the endings to the recent sequels had been pretty lousy, but I liked the ending for *Jason Goes to Hell*," he says. "It had lots of fireworks which was appropriate since we really thought that we were making the last film and that we really were sending Jason to hell." Hodder has kind words for first-time director Marcus. "I thought Adam did a really good job under tough circumstances. I feel like he accomplished what he set out to do and I felt like we explored some really interesting things about Jason. I loved how we ignored *Jason Takes Manhattan* because I wasn't happy with that film. The *Friday* directors that I've worked with have all had different strengths and I think that Adam's strength was in the production end of things. *Jason Goes to Hell* was a technically impressive film for the money."

As Steven and Jessica walk off into the sunset, seeking to start a new life together with their baby daughter, we close in on the remnants of Jason's hockey mask as, suddenly, the bladed glove of Freddy Krueger explodes out of the ground, smothering the franchise's iconic symbol.

Was this a blatant attempt to market *Freddy Vs. Jason*, ten years early? Maybe New Line was just trying to ingratiate its new monster to the company's slightly more sophisticated *Elm Street* fan base? "I'm really surprised it didn't happen

right after *Jason Goes to Hell*," says Marcus. According to De Luca, New Line wanted to use *Jason Goes to Hell* as a marketing test to gauge the level of interest in a *Freddy Vs. Jason* film. "We were hoping that *Jason Goes to Hell* would perform very well and provide the momentum for *Freddy Vs. Jason*," he says. "We wanted to give *Jason Goes to Hell* every chance to succeed because we loved the idea of a *Freddy Vs. Jason* film. It just wasn't good timing."

Unfortunately, when *Jason Goes to Hell* was finally released on August 13, 1993, the film's box office performance did little to convince anyone that Jason had, indeed, come back to life with a vengeance. Despite a respectable take opening weekend take of $7.5 million, the numbers soon slid and *Jason Goes to Hell: The Final Friday* ended up with a final box office take of $15.9 million. These numbers were slightly better than those of *Jason Takes Manhattan*, but did nothing to convince anyone that audiences were still clamouring to see more of Jason. Four years, it seems, had done little to make the hearts of jaded *Friday the 13th* fans grow fonder.

There are reasons, not least of which is the fact that, despite its ambitions and supernatural overtones, *The Final Friday* is a very silly film. *The Final Friday* production team deserve credit for ignoring the recent past and starting over, as well as for attempting to demystify Jason and create a new legend for the monster. Unfortunately, having opened up this can of worms, the film does not find much of substance, except maybe the sobering discovery that there's not much that can be done with a creature as one-dimensional, predictable and sullen as Jason Voorhees. Jason - the young boy who tragically drowned - seemed to have lots of interesting possibilities when he first appeared, years ago, but he had grown up to be something of a clunking bore.

Marcus however is proud of the fact that, if nothing else, *The Final Friday* wasn't just another teenage slasher film: "The film was really about the adult characters and all about Jason. Whether you like the film or not, we did something different. We made a supernatural horror film and we answered a lot of questions about how Jason keeps coming back to life and the secrets about his family."

What to do with Jason? End the series for good? That didn't seem to be a possibility. John Carpenter had once proposed, half-jokingly, that the only good place to send Michael Myers, the killer from his *Halloween* film series, was into outer space, realising that there was nothing much interesting that was left to be done with a monster once he becomes part of a tired franchise. Maybe Jason needed to be sent into outer space?

Jason in Space

He'd been sent to Manhattan and hell, but neither setting had proved to be powerful enough to fully resurrect Jason Voorhees to healthy commercial life. *The Final Friday* was released three-and-a-half years after 1989's *Jason Takes Manhattan*, but Jason was about to take a much longer rest, a commercial hibernation if you will, following the lacklustre performance of *The Final Friday*. Flash forward about five or six years. New Line Cinema still owned the rights to the *Friday the 13th* franchise, but showed no signs of wanting to make another film. However they were still, under the guidance of then-production head Michael De Luca, hoping to get *Freddy Vs. Jason* off the ground. Sean S. Cunningham was just as tired of the *Friday the 13th* films as anyone, as he too struggled to make *Freddy Vs. Jason* a reality.

At the start of 1999, Cunningham grudgingly began to seriously entertain the thought of getting the franchise back on its feet. "I didn't really want to do another *Friday the 13th* film, but I was growing impatient with the progress of *Freddy Vs. Jason* and I felt like I had to keep Jason active," he says. "I wasn't going to do it, regardless, if there wasn't a fresh concept because I really felt like there wasn't anything interesting to do with Jason anymore." The man who really provided the impetus was however Cunningham's friend, *The Horror Show* director, James Isaac.

Isaac, whose professional relationship with Cunningham began when he served as visual effects supervisor on *House II: The Second Story*, had been kept busy for a while trying to design visual strategies for the seemingly dormant *Freddy Vs. Jason*. Isaac then headed to Toronto to work as a visual and special effects supervisor for director - and long-time friend - David Cronenberg, on *eXistenZ*. Isaac was anxious to direct again after the disappointment of *The Horror Show*, a film he took over in mid-production after original director David Blyth was jettisoned. "I went to work on David's film and Sean had said no to the idea of doing another Jason film," says Isaac. "I was in Toronto for a year and, one day, I called up Sean and told him I was coming back to Los Angeles and that I was going to pitch him a Jason film."

Isaac was given tremendous support by his mentor, Cronenberg, who gave him invaluable advice about directing and would later appear in *Jason X* as one of the film's first victims. "David knew how much I wanted to be a director and he would always let me ask him questions because we've been working together since *The Fly*," says Isaac. "David wanted this for me almost as much as I did and I was very anxious to put *The Horror Show* behind me because I was young and weak on that film even though I was brought in as a replacement, and even though I was working on *DeepStar Six* for Sean at the same time. Maybe I just wasn't mature enough."

When Isaac got back to Los Angeles, he had his pitch down pat, even though there was no story. He appealed to Cunningham's proprietary

below:
Jason Voorhees (Kane Hodder) spills his guts onboard the *Grendel* spaceship. *Jason X* marked Kane Hodder's final screen appearance in the role he thought he had made his own. (Photo courtesy of John Dondertman.)

Interior corridor of the Grendel. One of the reasons *Jason X* was set in the distant future was so to make sure the storyline could not interfere with the development of *Freddy Vs. Jason*. (Photo courtesy of John Dondertman.)

interest in the *Friday the 13th* franchise: "*Freddy Vs. Jason* was going to be what it was going to be, but I knew that Sean really wanted to make a film bad. I said, 'Sean, you've got this franchise, you've got Jason. Why not do something with him rather than waiting around for *Freddy Vs. Jason* to happen?' He was very frustrated with *Freddy Vs. Jason* at this point, even more than he had been before."

Isaac's enthusiasm slowly caused Cunningham to warm up to the idea of doing another *Friday* film. "I was finally worn down from *Freddy Vs. Jason*," recalls Cunningham. "I had this asset, I owned this franchise and nothing was happening with it, and I felt like seven years was enough of a distance to make a new film feel fresh. Jim came in and we talked about three or four ideas, everything from sending Jason to an African Safari to sending him to the arctic. What really impressed me was the fact that Jim had lots of technical expertise and he told me that he wanted to put the money on the screen. You know, I felt like a farmer who owns a crop. You have to plant the seeds every once in a while to keep it going, to stay active, or else the crop dies. That's what *Jason Goes to Hell* and *Jason X* were, essentially, all about. I didn't think doing *Jason X* would affect *Freddy Vs. Jason* one way or the other."

Isaac was determined that a new film should have an increased budget, which could be maximised both due to his own technical expertise and the fact that they could film in Toronto, where Isaac had been working and living, off and on, for the better part of the previous fifteen years. Isaac insisted on hiring top-notch technical talent to work on the film - the kind of people who normally would never even look at a project like *Jason X*. He wanted *Jason X* to look like a $40 million picture, even though its eventual production budget would only end up being $14 million, modest by normal industry standards, but nevertheless the most expensive film in the series up to that point.

Academy-Award winning special makeup effects artist Stephan Dupuis was hired, along with visual effects supervisor Kelly Lepkowsky who, like Isaac, was a veteran from past David Cronenberg films and had also worked on *House II: The Second Story*. "I wouldn't have been caught dead doing a Jason film it if hadn't been for Jim," says Dupuis. "They promised us that *Jason X* was going to take a much different approach and we all thought the space setting was interesting. We all knew how much this meant to Jim."

Before Isaac could assemble a complete cast and crew however, there was still the niggling matter of coming up with a story and script for *Jason X*. Luckily for Cunningham and Isaac, it would turn out that all of the necessary pieces were right in front of them - they needed to be slotted into place. About ten years earlier, screenwriter Todd Farmer, a Texas native, had made the acquaintance of *The Final Friday* writer Dean Lorey through a mutual friend. The two writers struck up a quick friendship and Lorey, after reading a sample of Farmer's writing, encouraged him to move to Los Angeles immediately if he wanted to pursue his screenwriting career. Farmer followed his advice and, almost immediately, found work developing and writing scripts for Cunningham's production company.

Jason X was to mark a passing of the torch in the *Friday the 13th* franchise as Cunningham's son, Noel, would be given the job of producer on *Jason X*, having served a long apprenticeship stretching back to his days on the set of *Friday the 13th*, which is where Noel and *The Final Friday* director Adam Marcus first met each other. The Cunninghams, Isaac and Farmer collaborated to flesh out ideas for *Jason X*. The one thing all parties agreed on was that *Jason X* had to be different, but not so different that it would screw up plans for a *Freddy Vs. Jason* film should that project ever manage to squirm its way through development hell.

It was not long before the idea of space travel began to float through the air. Farmer wrote the script in three weeks. "Jim threw out the idea of having Jason in the snow and I think that would've been everyone's second choice if the space idea had been rejected," says Farmer. "The idea of having Jason in space was the only concept I pitched. I wanted to move Jason into space, but I also knew that we needed something new to get New Line excited because anything even remotely connected to the summer camp setting would've been rejected. It was a perfect concept for us because we could, basically, make up any story we wanted and because it was set four hundred years in the future, it wouldn't interfere with *Freddy Vs. Jason*. Plus, having the film set in the future would allow us to use different weapons and create a new space-age Jason. That's how Uber-Jason was created," says Isaac with a laugh. "We had an opportunity to build a much cooler looking and tougher Jason. I was excited and I had a blast writing the script."

Isaac recalls that the new concept was easy to sell to New Line and, in particular, Michael De Luca: "I went to New Line and pitched the idea to Michael and he was very enthusiastic. He loved the concept. This was, like the rest of the films, a negative pickup situation so we were basically going to deliver them a product that they were

JASON X
(2001)

Production Credits:
New Line Cinema presents
A Sean S. Cunningham
Production.
A Jim Isaac Film.
Executive Producers:
Sean S. Cunningham,
Jim Isaac
Produced by:
Noel Cunningham
Associate Producer:
Marilyn Stonehouse
Production Co-ordinator:
Vair MacPhee
Assistant Production
Co-ordinator:
Kimberlee Morley
Written by:
Todd Farmer
Based on characters
created by:
Victor Miller
Director:
Jim Isaac
1st Assistant Director:
Walter Gasparovic
2nd Assistant Director:
Penny Charter
Director of Photography:
Derick Underschultz
Editor:
David Handman
Music:
Harry Manfredini
Foley Artist:
Steve Baine
Sound Mixer:
Bruce Carwardine
Re-Recording Mixer:
Michael Baskerville
Boom Operator:
Markus Wade
Sound Effects Editors:
Mark Beck, Dan Sexton
Costume Designer:
Maxyne Baker
Assistant Costume Designer:
Lindsay Jacobs
Set Costumer:
Renee Bravener
Wardrobe Buyer:
Gayle Franklin
Wardrobe Special Effects:
Walter Klassen
Digital Film & Visual Effects:
Toybox
Physical Effects
Co-ordinator:
Bob Hall

going to buy. The good news was that we would be left alone to make the film because New Line had lots of other bigger films to worry about. That's also the bad news when it comes to the studio marketing the film and giving you a good release. When Michael left New Line, that's what happened to *Jason X*."

Prior to the start of principal photography on *Jason X*, Isaac and Noel Cunningham travelled to Toronto in October of 1999 for what would end up being almost six months of pre-production on the costumes and effects. They got together with Dupuis and Lepkowsky as a makeup effects shop was conjured out of thin air to handle the film's technical inventory. "I'd say that the hardest thing to create was the Uber-Jason," says Cunningham. "This wasn't the same Jason, it was like a robot machine, covered with metal. No more hockey masks. I stayed in Toronto until all of the work was done. The whole process was very exhausting and intensive."

While this was going on, casting had also begun in earnest and, in contrast to *The Final Friday*, the actors selected to appear in *Jason X* were mostly unknowns. The exceptions were the two female lead roles, which were given to Lexa Doig and Lisa Ryder - both veterans of the syndicated science-fiction television series *Andromeda*. Doig was cast as Rowan, a tough soldier whose quick thinking at the beginning of *Jason X* causes Jason to become cryogenically frozen, and Ryder got the part of Kay-Em 14, an android who proves to be a worthy adversary for

Jason. The actors, good friends from their work on *Andromeda*, found much humour in their respective roles. "It was certainly empowering, as an actress, to play a woman with superhuman strength, even if she was just an android," says Ryder. Doig found playing the character of an action-babe - along the lines of Sigourney Weaver's Ripley character from the *Alien* films - to be an exciting role reversal, given the characters that she and Ryder played on *Andromeda*. "I play an android on *Andromeda* and Lisa plays the action-chick," says Doig. "We had so much fun because these just aren't the kind of female roles you see every day."

Melyssa Ade, who played Janessa, felt that the characters in *Jason X* had a lot more depth and strength than in the previous sequels. "Jim Isaac was looking for strong horror women and we all really responded to that," she says. "I think it was a different climate because this was the first Jason film since the success of *Scream*, which kind of changed the whole horror landscape. I auditioned right in front of Sean Cunningham, father *Friday*, right around Christmas of 1999 with Sean reading the script to me. I liked Janessa because she wasn't just a helpless victim for Jason." Melody Johnson, who was cast as Kinsa, recalls being very impressed by the new Uber-Jason: "I thought the old hockey mask was starting to suck. They really gave Jason an upgrade for *Jason X*. My character, Kinsa, was a bit of a weakling, always scared, so I just tried to imagine that Uber-Jason was chasing after me, trying to chop my head off."

Todd Farmer, much like his friend Dean Lorey in *The Final Friday*, was given a small role in the film. He plays a marine named Dallas, who actually appears in the film for quite a while before getting his bald head crushed against a wall. Another cameo role was taken by undoubtedly the biggest name in the cast of *Jason X*, but this man was not an actor at all, at least not in terms of his full-time profession though he had previously played a memorable villain in Clive Barker's 1990 horror film *Nightbreed*. He was acclaimed writer-director David Cronenberg, who had long been supportive of Isaac's directing ambitions and was more than happy to appear, and spectacularly die, during the film's opening scenes. "Originally, Dean Lorey and David were going to appear as pilots, but Dean couldn't make it because of work," remembers Isaac. "I talked to David and we thought that a good idea would be to make him into some kind of evil scientist, the type of slimy character he'd played in other movies."

Kane Hodder, cast again as Jason, warmly embraced the Jason X concept: "I read the script and I thought it was the best *Friday* script I'd ever read. I could see that Jim was trying to do something along the lines of *Blade Runner* and *The Terminator*, and I thought that was the perfect direction to go in. I also loved the idea of Uber-Jason because what was there that was left to do with the old Jason? I was excited about the different kinds of weapons and different kills that the space setting would present to Jason."

Jason X opens in the near future, 2010 to be exact, quite a few years after *The Final Friday*, whose hellish ending would seem to present a problem for Jason's continuing adventures. Not so, say the makers of *Jason X* who defend the film's logic in terms of the overall series storyline. "The film takes place after *Jason Goes to Hell*, but that's not to say that we were actually going to explain how Jason escaped from hell," says Farmer. "We had to make a film that didn't get in the way of *Freddy Vs. Jason*, which would take place after *Jason Goes to Hell* so we set our story four hundred years in the future so it has no effect over what happens in *Freddy Vs. Jason* unless Jason was killed for good in *Freddy Vs. Jason*, which we didn't think was possible. Basically, *Jason X* took place after *Jason Goes to Hell* and *Freddy Vs. Jason*. One of the toughest things for us, while we were making *Jason X*, was the fact that *Freddy Vs. Jason* was still in development and could've very easily been made and released before *Jason X*. If we had known, just prior to making *Jason X*, that *Freddy Vs. Jason* was about to be made at that time, we would've gone with another setting, something like Jason in the winter - which was an idea that

Jim really liked - or Jason meeting a bunch of gang members. We thought of everything."

Jason X was filmed at the Downsview Airbase, an abandoned military location on the outskirts of Toronto. With its vast sets and wide-open spaces, the locale was perfect for Isaac and his team of technical wizards to work in, especially since much of *Jason X* was going to be computer-generated. The issue of the number of effects shots in *Jason X* is something of a sore point for Isaac as, during the course of production, there was a lot of fan speculation that *Jason X* was going to be nothing more than a CG-fest. "We had about 350 effects shots in the film," says Isaac. "There were lots of things, but most of it had to do with the space stuff."

Isaac enlisted effects expert and friend Dennis Berardi from Toronto's Toybox effects house to make the space setting a reality. The two men had worked together on *eXistenZ*. This led to persistent rumours that *Jason X* was shot on digital video. "That was a rumour that bothered me a lot," says Isaac. "That's not true. *Jason X* was shot entirely on 35mm and then we transferred the whole thing to high-definition digital. We had to transfer the footage to high-definition because we had so many effects shots to do. At the end, we were able to scan the whole thing back to film and it looked beautiful. We had to do this for monetary reasons and I think it turned out very well."

In the film's opening scene, Jason - and the dark legend of Crystal Lake - has become fodder for military researchers. At a research facility near Camp Crystal Lake, scientists fawn over the shackled remains of Jason Voorhees who has, presumably, escaped from hell, given the fate he suffered at the end of *The Final Friday*. Rowan (Lexa Doig) decides that Jason must be utterly destroyed for the good of what's left of mankind, but the ethically-challenged and downright cadaverous Dr. Wimmer (David Cronenberg) has different ideas, intrigued by Jason's regenerative powers and his possible value to the military. Working with Cronenberg was, for Isaac, one of the highlights of *Jason X*. "He'd come to me and say, 'Well, I don't like this scene. Could I rewrite the dialogue?'" says Isaac. "It was a little intimidating having to direct a legend like David Cronenberg, but he was such a help to me as a young director for the two or three days that he was on the set. David very much wanted to die really horribly and I was able to give him his wish."

After Rowan and Wimmer have their heated debate, Wimmer arranges for Jason to be transferred elsewhere for further research. It comes as no surprise at all when Jason escapes and

Gaffer:
David Fisher
Rigging Key:
Jason Board
Visual Effects Supervisor:
Kelly Lepkowsky
Set Key:
Jim McGillivary
Pyrotechnics Supervisor:
Arthur Langevin
Special Make-Up Effects
Designer & Supervisor:
Stephan DuPuis
Production Designer:
John Dondertman
Art Director:
James Oswald
Assistant Art Directors:
Neil Morfitt, Greg Beale, Wendy Robbins
Set Decorator:
Clive Thomasson
Set Decoration Driver:
Richard Gaal
Concept Artist:
Ron Mason
Unit publicist:
David Pond-Smith
Stunt Co-ordinator:
Steve Lucescu
Stunts:
Eric Bryson, Chad Camilleri, Brian Jagersky, Walter Masko, Jessica Meyer, Edward A. Queffelec, Robert Racki, Alison Reid, Kevin Ruston, Dave Stevenson, John Stoneham, Jr., Jamie Taylor, Jennifer Vey
Casting:
Robin Cook

CAST

Kane Hodder
(Jason/Uber Jason)
Lexa Doig
(Rowan)
Lisa Ryder
(Kay-Em 14)
Jonathan Potts
(Professor Lowe)
Melyssa Ade
(Janessa)
Peter Mensah
(Sgt. Brodski)
Dov Tiefenbach
(Azrael)
Todd Farmer
(Dallas)

kills several of the armed guards, before crudely impaling Dr. Wimmer with a pole. "It's funny because David's death is one of the most gruesome in the whole film, but we didn't have much trouble with the MPAA on that scene or any scene," claims Isaac. "We had the advantage of not having the summer camp stigma of just slaughtering teens one by one. We had a different story and I think the MPAA understood that and they just kind of left us alone. Dealing with the MPAA was, for the most part, the least of our problems." After the slaughter of Wimmer and his team, a quick-thinking Rowan is able to trick Jason by luring him into a cryogenic freeze chamber. Jason breaches the wall of the chamber with his machete, in the process gutting Rowan, who manages to activate the chamber's mechanism, freezing both of them into a limbo world between life and death.

More than four hundred years later - in the year 2455 to be exact - the two adversaries are still lying dormant while earth has become a desolate wasteland - a curiosity for adventurers and explorers. A group of science students have descended upon 'old Earth,' as the uninhabitable landscape is now known, where, amazingly, they happen to stumble upon the petrified remains of Jason and Rowan in the now dormant underground facility. They are rather implausibly accompanied by a group of marines, who seem to be acting as

their escorts; glorified 7-11 cops with high-tech military hardware. When it becomes clear that, using 25^{th} Century medical technology, they can bring the woman back to life, the overly curious, and very stupid, students decide to bring the two frozen bodies onto their ship, Grendel. They save Rowan, but ignore her advice to immediately dispose of Jason, and he inevitably thaws out, setting out on a space rampage. Things get worse after the crew tries to 'upgrade' Kay-Em 14 to fight off Jason, as Jason himself soon becomes upgraded, thereby creating the ultra-powerful Uber-Jason. In space, no one, it seems, can hear Jason ki-ki-ki-ma-ma-ma.

Isaac felt that the film's set-up was far more interesting than that of the previous few *Friday the 13th* sequels, space setting aside. "It's not just about Jason being thawed out and killing everyone," says the director. "You have the people on this ship wanting to get home and you see them being attacked by this alien monster who they don't know. They also have modern weapons and technology to fight Jason. They weren't just victims. The characters in the film actually had to come up with intelligent solutions to try and defeat Jason." Since Jason can't ever be really killed, given the financial interest in the franchise, doesn't the very idea of trying to destroy Jason become redundant? For his part, Sean S. Cunningham

agrees: "You can't kill Jason so it's hard to find interesting things to do with him, along with the fact that he doesn't have any personality. He's like a great white shark. You can't really defeat him. All you can hope for is to survive."

The actors in *Jason X* have generally high praise for Isaac's ambitious approach to the film. "I think the whole Uber-Jason idea took the Jason concept to a whole other level," says Melody Johnson. "Instead of using that stupid hockey mask again, Jim made everything a part of Jason's body and I thought Jason was a lot scarier in *Jason X* than he'd been in the previous sequels." Hodder feels that a six-year hiatus - following the release of *Jason Goes to Hell: The Final Friday* in 1993 - made the character of Jason fresh again. "*Jason X* was the first *Friday* film since *Scream* had come out and there was a definite change," he says. "There might've been too much humour for the *Friday* fans, but it had a lot more self-referential humour. If nothing else, *Jason X* wasn't a remake of any *Friday* film that had come before. There'll never be another *Friday* film like *Jason X*, good or bad."

Ambitions aside, admirable as they may be, *Jason X* is in fact more of the same. It just all happens to take place in a new setting. Whether it be inside Grendel or on the grounds of Camp Crystal Lake, it's still the same old stalk-and-slash structure. However, there are indeed a lot of new ideas in *Jason X*, particularly in the film's treatment of Lisa Ryder's character, Kay-Em 14, the female android assassin who's rigged to wage war against Jason. Unfortunately, perhaps the main legacy of *Jason X* is that it can be considered a true missed opportunity, as something that would have added an amazing spark to *Jason X*, and possibly enlivened the entire franchise, was planned, but did not happen. And the reasons for it not happening make it seem especially sad in hindsight. To best explain this issue however, it is first necessary to quickly recount a few more plot points...

As the crew members are being slaughtered by Uber-Jason in a variety of delightfully inventive ways, the few survivors come up with a plan to escape Grendel via an arriving transport ship. They need to distract Jason, so he is lured into the holodec area where a virtual-reality program is initiated, which creates a computer-generated image of good old Camp Crystal Lake, complete with two gorgeous, big-breasted summer camp babes (played by Tania Maro and Kaye Penaflor). In the film's single best moment, we cut back to the sight of Jason bashing the sleeping blanket-enshrouded bodies of the two girls against a virtual-reality tree stump (this could be construed as a backhanded tribute to a similar sequence from *The New Blood*). However, the highlight of the virtual-reality scene,

and therefore what would have, by default, been the best part of *Jason X*, should have been the surprise reappearance of Mrs. Pamela Voorhees, to have been played by Betsy Palmer herself!

"I wrote a scene where Jason meets his mother again, but they told me that negotiations with Betsy fell through and it was scrapped," claims Farmer. Ironically, Betsy Palmer was in Toronto in early 2000, when *Jason X* was filming. Palmer met with Sean S. Cunningham, then feeling somewhat burdened by the *Jason X* shoot. Why wasn't Betsy Palmer in *Jason X*? Money. Ultimately, the minor concessions that Palmer claims to have demanded, make that pleaded for, from Cunningham seem painfully frugal when one considers all of the fans (and hence, money), that *Jason X* failed to draw when the film was finally released in April of 2002. "I was in Toronto, doing a play, when I met with Sean about being in the film," says Palmer. "He told me that he didn't have much money to pay me and I cut him off and said, 'Sean, forget about the money, give me a piece of the action. Give me a small percentage of the profits.' You know, I haven't made a dime off of the films for all of these years. Sean said no and that was it. I wasn't in the film."

The film ends with Jason being thrust out into the depths of space where the ultra-courageous Brodski takes it upon himself to ride Jason like a bucking bronco into the atmosphere of what turns out to be Earth Two. Jason's mask is seen sinking down to the bottom of Crystal Lake, on an Earth Two that looks a lot nicer than the old one. Jason, or what's left of him, has once again come home.

Principal photography on *Jason X* ended in April of 2000, but Isaac and the rest of the *Jason X* team could never have imagined that it would be two long years before their film would see the light of day, at least as far as North American audiences were concerned. It seems that De Luca's uncere-

Phillip Williams
(Crutch)
Marcus Parilo
(Sgt. Marcus)
Chuck Campbell
(Tsunaron)
David Cronenberg
(Dr. Wimmer)
Melody Johnson
(Kinsa)
Derwin Jordan
(Waylander)
Kristi Angus
(Adrienne)
Boyd Banks
(Fat Lou)
Amanda Brugel
(Geko)
Steve Lucescu
(Condor)
Yani Gellman
(Stoney)
Dylan Bierk
(Briggs)
Barna Moricz
(Kicker)
Thomas Seniuk
(Sven)
Robert A. Silverman
(Dieter Perez)
Jeff Geddis
(Johnson (soldier #1))
Roman Podhora
(Rescue Pilot)
Kaye Penaflor
(VR Teen Girl #1)
Tania Maro
(VR Teen Girl #2)
Mika Ward
(Campfire Teen #1)
David Cook
(Campfire Teen #2)

above:
Grendel shuttle bay, from where Jason Voorhees is hurtled into space.
(Photo courtesy of John Dondertman.)

right:
Behind the scenes during the making of *Jason X*.
(Photo courtesy of John Dondertman.)

monious departure form New Line, early in 2001 - and the subsequent departure of many of the executive's deputies - meant that *Jason X* became something of a cinematic orphan. When Sean S. Cunningham and Isaac were finally ready to deliver the film to New Line Cinema, they found, much to their dismay, that there really wasn't anyone to deliver the film to. "When we delivered *Jason X* to New Line, there was no one left who had been involved with approving *Jason X*," says Isaac. "It was just the usual studio politics, nothing to do with anyone being ashamed of the film. No one knew what to do with it."

Jason X's two-year purgatory prompted many media pundits, particularly those on the Internet, to declare that *Jason X* was a cinematic white elephant. This outraged a completely frustrated Isaac, who took it upon himself to try and counter the negative media campaign against *Jason X* which, ultimately, ended up being released in Spain in November of 2001, months before the film's North American release. "Eventually, the marketing guys at New Line screened the film and became very enthusiastic about it," says Isaac. "However, I suppose that the damage had already been done from a commercial standpoint."

Jason X was finally released in North America on April 26, 2002, although one wonders if by this time this particular cinematic patient was already terminal. Whatever the reasons for *Jason X*'s dismal performance at the box office, audiences plainly were not interested in seeing Jason in space. The unstoppable killer may well have been upgraded to

Uber-Jason in *Jason X*, but the financial figures were distinctly downgraded, even by the paltry standards set by *The Final Friday* and *Jason Takes Manhattan*. Released in 1,878 theatres, *Jason X* grossed $6.6 in its opening weekend, eventually winding up with a total take of $12.6 million, which makes *Jason X* the least successful *Friday the 13th* film of all, a highly dubious distinction.

For his part, Cunningham feels that *Jason X* served its main purpose, namely to keep the Jason character visible in the marketplace while *Freddy Vs. Jason* was still heating up. "The fans seemed to like *Jason X* and we kind of knew that the film's appeal wouldn't extend much past the core *Friday* audience," says Cunningham. "There were some contractual issues as to why *Jason X* was made and released, but the bottom line is that *Jason X* didn't affect *Freddy Vs. Jason* at all." That's really the bottom line on *Jason X*. Even its producer admits the film was a piece of business, nothing more, nothing less: a snack to be devoured before the main course was ready to be served. *Jason X* was meant to stay out of the way of *Freddy Vs. Jason*, to keep Jason in the public eye without altering his profile one bit. Business.

By the time *Freddy Vs. Jason* began filming in September of 2002, *Jason X* really was just a footnote in the history books, both of the *Friday the 13th* franchise and New Line Cinema. Nothing that had occurred in the previous twenty years seemed to matter now. Old scores were about to be settled. Freddy Krueger and Jason Voorhees were ready to rumble.

Freddy the Thirteenth

The concept of a *Freddy Vs. Jason* film had been quietly buzzing around Hollywood for fifteen years, ever since the heated discussions that took place prior to the making of 1988's *Friday the 13th Part VII: The New Blood* in fact. Following the box office failure of *Jason Takes Manhattan* in 1989, there was no further progress until New Line Cinema acquired the *Friday the 13th* franchise in 1992, determined to remove all obstacles from the path of this dream pairing from hell. These obstacles were not only creative in nature, but also commercial, for example the fact that certain foreign rights were owned by Warner Bros. (who would subsequently release a special-edition *Friday the 13th* DVD to the overseas market in 2003). Regardless, by early 2002, enough of the legal obstacles had been cleared to make *Freddy Vs. Jason* a reality, even though *The Final Friday* and *Jason X* had done nothing to energize the *Friday the 13th* franchise, while 1994's *Wes Craven's The New Nightmare* had similarly failed to bring Freddy Krueger back to life. This wasn't going to be an *Elm Street* film or a *Friday the 13th* film; it was *Freddy Vs. Jason.*

New Line's ten year pre-production odyssey would redefine the term development hell, a popular Hollywood tag attached to film projects that are considered to be forever in inertia. According to Sean S. Cunningham, unofficial godfather of the *Friday the 13th* series, the biggest obstacle standing in the way of *Freddy Vs. Jason* was very simple: a workable script; it was plagued for years by the inability - on everyone's part - to come up with a great story. What do you do with Freddy and Jason anyway? This was a daunting question. "Everyone thinks they know what a *Freddy Vs. Jason* film is supposed to be like, but it's not that simple," says Cunningham, who kept in contact with Wes Craven during *Freddy Vs. Jason*'s development. "People want to see Freddy and Jason fight each other, and that's great, but you can't have them fighting for ninety minutes. That's maybe five minutes of the film, so what's the rest of the film about? What's the story? The bottom line was that we needed to find the hook; the third angle to the story that would tie the whole thing together."

Both Cunningham and Craven feel that the 1990s just weren't the right time for a *Freddy Vs. Jason* film, particularly with the spectre of the *Scream* films hanging over the entire horror universe. "The biggest obstacles to making a film like this are always the studio politics and finding the right concept and story. New Line and Paramount were going back and forth about it for so long and Sean and I were off doing other things, and we couldn't be bothered with the whole thing because we were both busy with other projects. I also had a contract with Miramax and was right in the middle of doing the three *Scream* films," says Craven who would, ultimately, serve as an uncredited executive producer on *Freddy Vs. Jason.*

below:
Special effects prop from *Freddy Vs. Jason.* (Photo courtesy of William Terezakis/ WCT Productions.)

Cunningham became the sole credited producer on *Freddy Vs. Jason*, with a myriad of New Line executives - such as Stokely Chaffin, Douglas Curtis and Renee Witt - receiving executive producer titles.

Cunningham says that many of the rejected *Freddy Vs. Jason* scripts had definite *Scream* overtones. "It was so funny because a lot of the scripts were just like *Scream* with all of the in-joke references and humour," he recalls. "Some of the writers were even trying to make Jason a real person, if you can believe that. I didn't want any of that stuff. I didn't feel like any of the writers really understood Freddy and Jason and what the fans really wanted."

In the ten-year period prior to the filming of *Freddy Vs. Jason*, there were plenty of scripts to choose from, with every type of storyline imaginable. "There were some really crazy ideas and scripts," recalls Cunningham. "I think we were looking for something that didn't dwell too much on the past films because we didn't want to make a film that only the purists could enjoy. I think most fans already know the basic story of Freddy and Jason. I didn't want the film to be obscure and a lot of the scripts had characters from some of the sequels, and I haven't seen the *Friday the 13th* sequels."

Perhaps the best place to start tracing the film's development history is with the efforts of makeup effects legend Rob Bottin who, in the early to mid-90s, was anxious to jumpstart a directing career following his groundbreaking work on such films as *The Howling*, *The Thing* and *Total Recall*, for which he received an Academy Award. Bottin teamed up with good friend - and Freddy Krueger himself - Robert Englund, to try and develop a storyline that would ultimately attract the collaboration of writers James Robinson and Mark (*Timecop*) Verheiden, not to mention David Goyer, best known for his shepherding of the popular *Blade* films. Goyer would ultimately contribute to the final *Freddy Vs. Jason* script. The story? This proposed *Freddy Vs. Jason* script aimed to prompt the return of several prominent characters from both of the respective franchises, including Alice (Lisa Wilcox) from the fourth and fifth instalments in the *Elm Street* series and Jessica, Steven and baby Stephanie from *The Final Friday*. Tommy Jarvis was also going to make an appearance, along with original *Elm Street* heroine Nancy (Heather Langenkamp).

Writers Camren Burton and Matt Thompson then penned a script that incorporated all of these combustible elements into a story that featured Freddy Krueger killing a child in the presence of the FBI, who later evacuate the entire population of the city over to Crystal Lake, where naturally, Jason appears. This is a Jason, we learn, who actually

drowned in Crystal Lake while working at the camp as a janitor. All of the aforementioned characters appear in the unhinged script that features, amongst other things, a crazy witch whose son was murdered by an evil cult of Jason-haters who suspected him of being a spawn of Jason. There's more, much more, in the completely ridiculous, but never dull script.

The next writer to try his hand at the seemingly impossible task was Peter Briggs, an urban legend in his own right after his unsolicited script for *Alien Vs. Predator* made him a minor genre sensation. If the previous *Freddy Vs. Jason* script had been unbelievably wild, Briggs's take on the subject was downright medieval. Including many of the characters from Bottin's original concept, Briggs proposed the theory that Freddy and Jason were, in fact, agents of Satan himself, pawns in Satan's ultimate plan for world destruction. "I thought I was going to direct the script," says the writer, whose *Alien Vs. Predator* script became trapped in an equally tortured development hell limbo. "I think everyone felt that my script would've been way too expensive to make, but I wanted to write the best story possible. I didn't even want to do it at first, but I was talked into it. I wrote a script that really stood on its own and I'm very proud of it."

Next up were writers Brannon Braga and Ronald D. Moore, really odd choices to enter the *Friday the 13th* universe given that their sole writing experience had, up until their script for *Mission: Impossible 2* in 2000, been limited to the television series *Star Trek: The Next Generation* and its various spin-offs. Showing a complete disrespect for, and lack of understanding of, both franchises, their script is set in the *Elm Street* universe, a world where the *Friday the 13th* films are just that: films. What's more, in their treatment Jason isn't the Jason we've come to know and love over the years, but rather a deformed psychopath who just happens to wear a hockey mask during his bloody rampages. Braga and Moore's script, which reveals, among other things, that Freddy slept with Jason's mother and tried to murder Jason when he was a kid, was ultimately rewritten by Deborah Fine, the only female writer to have ever been part of *Freddy Vs. Jason*'s interminable development process. However, the admittedly funny take on the *Freddy Vs. Jason* legend was ultimately, and wisely, jettisoned, leaving the whole process to drag on and on.

Writer David Schow, best known for his work on *The Crow* and *Leatherface: Texas Chainsaw Massacre III*, later took a stab at adapting *Freddy Vs. Jason*, as did Lewis Abernathy who had remained in contact with Sean S. Cunningham after penning his 1989 underwater directorial effort *DeepStar Six*. Actually, Abernathy rewrote Schow's extremely wacky version which - adopting many of the concepts from 1991's tepid *Freddy's Dead: The Final Nightmare* - concerned an army of Freddy Krueger cultists who are forced by Freddy to seek out and rape a young virgin whose desecration will, apparently, fully restore the monster's powers. The poor virgin and her friends resurrect Jason to fight Freddy. This very silly script also features a chainsaw, no doubt a tribute to Schow's earlier work.

Perhaps the most eclectic writing team to become involved with *Freddy Vs. Jason* were long-time partners Jonathan Aibel and Glenn Berger, best known for creating the hit television comedy series *King of the Hill*. "I was on a plane once with one of the guys from *King of the Hill* and he told me that he'd written a *Freddy Vs. Jason* script," recalls Englund. "It was so funny because it seems like every writer in Hollywood worked on a *Freddy Vs. Jason* script." Set in the real world, Aibel and Berger's treatment followed a young Freddy Krueger impersonator who kills people in Freddy's name. He then targets a young girl who has a boyfriend named Jason. The script is very much a reality-based affair as we meet Jason's friend, Todd, a horror movie junkie who explains the Freddy Krueger legend to the other characters, who start to get Freddy and Jason confused with each other. Events take a truly bizarre turn when the Freddy copycat breaks out of jail and then rips out Jason's heart, which he tosses into Crystal Lake, resulting in the rebirth of Jason Voorhees.

Aibel and Berger's effort is actually one of the more entertaining interpretations of the *Freddy Vs. Jason* concept, but all parties knew that it was too over-the-top to be workable, despite its goofy charms. The process plainly still had quite a way to go. Soon after *Scream* was released, during the 1996 Christmas holiday, writers Ethan Reiff and Cyrus Voris, best known for their work on the awful 1994 film *Tales from The Crypt: Demon Knight*, wrote a script that was almost approved by all parties involved before finally being rejected. *Buffy the Vampire Slayer* writer Joss Whedon also worked on a proposed *Freddy Vs. Jason* story that would have brought the two terror titans together inside a hellish elevator. Mark Protosevich, best known for writing *The Cell*, later jumped onboard.

Directors came and left the project as well. Aside from Bottin, there was *Blade* helmer Stephen Norrington, who briefly considered the project before departing. Ironically, *Blade II* and *Cronos* director Guillermo del Toro was also attached at one point, but nothing came of it. Writer David Goyer was tenuously involved at various stages too, as New Line executives considered - and according to some, still do - Goyer to be their brightest genre star. Among the various concepts discussed during this penultimate round of development was the

**FREDDY
VS. JASON**
(2003)

Production Company:
New Line Productions, Inc.
Executive Producer:
Douglas Curtis
Producer:
Sean S. Cunningham
Executive Producers:
**Robert Shaye, Stokely
Chaffin, Renee Witt**
Production Manager:
Kathy Gilroy-Sereda
Unit Manager:
James Perenseff
Written by:
**Damian Shannon,
Mark Swift**
Based on characters
created by:
Wes Craven & Victor Miller
Director:
Ronny Yu
First Assistant Director:
Robert Lee
Second Assistant Director:
Ivana Siska
Third Assistant Director:
Martina Lang
Director of Photography:
Fred Murphy
Camera Operators:
**Julian Chojnacki,
Chris Harris**
Gaffer:
Michael Ambrose
Best Boy Electrician:
Terry Calhoun
Art Director:
Ross Dempster
First Assistant Camera:
Dan Henshaw
Second Assistant Camera:
Cary Lalonde
Editor:
Mark Stevens
Music:
Graeme Revell
Sound Recordist:
Eric Flickinger
Boom Operator:
Dave Griffiths
Sound Engineer:
John Bires
First Assistant Editor:
James Durante
Special Effects
Co-ordinator:
James Wayne Beauchamp
Special Effects Make-Up:
WCT Productions

above:
Young Jason Voorhees
(Spencer Stump) smiles
for the camera on the set
of *Freddy Vs. Jason*.
(Photo courtesy of
William Terezakis/
WCT Productions.)

opposite:
The head of Blake's
Father (Brent Chapman).
(Photo courtesy of
William Terezakis/
WCT Productions.)

interesting idea of having multiple endings for *Freddy Vs. Jason* whereby Freddy and Jason could both be seen as defeating the other in separate versions. In some ways, the ultimate version of *Freddy Vs. Jason* would adopt much of this ideology, a kind of triple-ending concept whereby all sides could claim victory.

Then along came Damian Shannon and Mark Swift, friends and writing partners who had wowed Hollywood with their scripts for *Danger Girl* and *Gator Farm*, two writing samples that excited New Line executives suffficiently that they gave the duo a shot at trying to conjure up a *Freddy Vs. Jason* script that worked. The rest is history, but what was it about the Shannon and Swift script that succeeded where so many previous attempts had failed? According to Cunningham, Shannon and Swift's script was the only *Freddy Vs. Jason* script that was able to take Freddy and Jason into the future while also showing a deep understanding for the history of the two characters: "It was the only script that everyone seemed to like. The script had nods to the previous films, but the story wasn't stuck in the past. It also created a third angle to the Freddy and Jason conflict."

Enter Ronny Yu - Hong Kong-born director of classic films such as *The Bride with White Hair* and *Warriors of Virtue* - who had gained the attention of Hollywood when the surprise success of his 1999 film *Bride of Chucky* had seemingly resurrected the long-dormant *Child's Play* franchise. It was not only the commercial success of *Bride of Chucky* that impressed New Line, apparently. "When I met with New Line, the first thing they asked me was, 'Are you familiar with the *Elm Street* and *Friday* films?'" recalls Yu. "I told them I hadn't seen any of the films and they said, 'Good, we want a director with a fresh take on this.' I think New Line felt that both of the franchises had grown stale and they wanted someone with a completely new attitude."

For Robert Englund - who had been donning Freddy's bladed-glove ever since 1984's *A Nightmare on Elm Street* - *Freddy Vs. Jason* marked his first appearance as Krueger since *Wes Craven's New Nightmare* in 1994. It wasn't an easy re-adjustment for the fifty-four year old actor, but a necessary one. "It's hard on me, physically, playing Freddy, because my skin's not that resilient anymore when it comes to putting on the makeup," he admits. "People are very cynical about films like this and I understand that, but the fact is that none of us would've been involved with *Freddy Vs. Jason* if it wasn't a good story." Englund was very supportive of Yu: "I remember being at a horror convention and the fans were all cheering for this Ronny Yu guy because of this *Bride of Chucky* movie. I met with him and we talked and I really felt like he would bring a great dimension to *Freddy Vs. Jason*. He was so respectful towards me. I was his expert and he always asked me my opinion on certain scenes."

Englund also decries the notion - at least with respect to *Elm Street* - that *Freddy Vs. Jason* marked little more than the pairing of two ailing horror franchises. "The last film I did - before *Freddy Vs. Jason* - was *New Nightmare*, and everyone thinks that movie bombed," he says. "It didn't bomb. What happened was that the film came out two years before *Scream* and we just kind of missed the curve. When *Scream* came out, everyone went out to rent *New Nightmare* and I heard that it ended up making about $60 million."

Englund feels that the teaming of Freddy and Jason is nothing more than the natural progression of genre entertainment. "The kids who grew up watching these films are now winning Academy Awards and they have power to make films of their favourite comic books," he says. "When Bryan Singer was in town doing *X2*, he came to the set and he was like a kid in a candy store. You know, when I was a kid, you saw Batman fight Superman and

all of that stuff, and you're going to see movies made like that, like *Alien Vs. Predator*. If I had the power, I'd probably want to make a film from Blackhawk Comics. It's the future."

Whilst Englund was safe in the Krueger role, *Freddy Vs. Jason* is notable for marking the first time since 1986's *Jason Lives* that Kane Hodder would not be appearing as Jason Voorhees. It was a role that Hodder had made his own - or vice versa - and the actor was none too happy to lose out. "I was pissed off," says Hodder, who worked on the 2003 film *Daredevil* and at the time of writing is developing film projects with good friend Englund. "They didn't even give me a fucking reason why they made the decision not to use me. I can't believe they would use someone else because I don't think anyone can play Jason like me."

Cunningham and Englund will not be drawn to speculate about Hodder's departure. "I wanted Kane to be in the film, but it wasn't my call," claims Cunningham. According to Yu, the reason for Hodder's departure is that New Line wanted to minimise the links between *Freddy Vs. Jason* and the previous *Friday the 13th* sequels - a slew of ill-performing box office memories the studio wanted to wipe once and for all. That, and the fact that Yu was looking for a more flexible Jason. "I think New Line wants to start a new franchise with *Freddy Vs. Jason*," says the director. "Our attitude was that *Freddy Vs. Jason* was the first film, not the twentieth. I haven't seen the other films so why should I care what happened before? We made this film for the whole audience, not just the cult audience that knows everything about every sequel. We assumed that people knew the basic story of Freddy and Jason and moved from there. As for Jason, I wanted him to move very deliberately and slowly, not as aggressive as he was before. I did actually see the first *Friday the 13th* and the first *Elm Street* film before we came to Vancouver just to prepare for making the film, and I've seen lots of tapes of Jason, but I just didn't feel that it would've served me well to watch all of the sequels. New Line hired me because I didn't know anything about either series."

If the Jason in *Freddy Vs. Jason* required someone able to emote and move with subtlety, that would be news to Ken Kirzinger, the man who was hired to assume the Jason mantle. A British Columbia native, Kirzinger had grown up in the Vancouver movie industry during the early 1980s, and worked as an actor and stuntman on such films as *Insomnia* and *Thir13en Ghosts,* and the television series' *Wiseguy* and *The X-Files*. According to Kirzinger, getting the role of Jason was as casual a process as one could imagine. "I walked in, they sized me up and that was basically

it after a few call-backs," says the man who, at six-foot-five and 230 pounds, is certainly the largest actor ever to have played Jason.

As was metnioned elsewhere, Hodder and Kirzinger knew each other due to their time together on *Jason Takes Manhattan*. Kirzinger considers Hodder a friend and feels bad about the controversy surrounding the Jason casting process for *Freddy Vs. Jason*. "I was given an opportunity and I took it, and I'm sure Kane understands," he says. "I'm certainly not expecting *Freddy Vs. Jason* to make me a big star because I've been around lots of young actors in Vancouver who've crashed and burned. I suppose - if they make more films and I keep playing Jason - that I might become famous, but I'm not expecting anything. It's not a glamorous job."

One of the biggest changes, and strengths, of *Freddy Vs. Jason* was the film's musical score, courtesy of Graeme Revell, who has worked on such films as *Daredevil* and *Pitch Black*. The compositions devised by Revell for *Freddy Vs. Jason* do not call attention to themselves - he managed to deftly interweave the themes from each series without screaming at the audience, a technique no more evident than in the appearance of a brilliantly concealed quotation from Michael Zager's *Part 3* disco theme.

There does not seem to be a great deal of music in *Freddy Vs. Jason*, although an obnoxious heavy-metal track pounds the senses during the film's interminable end credits. Where was Harry Manfredini, long-time composer for the *Friday the 13th* series? Like Hodder and others, he was another casualty of New Line's 'clean-house' policy

Effect Make-up Artists:
Bill Terezakis, Patricia Murray, Margaret Yaworski, Monique Venier, Harlow MacFarlaine
Production Designer:
John Willett
Storyboard Artists:
Ling Yang, Salmon Harris, Robert Pratt
Graphic Artist:
Sally Hudson-Lawrence
Art Department Co-ordinator:
Slava Shmakin
Stunt Co-ordinators:
Monty L. Simons, Scott Ateah
"Freddy" Stunt Double:
Doug Chapman
"Jason" Stunt Double:
Glenn Ennis
Stunts:
Alex Chiang, Laura Lee Connery, Deb Macatumpag
Casting:
Matthew Barry, Nancy Green-Keyes
Canadian Casting:
Lynne Carrow
Casting Assistant:
Julia Reid
Extras Casting:
Annette McCaffrey

CAST

Robert Englund
(Freddy)
Ken Kirzinger
(Jason)
Monica Keena
(Lori)
Jason Ritter
(Will)
Kelly Rowland
(Kia)
Christopher George Marquette
(Linderman)
Brendan Fletcher
(Mark)
Katharine Isabelle
(Gibb)
Lochlyn Munro
(Deputy Stubbs)
Kyle Labine
(Freeburg)
Tom Butler
(Dr. Campbell)
David Kopp
(Blake)

above:
Special effects prop from
Freddy Vs. Jason.
(Photo courtesy of
William Terezakis/
WCT Productions.)

opposite:
Silicone puppet head for
Young Jason Voorhees.
(Photo courtesy of
William Terezakis/
WCT Productions.)

bring Freddy and Jason together, but he didn't change the story. The final shooting script was about ninety-seven pages."

Although the teenage characters in *Freddy Vs. Jason* would largely serve as distractions from the fights between Freddy and Jason, the cast of the film was certainly populated by lots of energetic youth. Kelly Rowland, a singer for the popular musical group *Destiny's Child*, was cast in the lead female role of Kia, primarily at the request of New Line executives eager to exploit *Freddy Vs. Jason's* pop culture potential. This casting ploy was part of a trend that was prevalent at the time, previous examples including Busta Rhymes's awkward appearance in *Halloween: Resurrection*, and the late Aaliyah's lead role in 2002's *Queen of the Damned*. Regardless, Yu loved working with the rookie actress. "I didn't know anything about her musical career and she was very humble on the set," he says. "I thought she was a real natural and I thought she had star quality."

The other young lead roles were taken by Monica Keena, as Lori, and Jason Ritter, who was cast as Will. Keena, a veteran of the television series *Dawson's Creek*, believes that her character was an example of how the young actors in *Freddy Vs. Jason* were hired to be more than just appetizers for the big battle between Freddy and Jason. "I liked how my character, and the other young characters in the story, had to be very pro-active in the story," she says. "The kids are the only ones who know that Freddy and Jason are alive and back because no one else believes in them. It's up to the kids to figure out how to stop them and the only way to do that is to force Freddy and Jason to fight and kill each other."

The character of Lori has all kinds of significance in relation to the history of the *Elm Street* franchise. It all has to do with a certain sleep-affecting drug called Hypnocil, manufactured by Lori's slimy, possibly murderous, father. Hypnocil was first introduced by Heather Langenkamp's character, Nancy, in 1987's *A Nightmare on Elm Street 3: Dream Warriors*. It seems that the residents of Springwood, Freddy's old murdering grounds, are now nightmare-free. Englund feels like this was one of the best ideas in *Freddy Vs. Jason*. "The kids in the film are from the Prozac generation and they just laugh at Freddy," he says. "They say, 'Freddy Kroeger...Freddy Kroeker...who the hell is he?' That's Freddy's challenge in the movie: to make the teenagers in Springwood believe in him again and become scared of him. If they're not scared and having nightmares, Freddy's powerless."

Lori's partner in *Freddy Vs. Jason*, and the real love of her life, is Will, played by Jason Ritter, son of the famed actor John Ritter, who had incidentally worked with Yu himself, on *Bride of Chucky*. The

regarding the film. Regardless of the way in which hardcore *Friday the 13th* fans reacted to the dismissal of Hodder and, to a lesser extent, Manfredini, who can argue with the success of New Line's business plan? Freddy and Jason are now alive, more than ever, when it had seemed like they were both down for the count in the years prior to the film's release.

Freddy Vs. Jason's $35 million budget makes it, by far, the most expensive *Elm Street* or *Friday the 13th* film. The increased expenditure showed up in all areas of the production, most notably in the technical departments, with a much improved effects budget, not to mention the hiring of accomplished cinematographer Fred (*Stir of Echoes*) Murphy, who would be an invaluable ally of Yu's in realising the director's quest to bring a *Matrix*-type look to the film.

Another important addition to the *Freddy Vs. Jason* crew, albeit a largely uncredited one, was writer David Goyer. At New Line's urging, Goyer came in and gave the *Freddy Vs. Jason* script a final polish, although Yu maintains that his contribution, however valuable, was entirely structural. "David Goyer came in and basically condensed and tightened up the script," says Yu. "If there was a line of dialogue that was ten lines long, he'd shrink it down. He did a great job of just helping us

younger Ritter was cast only after first choice actor Brad (*Apt Pupil*) Renfro was fired from the production over 'personality differences.' More important was the fact that Ritter, previously best known for his appearance in the 2002 film *Swimfan*, was a true horror fan. "The whole thing came down in about two days where the last actor left and they called me up to replace him," he recalls. "I flew up to Vancouver right away and the whole thing was like a big whirlwind. I knew Ronny Yu only because my father had told me what a good director he was when they did *Bride of Chucky*, but that's not what got me the job. It's kind of ironic because one of my first experiences, as a horror fan, was watching *Child's Play*. The best part of doing *Freddy Vs. Jason* was getting to be in a film with Robert Englund because I was the biggest Freddy fan as a kid. You know, the *Elm Street* films were better than the *Friday* films because they had a real story. The idea of a monster attacking you in your nightmares, where you're completely defenceless, always terrified me."

Ritter's character could be described as the unofficial Tommy Jarvis substitute in *Freddy Vs. Jason*, ironic since the idea of having Tommy appear in the film was actually floated around before being rejected prior to the start of production. "Will was a kid who'd been institution-alized, imprisoned by Lori's father because of what Will knows about the death of Lori's mother," explains Ritter. "He's got a lot of personal issues and he becomes a reluctant hero. I loved the fact that these characters weren't just your typical horror movie stereotypes. Will and Lori have to team up to find a way to destroy Freddy and Jason and the kids in the film are very intelligent about doing that." Other notable cast members included Brendan Fletcher, Jesse Hutch, Katharine (*Ginger Snaps*) Isabelle and Lochlyn (*Scary Movie*) Munro.

Aside from Hodder's absence from *Freddy Vs. Jason*, another actor that fans were hoping to see in *Freddy Vs. Jason* was Langenkamp, but the actress concurs with Yu that the only relics from the past to be seen in the film were Freddy and Jason themselves, even if Langenkamp's character, Nancy, was the prototypical opponent for Krueger. "It was my understanding that none of the previous actors were going to be invited back," says Langenkamp. "It's too bad because I think the fans would've liked to have seen Nancy come back." Well, there was one old character who would return for *Freddy Vs. Jason*, albeit in a ghostly form. Her appearance, and the effect that appearance would have on Jason, would serve as the main conflict in *Freddy Vs. Jason*.

Actress Paula Shaw had been around Hollywood for more that twenty years, appearing in films like *The Best Little Whorehouse in Texas* and,

in an ironic *Friday the 13th* twist, *A New Beginning* director Danny Steinmann's 1984 film *Savage Streets*. Shaw relocated to Vancouver to seek work in the midst of the film and television boom that has gripped the once peaceful city. Over the past few years, she has appeared on shows such as *Mysterious Ways*, *The Twilight Zone* and *The X-Files*, not to mention her key supporting turns in films like *Ignition* and *Insomnia*. It was in Vancouver where Shaw, who still regularly travels to Los Angeles, was contacted to play Pamela Voorhees. "I didn't realize what an important character she is in the whole scope of the *Friday the 13th* series until I got the part," she admits. "I thought Betsy Palmer did an amazing job, but I don't look like her so I just tried to make the character my own, especially since I kind of appear to Jason as a ghost. She's an important character in *Freddy Vs. Jason* because she fuels Jason's rage to want to kill Freddy in the film." Actually, Shaw's a dead-ringer for the Pamela Voorhees created by Carl Fullerton (with the help of actress Connie Hogan) in *Part 2* along with the brief image of the character - as played by Marilyn Poucher - as seen at the end of *Part 3*.

Regardless, Shaw's casting begs a familiar and - for long-suffering *Friday the 13th* fans - frustrating question: Where is Betsy Palmer and why wasn't she offered the chance to return, especially given the historical significance of *Freddy Vs. Jason*? For his part, Cunningham is sheepish with an explanation. "I know that Betsy was contacted, but it was my understanding that she was ill and maybe not physically up to appearing in

above:
Trey's (Jesse Hutch)
silicone head.
(Photo courtesy of
William Terezakis/
WCT Productions.)

below:
Sculpture of Jason
Voorheees's new face.
(Photo courtesy of
William Terezakis/
WCT Productions.)

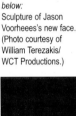

the film," he says. "I don't think it was necessary that any particular actress play the part of the mother in this film. She's not the killer in the film. Freddy manipulates her image to trick Jason."

The illusory appearance of Pamela Voorhees in *Freddy Vs. Jason* is vital to the film's story and the raging war that's eventually waged between the protagonists. The film opens with Freddy and Jason both hovering near the bowels of hell. This is okay for Jason, who seems to enjoy being there, but for Freddy, what's really hell is the fact that he just doesn't scare people anymore, certainly not the residents of his old stomping grounds, Springwood, who - thanks mainly to regular doses of Hypnocil, along with exposure to a cynical media culture - have become immune and, frankly, indifferent to Freddy's nightmares.

Plainly Freddy has to get the kids of Springwood to start having nightmares again, so who's he going to call? The only available killer out there who can fit the bill is Jason Voorhees who by now is not, in fact, in hell - at least not in a literal sense - as we see him still roaming the blood-stained grounds of Camp Crystal Lake. This is, presumably, after he's escaped - thanks to the workings of Freddy - the hellish burial he experienced at the very end of *The Final Friday*. Then again, maybe hell just wouldn't take Jason?!...

Viewers are soon given a dark insight into the sick mind of Freddy Krueger as we witness a series of hellish flashbacks detailing his child-murdering history, brought to an end when the parents of his

young victims set him on fire. "The main thing that attracted me to the script was the sick Freddy flashbacks because he was a real dog in this film, a mean prick," says Englund. "He has a kind of horrific *Elm Street* mother and daughter sandwich in this film (a scene that didn't make it into the final cut of *Freddy Vs. Jason*), really sick stuff. It's no more fun and games for Freddy, but what I really found most interesting was the fact that Freddy was older and weaker and not as resilient to punishment anymore. If he fought Jason, straight up, he'd lose, so how does he defeat Jason? He really can't, so Freddy has to outsmart Jason and I found that whole dynamic very intriguing."

The whole idea of opening the film with flashbacks was, to the credit of the *Freddy Vs. Jason* production team, a genius of marketing and narrative slickness in that it gave fans - namely the casual fans who hadn't spent the past twenty years of their lives pouring over the *Elm Street* and *Friday the 13th* films - a crash course, a quick refresher about the lengthy, but not terribly complicated history of the two villainous characters. That meant that Yu, and hence the film - and indeed the audience - are free to move on and simply enjoy the breezy, fast-moving, joyride that *Freddy Vs. Jason*, thankfully, turned out to be.

So we arrive at the aforementioned scene, where Freddy appears to Jason in the guise of his beloved mother, the mother that Jason has spent untold decades killing for in a grisly form of tribute. It's a nightmare, but what kind of nightmares does a monster like Jason Voorhees have? Jason is totally unaware of the fact that Freddy is manipulating his whole world - the sight of his mother, as we know from the previous *Friday the 13th* sequels, is the one image that never fails to get a reaction out of the otherwise emotionless monster.

Freddy convinces Jason to leave Camp Crystal Lake and head out for a killing spree in Springwood, in the process forcing the teenagers to start having nightmares again. Ultimately, Jason is just too good at his job, not only causing the residents of Springwood to have horrific nightmares, but in the process also becoming the biggest killing machine on the block, a mantle that a now reinvigorated Freddy wants to reclaim. When Jason discovers that Freddy used the image of his mother to trick him into doing his bidding, Jason's rage reaches a new intensity, and the battle between the terror titans is truly on, with the poor teenagers caught in the middle.

Jason begins his rampage at Lori's house, a significant location because she is actually living at 1428 Elm Street, the exact same house in which *A Nightmare on Elm Street* heroine Nancy Thompson lived! What's more the stream of Freddy flashbacks

that open the film include images of past *Elm Street* victims. In this respect, it could be said that Langenkamp and later *Elm Street* heroine Alice (as played by Lisa Wilcox) do appear in *Freddy Vs. Jason* - at least through the flashback images of their characters. (Langenkamp, Wilcox and several other former *Elm Street* cast members are listed during *Freddy Vs. Jason*'s end credits as a special thank you for their past contributions to the success of the *Nightmare on Elm Street* series).

However much the *Nightmare* elements are foregrounded early on in the film, Yu says that it is Jason's feelings about his mother that are at the heart of *Freddy Vs. Jason*. "You mess with Jason's mother and that's very bad, that's a big no-no. That's Jason's motivation in the film: to make Freddy pay and destroy everything that gets in Jason's way as he tries to kill Freddy. You know, I wanted the film to start fast and to move right through, from beginning to end, without many subplots. The film takes place over three days and I just wanted it to be a ninety minute thrill machine and that's what we accomplished. I would almost compare the film to a WWE show and compare Freddy and Jason to a couple of wrestlers. I watch wrestling because it's compelling in its outrageousness and sickness, and that's how I felt about Freddy and Jason. It's like the experience of watching a horrific train wreck. You don't want to watch, but you can't help it."

Kirzinger feels that Freddy's deception easily makes Jason the more sympathetic villain in the film. "I think you do cheer for Jason in the film, if that's the right word," he says. "Jason's a psychotic mama's boy gone horribly awry and everyone knows that you don't mess with his mother. Killing teenagers, that's just part of his job, his killing mandate, but the anger he feels towards Freddy in the film is personal anger. What I found interesting about Jason, as I played him for the first time, is the fact that he's so resilient and you really can't kill Jason. You can hurt him, and he certainly feels pain, but not like you or I or anyone else feels pain. When Jason starts having nightmares in the film, and he gets in Freddy's dreamworld, it's just another challenge that he has to overcome. He's never seen anything like this, but he just keeps on trucking."

Freddy Vs. Jason was filmed all over British Columbia, in some effectively creepy and unusual places. The filmmakers used Buntzen Lake, a dark piece of forest lake buried behind a mass of condos and skyscrapers in the town of Ioco, to represent the seminal Camp Crystal Lake location. *Freddy Vs. Jason* filmed for the better part of a month up there. "It was the perfect location because it could've been the setting from the first film," says Yu. "I wanted the audience to recognize the place, but also see it as a new place and a new time."

above:
Robert Englund and Ken Kirzinger appear together at a horror convention in the United Kingdom during 2004. *Freddy Vs. Jason* marked Englund's first appearance as Freddy Krueger since the 1994 film *Wes Craven's New Nightmare*. Kirzinger took over the role of Jason Voorhees from Kane Hodder, who'd portrayed the monster in four previous films. (Photo courtesy of Francis Brewster.)

above:
Freeburg's (Kyle Labine)
silicone dummy head.
(Photo courtesy of
William Terezakis/
WCT Productions.)

For Freddy's boiler room, Yu and his team sought out an abandoned asylum called Woodlands - now closed amidst charges of abuse and neglect - located deep in the bowels of the murky city of New Westminster. This location was also used - along with another closed asylum, Belleview - for the aforementioned institution scenes with Will. For a rave scene - where Jason kills most of the teenage victims in the film - Yu and his team utilised a desolate cornfield located on the outskirts of Vancouver. Yu was thrilled with the locations used in the film. "The lake was so beautiful and dark; a perfect Camp Crystal Lake for a new time and place," he enthuses. "I wanted the structure of the film to be simple. The film opens at Crystal Lake, then we go to Springwood, and then we finish back at Crystal Lake for the final battle between Freddy and Jason."

According to Englund, the boiler room and the lake are central to illustrating the main conflict and, more importantly, the respective weaknesses of Freddy and Jason; "The battle between Freddy and Jason in the film is for each of them to try and get the other in his world," he explains. "In the real world, Jason kicks Freddy's ass, but when Freddy gets Jason in his dreamworld, Freddy can dominate. What's Freddy scared of? Fire. What's Jason scared of? Water. That's the game they're playing against each other." Yu agrees that the basic elemental relationship between Freddy and Jason is key to their battles in the film; "That's why we were able to do so much of the *Matrix*-type wire stuff in the film," he says. "Freddy's world is mystical while Jason's world is entirely based in reality. Freddy's victims die in their dreams, but Jason kills for real."

One of the other locations used for filming was a large water tank located at the University of British Columbia. It was here that some of the Camp Crystal Lake water scenes were filmed during which Freddy shows a very different side of himself, in the form of a Demon Face. When Freddy appears out of the water, his face expands and ruptures, the full horror of his terrible past squirming out of his pores. "That was several weeks spent in that water tank and it killed my skin and Ronny wanted it top secret because he was really excited about what we were doing," says Englund. "I look like a bubblehead in the film; the face just expands and all of this sick stuff bursts out. I thought it looked great in the film." Unfortunately, however, most of this effect never made it into the final cut.

As for Jason's face, Kirzinger was outfitted with several different masks, in various stages of degradation, that he wore throughout filming. *Freddy Vs. Jason*'s makeup effects were handled by Bill Terezakis and his Vancouver-based effects company, WCT Productions. A past veteran of *Jason*

opposite:
Jason Voorhees (Ken
Kirzinger) figurine design.
(Photo courtesy of Diane
Kamahele/Sideshow
Collectibles.)

right:
Freddy Krueger's
(Robert Englund) new
Demon Face.
(Photo courtesy of
William Terezakis/
WCT Productions.)

Takes Manhattan, Terezakis and his partners have also worked on such high-profile horror films as *Final Destination 2*, *House of the Dead* and *Willard*. The makeup expert wanted to leave his own distinctive mark on Jason: "He was, basically, a mongoloid in the film, kind of like the original films," he says. "I wanted him to be less decomposed and rotted, and I wanted lots of definition so you see a new Jason, but you still recognise the face."

One of the biggest changes in Jason's appearance in *Freddy Vs. Jason* is that he is afflicted by a droopy, ripped-out eye (unfortunately not fully seen in the finished film). The effect meant that Kirzinger had to walk around half-blinded with the prosthetic hidden under the hockey mask. Kirzinger likes the new overall look of his Jason, even if much of his face was not actually visible in the theatrical release. "It was hard being blind in one eye, especially since Ronny wanted me to do very precise movements in the film," he says. "You know, I think I've set a precedent for being the biggest Jason so far. From now on, if they want to hire someone else to play Jason, he's going to have to be really big."

Freddy Vs. Jason was never destined to change history. It is not even a truly great horror film in and of itself, but the makers of *Freddy Vs. Jason* deserve a great deal of credit for getting Freddy and Jason this far - to their battle. With the back-story out of the way, the introductions made, it was time to get down to business. It was time for Freddy and Jason to fight to the death, the prize at stake being the title of the greatest horror villain of his era. Was it possible for either Freddy or Jason to truly defeat and kill the other? Who would win, and what would be left of them?

The Final Conflict?

When sizing up the impending battle between Freddy and Jason, one couldn't help but be slightly sceptical about Jason's chances. The *Elm Street* films virtually built New Line Cinema, helping to mould it into the major studio it is today. What had *Jason Goes to Hell: The Final Friday* and *Jason X* done for New Line except to suck the oxygen out of empty theatres? Writers Damian Shannon and Mark Swift believed that it was important to have a fair fight, more or less, obeying the rules and mythology of each series. "We wanted to make them fight in a way that wouldn't contradict the back-stories of the previous films," says Swift. "That's tough when you have them fighting in the real world and a dream world."

Shannon says that the key to unlocking the story of *Freddy Vs. Jason*, and the final conflict between the enemies, was to go back to the origins of each series. "All of the later sequels seemed to have forgotten or rewritten the rules that were established in the original films," he says. We wanted to take Freddy and Jason back to the mythologies that had been created for them back in the early '80s and have the fight arise from that." Obviously, the ending, the identity of the conflict's final victor, was a source of much consternation and debate for everyone involved with *Freddy Vs. Jason*. "We knew that we couldn't have a clear winner in terms of one of them being completely dead, but there had to be some kind of winner," says Swift. "The ending was changed a lot, even during filming, even from what we'd written, and I think it's satisfying. It's certainly not a tie. It's hard because, obviously, the final result can't be too cut-and-dried in case the studio wants to make more movies."

Before the horror fans could debate the aftermath of *Freddy Vs. Jason*'s final confrontation, Yu and his team still had to tell a story en route to the big Camp Crystal Lake showdown. This is where the teen characters came in, and plainly they were there to serve the same purpose as in all of the previous *Elm Street* and *Friday the 13th* sequels: look beautiful, die fast. However, Yu was adamant that the teenage characters be more than throwaway, horror movie trash. "I wouldn't have done the film if we hadn't had young characters that

were real people," says the director. "I was very reluctant to do the film, at first, because, like I said, I didn't know the franchises. I also read the script and I didn't like the fact that it didn't tell you who won the final battle. Bob Shaye (New Line Cinema CEO Robert Shaye, who actually has a cameo in *Freddy Vs. Jason*) gave me total creative freedom. I was at a point where I just wanted to make an entertaining, fun movie and it just happened to be *Freddy Vs. Jason*."

The pivotal murder that signals Jason's return - and therefore by extension, Freddy's return too - sees the killer, true to form, interrupting a romantic interlude, in this instance between Gibb (Katherine Isabelle) and Trey (Jesse Hutch), which happens to be taking place in the former Thompson house. After they have sex, Trey ends up being slashed to bits by Jason whilst Gibb is taking a shower, much to her screaming surprise when she returns from the bathroom to make the gruesome discovery. For his part, Kirzinger is more dismissive than Yu of *Freddy Vs. Jason*'s teenage characters. "They serve the purpose of getting Freddy and Jason together to fight and they make great victims, and that's kind of it," he says. "You can always dismiss the teens in films like this because they don't survive long enough for the audience to get to know them."

After the murder at her house, Lori begins to be haunted - exactly as Freddy had planned - after the police arrive to watch over her. One of them, Deputy Stubbs (Lochyn Munro), casually mentions Freddy's name, triggering the curiosity inside Lori that eventually turns into a nightmare. Pretty soon everyone is having nightmares again. The problem for Freddy is that, while he's being blamed for the new killing spree, Jason is having fun, so much fun in fact that there is no way he is going to stop now, especially after learning of Freddy's cruel deception. If Freddy wants to be the king of terror again, he has no choice but to get rid of Jason. According to Englund, Krueger has, with the resurrection of Jason, created a monster that he cannot control. "He's met his match; he made a big mistake by resurrecting Jason and he knows it," says Englund. "Jason is like Frankenstein in the film and it causes Freddy to just kind of look at Jason in stunned bewilderment and say, 'Why

opposite:
Proportionally scaled figurine designs of Freddy Krueger and Jason Voorhees. Stuntman Ken Kirzinger is the biggest man ever to play Jason Voorhees. (Photo courtesy of Diane Kamahele/Sideshow Collectibles

below:
Effects concept for Jason Voorhees's face. (Photo courtesy of William Terezakis/ WCT Productions.)

won't you die?' He doesn't know what to do with him. They're like two suicidal brothers in the film."

Meanwhile, Will is still stuck in the psychiatric hospital, now not only because of his suspicions about the death of Lori's mother, but also because the parents of Springwood have seemingly decided to institutionalize all teenagers who dare speak of Freddy Krueger, keeping them sedated on Hypnocil. When Will and his good buddy Mark (Brendan Fletcher), find out about the murder at Lori's house, they devise a plan to escape from the asylum so Will can warn Lori, his true love, about the Freddy Krueger legend. Of course, his actions inadvertently play right into Freddy's bladed hands.

Will and Lori hook up with her friends, Gibb (Katharine Isabelle) and Kia (Kelly Rowland), in order to try and prevent another massacre. However, very soon Jason goes on his aforementioned rampage at an outdoor rave, during which he kills most of the teenagers in sight - the most notable victim being Gibb - a fact that further disgusts and enrages Freddy, who thinks that Jason has just gotten too damn greedy. Yu feels very good about the way the rave sequence turned out. "I wanted that scene to be very atmospheric and dry and I think it was," he says. "It gets back to the clash of the two worlds: the mystical world and the reality-based world. One of the hard things about making the film was the fact that Jason was kind of sympathetic, but there's not much of a character there while Freddy's a really animated character. I think Freddy tends to dominate the film because of that, because Jason isn't able to show emotion, although I tried to have Ken move very specifically to project feelings. I tend to prefer characters who have personality and I think I was more partial to Freddy than I was to Jason, and I think it shows in the film. You know, Freddy reminds me a lot of Chucky in the way that neither character has any moral code, any regard for social constraints."

Jason's way of going about his business is, of course, a perfect contrast to Freddy's wise-cracking psychosis. "Jason likes to chop people in the head with a machete and that's pretty much it," says Kirzinger. "That's what I like about him; the fact that he's so simple. I really do think that both monsters make each other better in the film, make each other work. You know, I don't think fans were really interested in seeing another Jason movie or seeing another Freddy movie, but put them both together and it's a package that works." To be sure, Freddy is the more dominant character than the sullen Jason in the film, due to his very animated nature, but Yu deserves credit for balancing the need to make *Freddy Vs. Jason* both a *Friday the 13th* film and a *Nightmare on Elm Street* film. "It was hard because this isn't an *Elm Street* film or a

Friday film," says Yu. "What is it? I decided to make something different - an elemental fantasy horror film."

It is after the rave massacre - and the shock of both Gibb's murder at the hands of Freddy and the appearance of Jason - that the remaining friends - Kia, Lori, Mark and Will - finally realise that the only way the two monsters will be stopped is if they fight each other. Their small band is soon enhanced when they are joined by Linderman (Christopher Marquette), a shy, best friend type with a serious crush on Kia, and Freeburg (Kyle Labine), a stoner who turns out to be a lot smarter than he looks.

The friends eventually head to Westin Hills to discover the secret of the nightmare-suppressing drug Hypnocil, but before doing so, Lori and Will return to Lori's house on Elm Street, where Will has an angry confrontation with the girl's father, Dr. Campbell (Tom Butler). Will finally has the chance to confront the doctor over his belief that he had witnessed the murder of Lori's mother, but soon learns that he was wrong - and that it was actually Freddy who had killed Lori's mother in the guise of Dr. Campbell! Keena appreciates the depth of the part she was hired to play. "I think Lori's a very independent and tough character. She has an arc in the film because she learns that Freddy killed her mother and that inspires her to have a need to get revenge. She's the real hero of the story."

Following the death of Mark, who's killed during a nightmare fantasy about his dead brother, the film's action becomes centred on Westin Hills, which is where we get our first big battle between Freddy and Jason. Their confrontations, both in Freddy's dreamworld and reality, required the combined skills of the entire *Freddy Vs. Jason* production team, particularly special effects coordinator Wayne Beauchamp and visual effects supervisor Ariel Shaw. "Ronny Yu was determined to go all the way with the film's effects," says Shaw, who worked on over 300 different shots for the finished film. "Ronny wanted to do stuff that had never been seen before which meant building a CG-hell and all kinds of reveals on Jason's face."

Shaw - along with his companions in the effects crew - was required to bear in mind at all times that the two protagonists operate in fundamentally different realms. "They kill the same amount of people, but the challenge was in showing the different styles," he says. "Jason is very gory so we had to do lots of CG body parts and visual effects for the stuff that gets cut off. Freddy's a fantasy-based character so there was a lot of CG-created effects for illusions and stuff that doesn't really exist, like when Freddy turns into different creatures."

Beauchamp found water to be the biggest challenge when designing special effects. "We had to do so many effects tricks with the water," he says. "There was one scene, where Freddy jumps out of the water, where we had to use a crane to lift up the stuntman and spin him around at the same time... he could've been killed if something had gone wrong." The final battle at Camp Crystal Lake was a different matter entirely. "There were always effects to do, and lots and lots of blood," continues Beauchamp. "The final fight was done with lots of different rigs and air tanks, and every movement seemed to require a different effect. It was nice to know, while working on the film, that Ronny was making a film that was really going to deliver the goods as far as the effects were concerned."

At Westin Hills, the teens discover Springwood's dirtiest little secret - dozens of comatose patients, victims of overdoses during the Hypnocil drug trials, are found hidden away in a secret room like lab-rats, all under the care of Lori's father who, it turns out, really is a bad guy after all. The action is inadvertently kicked off by Freeburg, who takes a toke of marijuana, which causes him to have a Freddy hallucination, thus allowing Freddy to take over his body. To represent the transformation Labine was required to take on certain of Robert Englund's characteristics. "Robert has a

certain swagger that was fun to try and copy," says the actor. "The main thing I had to do was focus on the fact that Freddy's right hand is bladed so I had to pretend that my right hand was a bit more weighted than the left."

By this time, Jason has arrived, slaughtering Deputy Stubbs who was secretly helping to unravel the connection between Freddy and Jason. The kids scramble to get hold of the Hypnocil, but Freeburg - under the control of Freddy - destroys all of the samples. However, as the inner-Freeburg fights to retain some control of his possessed body, he injects Jason with a massive tranquilizer cocktail before the killer cuts him to pieces. Jason's out of it - asleep and about to enter Freddy's dreamworld, not to mention his own past.

The enemies proceed to battle in Freddy's boiler room, where the razor-fingered killer very quickly learns what a tough opponent Jason is. "This is where Freddy realizes what a big mistake he's made in bringing back Jason because there's really nothing he can do with him," says Englund. Jason cuts off Freddy's arm, which grows itself back, but it is not long before Freddy learns about Jason's fear of water as we flashback to Jason's days as an eleven-year old kid at Camp Crystal Lake. These flashbacks are in many ways the most disappointing part of the film as the events that

above:
Effects concept for Jason Voorhees's new face. (Photo courtesy of William Terezakis/ WCT Productions.)

below:
Effects expert William Terezakis toys with the severed head prop for Blake's Father. (Photo courtesy of William Terezakis/ WCT Productions.)

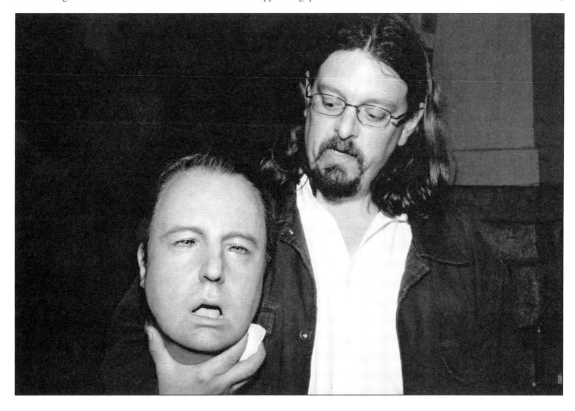

above and opposite bottom: Jason Voorhees costume concept sketches. (Illustrations courtesy of William Terezakis/ WCT Productions.)

occurred at Camp Crystal Lake, many years ago, are presented in the form of a parody, with camp counselors fornicating all over the place and poor, geeky-looking Jason being tormented by the other campers. Where's Steve Christy, no doubt a child himself at the time? And where, of course, is Mrs. Voorhees?

The kids use Mark's van to transport the comatose Jason to the real, waking-world Camp Crystal Lake, hoping that the monster will leave Springfield in peace if he can kill Freddy and then stay on his home turf permanently. Whilst en route, Lori injects herself with a tranquilizer in order to travel into Freddy's dreamworld in a desperate attempt to try and influence events. She winds up, in her dreams, at Camp Crystal Lake, where she sees the young Jason being cruelly tormented by the other campers. Jason ends up in the lake, drowning, so Lori tries to save him despite the attentions of Freddy who of course wants nothing more than to see his enemy die there and then.

The scene in which Freddy bursts out of the water, in Lori's dream, was supposed to mark the appearance of Freddy's aforementioned Demon Face, but most of the effect does not appear in the finished film. Yu says that time was the major factor in the edit suite: "The first cut of the film was about two-and-a-half hours and I liked it," he says. "The film had to be cut down to about ninety-five minutes and a lot of stuff had to go."

The kids arrive at Crystal Lake with Jason, and soon enough Freddy arrives too when Will revives Lori, her return to reality bringing Freddy into reality as well. Ritter believes that his character harbours great feelings of responsibility. "Will's willing to die for Lori, plain and simple," says the actor. "I think he feels guilty about Freddy because he realizes that it was a mistake to warn the others - not about the killings, but about Freddy, because Will caused the others to be afraid again by bringing up all of this old stuff that the town had buried."

The ensuing - real world - battle between Freddy and Jason soon claims the lives of both Kia and Linderman, the former being thrown into the side of a tree. Pop-star Rowland (making her film debut in *Freddy Vs. Jason*) found the long nights spent filming at Buntzen Lake to be as gruelling as anything she's experienced on tour. "The hardest part was the blood and the makeup, but it was a great learning experience," she says. "I wouldn't compare making a music video to doing a movie because they're totally different. At the beginning, I didn't want to get killed on-screen, but then I was okay with it. Robert Englund and I really bonded."

As Freddy and Jason battle to the death during the climactic scenes of *Freddy Vs. Jason* - using every weapon and trick at their disposal - the

Friday the 13th fan watching this film is left with the satisfying feeling that, yes, this film has brought the *Friday the 13th* series full circle. *Freddy Vs. Jason* did what it promised to do, which was to offer some sense of closure to the *Friday the 13th* series. This is especially true given the brutal ways that Freddy and Jason attack each other during their deadly face-off at the lake as Jason tears off Freddy's arm, and impales Freddy with his own blades, while Freddy ventilates Jason and slices off the tips of his fingers. That's not to say there will be no more sequels - in fact there may even be another endless cycle of films given the film's spectacular financial success. But *Freddy Vs. Jason* closes a chapter, at least. Fans had been waiting almost twenty years for Freddy and Jason to fight each other and *Freddy Vs. Jason* delivers on that basic and visceral level.

Freddy Vs. Jason's retrospective tone is affirmed when Lori, seeking revenge for her mother's murder, decides to intervene in the conflict between Freddy and Jason. Suddenly Lori is revealed to be the third part of Sean S. Cunningham's vision for *Freddy Vs. Jason*, the unexpected final deciding factor in the battle between the two villains, both of whom have by now been severely weakened by their brutal war of attrition. Lori, re-enacting Adrienne King's triumphant act of rage at the end of *Friday the 13th*, chops off Freddy's head with one mighty swoop of Jason's machete. Meanwhile Jason, having being disembowelled by Freddy during their climactic battle, has vanished into the depths of the lake. The bloodbath and the nightmare are over, at least for Lori and what is left of her friends, and the other residents of Springwood. Jason won. More importantly, the *Friday the 13th* series won. Well, sort of.

Clearly, Freddy's decapitation and Jason's survival is enough reason for Jason - and his fans - to claim victory even though Freddy's wounds are anything but fatal. In the film's final scene, we cut to dawn at Camp Crystal Lake with the sun's rays shining through a dry mist that hovers over the water like a phantom of death. Suddenly, Jason appears out of the mist and, as his hand slowly surfaces from beneath the surface of the water, Freddy's head appears, in Jason's grasp. Freddy winks at the camera.

There was a lot of deabte about the ending amongst Yu and the production team. "We had a triple ending planned, but then we decided to let Jason have the victory because we wanted to give the fans a winner," says Yu. "That didn't mean we'd have to kill off Freddy for good - of course not - but we didn't want fans to feel ripped off. There was another ending that was basically

Freddy and Jason fighting to a draw," he continues. "It was good, but we needed an ending that had some kind of victory for one of the monsters and that's why we chose the ending we did."

Freddy Vs. Jason is a surprisingly energetic and imaginative piece of work. Maybe the film's greatest accomplishment is the fact that it lives up to that rather baggage-laden title - it does manage to live up to the expectations that had been accumulating for over a decade. Ironically it is actually possible to fault the film for having too much ambition and back-story, but when was the last time you could criticise a *Friday the 13th* film for that? However, strictly speaking, this isn't a *Friday the 13th* film at all - that era has now past. It's not even a Jason film since, in another wise move, he doesn't get a lot of screen time in *Freddy Vs. Jason*. It's a *Freddy Vs. Jason* film, a new franchise, for better or worse. Maybe that's the film's greatest achievement.

In purely pragmatic terms, *Freddy Vs. Jason*'s greatest achievement occurred on August 15, 2003 when the film was finally released theatrically after New Line had pushed the opening date back from its original June slot to avoid competition with other big-studio blockbusters. It was a very smart move on the part of New Line Cinema as *Freddy Vs. Jason*'s only competition was the western *Open Range* and the teen comedy *Uptown Girls*. The only note of disharmony occurred on August 14, when a massive power blackout afflicted huge swathes of Eastern United States and in parts of Canada. "I was really nervous," says Yu. "I didn't think the theatres would even be open."

In the event, all went well on release day. Opening in an unprecedented 3,014 theatres, *Freddy Vs. Jason* made history of the box office kind, grossing an amazing $36.4 million in its first three days of release. These were record-breaking numbers for a *Friday the 13th* film, in fact *Freddy Vs. Jason* made more money in its first weekend of release than any of the previous seven *Friday the 13th* films had made in their entire theatrical runs (inflation-adjusted figures notwithstanding of course).

The film's totals cooled considerably in its second weekend of release - business dropping over sixty-percent to $13.1 million - but the film still smashed the $80 million barrier in North America. The makers of *Freddy Vs. Jason* were shocked and understandably delighted. "New Line trusted me to take care of this franchise and to see it do so well makes me very proud," says Yu. For his part, Sean S. Cunningham's recently faltering career has been thoroughly reinvigorated by the film's awesome commercial success. "I always knew the fans were out there, in big numbers, if we

could just deliver the right kind of film," he says. "It vindicates the fact that we waited so long to come up with the right story and the right elements. If we'd made *Freddy Vs. Jason* ten years ago, it might've been a mistake. It was the right time."

Will there be more *Freddy Vs. Jason* films? Certainly. But will the *Freddy Vs. Jason* franchise repeat the same tired sequel cycle that ended up hobbling the *Elm Street* and *Friday the 13th* franchises? "I feel like we've turned the page and we're starting a new chapter with all kinds of neat possibilities," says Englund. And what about Jason? According to Sean S. Cunningham, the man who truly started it all, Jason will live for as long as fans want to keep him alive. "The fans were the most important part of making *Freddy Vs. Jason* and it was their enthusiasm that brought the character back to life," he says. "No one can kill Jason."

A quarter of a century has passed since *Friday the 13th* first entered the public consciousness. How does 1980's *Friday the 13th*, the film that 'started it all,' stand up in the cold light of the modern day? As far as the summer camp horror films are concerned, it's still the best, as the first film of any series or trend invariably tends to be. Now, today, the seeds of success - the fan excitement that made *Friday the 13th* a part of pop culture - are back, embodied in the spirit of *Freddy Vs. Jason*. Everything old is new again.

It's impossible to go back in time and, let there be no doubt, the good old days of the summer camp slasher films are over. It was a wonderful cinematic period that saw the horror genre somehow taken back to a time of bloody and shocking innocence. But it is dead and buried now, and not coming back. Indeed, maybe it shouldn't. But the fans are still alive - in their secret millions. More importantly, the quarter-century hangover following the release of *Friday the 13th* - a period that saw the series slide from shocking brilliance to mediocrity - is mercifully over. The spirit is still alive. There might never be new films with the *Friday the 13th* tag proudly attached to them again, but the fans know where they, and the films, came from.

It all started with a small crew of unknown actors and crew who, towards the end of 1979, descended upon Blairstown, New Jersey to make film history. The simple story about a boy named Jason and his crazy, misguided mother has become warped and twisted over the years into something that no one associated with *Friday the 13th* could ever have imagined: a legacy of horror film immortality. The legend of Camp Blood is still there if you look hard enough - buried in the hearts of *Friday the 13th* fans around the world - and it will never die.

Friday the 13th Body Count

The *Friday the 13th* film series didn't invent the 'body count' genre, but it certainly came to dominate it, accumulating more kills than any other horror film series in history. Including faceless and uncredited victims (notably the countless number of people killed on the space station inadvertently destroyed by Jason in *Jason X*), the *Friday the 13th* franchise has notched up more than 200 kills. While many of the victims are scarcely remembered after all these years, a few are indelibly etched in the minds of *Friday the 13th* fans, their death throes never to be forgotten.

Probably the most famous of the *Friday the 13th* victims, in more ways than one, was Kevin Bacon's Jack character from the original classic, 1980's *Friday the 13th*. Jack's arrow-through-the-neck death made effects expert Tom Savini a legend, caught the MPAA totally by surprise, and gave horror fans something new and exciting. Other kills are memorable for different reasons, like the death of John Furey's Paul Holt character in *Friday the 13th Part 2*, the details of which are so murky that some fans aren't even sure if the character really died. Who can forget Laurie Bartram's sweet Brenda from *Friday the 13th* or Nick Savage's tough biker Ali, who was apparently killed by Jason Voorhees in *Friday the 13th Part 3*, before coming back to life and being killed a second time? Then there's Jason Voorhees himself, cinema's most prolific mass murderer, who's been killed, and reborn, countless times.

The first on-screen victim in the *Friday the 13th* universe was Willie Adams's Barry character. Adams was a production assistant on the film, and had auditioned for one of the main roles before getting his cameo, and a dubious place in horror film history.

The first true victim - and the most important victim in the history of the *Friday the 13th* franchise - was however Jason Voorhees, an eleven-year old disfigured camper who would be transformed into an unstoppable killing machine. If young Jason Voorhees hadn't tragically drowned at Camp Crystal Lake in the summer of 1957, the resulting quarter century of murder and mayhem never would have happened, and for millions of *Friday the 13th* fans around the world, that would have been the greatest tragedy of all.

opposite:
Tom Morga as Jason Voorhees - the most prolific killer in the history of the cinema - as seen in Friday the 13th Part V: A New Beginning.

below:
Friday the 13th
kill number 1
- Barry (Willie Adams)

FRIDAY THE 13th (1980)

1. Barry - knife in the gut
2. Claudette - throat slit
3. Annie - throat slit
4. Ned - throat slit
5. Jack - arrow through neck
6. Marcie - axe in the face
7. Brenda - stabbed with arrow
8. Steve Christy - knife in the chest
9. Bill - arrow through eye; throat slit
10. Pamela Voorhees - decapitated

FRIDAY THE 13th PART 2 (1981)

1. (11) Alice - icepick through temple
2. (12) Crazy Ralph - strangled with wire
3. (13) Cop - hammer to the head
4. (14) Scott - throat slit
5. (15) Terry - stabbed

6. (16) Mark - machete through skull
7. (17) Jeff and...
8. (18) Sandra - impaled with spear
9. (19) Vickie - stabbed
10.(20) Paul - vanished

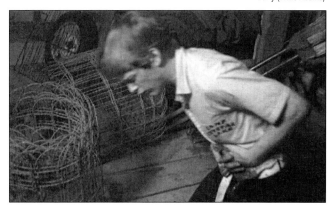

Friday the 13th
kill number 2
- Claudette (Debra S. Hayes)

Friday the 13th
kill number 3
- Annie (Robbi Morgan)

Friday the 13th
kill number 4
- Ned (Mark Nelson)

Friday the 13th
kill number 5
- Jack (Kevin Bacon)

Friday the 13th
kill number 6
- Marcie (Jeannine Taylor)

FRIDAY THE 13th PART 3 (1982)

1. (21) Harold - stabbed with cleaver
2. (22) Edna - knitting needle through head
3. (23) Fox - mounted with pitchfork
4. (24) Loco - stabbed with pitchfork
5. (25) Shelly - throat slit
6. (26) Vera - spear through eye
7. (27) Andy - sliced with machete
8. (28) Debbie and...
9. (29) Debbie's foetus - knifed from behind
10. (30) Chuck - electrocuted
11. (31) Chili - impaled with hot poker
12. (32) Rick - skull crushed
13. (33) Ali - hacked to death with machete

FRIDAY THE 13th:
THE FINAL CHAPTER (1984)

1. (34) Axel - neck cut with hacksaw
2. (35) Nurse Morgan - scalpel to the gut
3. (36) Hitchhiker - knife through neck
4. (37) Samantha - knife through torso
5. (38) Paul - speared
6. (39) Terri - speared through back
7. (40) Mrs. Jarvis - stabbed off-screen
8. (41) Jimmy - cleaver to the head
9. (42) Tina - thrown through window
10. (43) Ted - knife through head
11. (44) Doug - head crushed
12. (45) Sara - axe to the chest
13. (46) Rob - garden harrow through throat

FRIDAY THE 13th PART V:
A NEW BEGINNING (1985)

1. (47) Neil - killed with machete
2. (48) Les - icepick in the neck
3. (49) Joey - hacked to pieces
4. (50) Vinnie - flare in the mouth
5. (51) Pete - throat slit
6. (52) Billy - axe in the head
7. (53) Lana - axe in the chest
8. (54) Raymond - knife in the guts
9. (55) Tina - garden shears through the eyes
10. (56) Eddie - head crushed with a strap
11. (57) Anita - throat slit
12. (58) Demon - speared
13. (59) Junior - decapitated
14. (60) Ethel - cleaver in the head
15. (61) Jake - cleaver in the face
16. (62) Robin - killed with machete
17. (63) Violet - machete in the guts
18. (64) Duke - hacked to pieces
19. (65) Matt - spiked through the head

20. (66) George - blinded and thrown to his death
21. (67) Roy - impaled on tractor machinery
22. (68) Pam - stabbed

FRIDAY THE 13th PART VI:
JASON LIVES (1986)

1. (69) Allen - heart ripped out
2. (70) Darren - impaled with spear
3. (71) Lizbeth - spear in the mouth
4. (72) Burt - impaled on a tree
5. (73) Stan and...
6. (74) Katie and...
7. (75) Larry - all decapitated at the same time
8. (76) Martin - throat slashed with broken glass
9. (77) Steven and...
10. (78) Annette - killed together by a machete
11. (79) Nikki - face crushed
12. (80) Cort - knife to the head
13. (81) Roy - hacked to pieces
14. (82) Sissy - decapitated
15. (83) Paula - hacked to pieces
16. (84) Officer Thornton - dart in the head
17. (85) Officer Pappas - head crushed
18. (86) Sheriff Garris - snapped in two

FRIDAY THE 13th PART VII:
THE NEW BLOOD (1988)

1. (87) John Shepard - drowned
2. (88) Jane - spiked and impaled
3. (89) Michael - spiked in the back
4. (90) Dan - punched clean through, neck broken
5. (91) Judy - bashed to death
6. (92) Russell - axe in the face
7. (93) Sandra - drowned
8. (94) Maddy - neck cut with a scythe
9. (95) Ben - head crushed
10. (96) Kate - party horn through eye
11. (97) David - beheaded and stabbed
12. (98) Eddie - throat cut open
13. (99) Robin - thrown through window
14. (100) Amanda Shepard - speared
15. (101) Dr. Crews - sawed in stomach
16. (102) Melissa - axe to the face

FRIDAY THE 13th PART VIII:
JASON TAKES MANHATTAN (1989)

1. (103) Jim - shot with a spear gun
2. (104) Suzi - speared
3. (105) J.J. - head crushed
4. (106) Boxer - hot rock in the chest
5. (107) Tamara - stabbed with glass shard

6. (108) Jim Carlson - harpooned
7. (109) Admiral Robertson - throat slashed
8. (110) Eva - strangled
9. (111) Crew Member - accidentally shot
10.(112) Wayne - electrocuted
11.(113) Miles - impaled
12.(114) Deck Hand - axed to death
13.(115) Gang Banger #1 - stabbed with syringe
14.(116) Gang Banger #2 - scalded
15.(117) Julius - decapitated
16.(118) Cop - killed off-screen
17.(119) Charles McCulloch - drowned in sewage
18.(120) Colleen Van Deusen - caught in car fire
19.(121) Sanitation Worker - head smashed in

JASON GOES TO HELL: THE FINAL FRIDAY (1993)

1. (122) Coroner - possessed by Jason
2. (123) Coroner's Assistant - medical probe through the neck
3. (124) FBI Agent #1 - pencil through spine
4. (125) FBI Agent #2 - skull crushed
5. (126) Alexis - slashed with razor
6. (127) Deborah - stabbed with barbed wire
7. (128) Lou - head crushed
8. (129) Edna - head slammed against car door
9. (130) Josh - shot in head; impaled with poker
10.(131) Diana - speared through the back
11.(132) Robert Campbell - shot in head; impaled
12.(133) Officer Ryan - head bashed against locker
13.(134) Officer Mark and...
14.(135) Officer Brian - heads bashed together
15.(136) Ward - limbs broken
16.(137) Diner Patron - crushed
17.(138) Shelby - burned
18.(139) Diner Patron - stray shotgun blast
19.(140) Joey B. - face bashed in
20.(141) Vicki - head crushed
21.(142) Sheriff Landis - self-impaling with dagger
22.(143) Randy - neck slashed
23.(144) Creighton Duke - crushed to death

JASON X (2001)

1. (145) Private Johnson - head wounds
2. (146) Guard #1 - machine gun to the head
3. (147) Guard #2 - shot
4. (148) Guard #3 - face bashed in
5. (149) Guard #4 - choked to death
6. (150) Dr. Wimmer - impaled by noose pole
7. (151) Sgt. Marcus - thrown through metal door
8. (152) Adrienne - face frozen in liquid nitrogen
9. (153) Stoney - stabbed
10.(154) Azrael - back broken

11.(155) Dallas - head crushed
12.(156) Sven - neck broken
13.(157) Condor - impaled on drill
14.(158) Geko - throat slit
15.(159) Briggs - impaled on claw-hook
16.(160) Kicker - cut in half
17.(161) Fat Lou - hacked to pieces
18.(162) Dieter Perez - killed in explosion
19.(163) Professor Lowe - decapitated
20.(164) Kinsa - killed in explosion
21.(165) Crutch - electrocuted
22.(166) Waylander - killed in explosion
23.(167) Janessa - sucked through grate
24.(168) Sgt. Brodski - stabbed; sucked into space

FREDDY VS. JASON (2003)

1. (169) Little Girl - eyes gouged out
2. (170) Heather - pinned to tree with machete
3. (171) Trey - stabbed; folded in half
4. (172) Blake's Father - decapitated
5. (173) Blake - slashed with machete
6. (174) Frisell and...
7. (175) Gibb - impalemed together with long pipe
8. (176) Teammate - head twisted
9. (177) Shack - impaled by flaming machete
10.(178) Raver #1 - sliced with machete
11.(179) Raver #2 - sliced with machete
12.(180) Raver #3 - slashed to death
13.(181) Raver #4 - sliced in stomach
14.(182) Raver #5 - slashed with machete
15.(183) Raver #6 - sliced with machete
16.(184) Mark's Brother - slashed wrists
17.(185) Mark - set on fire; face slashed
18.(186) Security Guard - crushed by door
19.(187) Deputy Stubbs - electrocuted
20.(188) Freeburg - chopped in half
21.(189) Lori's Mother - stabbed
22.(190) Linderman - impaled on shelf bracket
23.(191) Kia - slashed to death; thrown into tree

Friday the 13th
kill number 7
- Brenda (Laurie Bartram)

Friday the 13th
kill number 8
- Steve Christy
(Peter Brouwer)

Friday the 13th
kill number 9
- Bill (Harry Crosby)

Friday the 13th
kill number 10
- Pamela Voorhees
(Betsy Palmer)

BOOKS

Armstrong, Kent Byron. *Slasher Films: An International Filmography, 1960-2001*. North Carolina: McFarland & Company, 2003.

Avallone, Michael. *Friday the 13th Part 3: 3-D*. Tower & Leisure Sales Co., 1982.

Clover, Carol J. *Men, Women, and Chain Saws*. Princeton University Press, 1993.

Dika, Vera. *Games of Terror: Halloween, Friday the 13th, and the films of the Slasher Cycle*. Fairleigh Dickinson University Press, 1990.

Gelder, Ken. *The Horror Reader*. Routledge, 2000.

Hawke, Simon. *Friday the 13th*. New American Library, 1987.

Hawke, Simon. *Friday the 13th Part VI: Jason Lives*. New American Library, 1986.

McCarty, John. *John McCarty's Official Splatter Movie Guide: Hundreds More of the Grossest, Goriest, Most Outrageous Movies Ever Made*. St. Martin's Press, 1992.

Morse, Eric. *Mother's Day: Friday the 13th, Book 1*. Berkley Publishing Group, 1994.

Skal, David. *The Monster Show: A Cultural History of Horror*. Penguin USA, 1994.

Szulkin, David A. *Wes Craven's Last House on the Left: The Making of a Cult Classic*. FAB Press, 1997.

Waller, Gregory A. *American Horrors: Essays on the Modern American Horror Films*. University of Illinois Press, 1988.

Wells, Paul. *The Horror Genre*. Wallflower Press, 2001.

Whitehead, Mark. *Slasher Movies*. Trafalgar Square, 2000.

MAGAZINES

Arnold, A.M. "Today's horror movies are just that - horrible." *Seventeen*, July 1982.

Chute, David. "Tom Savini: Maniac (special effects in horror films)." *Film Comment*, July-August 1981.

Everitt, David. "After The Final Chapter: Friday the 13th: A New Beginning." *Fangoria*, May 1985.

Grove, David. "Crystal Lake Memories." *Fangoria*, May 2002.

------- "Fruet of the Doom." *Fangoria*, June 2002.

------- "New Line wraps on Freddy Vs. Jason." *Rue Morgue*, January-February 2003.

------- "Freddy Vs. Jason." *Hot Dog*, March 2003.

------- "Freddy and Jason locked in arms race." *Cinescape*, April 2003.

------- "When sequels collide." *Rue Morgue*, March-April 2003.

------- "Resurrection." *CFQ* (online), June 2003.

------- "Freddy Vs. Jason." *Firelight Shocks*, Summer 2003.

------- "Freddy the Thirteenth." *Dark Side*, July 2003.

Martin, Bob. "Friday the 13th: A Day for Terror." *Fangoria*, June 1980.

McCarthy, Todd. "Trick and Treat." *Film Comment*, January-February 1980.

Rogal, J.C. "Harry Crosby - just taking off as an actor." *People*, June 30, 1980.

Scapperotti, Dan. "Danny Steinmann on directing Friday the 13th: A New Beginning." *Cinefantastique*, October 1985.

Shapiro, Marc. "The Women of Crystal Lake - Part One." *Fangoria*, June 1989.

------- "The Women of Crystal Lake - Part Two." *Fangoria*, July 1989.

Werner, L. "Horror Movies: Why we love to scream in the dark." *Glamour*, February 1980.

Page references in **bold** refer exclusively to illustrations, though pages referenced as text entries may also feature relevant illustrations.

ISBN 0-9529260-6-7

ISBN 1-903254-23-X

ISBN 1-903254-34-5

ISBN 1-903254-17-5

ISBN 1-903254-01-9

ISBN 1-903254-33-7

ISBN 1-903254-36-1

ISBN 1-903254-21-3

ISBN 1-903254-13-2

ISBN 1-903254-04-3

ISBN 1-903254-25-6

ISBN 1-903254-30-2

ISBN 1-903254-15-9

ISBN 1-903254-32-9

ISBN 1-903254-26-4

ISBN 1-903254-10-8

For further information about these books visit our online store, where we also have a fine selection of excellent DVD and soundtrack CD titles from all over the world!

www.fabpress.com